D1163793

COMPANY
DRAWINGS
in the India Office Library

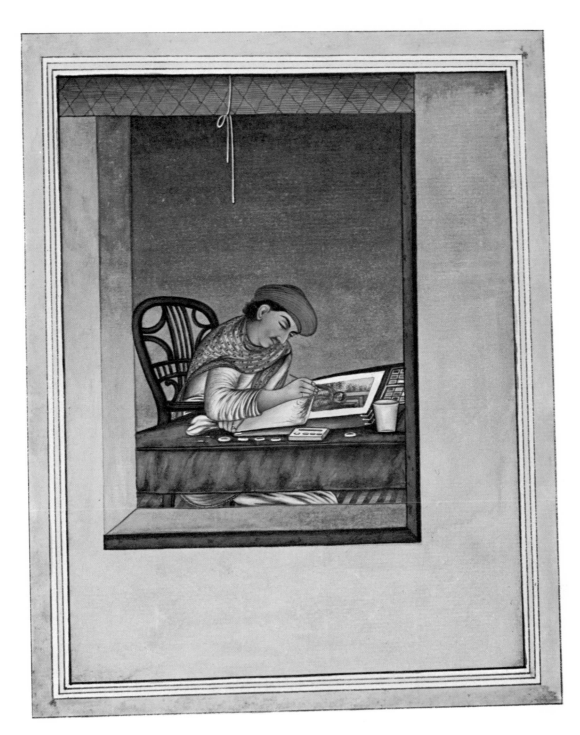

A An artist at work. Lucknow, *c.* 1815-20

COMPANY DRAWINGS

in the India Office Library

MILDRED ARCHER

LONDON
HER MAJESTY'S STATIONERY OFFICE
1972

(UD)
NC
327
.I52
1972

© Crown copyright 1972

Published by
HER MAJESTY'S STATIONERY OFFICE

To be purchased from
49 High Holborn, London WC1V 6HB
13A Castle Street, Edinburgh EH2 3AR
109 St. Mary Street, Cardiff CF1 1JW
Brazennose Street, Manchester M60 8AS
50 Fairfax Street, Bristol BS1 3DE
258 Broad Street, Birmingham B1 2HE
80 Chichester Street, Belfast BT1 4JY
or through booksellers

SBN 11 880422 7*

WITHDRAWN
LOYOLA UNIVERSITY LIBRARY

Printed in England for Her Majesty's Stationery Office by William Clowes & Sons, Limited, London, Beccles and Colchester
Dd. 501034 K.16

Preface

In this catalogue of drawings in the India Office Library, the third of a series, Mrs Mildred Archer, Assistant Keeper for Prints and Drawings, lists and describes the drawings made by Indians for British and other European patrons and clients. To this genus of Indian art, with its many local species, the name Company painting has become attached by reason of the East India Company's predominant position in the life of India in modern times and of the British in India. Company painting made its first appearance in the Madras Presidency in the early eighteenth century, and spread to Eastern India, moving from there across the North to reach Western India. It began to decline in the second half of the nineteenth century, lingering on here and there into the twentieth. By the time British rule was brought to an end, it had virtually ceased to exist.

The Library's collection, the largest and most comprehensive in the world, with some 2,750 drawings spanning the entire history of Company painting, is of great interest in showing how the Indian painter adapted his traditional skill and outlook to Western taste, techniques, media, and choice of subjects. The value of the collection and of this catalogue is not however restricted to the contribution which they can make to the study, hitherto almost entirely neglected, of this branch of Indian art. Company painting has a wider intellectual appeal. Since Independence, many scholars have investigated the political, social and cultural interactions between the West and the Indo-Pakistan sub-continent; but the role played by the visual arts, including Company painting, in this complex historical relationship has received little attention.

Aside from their artistic interest, the Company drawings are a valuable adjunct to other research collections in the India Office Library and Records. They depict in great detail certain aspects of the British way of life in India, especially British houses, servants and modes of travel. They serve accordingly as authentic contemporary illustrations for numerous letters, journals, travel narratives and other writings both in the Library's older printed books and in its European manuscript collections.

The drawings also record many features of the Indian scene and of the life of the Indian peoples which aroused the interest and curiosity of the British resident and visitor – costumes, crafts and castes, conveyances, religious festivals, social customs, the life of town and countryside, and buildings, particularly Mughal monuments. As the indexes to the Catalogue show, the Company painters, in

146781

meeting the British demand, were especially prolific in the depiction of trades, occupations, tools and economic processes. In this way they recorded and illuminated the economy and technology of a traditional civilisation which had endured almost unchanged for a millennium but which is today fast vanishing under the impact of Western values and industrial modernisation.

<div style="text-align: right">

S. C. SUTTON
Director

</div>

30 September 1971

Acknowledgements

In preparing the present catalogue I have relied on much oral information given to me in India by the following descendants of Company painters: at Patna, by Ishwari Prasad, Mahadev Lal, Radha Mohan and Shyam Bihari Lal; at Benares, by Rajaram Varma, and Sarada Prasad; and at Delhi, by M. Hasankhan Khurshed Hasankhan, a miniature painter of Chandi Chowk. In addition, Mr T. S. Dandapany of Madras recalled many traditions of the Tanjore painters, and Rai Krishnadasa, founder and Director of Bharat Kala Bhawan, supplied me with detailed information concerning Company painters at Benares. It is significant that whatever manuscript records have since come to light have in each case confirmed the accuracy of this oral evidence.

Besides these generous informants, I am deeply grateful to the following scholars for advice on inscriptions: Miss Jean Watson who has been continually helpful in translating from the Persian and in discussing Islamic subject matter, Dr Katherine Whitaker and Mr J. F. Ford, C.M.G. (Chinese), Dr J. R. Marr (Tamil), Dr A. Master, C.I.E. (Western Indian dialects) and Professor B. N. Goswamy (Hindi). For generous information on military uniforms I am indebted to Mr W. Y. Carman of the National Army Museum. Throughout I have been indefatigably helped by my colleagues on the staff of the India Office Library and Records. Above all I must thank my husband who first studied Company painting with me when we were stationed in Patna from 1941 to 1942, and who has patiently investigated its history with me since.

Mildred Archer
April 1970

Contents

Contents

Illustrations

COLOUR

MONOCHROME

Illustrations

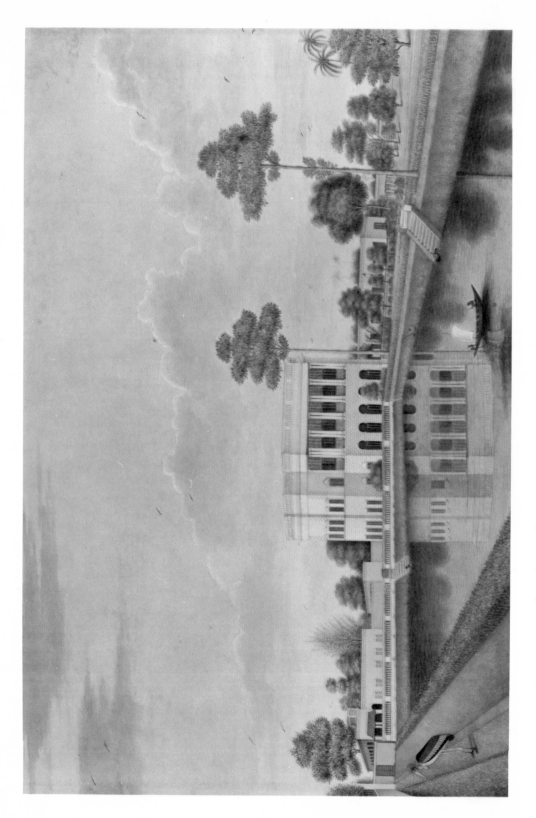

B House and garden, Calcutta. By Sheikh Muhammad Amir of Karraya, Calcutta, c. 1845

Introduction

Since the early years of the century the term 'Company Painting' has been used by Indian art-historians to denote a special kind of eighteenth- and nineteenth-century Indian painting. This painting was mainly a product of the British connection and, despite many local differences of manner, it illustrated a single phenomenon – an attempt by Indian artists to adjust their styles to British needs and to paint subjects of British appeal. Four main trading Companies – British, French, Dutch and Danish – were operating in India during the eighteenth century, but it was the British East India Company, familiarly known as 'John Company', whose servants were the chief patrons of this new kind of painting.

By the end of the eighteenth century the East India Company had assumed broad political and administrative functions in India. Large numbers of the British were going there, many of them no longer the tough adventurers and traders of earlier days, but people of greater education and from more cultured backgrounds. They went in the capacity of civil and military officers, lawyers and surgeons, and were often accompanied by their wives and families. They took with them the cultivated interests of their time. The late eighteenth and early nineteenth centuries were a period when knowledge of the world was rapidly expanding and there was a lively curiosity concerning the countries of the east. Many of the new arrivals shared the fashionable interest in 'the picturesque' and 'the exotic', and for those whose families had already served in India there was added a personal incentive. As Captain Bellew wrote, 'Long before the period of my departure arrived – indeed I may say almost from infancy – I had been inoculated by my mother, my great uncle, and sundry parchment-faced gentlemen who frequented our house, with a sort of Indo-mania. I was never tired of hearing of its people, their manners and dress. . . . What respect did the sonorous names of Bangalore and Cuddalore, and Nundy Droog and Severn Droog and Hookahburdars and Soontaburdars, and a host of others, excite in our young minds.'[1]

On arrival in India, many other human reactions added to the impact. There was a patriotic pride in the grand appearance of Fort St. George and Fort William with their Palladian-style mansions. 'The river', wrote Maria Graham of Calcutta, 'was covered with boats of every shape, villas adorned the banks, the scene became enchanting, all cultivated, all busy, and we felt that we were approaching a great capital. On landing, I was struck with the general appearance of grandeur in all

[1] Captain Bellew, *Memoirs of a Griffin* (London, 1843), 7–8.

the buildings; not that any of them are according to the strict rules of art, but groups of columns, porticoes, domes and fine gateways, interspersed with trees, and the broad river crowded with shipping, made the whole picture magnificent.'[2]

This discovery was enhanced by the brilliance and strangeness of the new environment. As Mrs Fay stepped off the boat at Madras in 1780, she noted, 'Asiatic splendour, combined with European taste [is] exhibited around you on every side, under the forms of flowing drapery, stately palanquins, elegant carriages, innumerable servants, and all the pomp and circumstance of luxurious ease, and unbounded wealth.'[3] And when the British ventured into the Indian parts of the towns, they were excited by the varied crafts and costumes which surrounded them. Lady Nugent noticed how 'copper vessels, crockery, rice, sugar, gods and goddesses, knives, muslins, silks ... were all displayed together – all sorts of coloured turbans and dresses, and all sorts of coloured people – the crowd immense – the sacred Brahmin bull walking about and mixing with the multitude.'[4]

Such experiences resulted in vivid impressions, but as the British penetrated more deeply into India, their sense of the exotic was further increased. They travelled up the great rivers and saw strange kinds of shipping – high-prowed country boats piled with bales, and Indian pleasure boats with peacock or crocodile heads. As they moved through the towns and villages they chanced upon picturesque festivals – the Muharram with brightly coloured *ta'ziyahs* being carried through the streets, or the Hook-swinging with devotees being whirled through the air. They saw bridegrooms riding to their marriages, and corpses carried to the burning ghats. Each season had its festivals gay with processions and with dancing crowds, and every city its individual character. Among these, Benares had a special fascination with its 'temples, idols, garlands, bells, conchs, Brahmins, fakeers.' Every sight and sound recalled 'the strange and ancient superstition of the place,'[5] and communicated an air of awesome mystery.

The ancient buildings of India also aroused enthusiasm in minds alerted to 'the picturesque'. The richly carved Hindu temples of South India impressed the British with their grandeur and complexity, but it was the Mughal architecture of Delhi and Agra which moved them most deeply with its shining white marble, delicate pietra dura work, pierced screens and swelling domes. The Taj Mahal, in particular, was viewed through a romantic haze. The ruined and dilapidated state of many of these monuments merely added to their glamour, for, as Mountstuart Elphinstone wrote, 'the mosques, the minarets, tombs and gardens of so many Mohammedan cities, the marble courts of the Palace of the Moguls,

[2] Maria Graham, *Journal of a residence in India* (Edinburgh, 1812), 132.
[3] Eliza Fay, *Original letters from India* (Calcutta, 1817), 221.
[4] Maria Nugent, *A Journal from the year 1811 till the year 1815* (London, 1839), i, 111.
[5] T. E. Colebrooke, *Life of the Hon. Mountstuart Elphinstone* (London, 1884), 335.

peopled with the recollections of former times, and surrounded with the remains of fallen greatness, could not but affect the imagination.'[6]

Emotions of this kind made a strong impact on the more intelligent of the British in India. Some were able to convey their excitement through letters; others published their memoirs. But for many, pictures were the best record and became one of their most valued possessions. John Bellasis, an enthusiastic amateur artist, remarked, 'my portfolio of drawings are thought a great treasure here. I take great care of them.'[7] The more talented of the British could themselves make drawings, but those who did not possess this skill turned to Indian artists to provide them with pictures of subjects which, whether for emotional, intellectual or purely personal reasons, excited them. 'I intend to get drawings of everything. . . . I mean to begin a collection of curiosities of all sorts, drawings, etc. for my dear children', exclaimed Lady Nugent; and the first time she went out in a tonjon with a cavalcade of out-runners she wrote, 'I mean to have a drawing of this procession.'[8] She was typical of many British men and women who were anxious to acquire pictures of the new environment into which they had suddenly been transported.

At first sight the procuring of paintings from Indian artists did not appear unduly difficult. With the collapse of the Mughal empire and the gradual break-up of the provincial administration, Indian painters who had previously been employed by Indian patrons were seeking more lucrative employment. They were willing to move to the main British settlements and work for the foreigners. But the British had strong views about the nature of art, and the following comments by various people show how painting as practised by Indian artists did not immediately satisfy them.

George Forster complained, 'The Hindoos of this day have a slender knowledge of the rules of proportion, and none of perspective. They are just imitators, and correct workmen; but they possess merely the glimmerings of genius.'[9]

Charles Francis, a Bengal doctor, met a Hindu painter in the Punjab and commented, '[He is] a man of very considerable taste for miniature painting. Some of his likenesses . . . were exceedingly faithful [but] like the whole race of artists in India, he is deficient in a knowledge of all those refinements of the art, which are to be acquired by the taste being rightly directed, and by the diligent study of first-rate works; by education in fact. When the value of an acquaintance with the intellectual treasures of England is universally diffused throughout India, it is to be hoped that native artists will find means of becoming more generally en-

[6] *Ibid*, i, 335.

[7] J. B. Bellasis, 'Scratchings from an Indian Journal, 1821–40', *Photo Eur.* 35, 34.

[8] Maria Nugent, *op. cit.*, i, 90, 109, 130.

[9] G. Forster, *A Journey from Bengal to England* (London, 1798), i, 80.

lightened upon those branches of their profession, in which at present they are so deficient.'[10]

Tennant noted that the arts 'are conducted by no scientific principles, and the effect produced is the result of patient exactness, or a happy knack, rather than of a well conceived design.' He quoted the Frenchman, Sonnerat: 'La peinture chez les Indiens est, et sera toujours dans l'enfance: ils trouvent admirable un tableau chargé de rouge et de bleu, et dont les personnages sont vêtus d'or. Ils n'entendent point le clair obscur, n'arrondissent jamais les objets, et ne savent pas les mettre en perspective; en un mot leurs meilleures peintures ne sont que de mauvaises enluminures.'[11]

Thomas Twining, a Bengal civilian, considered that 'the merit of their drawing is almost confined to a very accurate imitation of flowers and birds. I never saw a tolerable landscape or portrait of their execution. They are very unsuccessful in the art of shading, and seem to have very little knowledge of the rules of perspective'.[12]

The same limitation was echoed by Michael Symes who, while in Burma, lamented that Indian artists showed no interest in landscape painting. 'How much I regretted that my draftsman, though skilful in copying figures and making botanical drawings, was unacquainted with landscape painting and perspective.'[13]

Yet, despite such basic deficiencies, Indian painters were not regarded as wholly ill-equipped and from time to time some of the British were almost generous in their praise. Michael Symes himself was delighted with the way his Bengali draftsman drew the costumes of the Burmese. 'The representations of the costume of the country, I am persuaded, are as faithful as pencil can de-lineate: the native painters of India do not possess a genius for fiction, or works of fancy; they cannot invent or even embellish, and they are utterly ignorant of perspective; but they draw figures and trace every line of a picture, with a labori-ous exactness peculiar to themselves.'[14]

Baden Powell, a Punjab Civil Servant and lover of Indian handicrafts, was also aware of the Indian artist's qualities. 'In common with the inhabitants of lower India, [the artist of the Punjab] has an instinctive appreciation of colour, and, though without any knowledge of the principles which should regulate its use, is often more happy in his combinations than the educated workman of Europe. His colour is often exaggerated but it is always warm, and rich and fearless. The native artist is also patient: for weeks and months he will work at his design,

[10] C. R. Francis, *Sketches of native life in India* (London, 1848), 26–27.

[11] W. Tennant, *Indian recreations* (London, 1804–08), i, 298.

[12] T. Twining (ed. W. H. G. Twining), *Travels in India a hundred years ago* (London, 1893), 459.

[13] M. Symes, *An Account of an embassy to the Kingdom of Ava sent by the Governor-General of India in the year 1795* (London, 1800), 252.

[14] *Ibid*, Preface, xi.

painfully elaborating the most minute details; no time is considered too long, no labour too intense to secure perfection in imitation or delicacy in execution. The greatest failing in native artists is their ignorance of perspective and drawing, and it is fortunate that this want is the most easy to supply.'[15]

These words were only too true. Indian artists were amenable and adaptable and soon realised what their new patrons desired. Through a number of different channels and sources they came into contact with work by British artists both professional and amateur, and were able to acquire the necessary European skills.

Certain Indian artists began to work for the East India Company itself as draftsmen to engineer officers. They were trained in map-making or in preparing architectural drawings. In this way they learnt the use of pen-and-ink and wash, drawing to scale and making precise plans and elevations of buildings which sometimes involved the use of perspective. Other painters were employed as draftsmen on official surveys and missions in the course of which they prepared topographical, archaeological and natural history drawings or made paintings of the local people, their costumes and crafts. Certain Company institutions, such as the Sibpur Botanic Garden and the Barrackpore Menagerie, employed draftsmen for highly specialised work. These draftsmen all came into close contact with British officers who sometimes took great pains to instruct them in the relevant techniques. At Benares, Markham Kittoe is still remembered for the way in which he trained Benares painters to help him with designs for the new Sanskrit College and for his record of local monuments and sculpture.

Indian artists were also employed as assistants by certain European professional artists, especially in the production of engravings from their work. Baltazard Solvyns, for example, undoubtedly recruited Indian painters to help him colour the prints for his vast work *A Collection of 250 coloured etchings; descriptive of the manners, customs, character, dress, and religious ceremonies of the Hindoos* which he produced in Calcutta between 1796 and 1804. It seems probable that Thomas Daniell also used Indian artists to help him with the aquatints for his *Views of Calcutta* (1784–86). As printing presses became more common in the larger Indian cities, so Indian artists were employed to etch or lithograph drawings by Europeans for publication. The lithographs for James Prinsep's *Benares illustrated in a series of drawings* were first produced in Calcutta in 1831 and drawn on the stone by Indian craftsmen.

Amateur artists also made use of Indian painters to assist them. One of the most energetic of these amateur artists was Sir Charles D'Oyly who, while he was stationed at Patna, set up a lithographic press to reproduce not only his own drawings but those of an enthusiastic circle of amateurs living in Bihar. A Patna painter, Jairam Das, was entrusted with this work and there is no doubt that he, together with a number of his castemen, received direct instruction from D'Oyly

[15] B. H. Baden Powell, *Handbook of the manufactures and arts of the Punjab* (Lahore, 1872), 355.

and were shown a wide range of work by Europeans. The results were soon noticed by Captain Smith, of the 44th Regiment, who was himself a talented painter. Patna was quite celebrated, he says, 'for productions of the pencil, through, I was informed, the fostering care of Sir C. D'Oyly, who has endeavoured, and with great success, to inspire the natives with some of his own pure taste and artist-like touches, instead of the hard dry manner of the Indian painters. I was much pleased with what I saw.'[16]

Emily Eden, sister of the Governor-General, Lord Auckland, employed Indian artists to copy her drawings. She was well known for her lively sketches and needed copies which she could distribute to friends. It is clear that Indian artists were readily available for this work and her only difficulty was to curb their enthusiasm. 'Azim, the best painter, is almost a genius; except that he knows no perspective, so he can only copy. He is quite mad about some of my sketches, and as all miniatures of well-known characters sell well, he was determined to get hold of my book. There is a fore-shortened elephant with the Putteealah Rajah in the howdah, that particularly takes his fancy. However, I do not want them to be common, so I cut out of the book those that I wish to have copied, and I never saw a native so nearly in a passion as he was, because he was not allowed the whole book.'[17]

Occasionally private patrons commissioned Indian artists to copy pictures for them. Colonel Gentil in Faizabad employed an Indian painter to copy some of Tilly Kettle's large oil portraits of the Nawab 'in small' for him. Others such as Sir Elijah and Lady Impey retained several artists to make natural history drawings for them, and there is little doubt that they supervised the work closely and had it done to their precise instructions.

Quite apart from these various forms of direct contact, there were indirect ways in which Indian artists could observe, study and copy European techniques. With the constant changing of British personnel in India, illustrated books and prints were frequently sold in the sale-rooms and in the bazaars. Among them were works such as William Hodges' *Select Views* (1785–88) and Thomas and William Daniell's *Oriental Scenery* (1795–1808); and from such collections Indian painters with initiative could quickly find models.

Stimulated, then, by apprenticeship to Company servants, the deliberate copying of British originals, the study of prints and water-colours, and even by direct instruction, Indian painters began to modify their traditional techniques in a British direction. They gave up using gouache, which Europeans found hard and dry, and began to paint in water-colour on European paper. They ceased to paint on a prepared ground and learnt to draw in pencil or sepia wash direct on

[16] Captain Robert Smith, 'Pictorial journal of travels in Hindustan from 1828 to 1833', Indian Section, Victoria and Albert Museum, MSS, I.M. 15-1915, 118, 29 January 1829.
[17] Emily Eden (*ed.* E. J. Thompson), *Up the country* (Oxford, 1937), 264.

6

to the paper. They modified their colour, tempering brilliant reds, oranges and pinks with sombre sepia, indigo blue and muted greens. Flat patterns with bright patches of colour were replaced by rounded forms, light and shade being indicated with soft washes of colour. Different planes were also represented by perspective of the western type. At the same time, they devised subject-matter calculated to interest the British. Free-lance painters, working either singly or as family groups or 'shops', made their appearance, and the type of Indian painting known as 'Company' gradually emerged at all the main centres in India with sizeable British communities.

The first region to produce Company painting was the Madras Presidency in the South. Tanjore was a centre of traditional Indian painting and in the second half of the eighteenth century its artists gradually adjusted their style and subject-matter to suit British taste. Their methods were adopted by painters in Madras, Trichinopoly and Pudukkottai. A little later, Company painting appeared in Eastern India. In the last quarter of the eighteenth century, Indian artists at Murshidabad were producing pictures on a commercial scale for the British and this development was soon followed by the growth of Company painting in Calcutta and Patna, with offshoots at Cuttack, Chapra and Arrah, and, a little later, in Benares and Oudh. In the early years of the nineteenth century, painters at Delhi and Agra developed local styles and their example was followed in Lucknow and the Punjab. It was not until the second quarter of the nineteenth century that the new trend reached Western India.

With certain marked exceptions, Company painting took much the same form in every centre. The favourite subjects were costumes, trades, crafts, methods of transport and festivals, and to these were added, at times, Hindu deities and temples. Such subjects, arranged in sets, provided a conspectus of social life in India and, whether harsh and garish in style as in the South, or mild and soft as in the North and East, the pictures recorded in pseudo-British terms the exotic environment in which Company officers and their successors lived. In these sets, each trade, craft or occupation was shown with identifying attributes – a brick-layer with measure and trowel, a shoe-maker with awl and shoe, a cook with a chicken and a kettle – and in this way the British obtained a convenient guide to social and economic types. In the earliest stages, the inhabitants of towns and villages, rather than of their own bungalows and compounds, excited British attention, and it was the quaintness, the enigma, even the frenzy of India and its people which were chiefly emphasised in the pictures. Later, as India lost its first strangeness and, to many of the British, became as much their home as England, the bizarre was replaced by the gentle, and household servants – their tasks as clearly demarcated as those of any trade unionist today – became a favoured topic. It is noteworthy that whereas trades-people in the bazaar, members of a procession or participants in a festival were often depicted with hollow, anxious eyes, their straining figures racked by poverty, domestic servants were normally

presented with quiet dignity and unobtrusive grace. Their smooth unhurried postures and flowing robes suggested the calm assurance of British establishments whose owners were at one with India and whose Palladian-style mansions reflected the same cool poise.

This concentration on servants normally involved their reduction to certain standard types: each servant was depicted with the same kind of face and figure, and individuality was reduced to a minimum. But in certain instances painters transcended the general and produced for their patrons more intimate surveys of their households. Colonel Gilbert, moving between Hazaribagh in Chota Nagpur and Sambalpur in Orissa, availed himself of a Company painter to portray his clerks, table-servants and housemaids. Colonel Skinner at Hansi, north-west of Delhi, engaged Company artists from Delhi to depict his 'Yellow Boys', tent-pitchers, cultivators, and even his private troupe of dancing-girls. In Delhi Ochterlony was portrayed by a Company artist in a British-style bungalow with British portraits hanging on the walls and a group of dancing-girls performing before him. In Calcutta, Lady Impey hired a Company painter to depict the interior of her mansion, with her servants busy at their chores and her nurse-maids playing with her children.[18] Pictures of this kind were no mere record of private life in an exotic country – a drab study of manners, habits or customs – but vivid records of the actual persons with whom daily life was spent and on whose quiet devotion, comfort in India depended. It is no surprise that, just as in standard sets of pictures, typical servants are painted with ceremonious poise, particular servants are shown at times with almost noble gravity, the painter contriving to interpret in his hybrid manner the whole status of a servant in a Company household.

The same tendency is noticeable in studies of transport. Besides sets of trades and occupations, Company painters supplied their British clients with pictures of Indian conveyances – ekkas, tonjons, raths, palanquins, bullock-carts and elephants. These were as integral a part of exotic India as the hookah-burdars and silver-stick bearers whose picturesque functions had guaranteed their inclusion in sets of trades and crafts. In most cases, generalised examples were all that were needed, but at times a Company civilian or a military officer demanded a more personal record. The painter would then attend at his house and portray not only the horses which drew his carriages or which he raced, but the vehicles in which he and his family would take the air. In such cases, the names of the horses were often recorded and in this way we meet the race-horse, Barrister,[19] and the carriage horses, Hermit, Maggy and Lauder, owned by some long-forgotten Calcutta resident.

One further type of social document must be noted. As the British extended

[18] See Mildred Archer, 'British patrons of Indian artists', *Country Life*, 18 August 1955, 340.
[19] See Mildred and W. G. Archer, *Romance and poetry in Indian painting* (London, 1965), no. 79.

their power, visited Indian courts and established Residencies, they came into contact with Indian rulers – in Delhi, with the Mughal Emperor, in Murshidabad and Lucknow, with Muslim Nawabs, or as Gilbert found in Sambalpur, with a local raja. Artists were at times deputed or commissioned to commemorate durbars, levées, banquets and entertainments, and in this way a third type of subject entered Company painting. The pictures which resulted showed British officers and, in some cases, their wives mixing on terms of affable equality with their Indian counterparts and at times being entertained in a pseudo-British fashion. Of all courts Lucknow was the one which most rapidly adopted British social conventions, and we see Ghazi-ud-din Haidar seated at table with Lord and Lady Moira, and Wajid Ali Shah celebrating Lord Hardinge's visit with a levée. In Delhi, the Mughal Emperor clung to his titular supremacy, and dinners of the Lucknow brand were therefore unknown. It was rather in long ceremonial processions headed by the Emperor or in densely packed durbars that British Residents and their aides made a dignified appearance. In style these records of state occasions tended to reflect indigenous forms of painting, but even here perspective and portraiture of a British kind were resolutely present.

In contrast to subjects of a human or social interest, there were buildings, monuments and ruins, the other chief topic explored by Company artists. At Delhi and Agra, Muslim architecture epitomised in stone the romantic novelty of India, and at the end of the eighteenth century, and for much of the nineteenth, Indian painters recorded the most famous of the local monuments. Until 1803 when the British reached Delhi in force, only some of these structures were depicted and then mainly in the form of pastiches based on Hodges' pioneering views. The Company painters responsible had come from Murshidabad to Calcutta and it was possibly as part of their exploration of British needs and their desire to master new techniques that they embarked upon these ventures. Once the British had begun to live in Delhi and Agra, pictures of this kind became obsolete, and it was rather to local artists, trained in part by British engineers, that they turned. In drawings such as those of the Taj Mahal and of Itimad-ud-daula's tomb at Agra, to cite only the more striking examples, there are certain marked characteristics – exaggerated perspective, a passionless preoccupation with detail, a deep regard for minute and intricate shapes. Although the paintings are in no way an atmospheric or picturesque evocation of the buildings, they record with exquisite skill that etherial and lace-like delicacy of ornament which the British most valued in Indian architecture.

By the second half of the nineteenth century, Company painting had reached its apogee and, although it was to linger on until the twentieth century, especially in the form of paintings on ivory and mica, miniature paintings on paper went gradually out of fashion. Various circumstances explain their dwindling production. The coming of the camera spurred some of the British to make their own records of the Indian scene; but even more, the growing industrialisation of

India undermined the role of traditional artists. It is no accident that, at a time when miniature painters were losing their livelihood at Rajput courts, painters for the British were also facing extinction.

Today, Company painting must be regarded from two distinct angles – Indian and British. In terms of Indian painting, it is the last original contribution by Indian artists before the modern deluge. Its use of water-colour as a technique, its adoption of western-style perspective, its cult of realism and its concentration on the common people as prime subjects for painting broke sharply with prevailing conventions. In this respect, it is a clear precursor of modern trends and the first step towards that westernisation of style which is now a commonplace of contemporary Indian art. For the British, its appeal is more sentimental. As a panorama of the India in which their ancestors found delight, comfort and fulfilment, it evokes nostalgia for a charmed era. It records romantic fragments of a great, exotic whole – a whole by which not only British pockets but British minds were enriched. Above all, it supplements, in authentic Indian fashion, the paintings of India made by British artists. In these pictures, the 'wonder that was India' evoked British homage, and to such appreciation, Company painting supplies a vivid and lively appendage.

CATALOGUE

Introductory Note

Drawings by Indian artists in the India Office Library are conserved in two groups. The first is known as the 'Johnson Collection'. This consists of 64 albums of Indian and Persian paintings and calligraphy which were purchased from the widow of Richard Johnson by the East India Company in 1807 for its new Library. Johnson (died 1807) served the Company from 1770 to 1790 and was one of the first British collectors of Indian miniatures. Because of its great size and its historical significance, this collection has been kept as a separate entity and in Johnson's original arrangement.

The second group – the 'Additional Oriental Collection' – consists of smaller collections and separate pictures or albums that have been acquired by gift or purchase at various times since the founding of the Library. Each of these pictures is distinguished by a separate number (e.g. *Add. Or. 1*). Apart from a few Indian and Persian miniatures, as well as some examples of Indian village painting, the greater part of the Additional Oriental Collection consists of Company paintings (see p. 7). Further paintings of the same type, although few in number, are to be found in the European and Persian manuscript collections, as well as in a series of albums, consisting chiefly of photographs, which were assembled by the Library at the end of the nineteenth century. These volumes illustrate subjects such as 'The People of India', 'Costume', 'Jewellery', 'Arms and Armour', and are here referred to as 'India Office Albums'. The paintings in these volumes appear to have been sent to England for use in the exhibitions of the late nineteenth century to illustrate Indian handicrafts. Most of the Company paintings in the Library's collection are by Indian artists, but a few come from Nepal and China.

The present Catalogue describes all the Library's Company paintings, classifying them according to the area in which they were painted, and, within each area, chronologically. Each geographical section is prefaced by a historical note and a bibliography. In citing the names of towns, monuments and rulers long known to the British the popular form current during the British period has been used. Similarly the location of places is based on the administrative units of the British period. In the catalogue entries, inscriptions on drawings are indicated by italics. Dimensions are given, height before width, in inches to the nearest quarter of an inch.

For books dealing with the social background of Company painting and the attitude of the British in India to art, the reader is referred to detailed bibliographies given in Mildred and W. G. Archer, *Indian painting for the British, 1770–1880* (Oxford, 1955) and in Mildred Archer, *British drawings in the India Office Library* (London, 1969), volume II.

I South India

(i) MADRAS

Painting for Europeans in a style modified to suit European taste appears to have grown up earlier in South India than in any other part of the continent. During the first half of the eighteenth century, Madras was the most important of the British settlements and the first to grow to any size. It was a far busier trading centre than Bombay or Calcutta and by 1715 already had a population of 100,000.

As early as this date, paintings were being specially produced for Europeans in Madras. About 1702, seventy-eight paintings were made by an Indian artist for Niccolao Manucci, the Italian adventurer who after an eventful life had settled in Madras in 1686 and was busy writing his *Storia do Mogor*. In the first years of the eighteenth century he was engaged on the fourth volume of this work which described Indian manners and customs, and he wanted illustrations for it which he could despatch with the manuscript to Europe. The paintings (now in the Biblioteca Nazionale di San Marco, Venice) illustrate a number of subjects discussed by Manucci. They include amongst others Hindu gods and goddesses, ceremonies and religious festivals, men and women of different castes, the temple at Conjeeveram, and decorated temple-cars. These pictures are in a mixed style. They preserve certain characteristics of Golconda painting of the early seventeenth century which had spread to the south – figures with rugged profiles and swaggering stances, skies streaked with horizontal clouds, and backgrounds filled with sprigs and flower tassels. At the same time they already show marked European influences. They are on European paper and are painted not in gouache but in water-colour in sombre shades of grey, brown, dull green and red with only occasional touches of yellow and blue. The backgrounds are uncoloured and shading is used. There is also a note of exaggeration, amounting almost to caricature in the figures. It is clear that the artist was endeavouring to provide Manucci with the sort of picture he required.

As the century proceeded European influences in Madras rapidly increased, especially during the four Mysore Wars of 1767 to 1799. At that time Madras was a military arsenal and was filled with British troops in the employment of both the Crown and the East India Company. They patrolled South India and were garrisoned in many towns there. It was only natural that Madras should act as a magnet for craftsmen and painters, especially from Tanjore (*q.v.*), who hoped to

find employment of some kind in this flourishing and wealthy city. Some painters found work with the East India Company itself, as draftsmen and map-makers. During his surveys of Mysore and South India, Colonel Colin MacKenzie employed a number of Indian artists such as Shaikh Abdullah, Najibullah and Pyari Lal. Artists of this type, trained in a western manner, were always ready to execute commissions for Europeans in Madras.

A few examples of such work exist in the Library. A group of paintings depicting manners and customs (no. 2) appears to have been made for a German or Danish patron. Like Manucci's pictures, they are executed in sombre water-colour on European paper. Another set (no. 1), which can be dated to *c.* 1783, also appears to be an individual commission, for it contains two caricatures. Two more figure drawings in grey wash may possibly have been collected by Thomas Daniell while he was in South India in 1792 (no. 3). A picture of a European garden-house (no. 4) was probably made for its British tenant in about 1790. Finally, and showing that the process continued for many years, a painting of the costume of a Madras woman was specially made for the Paris Exhibition of 1867 (no. 5).

Apart from being executed in broken-down Indian styles with strong western influences, commissions of this type have no stylistic link, and were made by Indian artists who came from heterogenous backgrounds.

Bibliography

Archer, Mildred. 'Company painting in South India: the early collections of Niccolao Manucci', *Apollo*, August 1970, 104–113.

Archer, Mildred. *British drawings in the India Office Library* (London 1969), ii, 472–553.

Archer, Mildred and W. G. *Indian painting for the British, 1770–1880* (Oxford, 1955), 72–74.

Love, H. D. *Vestiges of old Madras, 1640–1800*, 3 vols. and index vol. (London, 1913).

Manucci, N. (trans. and ed. W. Irvine.) *Storia do Mogor or Mogul India, 1653–1708, by Niccolao Manucci, Venetian*, 4 vols. (London, 1907–8).

1 i–iii Three paintings from a set chiefly depicting occupations in South India.
By a Madras artist, *c.* 1783.
Gouache; orange borders with red rules.
Presented 1 July 1969; (i) and (ii) by Mildred and W. G. Archer; (iii) by Edwin Binney 3rd. *Add. Or. 2554–2556*

NOTE: These three paintings were part of a large set depicting occupations which also included two caricatures. Both caricatures had a Madras subject-matter which can be dated to 1782–83; see (iii). The set also included a picture of a Madras sepoy carrying a musket with the words 'HARISON. 1779', printed on the barrel. John Harrison was contractor to the Ordnance 1774–80. Although the style of these paintings closely resembles that of Tanjore painters, it is nevertheless a variant. It seems likely that the artist was of Tanjore origins but had settled in Madras and was executing an individual commission. Painting in Madras at this time appears to have been linked to

individual patronage. A set in the Victoria and Albert Museum (*I.S. 75(1–42)-1954*) dated 'Madras 1785' was made for 'J. P. Boileau Esq.' and contains pictures of occupations as in the present set, as well as two portraits of a European, probably Boileau himself.

i A Muslim scholar, greeted by an ascetic, is seated reading a book; another book is lying on a bookrest.
Inscribed: *34*.
Gouache; $9\frac{3}{4}$ by 7 ins. *Add. Or. 2554*

ii A mounted spearman, perhaps a Maratha.
Inscribed: *36*.
Gouache; 10 by $7\frac{1}{2}$ ins. *Add. Or. 2555*

iii Admiral Hughes, holding his three-cornered hat in his hand, stands facing Mrs Oakeley who wears a panniered dress and elaborate feathered head-dress.
Inscribed: *Admiral Hughs & Mrs. Oakeley. 64.*
Gouache; 10 by $7\frac{1}{2}$ ins. *Add. Or. 2556*

NOTE: Admiral Sir Edward Hughes (1720?–94) was Commander-in-Chief, East Indies, from 1779 to 1783. Mrs Helena Oakeley was the wife of Charles Oakeley who served in the Madras civil service from 1767 to 1794 and, as Sir Charles Oakeley, became Governor of Madras from 1792 to 1794. Between 1781 and 1784 he was President of the Committee of the Assigned Revenue of the Nawab of Arcot. This painting may be based on a British caricature of the time current in Madras, exposing a scandal involving Mrs Oakeley and Admiral Hughes.

Another caricature in the same series (Collection Edwin Binney 3rd, Brookline, Mass.) shows Sir John Burgoyne (Commandant of the 23rd Light Dragoons) portrayed as a bear, and Lord Macartney (Governor and President of Fort St. George, 1781–85) as a green monkey, approaching a table at which General Stuart sits holding a violin, his wooden leg projecting in front of him. Admiral Hughes is seated behind General Stuart with Mrs Oakeley and Mrs Sydenham (wife of William Sydenham of the Madras Artillery). Since General Stuart (Commander-in-Chief at Madras 1782–83) lost his leg at the battle of Polore in August 1781, and Admiral Hughes left Madras in 1783, the two caricatures would have been topical in *c.* 1782–83.

2 i–viii 8 drawings, originally pasted in an album but now mounted separately, depicting South Indian 'manners and customs'.
By a South Indian artist, probably at Madras, *c.* 1787.
Inscribed with titles and notes in English, and in some cases in German in Gothic script.
Wash and water-colour; various sizes.
Purchased by the East India Company from the widow of Richard Johnson 1807. *Johnson Collection, Album 63 ff.1–8*

NOTE: Richard Johnson (died 1807) was employed by the East India Company from 1770 to 1799, leaving India in 1790. He served as Resident at the Nizam's Court, Hyderabad, from 1783 to 1788. During his service he made a large collection of Indian manuscripts and miniatures which were purchased by the East India Company for its Library after his death. There is no record of how

Johnson obtained these particular drawings. The inscriptions suggest that they may have been collected by a German-speaking missionary in South India. Danish missionaries from Tranquebar and Tanjore, such as Heyne, Swartz and Gericke, were interested in Indian manners and customs and it is possible that one of them was instrumental in obtaining these drawings for Johnson. In the alternative he may have obtained them from a German-speaking merchant in the Dutch East India Company some of whose factories were in South India and Hyderabad.

I am indebted to Miss Nellie Kerling and Mr Christopher Smith for deciphering the almost illegible German inscriptions.

i An elephant with mahout, drummer and standard-bearer on its back.
 Inscribed: *An Elephant & Naggur.*
 Wash; 8 by 9¼ ins. *Johnson Album 63 f.1*
 NOTE: A 'Naggur' (*nagara*) is a form of large drum.

ii A hackery pulled by two oxen.
 Inscribed: *A Hickrie, the common conveyance of Gentoo & Malabar people who can afford to keep one*; in German: *Ein hiesiges Fahrzeug der vornehmen Schwarzen, dasz man Huckerie nennt* (A local conveyance of high class Blacks, which men call a hackery).
 Water-colour; 7 by 9 ins. *Johnson Album 63 f.2*

iii An Indian gentleman being carried in a palanquin (*Plate 1*).
 Inscribed: *A Gentoo Man in his Palankeen.*
 Wash; 7½ by 10 ins. *Johnson Album 63 f.3*

iv Coolie carrying a box on his head.
 Inscribed: *A Coolie.*
 Wash; 8¾ by 4¼ ins. *Johnson Album 63 f.4*

v Masula boat, Madras.
 Inscribed: *A Massula Boat, such as are used at Madras for crossing the Surf as no ship Boat can weather it*; in German: *Ein boot Mosuli boot genannt, womit man durch die brandung, durch die groszen Wellen geht, die hier zu sehen sind* (A boat, called a Masuli boat, with which people go through the surf and through the high waves, which you see here).
 Water-colour; 7¼ by 9 ins. *Johnson Album 63 f.5*

vi Irrigation; in the foreground gardeners at a well, in the background a Palladian house beside a tank and palm trees (*Plate 2*).
 Inscribed: *The machine (called a Pekota) by which the natives on the Coast of Choromandel draw water from rivers or wells to water rice fields or Gardens*; in German: *Art und Weise wie hier in Indien zur trockenen Zeit die Felder bewattret werden* (The way the fields are watered here in India in the dry season).
 Water-colour; 7 by 9¼ ins. *Johnson Album 63 f.6*

vii Women's jewellery as worn on the head, hands and feet.
 Inscribed: *Gentoo women's manner of ornamenting their heads, hands & legs*; in German: *So wie die vornehmsten Mädgen zu Händen und Füssen beringet sind,*

einige von Silber andere von Gold, die Ohr-ringe und Nasen ringe sind Allzeit von Gold (The way high-caste maidens wear rings on their hands and feet, some of silver, others of gold. The ear and nose rings are always of gold).
Water-colour; 4¾ by 7½ ins. *Johnson Album 63 f.7*

viii A dwarf and a leper.

Inscribed: *2 Lusus Natura objects at Madras*; in German: *Ein Zwerg. Ein Aussätziger. Von beyden Arten giebt es hier viel* (A dwarf. A leper. Of both kinds there are many here).
Wash; 7¼ by 4½ ins. *Johnson Album 63 f.8*

3 i, ii 2 drawings of figures.
By a South Indian artist, probably at Madras. *c.* 1790.
Purchased 15 December 1961. *Add. Or. 1948; 1949*

NOTE: In style similar to no. 2 which has a Madras provenance. The drawings originally came from the collection of Sir Henry Russell (1783–1852) and were in the same portfolio as no. 7. It seems probable, therefore, that they were included with the drawings of Thomas and William Daniell which were purchased in 1840 by Sir Henry Russell. The Daniells visited Madras in 1792 and may have acquired these drawings at that time.

i A young nobleman with bow, arrows and sword seated under a tree; horses tethered in the distance.
Wash; 6½ by 5½ ins. *Add. Or. 1948*

ii An Indian gentleman in flowing *jāma*.
Wash; 7 by 4 ins. *Add. Or. 1949*

4 Palladian garden-house near Madras.
By a Madras artist, *c.* 1790.
Inscribed on mount: *House built by Thomas Powney Esq., 2 miles from Fort St George on the Mount Road.*
Water-colour; 6½ by 13¼ ins.
Purchased 10 August 1957. *Add. Or. 740*

NOTE: Thomas Powney (1721–82) was a free merchant living in Madras from 1750. He came of a well-known family whose members had been going to Madras from the beginning of the eighteenth century. In 1761 he married Catherine de la Metrie and in 1764 he became Mayor of Madras. As a result of his increasing prosperity, he apparently felt justified in building a garden-house for on 1 November 1774 he was issued with a lease for a plot of 8 acres, rent 2 Pagodas, 'between the Road leading to the Mount & the river before Mr Stratton's house' (see Love, iii, 58). For Thomas Powney, see J. Shakespear, *George Nesbitt Thompson and some of his descendants* (Gateshead upon Tyne, 1937), 64–67.

The style of the drawing would suggest a date of about 1790 and the picture was probably made for a subsequent tenant of the house.

5 Woman of Madras.
By Jeru Naidu, a Madras artist, *c.* 1867.
Inscribed: *Portrait of a Hindoo female. Illustrating the manner of wearing jewels.
(Painted by Jeroo Naidoo of Madras.) (From Paris Exh. 1867.)*
Water-colour; 9½ by 7½ ins.
Deposited 1867. *India Office Albums, vol. 59, 'Jewellery', no. 5431*

6 i–xxxv 35 drawings; 12 menu cards and 23 place-cards depicting scenes from the *Rāmāy-ana*, *Mahābhārata* and its appendix the *Harivansa*.
By H. Hanumanta Rao of Madanapalle, Cuddapah. *c.* 1900.
All inscribed on reverse with story and name of artist.
Pen-and-ink; 6½ by 4¼ ins and 1½ by 3 ins.
Presented by Miss Joseph, 1926. *Add. Or. 491–525*

NOTE: This would appear to be an individual commission by an Englishman interested in Hindu mythology.

 i Rambha dancing before Devendra, his wife Sachi Devi and his ministers.
 Add. Or. 491
 ii Narayana and his consort Lakshmi listening to the singing of Narada and Thambuda. *Add. Or. 492*
 iii Venkataramansvami of Tripati meeting Padmavati. *Add. Or. 493*
 iv Savitri and Satyavan. *Add. Or. 494*
 v Kumarasvami on the mountain of Krauncha. *Add. Or. 495*
 vi Prambha meeting Pravana. *Add. Or. 496*
 vii Krishna listening to his wives Rukmini and Satyabhama playing on the *vīna*. *Add. Or. 497*
 viii Marriage of Venkatesvarasvami and Padmavati. *Add. Or. 498*
 ix Krishna stealing the Gopis' clothes. *Add. Or. 499*
 x Krishna with his wives Rukmini and Satyabhama, also Garuda and Narada. *Add. Or. 500*
 xi Bhima destroying Vakasura. *Add. Or. 501*
 xii Krishna killing Murasura. *Add. Or. 502*
 xiii Raja Dasaratha making war on Sambarasura. *Add. Or. 503*
 xiv Rama, Lakshmana, Hanuman and his retinue advise Vibhisana on the government of his kingdom. *Add. Or. 504*
 xv Ravana tells Maricha to disguise himself as a golden deer and appear before Rama. *Add. Or. 505*
 xvi Ravana chopping off the wings of Jatayu. *Add. Or. 506*
 xvii Hanuman and his army crossing the bridge of rocks to Lanka. *Add. Or. 507*
 xviii The war between Rama and Ravana. *Add. Or. 508*

(ii) TANJORE

In contrast to Madras, Tanjore produced paintings for Europeans on a large scale and in a distinctive manner. As elsewhere in the South, this development was stimulated by the Mysore Wars and by the presence of numerous British soldiers. Many army officers, especially of the Royal troops, came from cultured backgrounds and were themselves at times amateur artists. They spent only a few years serving in India and were eager to collect pictures of costume and customs which they could take back to England as souvenirs.

In Tanjore it was artists of the Moochy caste who responded to this demand. During the political confusion of South India in the eighteenth century the Maratha dynasty at Tanjore had managed to survive and provide conditions where artists

could still work and artistic traditions could continue unbroken. In 1776 a British garrison was established there and from 1782 there was peace in the area. Tanjore artists were already making procession scenes showing their Raja Tulsaji (1765–87) on horseback surrounded by his troops and retinue (see p. 30), and such pictures continued to be made showing his successors, Amar Singh (1787–98) and Sarabhoji (1798–1832, no. 12).

From about 1780 sets of pictures began to appear showing a man and woman of the various castes standing side by side holding the implements of their occupation. Sometimes these sets were extended to include pictures of bazaar shops, temples, religious festivals and even composite figures and animals (no. 9). So successful were these sets that they were marketed in the various towns in South India where Europeans were living, and some of the artists probably also migrated to these towns and worked there. A set in the Bibliothèque Nationale, Paris, came from Karikal, a French settlement to the south of Madras, and other sets were almost certainly sold or made in Madras. Charles Gold in his *Oriental Drawings* (London, 1806) reproduces a picture of a beggar which he says is by 'the Tanjore Moochy'. The fact that the artist is described in this way suggests that he was working away from his home, probably in Madras where Gold was stationed for part of his time in India. Other Tanjore artists appear to have worked as far afield as Vellore. The inscriptions and subjects of no. 14 suggest that this set was made there for a British officer who was Fort Adjutant.

In the first Tanjore sets produced for the British, the style and technique were predominantly Indian. Oral tradition records that artists from the Deccan moved south to Tanjore in the late seventeenth and eighteenth centuries, and this is confirmed by the Tanjore style which in its early phase includes idioms reminiscent of Golconda painting. In sets made during the last twenty years of the eighteenth century the swaggering figures, the fluttering drapery, the bright greens, yellows, pinks and mauves, the plain bright-coloured backgrounds and the strip of tangled cloud all suggest Golconda ancestry (no. 8).

As British power increased, European stylistic idioms began to influence painting. In the last years of the eighteenth century naturalistic clouds appear in the sky, bushes and palm trees line the horizon, the figures are shaded and curving shadows are attached to the feet (nos. 9–11). A few years later this influence becomes even more pronounced. Coloured backgrounds disappear and the figures are portrayed in a highly realistic manner against a blank background. European paper is used, the water-colour technique is adopted in place of gouache, and colours become more sombre (no. 13). Sets were sometimes specially commissioned and in these, portraits of the patron were inserted (no. 14). Painting of this type continued at Tanjore during much of the nineteenth century and also spread to neighbouring towns such as Trichinopoly (*qv.*). Portrait miniatures on ivory were also produced.

At Tanjore the Rajas themselves assisted in the spread of European influence.

Raja Sarabhoji had had Danish tutors and had learnt to draw in the European manner. He was in the habit of presenting sets of paintings, made under his supervision, to his guests and to British Residents. A volume of natural history drawings was given by him to Benjamin Torin, the British Resident from 1801 to 1803 (*NHD* 7). He also gave him architectural drawings of South Indian temples (no. 32). Sarabhoji's son, Sivaji (1832–53), continued this practice. He had the same interests in architecture and became a founder member of the Royal Institute of British Architects in 1836. On joining the Institute he presented it with ten drawings of his palace and of local temples. All are executed in a mixed Indian-British style in pen-and-ink and wash, sometimes enlivened with touches of water-colour.

Bibliography

Archer, Mildred. *Natural history drawings in the India Office Library* (London, 1962), 13, 14, 89, plate 17.

Archer, Mildred. *Indian architecture and the British* (London, 1968), 60–64.

Archer, Mildred. 'Company painting in South India: the early collections of Niccolao Manucci', *Apollo*, August, 1970, 104–113.

Archer, Mildred and W. G. *Indian painting for the British, 1770–1880* (Oxford, 1955), 74–82.

Brown, P. *Indian painting* (2nd edition, Calcutta, 1927), 63–65.

Hemingway, F. R. *Madras District Gazetteers: Tanjore* (Madras, 1906).

Thurston, E. *Castes and tribes of southern India*, 7 vols. (Madras, 1909).

7 i–vii 7 drawings depicting trades and castes of South India.
By a Tanjore artist, *c.* 1790.
Pen-and-ink and wash; with the exception of (i), which measures $15\frac{1}{2}$ by 10 ins, all 10 by $7\frac{1}{2}$ ins.
Purchased 15 December 1961. *Add. Or. 1950–1956*

NOTE: With the exception of (i) the figures are shown in pairs, a man and his wife, against a plain background. A slight indication of ground is given at their feet. These drawings which formerly belonged to Sir Henry Russell (2nd Baronet, 1763–1852) of Swallowfield Park, Berkshire, were possibly acquired by him while he was in India from 1798 to 1820. On reaching the Library, they were in a small portfolio together with no. 3 and a note: *Figures drawn by an Indian. 7. Last purchase*, the handwriting and the phrase, *Last purchase*, being repeated on a folder of drawings by Thomas and William Daniell acquired by the Library from the same source. It seems possible, therefore, that these pictures had been acquired by the Daniells in Tanjore or Madras in 1792 and had come to Sir Henry Russell along with the many Daniell drawings which he purchased after Thomas Daniell's death in 1840. Four of the present drawings are uncoloured versions of no. 8, iv, xii, xiii, xix and would appear to have been made at about the same time as this group. The pen-and-ink technique and English paper would suggest that these drawings were specially made for the purchaser and were not part of a stock set. For the Daniells see Mildred Archer, *British drawings in the India Office Library* (London, 1969), ii, 574–599.

 i Dancing girl, her right hand on her hip, her left holding a rose. *Add. Or. 1950*
 ii Tank-digger and wife; the man holds a digging tool and a rat, his wife carries a baby on her hip and a basket on her head. *Add. Or. 1951*
iii Artisan (perhaps a silver-smith with blow-pipe) with wife; the man holds a bag and bamboo under his arm. *Add. Or. 1952*
 iv Soldier and wife; the man holds a bow and arrows. *Add. Or. 1953*
 NOTE: Uncoloured version of no. 8 iv.
 v Maratha commander of cavalry with wife. *Add. Or. 1954*
 NOTE: Uncoloured version of no. 8 xiii.
 vi Governor of a fort with wife; the man holds a rose. *Add. Or. 1955*
 NOTE: Uncoloured version of no. 8 xii.
vii Wrestler and wife. *Add. Or. 1956*
 NOTE: Uncoloured version of no. 8 xix.

8 i–xxii 22 paintings portraying various trades and castes of South India.
By a Tanjore artist, 1797.
Gouache; 14 by 9 ins approx.
Mostly inscribed on back with titles by an Indian, writing in English; (i) dated 1797.
Purchased 4 September 1955. *Add. Or. 188–209*

NOTE: Closely related to no. 7, including coloured versions of iv, v, vi, vii. Bold colouring, a line of tangled cloud at the top of each picture.

 i Raja Amar Singh of Tanjore (ruled 1787–98); full length portrait facing right, holding a rose in his left hand (*Plate 3*).
 Inscribed: *The Present Rajah of Tanjore – 1797 – Rajah Hammah Sing Bonisilie.* *Add. Or. 188*
 ii Vaishnava begging from a woman; he holds a hand punkah and a begging bowl.
 Inscribed: *A Brahminy Beggar.* *Add. Or. 189*
iii A man from the uplands (*pāḷaiyakkāraṉ*); the man holds a spear and two horns; his wife a basket.
 Inscribed: *A Polygar – or Indian Highlander.* *Add. Or. 190*
 iv Soldier and wife; the man has a bow, arrows, sword and buckler.
 Inscribed: *An Indian Warrior.* *Add. Or. 191*
 NOTE: Coloured version of no. 7 iv.
 v Barber and wife; the man holds a razor and small bowl, his wife holds another razor.
 Inscribed: *Ampticara or barber.* *Add. Or. 192*
 vi Tanjore Maratha Brahmin and wife. *Add. Or. 193*
vii Blacksmith and wife; the man is holding a vice, the woman a pair of callipers.
 Inscribed: *Ironsmith.* *Add. Or. 194*

viii Indian sepoy of the 36th Native Infantry and wife; the sepoy carries a musket and wears white shorts, a red jacket, blue cummerbund and a blue bonnet-shaped turban with white tufted cockade. His wife carries a brass bowl and a bundle on her head.

Inscribed: *A Sepoy of the 36th Battn. N.I.* *Add. Or. 195*

NOTE: The 36th Battalion, Madras Native Infantry, was raised in August 1794. With some others it was kept on as an Extra battalion after the army reforms and renumbering of 1796 and it remained as the 36th Battalion until it was converted into the 2nd Battalion of the 13th Regiment on 12 October 1798 (see W. J. Wilson, *History of the Madras army* (Madras 1883), ii, 276–277, 350). In March 1797 an order required all Madras Native Infantry to wear a uniform turban and a cummerbund of blue cloth. A letter in the British Museum of 1806 (*B.M. Add. MSS. 49486*) shows, however, that the 36th Battalion and subsequently the 13th Native Infantry were allowed to continue wearing the distinctive turban which the 36th Battalion had worn since its formation in 1794 – a turban corresponding to 'the Scotch bonnet used in Highland regiments' . . . 'with a tuft and leather cockade'. The letter continues: 'The present 13th N.I., of which that battalion now forms a part, now wears as a particular indulgence granted at the intercession of the commanding officer, that same turban.'[1] This turban is worn by the sepoy in the present picture.

ix Brass-worker and wife; the man holds several implements and a brass vessel; his wife carries a brass lampstand.

Inscribed: *Kettle Smith Cast.* *Add. Or. 196*

x Silver-smith and wife; the man holds various implements, his wife carries a brass-bound box.

Inscribed: *Silver Smith.* *Add. Or. 197*

xi Fruit-seller and wife; the man holds a bunch of bananas.

Inscribed: *A Bazar Man. Shop Keepers. Fruiterer.* *Add. Or. 198*

xii Governor of a fort and wife; the man holds a rose, and his wife a betel leaf.

Inscribed: *A Killidar (Governor of a Fort) and his wife.* *Add. Or. 199*

NOTE: Coloured version of no. 7 vi.

xiii Maratha commander of cavalry with his wife; the man holds a rose and has his left hand on the hilt of his sword.

Inscribed: *A Mahratta Commander of Cavalry.* *Add. Or. 200*

NOTE: Coloured version of no. 7 v.

xiv Torch-bearer (*mashālchī*) and wife; the man holds a torch and a vessel of oil, his wife carries a pitcher in a basket.

Inscribed: *Masalche Cast and his wife.* *Add. Or. 201*

xv Brahmin astrologer and wife.

Inscribed: *Sanntery Cara or bramina fortune teller.* *Add. Or. 202*

[1] I am indebted to Mr S. G. P. Ward for this information.

xvi Muslim noble and wife; the man holds a rose and a dagger, his wife a betel leaf.

Inscribed: *Mogal Cast.* Add. Or. 203

xvii Arab and wife; the man is armed with a sword and buckler and holds a rose, his wife holds a betel leaf.

Inscribed: *Araube Cast.* Add. Or. 204

xviii Oil-seller and wife.

Inscribed: *Isle Manger Cast* (i.e. oil-monger). Add. Or. 205

xix Wrestler and wife; the man has a dagger under his arm, his wife holds a betel leaf.

Inscribed: *A Jattee answers to that of a Gladiator who performs.* Add. Or. 206

NOTE: Coloured version of no. 7 vii.

xx Weaver and wife; the man has a piece of cloth over his shoulder and his wife is reeling thread. Add. Or. 207

xxi Muslim mendicant and wife; the man holds a sword in his right hand and a bird cage in his left, his wife holds a rose. Add. Or. 208

xxii Washerman and wife; both figures carry bundles of clothes and the man also holds an earthen pitcher.

Inscribed: *A Washerman.* Add. Or. 209

9 i–xi 11 drawings from a series depicting occupations, ceremonies, temples, temple cars in South India and composite figures.

By a Tanjore artist, *c.* 1800.

Inscribed on back in ink with numbers and titles.

Gouache; 16$\frac{3}{4}$ by 12 ins.

Purchased 10 July 1968. Add. Or. 2526–2536

NOTE: These pictures were part of a set of fifty paintings sold at Sotheby's, 10 July 1968, lots 171–177.

The study of 'A crippled beggar and his wife' (iv) is similar to the painting of a beggar reproduced in Charles Gold, *Oriental Drawings* (London, 1806), plate 39, and attributed to the 'Tanjore Moochy'. Gold must have acquired it between 1791 and 1798 when he was serving with the Royal Artillery in the Mysore Wars, very possibly in Madras before leaving for England in 1798. In Gold's picture, the towering clouds, the trees and bushes on the horizon and the looped shadows attached to the feet, which are seen in the present set as well as in nos. 10 and 11, are already standard idioms.

i Artist standing at a table painting a figure in local costume; an assistant beside him, holding bowls.

Inscribed on back: *No. 41. A Painter.* Add. Or. 2526

ii Subadar of the Madras Native Infantry and wife. The subadar wears a red jacket with green facings and has a sword and musket; his wife holds a betel leaf (*Plate 4*).

Inscribed on back: *No. 44. A subidar & Wife.* *Add. Or. 2527*

iii Sepoy, probably of the Madras Native Infantry, on the march. The sepoy is in undress carrying a sword and is preceded by his wife and two children mounted on a white bullock. A man carrying a stick and a bundle leads the way.

Inscribed on back: *No. 1. A Seapoy & his wife.* *Add. Or. 2528*

iv Crippled beggar and wife. The beggar, his leg amputated at the knee, pours rice from a gourd into a dish held by his wife.

Inscribed on back: *No. 27. Beggars.* *Add. Or. 2529*

NOTE: This picture, as already noted, closely resembles plate 39 in Charles Gold, *Oriental Drawings* (London, 1806). There are a number of minor differences: Gold's picture is in reverse and includes two children standing beside the woman. The beggar is in profile whereas, in the present picture, he is shown full face. He holds the gourd with two hands, instead of one. His stick and crutch are differently placed and he has a bandage round his leg. The palm trees on the horizon are also differently grouped. In all other respects, however, the two pictures are alike and must have been produced by the same shop or family of artists at about the same date.

v Milkman and wife. The woman is churning butter, a customer and two children seated in front of her. Below, her husband is milking a cow with the calf tied to it.

Inscribed on back: *No. 17. Making Butter.* *Add. Or. 2530*

vi Cloth merchant seated in his shop selling chintz to a customer.

Inscribed on back: *No. 34. A Chintz Merchant.* *Add. Or. 2531*

vii Liquor vendor in his shop pouring drink into bowls. Four customers (three men and one woman) stand or sit around.

Inscribed on back: *No. 2. A Arrack Shop.* *Add. Or. 2532*

viii Sati scene. A wife clasps the corpse of her husband on the pyre. Two women and three Brahmins stand below.

Inscribed on back: *No. 4. A Man & Wife Burning.* *Add. Or. 2533*

ix Shaiva temple. In the foreground two priests and a statue of the bull Nandi.

Inscribed on back: *No. 3. A Pagoda.* *Add. Or. 2534*

x Temple car being drawn in procession by devotees (*Plate 6*).

Inscribed on back: *No. 11 A Swamy Coach.* *Add. Or. 2535*

xi Composite picture. Kama, the god of love, impersonated by a woman, mounted on a horse composed of five women.

Inscribed on back: *A Horse made of women.* *Add. Or. 2536*

10
i–xxvii
27 paintings portraying trades and castes of South India.
By a Tanjore artist, *c.* 1805.
Inscribed on back with titles.

Gouache; approximately 14 by 10 ins.
Purchased 4 April 1956. *Add. Or. 680–706*

NOTE: In style similar to no 11.

At the time of purchase these paintings were in a portfolio inscribed in ink in a late hand: *27 Paintings showing the different castes of South India brought to England in 1796 by Admiral Peter Rainier on his retirement as Commander in Chief R.N. Afterwards M.P. for Sandwich.*

Admiral Rainier (1742–1808) entered the navy in 1756 and went to India. He was Commander-in-Chief of the Royal Navy in the East Indies from 1794 to 1805. After his retirement he became M.P. for Sandwich. The statement in the inscription that he retired in 1796 is inaccurate, the true date being 1805. On grounds of style – the irregular shaped cloud, the plain ground, trees along the horizon and forked shadows – the paintings may well have been acquired in 1805.

 i Muhammadan nobleman and wife; the man holds a sword, his wife sits on a chair.
 Inscribed: *A Nabob & his Wife*. *Add. Or. 680*

 ii Gujarati merchant and wife; the man sits on a chair by a small table.
 Inscribed: *A Guzzerat Merchant & his Wife*. *Add. Or. 681*

 iii Rajput and wife; the woman dances, the man holds a bow and spear.
 Inscribed: *A Rajapoot & his Wife*. *Add. Or. 682*

 iv Muslim kneeling by a tomb; his wife stands behind him.
 Inscribed: *Caujee* *Add. Or. 683*

 v Brahmin pandit and wife; the pandit holds a manuscript.
 Inscribed: *A Pandit Bramin and his Wife*. *Add. Or. 684*

 vi Tenkalai Vaishnava Brahmin and wife; the man holds a rosary and a palm-leaf manuscript.
 Inscribed: *Iyengar Bramin & his Wife*. *Add. Or. 685*

 vii Shaiva mendicant and female devotee; the man carries a peacock-feather fan and hand punkah, the woman holds a spear and a garland.
 Inscribed: *Pandaweem & his Wife*. *Add. Or. 686*

 viii Muslim mendicant and wife; the man holds a *nārgīla* pipe and a bird in a cage, his wife a rosary and hand punkah.
 Inscribed: *A Fakeer & his Wife*. *Add. Or. 687*

 ix Astrologer (a Brahmin who interprets the almanac for villagers) and wife; the man holds a palm-leaf manuscript.
 Inscribed: *A Panchangee or Kalendar & his Wife*. *Add. Or. 688*

 x Dancers of the Mariyamman cult; a man dances with a flower-decked *karatam* or pot on his head; two musicians accompany him.
 Inscribed: *A Poojarus of Mariamun Church or Pagoda Dancers*. *Add. Or. 689*

 xi Dancers of the Mariyamman cult; a woman dances with a pot of fire on her head and a man beats a drum.
 Inscribed: *Agnee Cuppara of the Mariamen Covil*. *Add. Or. 690*

 xii Scribe and wife; the man carries a palm leaf and stiletto.
Inscribed: *A Conicopoly & his Wife or Writing Master.* *Add. Or. 691*

 xiii Caretaker and wife; the man carries a bunch of keys.
Inscribed: *A Golnardoo & his Wife.* *Add. Or. 692*

 xiv Washerman and wife; both carry bundles and the wife three sticks.
Inscribed: *A Washerman and his Wife.* *Add. Or. 693*

 xv Cook and wife; the man carries a cock and a kettle, the woman a fish.
Inscribed: *A cook and his wife.* *Add. Or. 694*

 xvi Milkman and wife; both carry pitchers of milk.
Inscribed: *A Cow-keeper & his Wife.* *Add. Or. 695*

 xvii Seller of attar of roses and his wife; the man carries a flower and a bundle.
Inscribed: *A Man who sells Utter of Roses.* *Add. Or. 696*

xviii Shoe-maker with wife and child; the man holds an awl and a shoe, his wife nurses the child.
Inscribed: *A Moochy & his Wife.* *Add. Or. 697*

 xix Bricklayer and wife; the man holds a measure and a trowel.
Inscribed: *A Bricklayer and his wife.* *Add. Or. 698*

 xx Silk-weaver and wife; the man holds a piece of material, his wife is reeling thread.
Inscribed: *A silk weaver and his wife.* *Add. Or. 699*

 xxi Weaver and wife; the man is combing the warp, the wife reeling cotton thread.
Inscribed: *A Weaver and his wife.* *Add. Or. 700*

 xxii Oil-seller and wife; the man carries a basket of pots and a measure, his wife also holds a measure.
Inscribed: *Vannier or Oilman & his Wife.* *Add. Or. 701*

xxiii Merchant and wife; the man holds a pen-case and accounts.
Inscribed: *Laula cast.* *Add. Or. 702*

xxiv Messenger and wife; the man carries a letter.
Inscribed: *A Hircarrah & his Wife.* *Add. Or. 703*

 xxv Peon and wife; the man holds a sword and buckler
Inscribed: *Gooty Peon & his Wife.* *Add. Or. 704*

xxvi Beggar, holding a snake-charmer's pipe, with his wife and child; both carry gourds.
Inscribed: *Opoo Corawar & His Wife of the Beggar Cast.* *Add. Or. 705*

xxvii Penitent and wife; the woman carries gourds and the man cuts his thigh with a knife and pours liquid over the wound.
Inscribed: *A Cullul Siddel & his Wife.* *Add. Or. 706*

II i–vii 7 paintings depicting trades and castes of South India.
By a Tanjore artist, *c.* 1805.

Inscribed on front in Tamil and also in English by an Indian.
Gouache; 18 by 12½ ins.
Purchased 10 November 1954. *Add. Or. 32–38*

NOTE: Similar in style to no. 10.

i Dancing-girl and four musicians.
Inscribed on front in English: *Same boll* (cymbal?) *with Dancing Girl*; in Tamil:
tāci . . . *Add. Or. 32*

ii Merchant holding a gold pen-case.
Inscribed in English: *This Picture Cast of Bygan*; in Tamil: *komati cāti paṭam.*
 Add. Or. 33

iii Cook and wife; the man holds a joint of meat and a kettle, his wife a fish and
a basket.
Inscribed in English: *Cook*; in Tamil: *Kuciṉikkāraṉ.* *Add. Or. 34*

iv Maratha tailor and wife; the man holds a measure and his wife a pair of
scissors.
Inscribed in English: *Maratah Taylor*; in Tamil: *maṟāṭiya tayyalkāraṉ.*
 Add. Or. 35

v Leather-worker and wife; the man holds a saddle and his wife a bridle.
Inscribed in English: *Moochy People*; in Tamil; *mocciyaṉ.* *Add. Or. 36*

vi Merchant and wife; the man holds a pen-case and a letter; his wife a betel leaf.
Inscribed in English; *Laulah Cast*; in Tamil: *lālā cāti.* *Add. Or. 37*

vii Maratha and wife; the man holds a rose and his wife feeds a green parrot.
Inscribed in English; *Marattah man*; in Tamil: *maṟāṭiya.* *Add. Or. 38*

12 Raja Sarabhoji of Tanjore (1777–1832, ruled 1798–1832) riding on horseback in
procession followed by his son Sivaji (ruled 1832–53). The raja is preceded by
elephants, musicians and red and gold banners. Behind him are attendants with
parasol, fly-whisk and fans; in the foreground, soldiers and followers with swords
and lances (*Plate 5*).
By a Tanjore artist, *c.* 1820.
Gouache on treated linen, varnished; 22½ by 30 ins.
Circumstances of acquisition unrecorded. *Add. Or. 2594*

NOTE: This picture shows Tanjore officers and men of both cavalry and infantry. The officer and
soldiers with long white pantaloons in the front of the procession are cavalry, the sepoys with
short drawers are foot soldiers.
 Pictures of its rulers in procession had long been made in Tanjore. A painting of Raja Tulsaji
(ruled 1765–86) is in the Victoria and Albert Museum (Indian Section, *I.M. 319–1921*), and a similar
one of Raja Amar Singh (ruled 1787–98) passed through the London sale rooms in 1968.

13 i–
xxxviii 38 drawings bound into an album depicting castes and occupations of South India and in most cases showing a man and woman facing each other and holding the appropriate tools of their trade.

By a Tanjore artist *c.* 1822.

Inscribed in ink with titles and notes.

Water-colour; size of picture 8¼ by 6¼ ins; size of page 11¾ by 9½ ins.

Water-marks of 1818, 1819 and 1820.

Purchased 12 December 1919. *Add. Or. 1622–1659*

NOTE: The set is marked by pale and sombre colouring – the sky being a pale blue and the ground light fawn with small green bosky trees on a low skyline. The colour of the dresses is duller than in earlier sets. Pale borders of lemon, pink, and mauve, a little gold added.

 i Brahmin astrologer and wife; the man holds a palm-leaf manuscript, his wife brass pots.

 Inscribed: *The usual Costume of the Brahmin Cast; called Punchanggum, or foreteller of Events.* *Add. Or. 1622*

 ii Rajput and wife; the man holds a dagger and the woman betel leaves.

 Inscribed: *The Costume of the Rajahpoot Cast or Descendants of Hindoo Kings.* *Add. Or. 1623*

 iii Man and woman of the 'Buljavar' caste; the man holds a sword and the woman betel leaves.

 Inscribed: *The Costume of the Buljavar or Gentoo Caste; the present Rajah of Mysore is of this tribe.* *Add. Or. 1624*

 iv Cotton trader and wife.

 Inscribed: *The Lingum Buljavar or Canadee Caste. They are generally dealers in the Cotton trade.* *Add. Or. 1625*

 v Maratha and wife; the man has a sword and buckler.

 Inscribed: *The Costume of the Mahratta Caste; the present Rajah of Tanjore is of this tribe.* *Add. Or. 1626*

 vi Silk-weaver and wife; the man holds silk purses and a length of cloth, the woman is reeling silk.

 Inscribed: *The Putvagur or Silk Weaver tribe.* *Add. Or. 1627*

 vii Bania and wife.

 Inscribed: *The Coomtee or Banian tribe: generally money Changers.*

 Add. Or. 1628

 viii Cotton-weaver and wife; the man holds a piece of cloth, the woman is setting up the warp.

 Inscribed: *The Salovar July or Cotton Weaver tribe.* *Add. Or. 1629*

 ix Cultivator and wife; the man carries a plough and the woman a stick and betel leaves.

Inscribed: *The Ryot or husbandman, bearing a plough used in the Carnatic, which makes but little impression on the soil.* *Add. Or. 1630*

x Oil-seller and wife; the man carries a basket of pots on his head and the woman has a small pot and measure.
Inscribed: *The Tailee or Oil-Monger tribe. This class as well as all Mechanics, wear a Cotton thread over the left shoulder.* *Add. Or. 1631*

xi Cowherd and wife; both carry pots and the man also has a stick and rope.
Inscribed: *The Dungur or Cow-herd tribe.* *Add. Or. 1632*

xii Glass-bangle seller and wife; both carry strings of bangles.
Inscribed: *The Bungadugar (a Gentoo tribe) generally deals in glass ornaments of different colours, worn on the Arm by the females of India.* *Add. Or. 1633*

xiii Carpenter and wife.
Inscribed: *The Carpenter tribe. The tools used by this class of people are only two in number.* *Add. Or. 1634*

xiv Bricklayer and wife; the man holds a trowel, the woman a small mattock and smoother.
Inscribed: *The Camatee or Bricklayer tribe.* *Add. Or. 1635*

xv Torch-bearer and wife; the man carries a torch and brass oil vessel, the woman carries oil and a measure.
Inscribed: *The Mussalchee tribe or linkboy; and generally accompanies a travelling palankeen.* *Add. Or. 1636*

xvi Potter and wife. The man is working at his wheel, the woman carries a basket of pots.
Inscribed: *The Comar or potmaker at his daily work.* *Add. Or. 1637*

xvii A man of the Moochy caste and his wife. Both carry fans.
Inscribed: *The Moochie Man. This tribe is one of the most useful in India; they are excellent copyists. They gain their livelihood by painting and working in leather.* *Add. Or. 1638*

xviii Blacksmith and wife.
Inscribed: *The Indian Blacksmith.* *Add. Or. 1639*

xix Vaishnava mendicant (*Dāsari*) and female devotee; the man carries various pots and a gong, and blows on a conch shell; the woman carries a lampstand and peacock feather fan.
Inscribed: *The Costume of the Dassary, a religious Mendicant who gives notice of his approach, by blowing a horn and striking a gong.* *Add. Or. 1640*

xx Vaishnava mendicant (*cāttāni*) and female devotee; the man carries a pot and a fan, the woman a rosary.
Inscribed: *The Satana, a religious Mendicant, he announces his approach by singing.* *Add. Or. 1641*

xxi Two Hindu dancing-girls with four musicians.
Inscribed: *Hindoo dancing women, with their attendant Musicians.*

Add. Or. 1642

xxii Two Muslim dancing-girls with three musicians.
Inscribed: *Mahometan dancing women with their musicians.* *Add. Or. 1643*

xxiii Three types of Hindu ascetic: Pandaram, Gosain and Bairagi.
Inscribed: *Panadarum. Goossain. Byragee. The three different sects of Hindoo Devotees.* *Add. Or. 1644*

xxiv Man and woman of the Mariyamman cult; the man balances pots on his head and beats a drum, the woman also beats a drum.
Inscribed: *The Poojaree; or person appeasing the wrath of the Goddess Mariama who presides over Diseases.* *Add. Or. 1645*

xxv Barber and wife; the man holds a razor and small bowl.
Inscribed: *The Indian Tonser.* *Add. Or. 1646*

xxvi Tailor and wife; the man holds scissors and a needle-case, the woman holds thread.
Inscribed: *The dirzee or Hindoo tailor.* *Add. Or. 1647*

xxvii Bamboo mat-maker and wife; the man carries a knife and bamboo-mat basket on his head, the woman carries a hand punkah.
Inscribed: *The Burrod tribe, or Bamboo Mat-Maker.* *Add. Or. 1648*

xxviii Toddy-tapper and wife; the man carries a ladder, rope and earthen pot, the woman a pot of juice.
Inscribed: *The Tansa, or Toddy man, the toddy is a favourite Indian beverage procured from the Cocoanut & Palmyra trees, & when fermented is very intoxicating.* *Add. Or. 1649*

xxix Palanquin-bearer and wife.
Inscribed: *The Bestavar Caste, or the palankeen bearer.* *Add. Or. 1650*

xxx Shoe-maker (*cakkiliyan*) and wife; the man holds a pair of boots, the woman various tools.
Inscribed: *The Chuckler or Indian Shoemaker.* *Add. Or. 1651*

xxxi Washerman and wife; both carry bundles of clothes and the woman also carries two sticks.
Inscribed: *The Dobee or Washerman.* *Add. Or. 1652*

xxxii Fisherman and wife; the man carries a net, basket and a fish, the woman carries baskets of fish.
Inscribed: *The Chumbadavar or fisherman.* *Add. Or. 1653*

xxxiii Tank-digger with wife and baby; the man carries a mattock, stick and rat, the woman carries her baby and digging tool and basket.
Inscribed: *The Vaddavar or tank digger. A tank is a reservoir of water.*
 Add. Or. 1654

xxxiv Basket-makers; both man and woman carry baskets.
Inscribed: *The Coroavaur; or Basket Maker. This tribe of men live in the woods, and answer to the description of our Gypsies.* *Add. Or. 1655*

xxxv Buttermilk-sellers; the woman carries a pot, the man a pot and measure in a basket.

 Inscribed: *The Canadavar Caste, or Butter Milk Seller.* *Add. Or. 1656*

xxxvi Scavenger and guide; the woman carries a basket, the man a staff.

 Inscribed: *The Tallary tribe. These persons are the scavengers of villages, & if necessary become guides to travellers.* *Add. Or. 1657*

xxxvii Pathan and wife; the man holds a cloth and the hilt of his sword, the woman holds betel leaves.

 Inscribed: *The Pathan tribe, or 4th sect of the Mussulmans.* *Add. Or. 1658*

xxxviii Mughal and wife; the man holds a rose and the wife betel leaves.

 Inscribed: *The Mogul Musselmans, the above description of persons are generally Moonshees or instructors of the oriental languages.* *Add. Or. 1659*

14
i–xxxii 32 drawings bound into a volume; 24 depicting castes and occupations of South India, 2 festivals, 5 methods of transport and one showing a European house in Vellore.

Probably by a Tanjore artist, working at Vellore (Madras), *c.* 1828.
Inscribed with titles. Water-marks of 1823 and 1826.
Gouache and water-colour; 19½ by 13½ ins.
Purchased 6 November 1954. *Add. Or. 39–70*

NOTE: Although modelled on standard South Indian sets produced chiefly at Tanjore, the present series also contains a drawing (xxxii) of the bungalow of the Fort Adjutant at Vellore, and may therefore have been specially commissioned by him. It also contains three paintings (xxix, xxx, xxxi) which are clearly portraits of the Adjutant's servants and office staff. In style the series differs from the standard sets since the figures are shown on an uncoloured background without sky, clouds, bushes or shadows. It is significant that the Moochy caste, to which the painter who made these drawings would himself have belonged, figures first in the book, (i) being possibly a self-portrait of the artist. The British officer in the palanquin (xxi) is probably the Fort Adjutant who commissioned the set.

 i Painter, cotton-thread weaver and tailor with their wives.

 Inscribed: *Moochy, Painter etc; Ruee Walla, Cotton Man; 'Dergee' or Tailor.* *Add. Or. 39*

 ii Bangle-maker, palanquin-bearer and barber, with their wives.

 Inscribed: *'Wulgeewaun' or Bangle Maker; Palankeen Bearer; 'Uggaun' or Barber.* *Add. Or. 40*

 iii Buttermilk-seller, cotton-spinner and potter with their wives.

 Inscribed: *'Mugjoo Walla' or Buttermilk Man; 'Ruee Walla' or Cotton Spinner; 'Andee Walla' or Chattee Maker.* *Add. Or. 41*

 iv Fish-seller, tank-digger and basket-maker with their wives.

 Inscribed: *'Muchee Walla' or Fisherman; 'Wudda Walla' or Tank Digger; 'Cadjan Walla' or Basket Maker.* *Add. Or. 42*

 v Shoe-maker, boot-maker and messenger with their wives.

Inscribed: '*Jootee Walla*' or *Shoe Maker*; '*Sumpan*' or *Boot Maker*; '*Tallanee*' or *Messenger, Guide etc.* *Add. Or. 43*

vi Oil-seller, torch-bearer and basket-maker with their wives.
Inscribed: '*Taile Walla*' or *Oilman*; '*Massaulghe*' or *Torch bearer*; '*Cadjan Walla*' or *Basket Maker*. *Add. Or. 44*

vii Cultivator, gardener and bricklayer with their wives.
Inscribed: '*Riot*' or *Cultivator*; '*Bang Walla*' or *Gardener*; '*Kholut Walla*' or *Bricklayer*. *Add. Or. 45*

viii Blacksmiths.
Inscribed: *Smiths at work.* *Add. Or. 46*

ix Gold and silversmith, carpenter and goldsmith with their wives.
Inscribed: '*Soonar*' or *Gold & Silver Smith*; '*Buraye*' or *Carpenter*; '*Soonar*' or *Goldsmith*. *Add. Or. 47*

x Baker, ironing man and washerman with their wives.
Inscribed: '*Rootee Walla*' or *Baker*; '*Stree Walla*' or *Iron Man*; '*Dobee*' or *Washerman*. *Add. Or. 48*

xi Huntsman, bird-catcher, fox and jackal-catcher with their wives.
Inscribed: '*Shickarree*' or *Sportsman*; '*Beekarree*' or *Bird Catcher*; '*Colar Walla*' or *Fox & Jackal Catcher*. *Add. Or. 49*

xii Three ascetics: (a) Vaishnava ascetic (b) Shaiva ascetic (c) Vaishnava ascetic with female devotees.
Inscribed: '*Wusteewar*' or *Religious Devotee*; '*Wusteewar*' or *Religious Mendicant*; '*Taddha Walla*', *Proclaimer of Deaths, Marriages etc.* *Add. Or. 50*

xiii Hindu money-changers with their wives.
Inscribed: *Sheroffs or Money Changers, 'Hindoo'.* *Add. Or. 51*

xiv Merchants from Gujarat, Malabar and Canara with their wives.
Inscribed: *Goozerat Soukar or Merchant; Malabar Soukar or Merchant; Canary Soukar or Merchant.* *Add. Or. 52*

xv Hindu merchants with their wives.
Inscribed: '*Soukars*', *Hindoo Merchants.* *Add. Or. 53*

xvi Shaiva and Vaishnava Brahmins with their wives.
Inscribed: '*Sheeva*' *Bramin*; '*Vishnoo*' *Bramin*; *Bramin* '*Sheeva*'. *Such as missionaries might call impracticables.* *Add. Or. 54*

xvii Water-carrier and bullock-cart.
Inscribed: '*Puckauly*' or *Waterman*; *Bullock* '*Bandy*' or *Cart.* *Add. Or. 55*

xviii Riding-bullock and buffalo-cart.
Inscribed: '*Surwaree*' or *Riding Bullock*; *Buffalo Bandy or Cart.* *Add. Or. 56*

xix A palanquin as used by Indian gentlemen of rank.
Inscribed: *Native Palankeen.* *Add. Or. 57*

xx A travelling palanquin as used by Europeans.
Inscribed: *Palankeen travelling. A set of Bearers as above will run from Madras to Raja's Choultry about 40 miles in about 8 hours.* *Add. Or. 58*

xxi A station palanquin with an army officer, perhaps the Fort Adjutant who commissioned the set (*Plate 7*).

Inscribed: *Palankeen at a Station.* *Add. Or. 59*

xxii Two Muhammadan gentlemen and a 'half Hindu Muhammadan' with their wives.

Inscribed: *Mahomedan Gentleman; Mahomedan do.; 'Subba' Half Hindoo Mahomedan.* *Add. Or. 60*

xxiii A Hindu, Rajput and Maratha with their wives.

Inscribed: *'Hindoo'; 'Rajpoot'; 'Marhatta'.* *Add. Or. 61*

xxiv Dancing-girls and musicians (*Plate 8*).

Inscribed: *'Kunchinee' or Dancing Girls.* *Add. Or. 62*

xxv Hindu, Maratha and Muhammadan religious beggars.

Inscribed: *'Hindoo Fakeer'; 'Marhatta Fakeer or Religious Beggar; Mahomedan Fakeer or Religious Beggar.* *Add. Or. 63*

xxvi Six Boyim (?) Festival Costumes.

Inscribed: *Boyim Festival Costumes.* *Add. Or. 64*

xxvii Muharram festival procession.

Inscribed: *Mahomedan Procession. Mahorum Festival.* *Add. Or. 65*

xxviii Holi Festival.

Inscribed: *Hindoo Rajpoot Procession.* *Add. Or. 66*

xxix Five clerks in the Fort Adjutant's Office, Vellore.

Inscribed: *Armogum Pension Writer, Fort Adjutant's Office, Vellore; Soobroyloo Pension Writer, F.A. Office, Vellore; Appoo Moodelien, Head Writer, F.A. Office, Vellore; Veerasawmy Writer, F.A. Office, Vellore; Verdamally, Family Writer, F.A.'s Office, Vellore.* *Add. Or. 67*

xxx Four orderlies and servants.

Inscribed: *Orderly Boy, 10 Regt. N.I.; 'Chocra' Servant, Erasing (i.e. Hira Singh) (Rajpoot); Orderly Boy, 16 Regt. N.I.; 'Chocra', Hussain Khan.* *Add. Or. 68*

xxxi Orderly and two peons with their wives.

Inscribed: *Tent Lascar; Police 'Peon', Military Bazar; Revenue 'Peon'.* *Add. Or. 69*

xxxii Adjutant's bungalow, Vellore.

Inscribed: *House of the late Fort Adjutant of Vellore.* *Add. Or. 70*

(iii) TRICHINOPOLY, SRIRANGAM AND PUDUKKOTTAI

During the Carnatic War with the French (1756–63) and later during the Mysore Wars (1767–99), British personnel often passed through Trichinopoly or stayed in the neighbourhood. Individual contact with local artists was established and under British guidance commissions were occasionally executed. In 1785 and 1786, for example, an Indian painter made a large set of natural history drawings for a British patron. It included one hundred and thirty-three studies of trees, plants, butterflies, mammals, reptiles and birds, and was mounted in an album later owned by William Jackson, Registrar of the Supreme Court, Calcutta. The fly-leaf was inscribed 'Drawings from Nature by a native artist at Tritchinopoly in 1785 and 1786'.[1] No details of this painter are known but the series shows clear British influence and is a possible precursor of sets of natural history subjects later popularised on mica (see no. 18). Another Indian artist, 'Mootoo Kistnah', is represented in the same album by two topographical pictures. These are inscribed 'Captain Chase's Hermitage at Warriore with some late improvements in the Garden. Captain Trapaud delin. Mootoo Kistnah fecit' and 'Captain Dyce's Seat. Taken on the spot by Mootoo Kistnah, first Landscape painter in Tritchinopoly'. Trapaud was promoted Captain in the Madras Engineers in 1784 and was at Trichinopoly and Srirangam in 1785.[2] It seems possible, therefore, that the first picture was either drawn by him and coloured by 'Mootoo Kistnah' or was painted by 'Mootoo Kistnah' after a sketch supplied by Trapaud. Of 'Mootoo Kistnah's career nothing further is known but the second of the two inscriptions suggests that by the early seventeen-eighties, he had already built up a considerable reputation among the British for topographical painting.

From 1790 to 1830 no other drawings by local artists for British patrons have so far come to light, but by the eighteen-thirties, an offshoot from Company painting at Tanjore had developed in Trichinopoly, some forty miles distant. Trichinopoly was transferred to the Company in 1801 and in succeeding years many of the British visited the area to view its great Rock and Fort which had been besieged in the Carnatic War. About three miles north of Trichinopoly on an island in the Cauvery River was the town of Srirangam linked to the mainland by a long bridge. It was a crowded pilgrimage centre, comparable to Benares in the north, with its great temples of Raghunathaswami and Jambukeswar. Both places were clearly good markets for selling souvenirs to British sight-seers. Paintings on paper of costumes and of deities were accordingly made. In style, they were marked by figures isolated against plain backgrounds or small landscapes and by brilliant acidic colouring: arsenic green, lemon yellow and hot orange-brown

[1] See Christie's sale, 29 April 1970, Lot 78, reproducing a drawing of a 'Jack Tree'.
[2] See Archer (1969), i, 345–348. Inscriptions on Trapaud's drawings show that he was in Trichinopoly and Tanjore in 1785.

(no. 15). A volume of these pictures collected by Sir Robert Dick, who commanded a division in Madras from 1838 and was Commander-in-Chief from 1841 to 1842, appeared in the London salerooms in 1967, showing that by the eighteen-forties the style was firmly established and large sets were being produced.

Paintings of deities were a speciality of Trichinopoly and Srirangam, satisfying the interest in the Hindu religion aroused by the temples there. Sets of the ten avatars or incarnations of Vishnu were especially popular. These consisted of the following incarnations – the Fish, Turtle, Boar, Man-Lion, Dwarf, Parasurama, Rama, Krishna, Balarama and Kalki; Buddha, who is the ninth incarnation in north Indian iconography, was often replaced by Balarama. Such paintings were prototypes for the plates in *The Hindoo Pantheon*, published in Madras by the Oriental Lithographic Press between 1841 and 1845, and *The Religion of Vishnoo*, published in 1849 to 1850. The drawings for these plates were made by Étienne Alexander Rodriquez, the Company's Head Draftsman at Madras, and were clearly copied from Trichinopoly paintings.

It was, however, mainly painting on mica and ivory that flourished in these centres, the mica being brought from Cuddapah and Madras and the ivory from Palghat. By the mid-nineteenth century delicate little paintings on ivory were being made for buttons, tie-pins and lockets, and sets of paintings on mica of gods (no. 31), rulers (no. 22), castes, costumes and occupations (nos. 23–26) transport (no. 27), ceremonies and festivals (nos. 28, 29), temples (no. 21 xxii–xxiv), birds, animals, flowers, butterflies (no. 18), as well as military uniforms (no. 17) were produced in their hundreds. In 1888 T. N. Mukharji recorded that a packet of a dozen mica paintings could be bought for four rupees at Trichinopoly. Four bound volumes of such drawings in the Victoria and Albert Museum, entitled 'Trichinopoly Exports', have a cover-paper with an 1851 watermark, showing that by the mid-nineteenth century mica-painting was well established. When E. B. Havell submitted a report on the arts and industries of the Madras Presidency in 1885 to 1888, it was still flourishing, and it continued until the end of the century.

In the small state of Pudukkottai, forty miles to the south of Trichinopoly, an off-shoot of Tanjore and Trichinopoly painting also flourished. Culturally the state was closely linked to Tanjore, the Tondaiman rulers of Pudukkottai being related to the Tanjore rulers. After the latters' patronage became limited by British control, the Pudukkottai court absorbed some of its artists and musicians. At the same time the state was closely allied to the British and in the mid-eighteenth century had joined forces with them against Haidar Ali and the French. A Residency colony grew up there and the local artists sought their livelihood from both the palace and Europeans. Like the Tanjore raja, the Pudukkottai ruler, Raja Vijaya Ragunatha Raya Tondaiman (ruled 1807–25), was under strict supervision by the English Resident as a minor from 1807 to 1817 and received a western-type education.

During the nineteenth century artists from Tanjore, working in a semi-British style, painted portraits of the rajas and local notables. In the palace there are portraits of this type depicting Vijaya Raghunatha Tondaiman (1789–1807), Vijaya Raghunatha Raya Tondaiman (1807–25), Raja Raghunatha Tondaiman (1825–39), and Raja Ramachandra Tondaiman (1839–86), as well as portraits of General Sir William Blackburne, Resident in Tanjore and Pudukkottai from 1810 to 1823. The first of these portraits of the rajas is by Ramaswami Maistry of Tanjore, and the last by Govindaswami Maistry of Tanjore.

Paintings on mica were also made here in the Trichinopoly style and it is virtually impossible to distinguish the mica sets made at Pudukkottai from those made at Trichinopoly and Srirangam. Towards the very end of the nineteenth century similar pictures were also made on glass.

In these three cities – Trichinopoly, Srirangam and Pudukkottai – painting was clearly a sub-style of Tanjore painting and the artists there were considered by Tanjore painters as inferior and commercialised. Their mica and ivory pictures, however, so popular as souvenirs, outlived painting at Tanjore and persisted until the end of the nineteenth century.

Bibliography

Archer, Mildred. *British drawings in the India Office Library* (London, 1969).

Archer, Mildred and W. G. *Indian painting for the British, 1770–1880* (Oxford, 1955), 82–84.

Bidie, G. 'The Art Industries of Madras,' *Journal of Indian Art*, iii, no. 29, January 1890, 25.

Havell, E. B. *Reports (no. vi) on the arts and industries of certain districts of the Madras Presidency, submitted by Mr E. B. Havell during the years 1885–1888* (Madras, 1909).

Hemingway, F. R. *Madras District Gazetteers: Trichinopoly* (Madras, 1907).

Jouveau-Dubreuil, G. *Archéologie du sud de l'Inde, vol. II. Iconographie* (Annales. Bibliothèque d'études, Musée Guimet, xxvii, Paris, 1914).

Mukhariji, T. N. *Art manufactures of India* (Calcutta, 1888), 24.

Rodriguez, E. A. *The Hindoo pantheon* (Madras, 1841–45).

Rodriguez, E. A. *The Religion of Vishnoo* (Madras, 1849–50).

Venkatarama Aiyyar, K. R. ed. *A Manual of the Pudukkottai State*, 2 vols. (Pudukkottai, 1938–44).

(a) *Paintings on paper.*

15 i–vii 7 drawings; 3 of deities and 4 of occupations.
Probably by a Trichinopoly artist, *c.* 1850.
Gouache; approx. 6 by 4 ins.
Presented by Mrs Marsden Jones, 3 May 1961. *Add. Or. 1898–1904*

NOTE: Similar in style to mica paintings no. 31.

 i Madura deity with distinctive headdress; a form of Vishnu. *Add. Or. 1898*
 ii Vishnu. *Add. Or. 1899*
 iii Vishnu as Rama. *Add. Or. 1900*

iv	Drummer, perhaps from the Deccan.	*Add. Or. 1901*
v	Vaishnava devotee from the Carnatic with conch shell.	*Add. Or. 1902*
vi	Shaiva non-Brahmin mendicant from Kerala.	*Add. Or. 1903*
vii	Tamilnad Shaiva ascetic.	*Add. Or. 1904*

16 Hanuman, the monkey god, carrying the Himalayas in his hand. Illustration to the *Rāmāyana*.
Probably by a Trichinopoly artist, *c.* 1862.
Inscribed on front: *A Man with a Monkey's Head*; on back: *Taken from the wall of a temple by a native.*
Pen-and-ink and water-colour; 6 by 4¾ ins.
Presented by Miss Helen Hamilton through Mrs Pilgrim, a descendant of Maxwell Graham, 27 July 1960. *Add. Or. 989*

NOTE: This drawing formed part of an album (*WD 1355–1361*) belonging to Maxwell Graham, Bombay Army, 1858–64. The sketches all relate to the Madras presidency, *c.* 1862, and its seems probable that Graham acquired this drawing at the same time. In style it is similar to the mica painting no. 20i.

(b) Paintings on mica

17 i–iv 4 mica paintings depicting Madras uniforms.
By a Trichinopoly artist, *c.* 1820–30.
Gouache on mica; 4¾ by 3 ins.
Purchased 20 March 1967. *Add. Or. 2668–2671*

i	Uniform of a sepoy of the Madras Native Infantry.	*Add. Or. 2668*
ii	Uniform of an officer of the Madras Native Infantry.	*Add. Or. 2669*
iii	Uniform of a sawar trooper of the Madras Light Cavalry.	*Add. Or. 2670*
iv	Uniform of an officer of the Madras Light Cavalry.	*Add. Or. 2671*

18 i–vi 6 mica paintings depicting plants, birds, butterflies and a moth.
By a Trichinopoly artist, *c.* 1850.
Gouache on mica.
Purchased 10 March 1968. *Add. Or. 3006–3011*

i	Egg Fruit (*Solanum melongena*). Oval; 5½ by 3¾ ins.	*Add. Or. 3006*
ii	A flower of the *Polygala* species. Oval; 5½ by 3¾ ins.	*Add. Or. 3007*
iii	Wood Snipe (*Capella nemoricola*). 5¾ by 4¼ ins.	*Add. Or. 3008*

 iv Grey-headed Lapwing (*Microsarcops cinereus*).
 $5\frac{3}{4}$ by $4\frac{1}{4}$ ins. *Add. Or. 3009*
 v Two butterflies (*Adelpha serpa* and *Apatura iris* L) on an *Allamanda cathartica*.
 $5\frac{3}{4}$ by $4\frac{1}{4}$ ins. *Add. Or. 3010*
 vi A moth (*Chrysiridia rhipheus*) on a *Tamarindus indica*.
 $5\frac{3}{4}$ by $4\frac{1}{4}$ ins. *Add. Or. 3011*

19
i–xiv 14 mica paintings depicting castes and occupations in South India. Most of the figures are shown paired with their wives.
By a Trichinopoly artist, *c.* 1850.
Inscribed on old mounts with names of castes.
Gouache on mica; $4\frac{3}{4}$ by $3\frac{1}{4}$ ins; xiii and xiv $4\frac{1}{4}$ by 6 ins.
Purchased 10 February 1914. *Add. Or. 592–605*

NOTE: These mica paintings were previously mounted in a small scrap-book entitled 'Indian Costumes'. The figures are set against a background of trees and huts and are standing on a streaky yellow and green ground.

 i Vaishnava mendicant playing a trumpet and leading a gaily caparisoned bullock.
 Inscribed: *Indoo Caste. Bull Beggar* *Add. Or. 592*
 ii Woman fish-seller with basket and fish.
 Mis-inscribed: *Wife.* *Add. Or. 593*
 iii Rajput with a spear.
 Inscribed: *Raj Pootter Cast. Man.* *Add. Or. 594*
 iv Rajput Woman.
 Inscribed: *His wife.* *Add. Or. 595*
 v Tumbler standing on his hands.
 Inscribed: *Players. Man.* *Add. Or. 596*
 vi Woman tumbler doing a balancing act.
 Inscribed: *Wife.* *Add. Or. 597*
 vii Mendicant carrying hand-punkah, brass vessel etc.
 Inscribed: *Pukeree Caste. Man.* *Add. Or. 598*
 viii Mendicant's wife with hand-punkah.
 Inscribed: *Wife.* *Add. Or. 599*
 ix Milkman with pot on his head.
 Inscribed: *Dood wallah. Milkman.* *Add. Or. 602*
 x Milkman's wife with a basket of pots on her head.
 Inscribed: *Wife.* *Add. Or. 603*
 xi Arab.
 Inscribed: *Arab Caste. Man.* *Add. Or. 604*
 xii Arab woman.
 Inscribed: *Wife.* *Add. Or. 605*

xiii Blacksmith and assistant at work.
 Inscribed: *Iron Smith's Shop.* *Add. Or. 600*
xiv Grain Shop.
 Inscribed: *Comattee Bazaar.* *Add. Or. 601*

20
i–xlii
42 mica paintings depicting Hindu deities and occupations.
By a Trichinopoly artist, *c.* 1850.
Inscribed on original mounts with titles.
Gouache on mica; i–vi 6 by 4 ins; vii–xlii 5 by 3 ins.
Presented 10 February 1914. *Add. Or. 614–655*

NOTE: These mica paintings were originally mounted in a scrap album together with eight Benares mica paintings (no. 117), and four photographs of ascetics (*Photo 34*).

 i Hanuman carrying the Himalayas on his right hand.
 Inscribed: *Hunaman the Monkey God.* *Add. Or. 614*
 ii Pasupati Shiva: Shiva as Lord of the Beasts wearing deer horns kneeling
 before a lingam.
 Inscribed: *Muni or Sogo devotee of Siva worshipping the Lingam.*
 Add. Or. 615
 iii Vishnu as Rama.
 Inscribed: *Vishnu as Ram chumdra.* *Add. Or. 616*
 iv Vishnu.
 Inscribed: *Vishnu.* *Add. Or. 617*
 v Krishna, playing on his flute, a cow at his feet.
 Inscribed: *Crishna.* *Add. Or. 618*
 vi Vishnu as Narayan holding lotus flowers.
 Inscribed: *Narayan.* *Add. Or. 619*
 vii Two carpenters.
 Inscribed: *Carpenters at work.* *Add. Or. 620*
 viii Woman setting a warp.
 Inscribed: *A woman spinning.* *Add. Or. 621*
 ix Elephant with mahout accompanied by spearmen.
 Inscribed: *Elephant with Howdah & Mohent on his back.* *Add. Or. 622*
 x School-master and pupils in school.
 Mis-inscribed: *A Band of Musicians playing in the Verandah of a house.*
 Add. Or. 623
 xi Washerman ironing on a table.
 Inscribed: *An Ironing man at work.* *Add. Or. 624*
 xii Box-wallah selling cloth.
 Inscribed: *A Hawker or pedler selling his Goods.* *Add. Or. 625*

xiii	Pedlar with an umbrella under his arm.	
	Inscribed: *Hawker or Pedler.*	*Add. Or. 626*
xiv	Coolie with box on his head.	
	Inscribed: *Bearer with box of Goods for sale.*	*Add. Or. 627*
xv	Head clerk with umbrella and pen-case.	
	Inscribed: *A Gomastah or Head Clerk.*	*Add. Or. 628*
xvi	Head clerk's wife.	
	Inscribed: *Wife.*	*Add. Or. 629*
xvii	Man with walking stick, wearing a green shawl.	
	Probably mis-inscribed: *Butler.*	*Add. Or. 630*
xviii	Wife of the above.	
	Inscribed: *Wife.*	*Add. Or. 631*
xix	Oil merchant with a basket of pots on his head.	
	Inscribed: *Oil Merchant.*	*Add. Or. 632*
xx	Oil merchant's wife with pot and measure.	
	Inscribed: *Wife selling oil.*	*Add. Or. 633*
xxi	Potter at his wheel.	
	Inscribed: *Potter.*	*Add. Or. 634*
xxii	Potter's wife carrying pots on her head.	
	Inscribed: *Wife carrying vessels.*	*Add. Or. 635*
xxiii	Barber holding a razor.	
	Inscribed: *Barber.*	*Add. Or. 636*
xxiv	Barber's wife with razor.	
	Inscribed: *Wife.*	*Add. Or. 637*
xxv	Shoe-maker holding a pair of boots.	
	Inscribed: *Chuchdar or Shoemaker.*	*Add. Or. 638*
xxvi	Shoe-maker's wife.	
	Inscribed: *Wife.*	*Add. Or. 639*
xxvii	Merchant seated on a chair.	
	Inscribed: *Banker or Merchant.*	*Add. Or. 640*
xxviii	Merchant's wife holding a paper.	
	Inscribed: *Wife.*	*Add. Or. 641*
xxix	Clerk holding a book.	
	Inscribed: *Writer.*	*Add. Or. 642*
xxx	Clerk's wife holding a paper.	
	Inscribed: *Wife.*	*Add. Or. 643*
xxxi	Muslim gentleman with a sword.	
	Inscribed: *Mussolman.*	*Add. Or. 644*
xxxii	Muslim woman holding a flower.	
	Inscribed: *Mussolmanee.*	*Add. Or. 645*
xxxiii	Brahmin.	
	Inscribed as above.	*Add. Or. 646*

xxxiv	Brahmin's wife and child.	
	Inscribed: *Wife & Child.*	*Add. Or. 647*
xxxv	Tailor seated on a mat sewing.	
	Inscribed: *Tailor.*	*Add. Or. 648*
xxxvi	Tailor's wife holding scissors.	
	Inscribed: *Wife.*	*Add. Or. 649*
xxxvii	Bearer or valet holding a dish.	
	Inscribed: *Bearer or Child's boy.*	*Add. Or. 650*
xxxviii	Nurse with English child.	
	Inscribed: *Ayah & English child.*	*Add. Or. 651*
xxxix	Carpenter.	
	Inscribed as above.	*Add. Or. 652*
xl	Carpenter's wife holding tools.	
	Inscribed: *Wife.*	*Add. Or. 653*
xli	Washerman ironing on a table.	
	Inscribed: *Ironing Man.*	*Add. Or. 654*
xlii	Washerman's wife holding an iron.	
	Inscribed: *Wife.*	*Add. Or. 655*

21
i–xxiv

24 mica paintings depicting occupations, methods of transport, hunting scenes, festivals and Indian scenes.
By a Trichinopoly artist, *c.* 1850.
Inscribed on old mounts with notes.
Gouache on mica; 4 by 6 ins.
Presented by the Rev. M. S. Douglas, 3 August 1954. *Add. Or. 656–679*

 i Buttermilk-sellers.
 Inscribed: *Native Rest House for Travellers with Native Women selling Moar or Buttermilk to Travellers.* *Add. Or. 656*

 ii Women pounding and husking rice.
 Inscribed: *A Hut and Native Women preparing Rice. 1 Woman carrying in the husk which has been boiled & dried. 2 Women husking the Rice in a Mortar with wooden Pestiles shod with iron rings, (Prov. 27.22). 3 Women separating the clean Rice from the husks & bran with the cholohoo or winnowing Fan of the Scriptures, (Matth. 3.12).* *Add. Or. 659*

 iii Fish-sellers.
 Inscribed: *Natives with their Fish exposed for sale on a hair Blanket spread on the ground & a Woman making a bargain.* *Add. Or. 660*

 iv Box-wallah selling cloth.
 Inscribed: *Native Hawker & Servant exhibiting his goods (on a Cumbly or hair Blanket) to a Customer.* *Add. Or. 661*

 v Washerman and his wife with donkeys.

Inscribed: *A Native Washerman & his Wife going to a Tank or River (The Asses carrying the clothes) to Wash Clothes. Strikingly Correct.*　　Add. Or. 666

　vi　Washing clothes in a river.

Inscribed: *Stream of Water with 1. A Brahmin washing himself and Clothes, and 2. Two washermen & one Washerwoman washing the Clothes of Lower Caste. Very correct.*　　Add. Or. 667

　vii　Sawyers at work.

Inscribed: *Native Sawyers at work. A correct representation.*　　Add. Or. 668

viii　Carpenters.

Inscribed: *Native Carpenters at Work. A correct representation.*　　Add. Or. 669

　ix　Irrigating with bullocks.

Inscribed: *Bullocks drawing water out of a Well for watering a garden.*

　　Add. Or. 670

　x　Water-carrier.

Inscribed: *1. Native standing on, & leaning over a well Water. 2. Water Carrier, with Bullock and leather Bottles on either side.*　　Add. Or. 671

　xi　Snake-charmers.

Inscribed: *A Group of Native Serpent Charmers. Nothing would give a Stranger a better idea of the reality than this representation.*　　Add. Or. 676

　xii　Travelling with pack-bullock.

Inscribed: *A Respectable Native on a Journey with a Servant.*　　Add. Or. 657

xiii　Elephant with howdah and mahout.

Inscribed: *Domes & Minarets of a Native Palace with an Elephant adorned for a Procession.*　　Add. Or. 665

xiv　Englishman hunting tiger on an elephant.

Inscribed: *Tiger hunting in the Neilgherries.*　　Add. Or. 662

　xv　Tiger-hunting on elephants.

Inscribed: *A European with Natives Tiger Hunting on Elephants.*

　　Add. Or. 663

xvi　Bullock-carriage with cheetahs.

Inscribed: *Natives with tame tigers.*　　Add. Or. 664

xvii　Marriage customs.

Inscribed: *High Caste Natives. Friends bringing Presents to a Newly Married Pair.*　　Add. Or. 658

xviii　Image of Vishnu being carried in procession.

Inscribed: *Image of Streerangam being carried in Procession to the Temple. A strikingly correct representation. Mark the difference in the appearance and dress of the various parties of the Group. 1. The Brahmin. 2. Bearers. 3. Singers. 4. Dahsee or Dancing Woman. 5. An Attendant. 6. Native Drummer. Imagine this surrounded by crowds of excited & shouting Spectators.*　　Add. Or. 677

xix　Muharram Festival.

Inscribed: *A Mohammedan Procession commemorative (as far as I can judge) of*

*some event connected with the Subjugation of the Natives of India who are repre-
sented in a ridiculous and degrading light, & bound together with Chains. The
Man on the Camel & the [ones] dressed like him are Mohamedans. The 2 Men
to the extreme left are Musicians.* *Add. Or. 678*

 xx Hook-swinging Festival (*Charak Puja*).
 Inscribed: *Churuck Poojah or Swinging Festival. Requires to be surrounded with
 a dense crowd of delighted spectators to give anything like an idea of the reality, but
 still strikingly correct so far as it is given.* *Add. Or. 679*

 xxi Religious edifice on raft during a festival, probably at Trichinopoly.
 Inscribed: *A Tank connected with a Temple, on which are Two Floats carrying a
 mimmic Temple & Choultry.* *Add. Or. 673*

 xxii Temple of Srirangam, Trichinopoly.
 Inscribed: *Temple of Streerangam, Trichinopoly.* *Add. Or. 672*

 xxiii Rock, fort and bridge between Trichinopoly and Srirangam.
 Inscribed: *A Temple on a Hill and a Bridge near to Trinchinopoly.* *Add. Or. 675*

 xxiv Choultry at Rameswaram.
 Inscribed: *Cocoa Nut Trees, a Temple built in the Sea, Native Boats & small
 Craft.* *Add. Or. 674*

22 i–iv 4 mica paintings depicting rulers, probably of Tanjore.
 By a Trichinopoly artist, *c.* 1850.
 Gouache on mica; 6 by $4\frac{1}{4}$ ins.
 Purchased 10 December 1962. *Add. Or. 2411–2414*

NOTE: Nos. 22–30 were purchased at the same time and came from the same collection (Sotheby's
sale, 1962).

 i A ruler, probably Raja Sarabhoji of Tanjore (ruled 1825–39), seated on a
 throne. *Add. Or. 2411*

 ii The same ruler seated on a throne, an attendant with a fan standing behind him,
 being entertained by a dancing-girl and three male musicians. *Add. Or. 2412*

 iii A bearded ruler, probably Raja Sivaji of Tanjore (ruled 1839–86), seated on
 a throne with a table and vase of roses beside him. *Add. Or. 2413*

 iv The same ruler standing with a son, or minister, on a dais under a canopy;
 attendants on either side with silver-sticks, fans and fly whisks. *Add. Or. 2414*

23 i–x 10 mica paintings depicting the costumes of various castes in South India.
 By a Trichinopoly artist, *c.* 1850.
 Gouache on mica; 6 by $4\frac{1}{4}$ ins.
 Purchased 10 December 1962. *Add. Or. 2415–2424*

 i Nawab with sword. *Add. Or. 2415*

ii Parsee with sword.	*Add. Or. 2416*
iii Cloth or sari-seller.	*Add. Or. 2417*
iv Orderly with letter.	*Add. Or. 2418*
v Washerman ironing clothes.	*Add. Or. 2419*
vi Toddy-tapper about to climb a palm tree.	*Add. Or. 2420*
vii Village woman with rain hat, probably from Kerala.	*Add. Or. 2421*
viii Muhammadan woman.	*Add. Or. 2422*
ix Hindu woman.	*Add. Or. 2423*
x Hindu woman.	*Add. Or. 2424*

24 i–xv 15 mica paintings depicting the dress of various castes in South India.
By a Trichinolopy artist, *c.* 1850.
Gouache on mica; 5 by 3¼ ins.
Purchased 10 December 1962. *Add. Or. 2425–2439*

i Nawab with sword.	*Add. Or. 2425*
ii Officer of native infantry with green coat and sword.	*Add. Or. 2426*
iii Hookah-burdar carrying a hookah and hookah mat.	*Add. Or. 2427*
iv Steward (*sarkār*).	*Add. Or. 2428*
v Orderly with silver-stick.	*Add. Or. 2429*
vi Orderly with gold-stick.	*Add. Or. 2430*
vii Letter writer.	*Add. Or. 2431*
viii Cultivator with plough.	*Add. Or. 2432*
ix Shaiva ascetic with palm leaf fan.	*Add. Or. 2433*
x Mendicant with fan, etc.	*Add. Or. 2434*
xi Hindu woman.	*Add. Or. 2435*
xii Muhammadan woman.	*Add. Or. 2436*
xiii Female juggler with dagger.	*Add. Or. 2437*
xiv Female entertainer with tambourine.	*Add. Or. 2438*
xv Female vegetable-seller.	*Add. Or. 2439*

25 i–iii 3 mica paintings depicting occupations of man and wife in South India.
By a Trichinopoly artist, *c.* 1850.
Gouache on mica; 6 by 4¼ ins.
Purchased 10 December 1962. *Add. Or. 2440–2442*

i Stone-mason and wife.	*Add. Or. 2440*
ii Cultivator hoeing, his wife carrying earth.	*Add. Or. 2441*
iii Bird-catcher and wife selling small birds and peacocks (*Plate 11*).	*Add. Or. 2442*

26
i–xxxii 32 mica paintings depicting occupations in South India.
By a Trichinopoly artist, *c.* 1850.

Gouache on mica; 4¼ by 6 ins.
Purchased 10 December 1962. *Add. Or. 2443–2474*

 i, ii Two dancing-girls with three male musicians. *Add. Or. 2443; 2444*
 iii, iv Dancing-girl with four male musicians. *Add. Or. 2445; 2446*
 v Three musicians with a woman standing by. *Add. Or. 2447*
 vi Man and wife with two performing bears. *Add. Or. 2448*
 vii Jugglers with a performer on stilts. *Add. Or. 2449*
 viii Dancers of the Mariyamman cult with a woman carrying fire.
 Add. Or. 2450
 ix Dancers of the Mariyamman cult, a man carrying fire on his head.
 Add. Or. 2451
 x School master and pupils in school *Add. Or. 2452*
 xi, xii Prisoner before a court (*Plate 9*). *Add. Or. 2453; 2454*
 xiii Grain-seller with customer (see 19 xiv). *Add. Or. 2455*
 xiv Grain-seller. *Add. Or. 2456*
 xv, xvi Oil press. *Add. Or. 2457; 2458*
 xvii Sugar press. *Add. Or. 2459*
 xviii Potter and wife. *Add. Or. 2460*
 xix Blacksmith and assistant at work (see 19 xiii). *Add. Or. 2461*
 xx Carpenters. *Add. Or. 2462*
 xxi Basket-maker and wife. *Add. Or. 2463*
 xxii Woman stick-warping. *Add. Or. 2464*
 xxiii Two women grinding. *Add. Or. 2465*
 xxiv Two men cultivating; a woman carrying earth. *Add. Or. 2466*
 xxv–xxvii Cloth-seller with assistant and customer. *Add. Or. 2467–2469*
 xxviii Tailor with customer. *Add. Or. 2470*
 xxix Milkman. *Add. Or. 2471*
 xxx Washerman ironing. *Add. Or. 2472*
 xxxi Water-carriers filling water-cart. *Add. Or. 2473*
 xxxii Water-carrier and bullock with water-skins. *Add. Or. 2474*

27 i–xv 15 mica paintings depicting various methods of transport.
By a Trichinopoly artist, *c.* 1850.
Gouache on mica; 4¼ by 6¼ ins.
Purchased 10 December 1962. *Add. Or. 2475–2489*

 i, ii Palanquin and bearers. *Add. Or. 2475; 2476*
 iii Chair (*tonjaun*). *Add. Or. 2477*
 iv Horseback; gentleman on a horse with two silver-stick bearers, two fan
 and umbrella bearers. *Add. Or. 2478*
 v, vi Bullock-carriage (*rath*). *Add. Or. 2479; 2480*

vii, viii	Camel with rider.	*Add. Or. 2481; 2482*
ix	Elephant with howdah.	*Add. Or. 2483*
x	Elephant-carriage; ruler (perhaps Raja Sarabhoji) with attendants in carriage drawn by two elephants.	*Add. Or. 2484*
xi	Elephant-carriage; ruler and attendants in carriage drawn by three pairs of elephants.	*Add. Or. 2485*
xii–xv	Elephant with howdah.	*Add. Or. 2486–2489*

28 Temple festival scene; deity in car pulled by ropes.
By a Trichinopoly artist, *c.* 1850.
Gouache on mica; $4\frac{1}{4}$ by 6 ins.
Purchased 10 December 1962. *Add. Or. 2490*

29
i–viii 8 mica paintings depicting the various ceremonies of life.
By a Trichinopoly artist, *c.* 1850.
Gouache on mica; $4\frac{1}{4}$ by $6\frac{1}{4}$ ins.
Purchased 10 December 1962. *Add. Or. 2491–2498*

i	Naming ceremony.	*Add. Or. 2491*
ii	Funeral ceremony.	*Add. Or. 2492*
iii, iv	Bridegroom's party; bridegroom carrying a rose, riding a white horse accompanied by an umbrella bearer, dancing-girl and musicians.	*Add. Or. 2493; 2494*
v, vi	Marriage ceremony.	*Add. Or. 2495; 2496*
vii, viii	Bride and bridegroom in decorated palanquin.	*Add. Or. 2497; 2498*

30 i–xv 15 mica paintings of Hindu deities, including incarnations of Vishnu.
By a Trichinopoly artist, *c.* 1850.
Gouache on mica; 6 by 4 ins.
Purchased 10 December 1962. *Add. Or. 2499–2513*

i	Unidentified deity carrying a flag (?).	*Add. Or. 2499*
ii	Parasurama (Rama with the axe), sixth incarnation of Vishnu.	*Add. Or. 2500*
iii	Balarama with his ploughshare, ninth incarnation of Vishnu.	*Add. Or. 2501*
iv	Rama with his bow, seventh incarnation of Vishnu.	*Add. Or. 2502*
v	Manmatha, the God of Love, with his bow (*Plate 10*).	*Add. Or. 2503*
vi	Parrot-beaked god, perhaps Garuda.	*Add. Or. 2504*
vii	Dancing deity with sword and buckler.	*Add. Or. 2505*
viii	Vamana (the dwarf), fifth incarnation of Vishnu.	*Add. Or. 2506*
ix	Unidentified deity; perhaps Balarama.	*Add. Or. 2507*
x	Vishnu on the shoulders of Garuda.	*Add. Or. 2508*

 xi Narasimha (man-lion), fourth incarnation of Vishnu. *Add. Or. 2509*
 xii Matsya (the fish), first incarnation of Vishnu. *Add. Or. 2510*
 xiii Kurma (the tortoise), second incarnation of Vishnu. *Add. Or. 2511*
 xiv Varaha (the boar), third incarnation of Vishnu. *Add. Or. 2512*
 xv Kalki (the horse), tenth incarnation of Vishnu. *Add. Or. 2513*

31
i–xxx

30 mica paintings depicting deities of South India, including an incomplete set of the incarnations of Vishnu.
By a Trichinopoly artist, *c.* 1890.
Originally mounted on paper with inscriptions in English and Tamil. Some of the paintings had become separated from their inscriptions.
Gouache on mica; 6 by 4 ins.
Presented by the Society for the Propagation of the Gospel in Foreign Parts, London, 7 July 1932. *Add. Or. 959–988*

NOTE: The Society believes that these paintings were collected by the Rev. Arthur Westcott, Principal of the S.P.G. College, Madras, 1887 to 1901.

 i Indra seated, with his son Bali, the monkey king, flying through the air.
 Inscribed in English: *Indra Sittu*; in Tamil: *intiracittu.* *Add. Or. 959*
 ii The child Krishna dancing.
 Inscribed in English: *Thandava Krishnan*; in Tamil: *tāṇṭavakiruṣṇaṉ.*
 Add. Or. 960
 iii Unidentified deity.
 Inscribed in English: *Bala Raman*; in Tamil: *pala irāmaṉ.* *Add. Or. 961*
 iv Rama with his bow, seventh incarnation of Vishnu.
 Inscribed in English: *Siri Rama*; in Tamil: *śrī irāmar.* *Add. Or. 962*
 v Manmatha, the God of Love.
 Inscribed in English: *Manmatha*; in Tamil: *maṉmataṉ.* *Add. Or. 963*
 vi Narada, the great sage.
 Inscribed in English: *Naratha*; in Tamil: *nāratar.* *Add. Or. 964*
 vii Madura deity with sword, club and distinctive headdress, perhaps Madurai-vira or Ayyanar.
 Inscribed in English: *Madurei Veeran*; in Tamil: *maturaivīraṉ.* *Add. Or. 965*
 viii Unidentified deity with sword and buckler.
 Inscribed in English: *Beeman*; in Tamil: *pīmaṉ.* *Add. Or. 966*
 ix Madura deity with sword, club and distinctive headdress, perhaps Maduraivira or Ayyanar.
 Inscribed in English: *Mada Swami*; in Tamil: *māṭasvāmi.* *Add. Or. 967*
 x Madura deity (duplicate of ix). *Add. Or. 968*
 xi Parasurama (Rama with the axe), sixth incarnation of Vishnu.
 Inscribed in English: *Parasu Raman*; in Tamil: *Paracu irāmaṉ.* *Add. Or. 969*

xii Parasurama (duplicate of xi). *Add. Or. 970*

xiii Unidentified deity with flag (?).
Inscribed in English: *Dharma Raja*; in Tamil: *tarma irājaṉ*. *Add. Or. 971*

xiv Unidentified deity (duplicate of xiii). *Add. Or. 972*

xv Subrahmanya, the God of War.
Inscribed in English: *Subramanian*; in Tamil: *cuppiramaṇiyaṉ*. *Add. Or. 973*

xvi Subrahmanya.
Inscribed in English: *Udumbu Subramaniar*; in Tamil: *uṭumpu cuppiramaṇi-
yar*. *Add. Or. 974*

xvii Unidentified deity.
Inscribed in English: *Nakulan*; in Tamil: *nakulāṉ*. *Add. Or. 975*

xviii Parvati (?) dancing holding lotuses. *Add. Or. 976*

xix Rama with his bow, seventh incarnation of Vishnu.
Inscribed in English: *Kothundapani*; in Tamil: *Kōtaṇṭapāṇi*. *Add. Or. 977*

xx Kinnara; horse-headed deity playing on a stringed instrument.
Inscribed in English: *Kabanthan*; in Tamil: *Kapantaṉ*. *Add. Or. 978*

xxi Kalki (the white horse), tenth incarnation of Vishnu.
Inscribed in English: *Kaliga Avatar*; in Tamil: *kalika avatāram*. *Add. Or. 979*

xxii Kalki (duplicate of xxi). *Add. Or. 980*

xxiii Vamana (the dwarf), fifth incarnation of Vishnu.
Inscribed in English: *Vamana Avatar*; in Tamil: *vāmaṉa avatāram*.
Add. Or. 981

xxiv Vamana (duplicate of xxiii). *Add. Or. 982*

xxv Varaha (the boar), third incarnation of Vishnu.
Inscribed in English: *Varaka Avatar*; in Tamil: *varāka avatāram*. *Add. Or. 983*

xxvi Varaha (duplicate of xxv).
Inscribed in English: *Bū Varaka Avatar*; in Tamil: *pū varāka avatāram*.
Add. Or. 984

xxvii Matsya (the fish), first incarnation of Vishnu.
Inscribed in English: *Matcha Avatar*; in Tamil: *macca avatāram*. *Add. Or. 985*

xxviii Shiva lingam with Rama worshipping.
Inscribed in English: *Rama Lingam, Rama worships Linga*; in Tamil: *irāma-
liṅkam*. *Add. Or. 986*

xxix Narasimha (man-lion), fourth incarnation of Vishnu.
Inscribed in English: *Nrsimha*. *Add. Or. 987*

xxx Narasimha.
Inscribed in English: *Nara Simha Avatar*; in Tamil: *naracimma avatāram*.
Add. Or. 988

(iv) MADURA

Madura was brought under British administration in 1801 and its monuments with their rich sculpture soon attracted travellers and touring officers. The Daniells had visited the town in 1792 and their aquatints of the Fort, the Great Temple and Choultry, published in 1797 and 1798, made this architecture familiar to a wider public. It was natural therefore that Indian artists at Madura should concentrate on architectural subjects and depict the Great Temple, with its Hall of a Thousand Pillars, the Choultry and Palace of Tirumala Nayyak, as well as other famous temples in South India such as those at Tanjore and Rameswaram. These pictures were of two types – black and white line drawings, sometimes with touches of sepia wash, and full water-colour paintings in warm tones of sepia with touches of red, blue and yellow. Colonel Colin MacKenzie acquired a set of fifty-one line drawings of the Great Temple at Madura and the Choultry of Tirumala Nayyak in about 1801 to 1805 (*WD 1063*), and the Indian Section, Victoria and Albert Museum has a number of full water-colour paintings of Madura subjects (*08100 to 08107 I.S., I.M. 55–1924* and *I.M. 56–1924*).

Sometimes Indian artists appear to have assisted British amateur artists. According to their inscriptions, three drawings in the Library were a joint effort by Lieutenants Jenkins and Whelpdale and a Madura artist, Ravanat Naig (*WD 557–9*). It seems probable that the army officers did the architectural perspective drawing and the Indian painter filled in the elaborate sculptural detail. Ravanath Naik (who anglicised his name to Ravanat Naig) may have been working on survey with the lieutenants as a Company draftsman.

Like other South Indian artists, Madura painters sometimes migrated to other centres where they could find a ready market. It was probably a Madura painter who made the pictures of Tanjore and Madura architectural subjects for Raja Sarabhoji which were presented to the British Resident, Benjamin Torin (no. 32), and it may well have been a Madura painter who worked for Sarabhoji's son, Raja Sivaji of Tanjore (see p. 23).

Bibliography

Archer, Mildred. *British drawings in the India Office Library* (London, 1969) i, 233 and ii, 531–582.
Archer, Mildred and W. G. *Indian painting for the British, 1770–1880* (Oxford, 1955), 84.
Francis, W. *Madras District Gazetteers: Madura* (Madras, 1906).

32 i–ix 9 drawings of buildings and architectural detail at Tanjore and Madura (Madras).
Probably by a Madura artist working in Tanjore, 1803.
Inscribed with titles in ink; also with notes and measurements.
Pen-and-ink and wash; (ii) in pen-and-ink and water-colour.
Presented to the East India Company by Benjamin Torin, 1807.

Add. Or. 756–764

NOTE: Raja Sarabhoji of Tanjore (1777–1832, ruled 1798–1832) had been educated by the British authorities. His tutors were the Danish missionaries, the Rev. C. W. Gericke and Dr Swartz. As a result of their instruction he learnt to draw in the European style and became interested in subjects such as natural history and architecture. He built a temple at Tanjore and a new palace in mixed Indo-British style. When his old tutor, Dr Swartz, died, he commissioned Flaxman to make a memorial to him in Swartz's Church in the fort, Tanjore.

His son, Sivaji (ruled 1832–53), inherited his father's interests and also commissioned Flaxman to make a statue of his father for the Palace Durbar Hall. He became a Founder Honorary Member of the Royal Institute of British Architects and his name appears in the 1836 list of members (the first list published) together with the name of the King of Oudh. See 'Address of the Institute of British Architects explanatory of their views and objects and the Regulations adopted at a meeting, held July 2nd, 1834.' 'Honorary Members. The third class shall consist of noblemen and gentlemen who may be Donors to the amount of not less than twenty-five guineas in one sum, and also of foreigners and others distinguished for their scientific or architectural acquirements. They shall be denominated by Honorary Members'. In 1838 he presented 10 architectural drawings to the Royal Institute of British Architects (*no. F 3/17, 1–10*).

In the second half of the nineteenth century, the present drawings were mounted in a scrap-book with drawings of Java and Siam (see *WD 957–959; 972–1001*) and mis-inscribed *Mysore Collection of Drawings*, red serial numbers being written on them. A collection of natural history drawings (*NHD 7, 1101–1116*) was also separately mounted and mis-inscribed *Mysore Collection of Drawings*. It is clear from internal evidence that this latter collection is 'The Natural Products of Hindostan, painted under the direction of the Rajah of Tanjore', which Benjamin Torin, Resident of Tanjore from 1801 to 1803, presented to the East India Company in 1807.[1] Inscriptions on the present drawing as well as the wrong inscription, *Mysore Collection of Drawings*, would suggest that both the natural history drawings and architectural drawings were part of the same collection.

Raja Sarabhoji appears to have been in the habit of presenting visitors with architectural drawings, Lord Valentia receiving from him in 1804 a drawing of the Great Temple at Tanjore.

Bibliography

Archer, Mildred. *Natural history drawings in the India Office Library* (London, 1962), 13–14, 89.

Archer, Mildred. 'Company architects and their influence in India', *Journal of the Royal Institute of British Architects*, August 1963, 317–321.

Archer, Mildred. *Indian architecture and the British* (London, 1968), 60–64.

Annesley, G. (Lord Valentia). *Voyages and travels to India, Ceylon, the Red Sea, Abyssinia and Egypt in 1802–1806* (London, 1809), i, 356, 359–360.

i North-east view of the Vighnesvara temple, Tanjore (Madras).
Inscribed: *83. North East View of the Vignaswar Pagoda of the little fort of Tanjour. Constructed by His Excellency Serfojee Maha Rajah. 1st June, 1803.* Also notes and measurements.
9 by 14$\frac{3}{4}$ ins.

Add. Or. 756

[1] *Court Minutes*, B/145, 311.

ii South view of the temple of Avutaiyar Kovil, near Tanjore (Madras).
Inscribed: *84. No. 10. A South View of the Selebrated Pagoda of Auvedayar covil. Mysore Coll. of Drawings.* Also measurements.
16½ by 22¾ ins. *Add. Or. 757*

iii Carved pillars on the temple of Avutaiyar Kovil, near Tanjore (Madras).
Inscribed: *85. Pillars of the Pagoda at Auvedayar covil. Representing Nurshimha. Representing the Dancing of the Kauly. Representing the Dancing of the Eshwer. Representing the Begging of the Eshwer. Mysore Coll. of Drawings.*
18 by 22 ins. *Add. Or. 758*

iv Carved pillars on the temple at Avutaiyar Kovil, near Tanjore (Madras) (*Plate 14*).
Inscribed: *87. Pillars of the Pagoda at Auvedayar Covil. Representing Veerabadra. Representing Kauly. Representing the Brother of Vanagamoody Pundarom. Representing Eshwer. Mysore Coll. of Drawings.*
16½ by 22 ins. *Add. Or. 760*

v Six carved pillars of the temple at Avutaiyar Kovil, near Tanjore (Madras).
Inscribed: *88. Pillars of the Pagoda at Auvedayar Covil. Mysore Coll. of Drawings.*
17½ by 22 ins. *Add. Or. 761*

vi Carved pillars of the choultry in front of the temple of Avutaiyar Kovil, near Tanjore (Madras).
Inscribed: *86. Pillars of the Choultry before the Pagoda at Auvedayar covil. Representing the Prince Riding on horseback & a God named Soobramany. Representing Veerabadra. Representing Agoremoorty. Mysore Coll. of Drawings.*
17 by 21½ ins. *Add. Or. 759*

vii Carved pillar of the choultry in front of the temple of Avutaiyar Kovil, near Tanjore (Madras).
Inscribed: *90. A Pillar in the Choultry adjoining to the Pagoda of Auvedayar Covil, the Statue upon it represents an emage of Wanagamoody Pundaurom who was the founder of it & a Poligar subject to Tanjore kingdom. Mysore Coll. of Drawings.*
18 by 11 ins. *Add. Or. 763*

viii Carved pillar of the choultry of Tirumala Nayyak, Madura (Madras).
Inscribed: *89. A Pillar of the Choultry of Trimal Naig at Madura Representing the Sheva killing the Asoor who had the shape of an Elephant. Its Height is 25 feet. Mysore Coll. of Drawings.*
18 by 11 ins. *Add. Or. 762*

ix Carved pillar of the choultry of Tirumala Nayyak, Madura (Madras).
Inscribed: *91. A Pillar of the Choultry of Tremul Naig at Madura Representing the Dancing of Shiva. Its Height 25 feet. Mysore Coll. of Drawings.*
18 by 11 ins. *Add. Or. 764*
NOTE: Similar to *WD 1063 f.15* in MacKenzie's collection of drawings of Madura.

(v) MALABAR AND COORG

In addition to the centres already discussed, a minor style of Company painting also developed in Malabar where a number of Company factories, with small European communities, were strung out along the Malabar Coast. In 1792, the area was ceded to the British at the Treaty of Seringapatam and by the early years of the nineteenth century pictures illustrating the costume and occupations of the area had begun to be produced. They show the different types of South Indian Brahmin and various occupations including those connected with the coconut palm, such as coir yarn-making. Of particular interest to Europeans was the existence of the Syrian Christian community, and pictures of Christians, their bishops and priests, were included in these sets. Although closely related to other forms of Company painting in South India, the Malabar drawings have a distinctive style of their own. They are executed in a restrained palette of brown, fawn, white, green and yellow, with occasional touches of blue and red in the dress of the bishops and priests. The figures are drawn with great delicacy and a flowing suavity of line, and the paint is applied smoothly to give an almost enamelled quality (nos. 33, 34). The carefully executed sets of 1810 to 1830 gradually gave way to smaller-sized and more summary productions in the period, 1830 to 1850 (no. 35), and these continued to be produced until the late nineteenth century.

Costume drawings were occasionally made in Coorg, to the north of Malabar. This small state came under British rule in 1834 and coffee plantations were soon developed there. The dress of the local people with their distinctive waist-knives aroused interest amongst British residents and in the mid-nineteenth century somewhat naive drawings concentrating on male dress were made for them (no. 36).

Bibliography

Archer, Mildred and W. G. *Indian painting for the British, 1770–1880* (Oxford, 1955), 84.

India. *Imperial Gazetteer of India, vol.* xi (Oxford, 1908), Coorg, 33–51.

Rice, B. L. *Mysore and Coorg: a gazetteer; vol. iii, Coorg* (Bangalore, 1878).

33 i–iii 3 drawings depicting Syrian Christians of South India. Illustrations to a copy of a manuscript by Captain Charles Swanston, 'A Memoir of the Primitive Church of Malay-Ala or of the Syrian Christians of the Apostle Thomas from its first rise to the present day'.

By a Malabar Coast artist, *c.* 1810–27.

Gouache; 8 by $12\frac{1}{2}$ ins.

Presented to the East India Company by the author. Received 13 November 1828. *Mss. Eur. D. 152* (Kaye no. 391), facing pp. 3, 173, 175.

NOTE: Swanston of the Madras Army had collected his material in 1809 to 1811 while he was on survey, and in 1816, when in attendance on the Bishop of Calcutta. The drawings illustrating his manuscript were probably acquired by him during the earlier period *c.* 1810 although they may have been inserted just before despatch in 1828. They appear to be from a set similar to no. 34 with the same composition and colouring. Another copy of the manuscript was sent to the Madras Literary Society who forwarded it to the Royal Asiatic Society, 31 August 1827. It was published in the *Journal of the Asiatic Society*, i, 1834, 171–192 and ii, 1835, 51–62, 234–247.

i Bishop in red robe with yellow surcoat and mitre, holding a crozier.
Inscribed: *No. 1. Metropolitan of the Syrian Christians of Malay-Ala.*
REPRODUCED: *Journal of the Royal Asiatic Society*, i, 1834 frontispiece.
Similar to left hand figure in no. 34 xi.

ii Two priests; one in a white cassock and red head cloth. holding a book; the other in a white tunic with a red head covering and a blue cloth over the shoulder, holding a silver-topped staff.
Inscribed: *No. 2. Cattanars or Priests of the Syrian Christians of Malay Ala.*
Right-hand figure similar to right-hand figure in no. 34 xi.

iii Two Christians; the man in a white *dhotī* holding a palm-leaf parasol, the woman in white shirt and *dhotī*, with a white cloth over her shoulder. She holds a rosary, wears gold jewellery and has a red amulet around her neck.
Inscribed: *No. 3. Syrian Christians of Malay Ala.*

34
i–xiii
13 drawings bound into a volume depicting castes of the Malabar Coast. In most cases a man and woman are shown together holding the implements of their trade. They are depicted against a plain white background with a fawn band of ground at their feet.
By a Malabar Coast artist, *c.* 1828.
Lettered on cover: *Costumes of the Malabar Coast*; drawings inscribed with titles.
Water-marks of 1826.
Water-colour; 9¾ by 12 ins.
Purchased 3 March 1911. *Add. Or. 1334–1346*

NOTE: The two figures in xi are almost exact duplicates of no. 33, i and ii.

i Three male figures; two with drums, one with cymbals.
Inscribed with names of instruments: *Magudam. Murashu,* *Add. Or. 1334*

ii Two Kerala Brahmins; the man with a parasol and a palm-leaf fan, the woman with a parasol (*Plate 16*).
Inscribed: *Nambūree. Nambūrechee.* *Add. Or. 1335*

iii Man and woman of the rice-pounder caste, chiefly found in the coastal areas of Travancore; the man with a mattock, standing by a rice pounder; the woman with baskets and coconuts (*Plate 17*).
Inscribed: *Cudumbee. Cudumbechee.* *Add. Or. 1336*

iv Shepherd caste; the man with a calf; the woman with a bucket and pitcher
on her head.
Inscribed: *Edayen. Edachee.* *Add. Or. 1337*

v Three male musicians; two with drums; one with a wind instrument.
Inscribed: *Tavil. Nāgasuram.* *Add. Or. 1338*

vi Coir yarn-makers; the man making coconut-fibre string; the woman beating
coconut-fibre.
Inscribed: *Nholayen. Nholachee.* *Add. Or. 1339*

vii Toddy-tappers the man with sickle, crutch-stick and baskets; the woman with
pitcher and basket.
Inscribed: *Nādān. Nādāthee.* *Add. Or. 1340*

viii Headman of Tiyor and Chegon castes with wife; both holding coconuts.
Inscribed: *Thandān. Thandāthee.* *Add. Or. 1341*

ix Fisherman with paddle and fish; his wife with baskets of fish.
Inscribed: *Maracāthee. Maracān.* *Add. Or. 1342*

x Raja's bodyguard with staff; his wife with basket.
Inscribed: *Chēgōn Chēgōthee.* *Add. Or. 1343*

xi Bishop and priest of the Syrian Church. The Bishop wears red, yellow and
blue robes and carries a crozier; the priest wears a white dress with red head-
cloth and carries a staff (*Plate 15*).
Inscribed: *Serian Bishop & Cathanar.* *Add. Or. 1344*

xii Temple Brahmins; the man carries a rosary and brass vessel, the woman a
parasol.
Inscribed: *Pōtty-amah. Pōtty.* *Add. Or. 1345*

xiii Carpenter and wife; the man has a mallet, measuring stick and mat; the
woman a leaf-plate.
Inscribed: *Āshāree. Āshārechee.* *Add. Or. 1346*

35 i–ii 2 drawings depicting castes and occupations of the Malabar Coast.
By a Malabar Coast artist *c.* 1850.
Water-colour; $7\frac{1}{2}$ by 9 ins.
Presented by Michael Archer, 20 April 1968. *Add. Or. 950; 951*

NOTE: A later version of no. 34 vi. For other examples from this series, see Mildred Archer,
Indian miniatures and folk paintings (Arts Council, London, 1968), nos. 54–56, and Indian Section,
Victoria and Albert Museum, *I.S. 255 to 265–1951.*

i Cultivators transplanting paddy; the man digging with a mattock, the woman
transplanting seedlings.
Inscribed: *Corroven.* *Add. Or. 950*

ii Coir yarn-makers; the man making coconut-fibre string; the woman beating
coconut fibre.
Inscribed: *Nolayen.* *Add. Or. 951*

36 i–v 5 drawings depicting the dress of men from Coorg (Kodagu).
By South Indian artists, probably of Coorg, *c.* 1850.
Circumstance of acquisition unrecorded.

India Office Albums, vol. 43, 'The People of India', nos. 4517–4521.

NOTE: (i–iii) appear to be by the same hand and (iv, v) by a different artist.

 i Man from Coorg; back view, wearing white dress and red patterned girdle with waist knife.
 Inscribed: *A Coorg (showing mode of carrying knife).*
 Water-colour; 9¾ by 3¾ ins. *No. 4517*
 ii Man from Coorg wearing a dark coat with short knife fastened by chains to his red girdle; he holds a waist knife and a matchlock.
 Inscribed: *Coorg.*
 Water-colour; 12¼ by 7½ ins. *No. 4518*
iii Coorg man in black coat with waist knife in red girdle; side view, holding a bow and arrows.
 Inscribed: *Coorg.*
 Water-colour; 12½ by 7¼ ins. *No. 4521*
 iv Coorg man in dark blue coat with short knife in red and yellow girdle; front view, holding a matchlock and waist knife. Hills in background (*Plate 12*).
 Inscribed: *Coorgs.*
 Water-colour; 9 by 5½ ins. *No. 4519*
 v Coorg man in dark green coat with waist knife in red and yellow girdle; back view, holding a bow and arrows. Hills in background (*Plate 13*).
 Inscribed: *Coorgs.*
 Water-colour; 9 by 5½ ins. *No. 4520*

37 A pile-carpet loom at Hunsur (Mysore).
By a South Indian artist, 1850.
Pen-and-ink and water-colour; 17½ by 24½ ins.
Inscribed in Persian: *ghālīchah būnī (bunnī) kā pāthrā* (Rug weaving loom): in English: *Plan and Elevation of a Carpet loom with five men at work. Grazing Farm. Hoonsoor. 1st November, 1850.*
Presented to the East India Company's Museum, 1850. *Add. Or. 755*

NOTE: The Amrit Mahal cattle-breeding establishment was at Hunsur, on the south-western side of Mysore adjoining Coorg. Until 1864 it had a large tannery, blanket manufactory and timber yard maintained by the Madras Commissariat. This drawing may well have been sent to the East India Company together with a specimen carpet for the Museum.

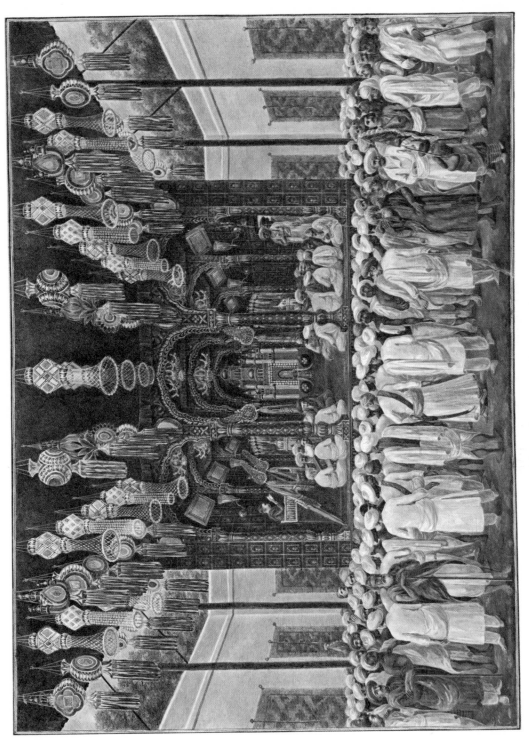

C Muharram festival. By Sewak Ram, Patna, 1807

II Eastern and Upper India

(i) MURSHIDABAD

Painting, similar in subject-matter to that in South India, also developed for the British in the Bengal Presidency, although at a slightly later date. The origins of this painting lay in Murshidabad, capital of the Mughal province of Bengal. During the first half of the eighteenth century the Nawabs, as Mughal Viceroys, supported a splendid court there. Both they and the wealthy gentry of the city patronised painters, and many portraits, scenes of court life, and *rāgamālā* sets were produced for them in a provincial Mughal style of painting which was strongly related to that practised at the Mughal provincial courts of Azimabad (Patna) and Faizabad in Oudh. After the death of Nawab Alivardi Khan in 1756, however, the power of the Nawabs began to decline through administrative weakness. From 1760 onwards the British gradually gained control in eastern India and the balance of power shifted. There had long been a British factory trading in cotton and silk goods at Kasimbazar five miles away, but in the second half of the eighteenth century increasing numbers of British lived in Murshidabad or its neighbourhood. In 1767 barracks for British troops were built at Berhampore, six miles to the south, and after 1775 a Resident was appointed to the Nawab's durbar. British residents were also attracted to Murshidabad by its situation on the Bhagirathi River which linked Calcutta to the main channel of the Ganges. Until the mid-nineteenth century this was the great highway from Calcutta to upper India and all boats tied up at Murshidabad to take on fresh provisions and water. The city was thus a busy and wealthy centre with a large number of the British either living there or passing through it. As patronage by Indian society diminished, it was natural that Murshidabad artists should look for their livelihood to these new residents and visitors.

The first paintings executed for the British at Murshidabad were portrait miniatures in Mughal style. In the Victoria and Albert Museum there is a portrait, probably of William Fullarton, which was painted in about 1760.[1] Fullarton was a surgeon in Bengal and Bihar from 1744 until about 1766, and was well acquainted with many of the leading Indian noblemen in Murshidabad. He was clearly interested in Indian painting and made a collection of miniatures, some of them by an artist of Murshidabad, Dip Chand. His portrait shows him reclining on a

[1] Skelton, plate 11.

terrace smoking his hookah. He is attended by servants and is talking to an Indian visitor. The Indian Museum, Calcutta, also possesses a number of portraits, made in Murshidabad in about 1780, showing Europeans with powdered hair and tricorne hats.[2]

At about the same time whole sets of pictures were being made by Murshidabad artists specially for the British, comprising portraits of Mughal and Murshidabad rulers, as well as neighbouring rulers and landlords (no. 39). The Lucknow Nawabs and their ministers are often included in these sets for, as provinces of the old Mughal empire and centres of the Muslim religion, Murshidabad and Oudh preserved strong links for many years. The portrait sets also included Indian rulers such as Chet Singh of Benares or Badi al-Zaman Khan of Birbhum who figured prominently in the complicated politics of the second half of the eighteenth century. These portraits are simplified versions of the earlier miniatures with similar compositions – a figure seated amongst cushions on a marble terrace fringed with a border of flowers, or standing against a blue sky and low horizon.[3] Gradually, however, British taste made itself felt. Shadows were attached to the feet of the figures, water-colour on English paper in pallid blues and greens took the place of bright gouache, and broader washes replaced the earlier meticulous brushwork.

Simultaneously with portraits, sets of pictures were made depicting the various occupations and costumes of the local people. Particular emphasis was given to those who worked as servants for the British or who had everyday relations with their households – the milk-woman, the butter-maker, the vegetable-seller, the barber. These figures were portrayed in a similar way to the ruler, showing a single figure standing against a blue sky with a low horizon edged with small rounded trees or bushes (plate 20). The first paintings of this type were in gouache (no. 38) and strongly reminiscent in style of earlier Murshidabad miniatures. In certain cases they have the bright colours – oranges, pinks and greens – that are associated with painting at Lucknow. It is known that a number of Oudh artists came to Murshidabad in the mid-eighteenth century and their influence may well have left its mark on painting there.

By the turn of the century, a new style had developed which was even more clearly influenced by western techniques of the 1780 to 1800 period. It did not replace the earlier style derived from Mughal miniatures but existed alongside it. Elongated figures with long *jāmas*, the folds indicated at the bottom of the skirt with a jagged line, begin to appear. A wide oblong format is common; sepia wash in varying shades of grey and brown is dominant with only a few touches of local colour; the paintings are frequently surrounded with a heavy black border and the whole effect is sombre to a degree.

[2] Havell, plates lxix and lxx.
[3] Compare plate 19 with Skelton, plates 3 and 10.

This new style was linked to a freer development in subject matter. Large scenes were produced showing the Nawabs of Murshidabad or Lucknow in a variety of situations. A set in the Victoria and Albert Museum shows Nawab Mubarak-ud-daula of Murshidabad seated with his son and the British Resident, Sir John Hadley D'Oyly.[4] Another picture shows the same Nawab of Murshidabad proceeding to prayers at the Mani Begam's Mosque on the occasion of Bakr Id. A picture similar in style to these shows another Nawab, perhaps his son, riding in procession through the city (no. 40). Others show Nawab Asaf-ud-daula listening to music or celebrating the Muharram festival in the great Imambara at Lucknow (no. 41). Many other festivals or ceremonies were also depicted: Hook-swinging, Muharram, Holi, Chait, and Hindu and Muslim marriages. These pictures were clearly meeting a new demand from the British. The first compositions, linked to earlier Mughal miniatures, slowly gave way to a more realistic depiction of a wider variety of subjects and to painting in a style more reminiscent of British aquatints and engravings. It is likely that, as at Calcutta, Indian painters had seen examples of prints in the bazaar and were modelling their pictures on them. This type of painting was practised at Murshidabad until the second decade of the nineteenth century and it persisted at Calcutta, perhaps through the agency of Murshidabad artists, until the eighteen-thirties.

Beside paintings in water-colour on paper, painting on mica for the British also developed in Murshidabad in the late eighteenth century. Mica was plentiful in the Chota Nagpur plateau to the west of Murshidabad and the technique of mica painting had long been practised in making lamps and ornamental constructions for the magnificent celebrations of Muslim festivals for which the city was famous. A Muslim historian, writing of the reign of Murshid Quli Khan (1703–27), describes how 'during the first twelve days of the month Rubby al Avul, which include the birth and death of the holy Prophet, he feasted people of all conditions: and on those nights, the road from Maheenagar to Loll Baugh, which is above three miles, was illuminated with lamps, representing verses of the Koran, mosques, trees, and other figures. Nearly a hundred thousand persons were employed on these occasions; and on firing of a gun, the whole was illuminated at once, exhibiting, in an instant, such a sheet of light as astonished the beholders.'[5] As this extravagant patronage of the Nawabs declined, artists began to develop the old technique in a different direction. During the last twenty years of the eighteenth century, paintings for the British were made on small rectangles of mica. It seems probable that Murshidabad set this fashion and that mica painting in South India at Trichinopoly, Srirangam and Pudukkottai (see p. 38) developed somewhat later. The sets of pictures which were made at Murshidabad showed the usual popular subjects of costumes, occupations, methods of transport, festivals and ceremonies (no. 42).

[4] For details of this set see p. 70. [5] Quoted Stewart, 406.

From the early nineteenth century, Murshidabad declined in importance. Trade was diverted to Calcutta and, with the coming of the railways, the river ceased to be the main highway. As early as 1812 Lady Nugent noted in her journal, 'this once flourishing capital of Bengal is fast falling into decay, in point of trade in particular'. Murshidabad gradually became a quiet district headquarters with particular attractions for visitors from Calcutta. It was situated in good shooting country and the palace and mosques provided a touch of romantic Mughal splendour. The Nawab gave lavish hospitality to British guests. Although his administrative power and great wealth had declined, he remained a wealthy nobleman. As late as 1837 an enormous palace in European neo-classical style was built for him by a British engineer officer, Duncan MacLeod. The Nawab furnished it in up-to-date Victorian style with large-scale portraits by British artists such as B. Hudson, W. H. Florio Hutchisson and F. C. Lewis. For Indian painters, however, the city had ceased to be a flourishing centre. There is little doubt that in the early years of the nineteenth century many Murshidabad artists migrated to Calcutta or marketed their pictures there. It is significant that Lady Nugent, who was an enthusiastic collector of Company paintings, does not refer to them at Murshidabad, although she made purchases in Calcutta, Patna and Lucknow.

Bibliography

Archer, Mildred, and W. G. *Indian painting for the British, 1770–1880* (Oxford, 1955), 20–26.

Havell, E. B. *Indian sculpture and painting* (London, 2nd edition, 1928), plates lxix, lxx.

Mazumdar, P. C. *The Musnad of Murshidabad* (Murshidabad, 1905).

Nugent, Maria. *A Journal from the year 1811 till the year 1815*, 2 vols. (London, 1839), i, 173 and ii, 190–196.

O'Malley, L. S. S. *Bengal District Gazetteers: Murshidabad* (Calcutta, 1914).

Skelton, R. W. 'Murshidabad Painting', *Marg*, x, no. 1, December 1956, 10–22.

Stewart, C. *The History of Bengal* (London, 1813).

Walsh, J. H. T. *A History of Murshidabad District* (London, 1902).

(a) Paintings on paper

38
i–xxii

22 paintings bound into a volume depicting occupations and types in Bengal.
By a Murshidabad artist, *c.* 1780–90.
Book plate of 'John White Esqr'.
Some pictures inscribed on back in English with subject; (xxii) inscribed in Persian characters.
Gouache and water-colour; size of album 12 by 9½ ins; size of paintings: approx. 6½ by 9 ins.
Purchased 4 December 1908. *Add. Or. 1009–1030*

NOTE: The paintings can be divided into 3 groups:
(i) is in a slightly different style from the rest and is closely related to no. 120, having the same composition in reverse.

(ii) – (xviii) show the figures set against a green ground with grassy clumps in the foreground and a line of small bushes on the horizon, a blue sky shading down to white. The colours are bright and clear and the folds of drapery are sharply defined. It is possible that, together with (i) these drawings were made by a Murshidabad artist with Lucknow antecedents.

(xix) – (xxii) show the figures against a plain background.

The volume belonged to John White who served in the Bengal civil service from 1778 to 1800, resigning in 1801. Apart from accompanying an embassy to the Raja of Berar in Central India from 1781 to 1783, he appears to have spent most of his service based on Calcutta. 6 drawings in this album (*WD 1394–1399*) were probably made by him (see Mildred Archer, *British drawings in the India Office Library* (London, 1969), i, 349).

i	Dancing-girl seated on a sofa.	*Add. Or. 1009*
ii	Two musicians with trumpet and horn.	
	Inscribed: *Native Musicians.*	*Add. Or. 1010*
iii	Potter and wife at work.	
	Inscribed: *Earthen potters.*	*Add. Or. 1011*
iv	Two sawyers at work.	*Add. Or. 1012*
v	Rope-makers.	*Add. Or. 1013*
vi	Shaiva ascetic with raised arms and long nails (*urdhvabāhu*) seated on a tiger skin; also labourer breaking bricks.	
	Inscribed: *Native beggar.*	*Add. Or. 1014*
vii	Two washermen at work (*Plate 18*).	
	Inscribed: *Washerman.*	*Add. Or. 1015*
viii	Two palanquin bearers carrying a woman's palanquin.	
	Inscribed: *A Native woman's palanquin.*	*Add. Or. 1016*
ix	Two barbers at work.	
	Inscribed: *Barbers*	*Add. Or. 1019*
x	Two men measuring land for revenue purposes.	
	Inscribed: *Measuring land for taxation.*	*Add. Or. 1020*
xi	Two straw rope-makers.	*Add. Or. 1022*
xii	Two men fishing in paddy fields.	
	Inscribed: *Fishermen.*	*Add. Or. 1023*
xiii	Two weavers, one combing a warp.	
	Inscribed: *Cloth Maker.*	*Add. Or. 1024*
xiv	Two carpenters.	
	Inscribed: *Carpenters.*	*Add. Or. 1025*
xv	Three turners at work.	
	Inscribed: *Native Carpenter and Turner.*	*Add. Or. 1026*
xvi	Two torch-bearers.	*Add. Or. 1028*
xvii	Two water-carriers with goat skins.	*Add. Or. 1029*
xviii	Two Vaishnava ascetics; one with arm upraised (*urdhvabāhu*), one carrying a bowl of fire (*bairāgī*).	*Add. Or. 1030*

xix Toddy-seller.
　　Inscribed: *Arrack Seller.* *Add. Or. 1017*
xx Woman carrying water-pots. *Add. Or. 1018*
xxi Indian jockey.
　　Inscribed: *A Native Jockey.* *Add. Or. 1021*
xxii Man and woman cooking their food.
　　Inscribed in Persian characters: *Zan u mard bā ham-dīgar ṭaʿām mī-pazand* (A
　　man and woman cooking food together). *Add. Or. 1027*

39
i–lxx

70 drawings mounted in a volume: 12 (i–xii) depicting Mughal rulers, their relations and contemporaries; 21 (xiii–xxxiii) depicting rulers of Bengal, Bihar and Oudh in the 18th century; 27 (xxxiv–lx) depicting occupations and boats; 9 (lxi–lxix) depicting 2 buildings, 5 musical instruments and 2 figures; one (lxx) a landscape.
(i–lx) by a Murshidabad artist; (lxi–lxix) by a Murshidabad artist working to the directions of a European; (lxx) by Robert Nichols Brouncker. *c.* 1785–90.
Mostly inscribed with titles.
(i–lx) water-colour; 10¾ by 7½ ins. approx.; (lxi–lxx) pen-and-ink and wash, varying sizes.
Purchased 30 December 1912. *Add. Or. 2674–2743*

NOTE: (i–lx) appear to be by the same artist and are distinguished by pale colouring – pale blue sky, light sandy yellow ground, white terraces – and by touches of bright local colour.

The inscriptions on the drawings were probably written not later than 1795, since Chet Singh (xxxii) is referred to as 'the late Nabob of Benares'. Chet Singh was deposed in 1781 and his successor, Mahip Narain Singh died in 1795.

Drawings (xiii–xxxiii) include portraits of rulers and officials in Bengal and Oudh who figured prominently in the political upheavals of the eighteenth century when the British were establishing themselves in Bengal. They are the characters who appear in accounts such as Luke Scrafton, *Reflections on the government of Indostan with a short sketch of the history of Bengal from mdccxxxviii to mdcclvi; an account of the English affairs to mdcclviii* (London, 1763); Salim Allah (F. Gladwin trans.) *A Narrative of the transactions in Bengal, during the Soobahdaries of Azeem us Shan, Jaffer Khan, Shuja Khan, Sirafraz Khan and Alyvirdy Khan* (Calcutta, 1788); Ghulam Husain Khan (Hajji Mustafa trans.) *Seir Mutaqherin*, 4 vols. (Calcutta and Madras, 1789). See also K. Datta, *Alivardi and his times* (Calcutta, 1939) and J. Sarkar, *The History of Bengal, vol. 2, Muslim period* (Dacca, 1948).

Three paintings of Lucknow personalities, those of Shuja-ud-daula (xiv), Haidar Beg Khan (xv) and Husain Riza Khan (xvii), illustrate how Indian artists in the late eighteenth century were copying oil paintings by European artists. The prototypes of these pictures first made in Faizabad and Lucknow were based on portraits by Tilly Kettle. Once copies had been made, artists in Lucknow continued to reproduce them and their versions were re-copied by Murshidabad artists.

The dwarf depicted in lxviii, may be the famous dwarf of Kasimbazar who is portrayed in a set of Murshidabad paintings at the Victoria and Albert Museum (*11 (4)–1887 I.S.*).

It is possible that this volume of paintings belonged to Robert Nichols Brouncker who drew the last picture. His name cannot be traced in the East India Company records and he may possibly have been a Dutchman from one of the Bengal Dutch factories near Murshidabad. The last nine drawings (lxi–lxix) show marked European influence and were probably made for Brouncker by an Indian draftsman working under his supervision. The bungalow shown in the last picture may be Brouncker's own house.

i The Emperor Farrukhsiyar (ruled 1713–19).
Oval; head and shoulders, facing right, wearing a purple costume and holding a jewel.
Inscribed: *Furrokseer.* *Add. Or. 2674*

ii The Emperor Babar (ruled 1526–30).
Oval; half length, facing half left, wearing a white costume.
Inscribed: *Baber.* *Add. Or. 2675*

iii The Emperor Bahadur Shah (ruled 1707–12).
Oval; head and shoulders, facing left, wearing a scarlet coat, his left hand on the hilt of his sword.
Inscribed: *Bahadar Shah.* *Add. Or. 2676*

iv The Emperor Akbar (ruled 1556–1605).
Oval; half length, facing half left, wearing a pink coat, a falcon on his right wrist.
Inscribed: *Acbar Shah.* *Add. Or. 2677*
NOTE: Compare no. 119.

v The Emperor Shah Jahan (ruled 1628–57).
Oval; half length, facing right, wearing a purple coat.
Inscribed: *Shah Jehan.* *Add. Or. 2678*

vi Nur Jahan, wife of the Emperor Jahangir (ruled 1605–27).
Full length, facing right, wearing a red turban and white dress over crimson *pāijāmas.* Sandy ground with narrow line of trees and hills on the horizon.
Inscribed: *Noor Jehan. Jehan Geeas's Favourite Queen.* *Add. Or. 2679*

vii Sha'istah Khan, son of Asaf Khan and brother of Nur Jahan (died 1694).
Full length, facing right, holding a lance and wearing a sword and shield. Sandy ground with narrow line of trees and hills on horizon.
Inscribed: *Shasta Khan Son of Asaph Jah. Noor Jehan's Brother.*
Add. Or. 2680

viii The Emperor Muhammad Shah (ruled 1719–48).
Oval; head and shoulders facing right, wearing a green coat and smoking a hookah.
Inscribed: *Mahommed Shah.* *Add. Or. 2681*
The Emperor Shah Alam II (ruled 1759–1806).

Oval; half length, facing left, wearing a fur-trimmed gold coat, and holding a book.

Inscribed: *Shah Alum Emperour of Indoston.* *Add. Or. 2682*

x Jawan Bakht (1749–88), heir apparent, eldest son of Shah Alam II.
Oval; three quarter length, front face, wearing a white costume and leaning against a green cushion, his hands on the hilt of his sword.

Inscribed: *Shah Jehan Bukt.* *Add. Or. 2683*

xi Shah Abbas the Great (ruled 1587–1629).
Kneeling on a rug, facing left, hills and trees in the background.

Inscribed: *Shah Abbas Shah.* *Add. Or. 2684*

xii Ahmad Shah Durrani, Amir of Afghanistan (ruled 1747–73).
Oval; three quarter length, wearing a green fur-trimmed coat over a red dress and holding an axe.

Inscribed: *Hamed Shah Duranny.* *Add. Or. 2685*

xiii Mansur Ali Khan, Safdar Jang, Nawab of Oudh (ruled 1739–54).
Full length, facing right, wearing a fur-trimmed blue-green coat over a white *jāma*, his left hand on the hilt of his sword. Sandy background with narrow line of hills and trees on the horison.

Inscribed: *Munsah Ali Khan Sujah Dowlah's Father.* *Add. Or. 2686*

xiv Shuja-ud-daula, Nawab of Oudh (ruled 1754–75).
Full length, facing front, wearing a fur-trimmed blue-green coat over a white *jāma*, his left hand on his dagger, his right on the hilt of his sword. Sandy background with narrow line of hills and trees on horizon.

Inscribed: *Sujah Dowlah Nabob of Oude.* *Add. Or. 2687*

xv Haidar Beg Khan, minister of Asaf-ud-daula, Nawab of Oudh (ruled 1775–97).
Dressed in white seated on a rug against blue cushions.

Inscribed: *Hyder Beg Khan.* *Add. Or. 2688*

xvi Sarfaraz Khan, Nawab of Bengal (ruled 1739–40).
Facing right, seated on a crimson rug amongst crimson cushions and holding a rose; a low marble balustrade in the background.

Inscribed: *Suffraz Khan.* *Add. Or. 2689*

xvii Husain Riza Khan, minister of Asaf-ud-daula, Nawab of Oudh (ruled 1775–97).
Full length in a white *jāma* against a sandy background with hills.

Inscribed: *Hussain Raza Khan.* *Add. Or. 2690*

xviii Raja Nawal Rai (died 1750), Deputy of Safdar Jang, Nawab of Oudh (1739–54).
Facing right, seated on a crimson carpet, amongst crimson cushions, a low marble balustrade in the background. He is wearing a fur-trimmed gold coat over a white *jāma*, and holds a jewel in his left hand.

Inscribed: *Raja Nevel Roy Sujah Dowlah's Paymaster.* *Add. Or. 2691*

xix Abdullah Khan, Governor of Bengal and chief minister of the Mughal Empire 1716–20 (died 1722).
Full length, facing left, wearing a fur-trimmed green coat over a white *jāma* and holding a letter in his right hand. Sandy ground with hills and trees on the horizon.
Inscribed: *Abdulla Khan.* *Add. Or. 2692*

xx Alivardi Khan, Nawab of Bengal (ruled 1740–56).
Full length, facing right, in a white *jāma*; sandy ground with hills and trees on horizon.
Inscribed: *Aliverdi Khan Nabob of Bengal.* *Add. Or. 2693*

xxi Hajji Ahmad, brother of Alivardi Khan (see above), died 1748.
Full length, facing right, wearing a white *jāma* and holding a bow and arrows; sandy ground with hills and trees on horizon.
Inscribed: *Hadje Hamett Aliverdi Khan's Brother.* *Add. Or. 2694*

xxii Jafar Ali Khan (Mir Jafar), Nawab of Bengal (ruled 1757–60).
Facing left, seated on a white rug with white cushions. He wears a white *jāma* and holds a spray of roses in his right hand; low marble balustrade in background.
Inscribed: *Jaffier Ali Khan, Subah of Bengal.* *Add. Or. 2695*

xxiii Roshan Khan, Faujdar of Shahabad, murdered *c.* 1741.
Facing right, seated on a white rug with white cushions, a low white balustrade in the background. He wears a white *jāma* and his hands are folded together.
Inscribed: *Rushan Khan Fowsdar of Arrah in the Reign of Aliverdi Khan.*
 Add. Or. 2696

xxiv Ahmad Khan Bangash, Nawab of Farrukhabad, 1750–71.
Facing left, seated on a rug leaning against cushions, holding a rose in his right hand; a low white balustrade in the background.
Inscribed: *Ahmed Khan Bangish Nawab of Farruckabad.* *Add. Or. 2697*

xxv Saulat Jang (father of Shaukat Jang), Faujdar of Purnea, 1748–56, died 1756.
Facing right, seated on a rug against green and crimson cushions holding a hookah-snake in his right hand. His shield and sword lie beside him. In the background a low white balustrade.
Inscribed: *Soulet Jung Soubadar of Purnea in the reign of Ahmed Shah.*
 Add. Or. 2698

xxvi Husain Quli Khan, Subadar of Dacca, murdered by Siraj-ud-daula 1755.
Facing right, seated on a white rug, holding a rose in his left hand and leaning against a white cushion; a low white balustrade in the background. His sword and shield lie beside him (*Plate 19*).
Inscribed: *Hussein Kuli Khan. Subahdar of Dacca.* *Add. Or. 2699*

xxvii Shitab Rai, Diwan of Bihar for Mughal Emperor, later given sole auth-

ority over province of Azimabad by Council of Calcutta, died 1772.
Facing left, seated on a white rug, leaning against a white cushion and
holding a spray of roses in his right hand.

Inscribed: *Sittab Roy Nabob of Patna.* *Add. Or. 2700*

xxviii Unidentified ruler seated on a white rug leaning against blue and green
cushions; a low white balustrade in the background. *Add. Or. 2701*

xxix Badi al-Zaman Khan, Afghan zamindar of Birbhum (*c.* 1718–*c.* 1750).
Facing right, seated on a white rug, leaning against white and blue
cushions. His shield and sword lie beside him and he holds a rose in his
right hand; low white balustrade in the background.

Inscribed: *Budda Juma Khan Rajah of Beerboom.* *Add. Or. 2702*

xxx Raja Balabh, Deputy Governor of Azimabad, 1761–62, died 1763.
Facing left, seated against crimson and green cushions, holding a rose in
his right hand; low white balustrade in the background.

Inscribed: *Rajah Bullub.* *Add. Or. 2703*

xxxi Janaki Ram, Deputy Subadar of Bihar, 1748–53.
Full length, facing left, holding a rose in his right hand, his left resting on
the hilt of his sword. He wears a blue *jāma* and green *pāijāmas.*

Inscribed: *Rajah Jaunka Ram Subidar of Patna in the Reign of Amed Shah.*

 Add. Or. 2704

xxxii Chet Singh, Raja of Benares (ruled 1770–81).
Facing left, seated on a white rug against crimson and green cushions,
his hands resting on his sword; low white balustrade in the background.

Inscribed: *Cheyt Sing late Nabob of Benares.* *Add. Or. 2705*

xxxiii Raja Ram Narayan, Deputy Governor of Bihar (1753–60), driven from
Patna 1760, died 1763.
Facing left, seated on a white rug holding a spray of roses in his right
hand, his left resting on a yellow cushion. Behind him a yellow and crim-
son cushion; in the background a low white balustrade.

Inscribed: *Rajah Ram Narrain.* *Add. Or. 2706*

xxxiv Mace-bearer (*chobdār*).
Inscribed: *Chubdar.* *Add. Or. 2707*

xxxv Hookah-bearer (*huqqābardār*).
Inscribed: *Hookahbadar.* *Add. Or. 2708*

xxxvi Footman carrying a white fly-whisk.
Inscribed: *Footman.* *Add. Or. 2709*

xxxvii Servant carrying a huge crimson cloth fan (*pankhā*).
Inscribed: *A Punka Bearer.* *Add. Or. 2710*

xxxviii Groom (*sāis*).
Inscribed: *Sice or Groom.* *Add. Or. 2711*

xxxix Tailor (*darzī*).
Inscribed: *A Taylor at Work.* *Add. Or. 2712*

xl A water-cooler (*ābdār*) carrying a flask and glass.
Inscribed: *An Abdar or Waiter.* *Add. Or. 2713*

xli Torch-bearer (*mashālchi*) with torch and oil-can.
Inscribed: *Flambeau Bearer or Masaulje.* *Add. Or. 2714*

xlii Sweeper (*mehtar*) with his broom.
Inscribed: *A Jarroo Wallah or Sweeper.* *Add. Or. 2715*

xliii Embroiderer seated at his frame.
Inscribed: *Embroiderer.* *Add. Or. 2716*

xliv Washerman (*dhobī*) beating clothes on a plank (*Plate 20*).
Inscribed: *A Washerman.* *Add. Or. 2717*

xlv Water-carrier (*bihishtī*) with a skin of water.
Inscribed: *Water Carrier or Bhestie.* *Add. Or. 2718*

xlvi Man churning butter.
Inscribed: *Butter Man.* *Add. Or. 2719*

xlvii Ice-seller carrying a load on his head.
Inscribed: *Seller of Ice.* *Add. Or. 2720*

xlviii Village woman carrying water on her head; a rope and pail in her hand.
Inscribed: *A Woman carrying Water from the Well.* *Add. Or. 2721*

xlix Woman milk-seller carrying pots in a basket on her head.
Inscribed: *Milk Woman.* *Add. Or. 2722*

l Grain-seller with scales and baskets of grain.
Inscribed: *Corn Merchant.* *Add. Or. 2723*

li Woman spinning cotton.
Inscribed: *A Woman Spinning.* *Add. Or. 2724*

lii Cotton-carder (*dhuniyā*).
Inscribed: *Doonea or Cotton Cleaner.* *Add. Or. 2725*

liii Vegetable-seller seated with scales and baskets.
Inscribed: *A Seller of Greens.* *Add. Or. 2726*

liv Potter seated at his wheel.
Inscribed: *A Potter.* *Add. Or. 2727*

lv Carpenter with an adze.
Inscribed: *A Carpenter.* *Add. Or. 2728*

lvi Workman with a mattock.
Inscribed: *A Bildar.* *Add. Or. 2729*

lvii Peacock boat (*morpankhī*) on the river.
Inscribed: *A Moor Punkhee.* *Add. Or. 2730*

lviii Shaiva ascetic with arm upraised (*urdhvabāhu*).
Inscribed: *A Fakier doing Penance.* *Add. Or. 2731*

lix Boatman (*dāndī*) cooking his meal beside the river.
Inscribed: *A Dandy or Boat-man Dressing his Dinner.* *Add. Or. 2732*

lx Baggage boat being towed along a river.
Inscribed: *A Baggage Boat.* *Add. Or. 2733*

 lxi Interior of the tomb of Jalal al-Din.
 Inscribed in Persian characters: *andūrūn i rauzah i Jalāl al-Dīn.*
 Pen-and-ink; 11½ by 8½ ins. *Add. Or. 2734*
 lxii Another view of the interior of the tomb of Jalal al-Din.
 Inscribed in Persian characters: *andūrūn i rauzah i Jalāl al-Dīn.*
 Pen-and-ink; 11½ by 9 ins. *Add. Or. 2735*
 lxiii Musical instrument (*sārangī*), back view.
 Pen-and-ink and wash; 11½ by 7 ins. *Add. Or. 2736*
 lxiv Musical instrument (*sārangī*), front view; also bow.
 Pen-and-ink and wash; 11¾ by 7 ins. *Add. Or. 2737*
 lxv Musical instrument; another type of *sārangī*, front view; also bow.
 Pen-and-ink and wash; 11½ by 6 ins. *Add. Or. 2738*
 lxvi Musical instrument (*sārangī*), back view.
 Pen-and-ink and water-colour; 12 by 7¼ ins. *Add. Or. 2739*
 lxvii Musical instrument with two gourd resonators (*vīna*).
 Pen-and-ink; 4 by 7¼ ins. *Add. Or. 2740*
 lxviii Dwarf.
 Inscribed: *Bond Man. A man seen about 44 fingers high.*
 Wash; 7½ by 7¼ ins. *Add. Or. 2741*
 lxix Ascetic seated on a *chauki*.
 Pen-and-ink and wash; 10¾ by 7½ ins. *Add. Or. 2742*
 lxx River scene with a European bungalow on the bank and boats in the
 foreground.
 Inscribed: *Robert Nichols Brouncker Delineat.*
 Wash; 7 by 9 ins. *Add. Or. 2743*

40 Procession scene headed by a figure on horseback, perhaps Nawab Babar Ali (1793–1810) of Murshidabad, proceeding to prayers at the Chauk Masjid (*Plate 21*). By a Murshidabad artist, *c.* 1800.
Water-colour; 15¼ by 27½ ins.
Purchased 14 November 1954. *Add. Or. 745*

NOTE: In style this painting closely resembles a set in the Victoria and Albert Museum (*11(1-49)- 1887 I.S.*) which has strong Murshidabad affinities. It includes a painting of Nawab Mubarak-ud-daula of Murshidabad (1770–93) entertaining Sir John Hadley D'Oyly (British Resident 1780–85), inscribed: *The Court of the Newaub Moobaruck ul Dowlah. Father of the present Newaub Nauser ul Moolk* (i.e. Babar Ali, died 1810) *Receiving the then British Resident Sir John D'Oyley Bart.* (reproduced M. Archer, 'Baltazard Solvyns and the Indian Picturesque', *The Connoisseur*, January, 1969, 16. fig. 7). Another is inscribed: *A View of Munny Begum's Musjid and the Chandi Chowk in Murshidabad at the Festival of Buckra Ede on which occasion the Nawaab usually goes to prayers at the Musjid.* Yet a third picture is of a dwarf from *Manicknagur, in the island of Cosimbazar*. The set also has close links with Lucknow and includes pictures of the Jami Masjid and Great Imambara. The presence in the set of three paintings with detailed references to Murshidabad and nearby Kasimbazar raises

a strong presumption that the set was made and obtained there. In view of the close social and political links between Lucknow and Murshidabad, the presence of pictures of Lucknow also suggests a Murshidabad provenance.

41 i–ii 2 drawings depicting Asaf-ud-daula (Nawab of Oudh 1775–97).
By a Murshidabad artist, *c.* 1812. *Add. Or. 2595; 2600*

NOTE: Although acquired by the Library separately, both drawings originally came from a set belonging to Sir George Nugent, Commander-in-Chief in India, 1811–15. His wife was a keen collector of Company paintings (see Nugent, 1839). In her journal Lady Nugent does not refer to buying paintings while at Murshidabad in 1812, and may well have bought them from a Murshidabad painter marketing his work in Calcutta.

For a reproduction of a further picture from this series see Maggs Bros., *Oriental miniatures and illumination, Bulletin no. 6* (London, 1964), no. 142.

i Nawab Asaf-ud-daula celebrating the Muharram festival at Lucknow. He is seated at night in the Imambara listening to the maulvi reading from the scriptures. The maulvi sits in the centre on a dais beneath a canopy. The Nawab sits below on a rug smoking a hookah, with his sword and shield lying beside him. He is surrounded by courtiers and attendants. To the right a group of soldiers. In the background Muharram standards. The mosque is lit by candle-light.
Inscribed on back in English: *Nuwab Imambara Usfooda . . .;* in *nāgarī* characters: *Luknau imāmbāra asaf-ud-daula.*
Water-colour; $15\frac{1}{4}$ by $21\frac{3}{4}$ ins.
Purchased 17 March 1964. *Add. Or. 2595*

ii Nawab Asaf-ud-daula seated on a rug smoking a hookah and listening to a party of male musicians. He is surrounded by a group of courtiers and attendants (*Plate 22*).
Inscribed on back in English in ink: *Lukhnou Nawab Asoofooddoala*; in *nāgarī* characters: *Luknau asaf-ud-daula nawāb.*
Water-colour; 16 by 22 ins.
Purchased 10 January 1965. *Add. Or. 2600*

(b) Paintings on mica.

42 i–iii 3 mica paintings depicting festivals and ceremonies.
Probably by a Murshidabad artist, *c.* 1800.
Gouache on mica; various sizes.
Purchased 10 February 1914. *Add. Or. 584–586*

NOTE: These mica paintings were originally mounted with James Blunt's sketches and accompanied by descriptive notes and keys in English and Persian script (see WD 156, ff. 27–29). Blunt was in India until 1807 and it is probable that he collected these mica paintings during his last years when

he was based on Calcutta. For Blunt, see Mildred Archer, *British drawings in the India Office Library* (London 1969), i, 132–133.

For sets of mica paintings in similar style, see Maggs Bros., *Oriental miniatures and illumination, Bulletin no. 7* (London, 1964), nos. 179–182, 184–186.

i Muhammadan wedding.
 8 by 10 ins. *Add. Or. 584*
ii Hindu wedding.
 7¼ by 9¼ ins. *Add. Or. 585*
iii Muharram festival; scene in the Imambara.
 6½ by 9¼ ins. *Add. Or. 586*

(ii) CALCUTTA

As an artificial creation of the British, founded in 1690 on the mud-flats of the Hooghly River, Calcutta had no indigenous artistic traditions. Fort William and a 'factory' were built to protect the East India Company's employees and gradually the small fortified trading station developed into a great and rich city. After 1759 when the Nawab of Murshidabad had been defeated and the Company had obtained jurisdiction over the city and the countryside to the south, the British began to feel themselves more secure. By 1773 Calcutta had become the effective capital of British India. Fine residences and imposing public buildings began to be built and, for at least a section of the population, life became comfortable and even elegant. As Thomas and William Daniell wrote, 'the bamboo roof suddenly vanished; the marble column took the place of brick walls'.[1]

While this British settlement was growing in size and importance, Indian culture in cities such as Dacca, Murshidabad and Patna was declining. Artists who had worked at the courts of the Mughal viceroys and for the nobles there found patronage collapsing. Some of them accordingly migrated to Calcutta in hopes of finding work with the new power.

In certain cases, these outside artists found patronage with individual British residents. As early as the seventeen-seventies, Indian artists were being employed for the painting of natural history subjects. Zain al-Din, Ram Das and Bhawani

[1] T. and W. Daniell, *A Picturesque voyage to India* (London, 1810), pl. 50.

Das, formerly of Patna, worked for the Chief Justice, Sir Elijah Impey, and his wife from 1774 to 1783; and about the same time, other Indian artists did similar work for Mrs Edward Wheler and Nathaniel Middleton. This type of painting for private patrons was to continue into the nineteenth century, and as late as 1821 a Calcutta artist was painting flowers for Lady Nicolls, wife of General Sir Jasper Nicolls, Commander-in-Chief (*NHD 45/1, 2*).

In addition to private patronage, a number of artists also found employment with the East India Company and were engaged on official work of various kinds. Some became specialists in natural history drawings for the Botanic Garden at Sibpur and the Barrackpore Menagerie. Others made maps and drawings of antiquities for surveys, such as those conducted by Dr Francis Buchanan and Lieutenant Robert Kyd, or medical drawings for Company surgeons (no. 58). Calcutta was also the place where officials leaving for assignments outside India usually recruited their staff. Michael Symes when setting off for his embassy to the Kingdom of Ava in 1795 took with him a Bengali artist, 'Singey Bey', and Richard Parry when leaving for Sumatra in 1807 engaged another Calcutta painter, Manu Lal (no. 52).

There were also minor openings in Calcutta with commercial houses. From 1783 the firm of Steuart and Company had a flourishing carriage-building business, and Indian artists were employed to assist British craftsmen in painting and decorating not only carriages, palanquins and sedan chairs but ceremonial elephant-housings (no. 54).

By the turn of the century, however, the commonest employment for artists in Calcutta was of yet another character – the making of sets of drawings of Indian life, scenery and monuments for sale to British visitors and residents. As at Murshidabad, these sets often focussed on castes, costumes, occupations, transport methods and festivals, but at Calcutta a new type of subject was quickly developed – the illustration of monuments, especially Mughal ones, with which the British were coming into contact or of which they were hearing reports.

These different kinds of patronage and employment affected in varying degrees the artists of Calcutta. In some cases they resulted in only minor modifications in the personal styles of the painters. Nos. 48 and 49, for example, which are still strongly Mughal in technique and style, may well be the work of up-country artists from centres such as Patna or Lucknow. Others (no. 47) are a carry-over to Calcutta conditions of the more brightly-coloured type of Murshidabad painting, gay with yellow, orange, red and bright green (see no. 38). Certain paintings (nos. 44–46), on the other hand, reveal a sharp abandonment of Indian methods and a conscious adaptation to British requirements. As models for natural history drawing the artists had been shown European publications by their British patrons and their work was consciously based on illustrations such as those in Edwards' *A Natural history of birds* (1745–51), Latham's *A General synopsis of birds* (1781–1802) or the flower drawings in Curtis's *Flora Londiniensis* (1777–98). The same process

occurred with the illustration of monuments. As noted in the previous section, certain European conventions such as a large format, the water-colour technique and the use of European paper, sombre tones and elongated figures, had already found their way into Murshidabad painting. At Calcutta the influence of these conventions was even stronger and in certain cases they can be connected with specific sources. There is no doubt that painters became more aware of European taste in Calcutta than in any other city. Professional British artists who came to India spent much of their time in the Presidency capital and Indian painters may sometimes have seen their work. Of more relevance, however, was the availability of illustrated books. The wealthier inhabitants of Calcutta had libraries and frequently subscribed to the lavish publications of the late eighteenth and early nineteenth centuries which were illustrated with coloured engravings. Many Calcutta residents possessed books such as William Hodges' *Select Views* (1785–88) and Thomas and William Daniell's *Oriental Scenery* (1795–1808), or such amateur works as *Views in the Mysore country* (London, 1794) by Captain A. Allan and *Twelve views of places in the Kingdom of Mysore* (London, 1794) by Captain R. H. Colebrooke. When these Calcutta residents retired or died, their books were sold in the Calcutta auction rooms. In 1788 Thomas Daniell wrote to Ozias Humphry saying that 'the commonest bazaar is full of prints – and Hodges' *Indian Views* are selling off by cart loads.'[2] Since Hodges executed his aquatints of Indian landscapes in England after his return there in 1784, and issued them in parts between 1785 and 1788, it is possible that Calcutta shop-keepers had ordered over-large stocks of the earlier parts and were therefore selling them off cheaply in 1788. It is prints such as these which were to influence Company paintings of monuments produced in Calcutta.

At the turn of the century, sets of views were being made which included up-country Mughal monuments at Delhi, Agra and Fatehpur Sikri and even buildings as far removed as the palace at Seringapatam and the Shwehmawdaw Pagoda at Pegu (no. 43). Few, if any, of the painters in Calcutta could have had first-hand experience of these places and there is little doubt that their 'select views' were based mainly on prints and perhaps to a lesser degree on British amateur sketches. The Pagoda at Pegu is clearly taken from the engraving in Michael Symes' publications after his embassy to Ava in 1795, while two pictures in a set of views in Wellesley's collection (1798–1805) are copies of two aquatints of Fatehpur Sikri in William Hodges' *Select Views* (no. 44, iii, iv). Indeed of all publications, Hodges' appears to have had the strongest formative influence on Calcutta artists, for many of his stylistic idioms, such as bare leaning trees, dark rocks in the foreground, and his very distinctive palette, were frankly adopted. Moreover, Daniell's observation that prints by Hodges were 'selling off in cartloads' is significant for, consequent on these sales, many Calcutta artists

[2] Letter of 7 November 1788 in Royal Academy.

74

probably acquired examples and used them as models both for architecture and for landscape. The same circumstance might explain the emergence at Calcutta of this particular type of set in the seventeen-nineties.[3] Although they are in a basically Murshidabad style and were almost certainly executed by Murshidabad painters settled in Calcutta, it is the influence of Hodges' *Select Views* which gives these drawings their Company character.

During the same period, sets of paintings of costumes and occupations made in Calcutta show a similar derivation from European prints. One type of set (no. 46) obviously owed much to the massive work by Baltazard Solvyns, *A Collection of 250 coloured etchings; descriptive of the manners, customs, character, dress and religious ceremonies of the Hindoos* published in 1796. This work was issued in twelve parts depicting costumes, occupations, ascetics, musical instruments, methods of transport, the various kinds of pipe for smoking, servants in European households, boats, festivals and a few views of Calcutta architecture. Here in fact were the very subjects which, as Indian artists had already come to realise, appealed to Europeans. The book must have confirmed their tentative efforts and given them confidence as well as stylistic guidance. Solvyns' etchings are marked by tall elongated figures with an air of sad melancholy, executed in tones of grey and brown sepia, the whole surrounded by a heavy black border; and it is these qualities which appear in sets by Calcutta painters. Solvyns must almost certainly have used Indian artists to assist him in his work, and to print and colour the plates. It also seems likely that Calcutta artists completed certain unfinished copies of his book. A copy of the work which is now in the Harry Elkins Widener collection in Harvard College Library and which originally belonged to Major Charles Fraser, A.D.C. to Marquis Wellesley from 1803 to 1805, includes a number of pictures that are not engravings but water-colour versions of the original Solvyns plates. Through assisting in the production of books such as these, Indian painters acquired European techniques, and it can be no coincidence that many sets of paintings made in Calcutta in the first thirty years of the nineteenth century employ these same idioms – tall brooding figures, sombre colours and heavy black borders. Since Calcutta was so closely linked to Murshidabad, it was natural that similar European idioms should appear in Murshidabad painting at about the same time (see p. 60).

As the nineteenth century progressed, Indian artists gradually came into closer contact with the British and received individual commissions. One of their patrons was Lieutenant-Colonel W. R. Gilbert. Gilbert, who was A.D.C. to Sir George Nugent from 1812 to 1814, moved in a social group which was very conscious of drawing and painting as a sophisticated amusement. His wife was

[3] The use of engravings as models was again confirmed at Patna where I found engravings of British country houses and landscapes among the papers of the Patna artist, Shiva Lal (see below, p. 100).

the sister-in-law of Sir Charles D'Oyly, one of the most enthusiastic of amateur artists. Lady Nugent herself was a keen collector of Company paintings and her journal refers on several occasions to the commissioning of paintings from artists in Calcutta. On 24 April 1812, for example, she notes 'Went out in the evening, in a tonjon, for the first time – the cavalcade was very curious – twenty-four men attended me – I mean to have a drawing of this procession, so I will not describe it'. And on 1 May she writes, 'Had a native painter to draw the house etc.'[4] The similarity of some of the paintings in her collection to others in Gilbert's (no. 56) suggests that the painter who supplied Lady Nugent with these pictures (no. 41) was later employed by Gilbert. On stylistic grounds Lady Nugent's pictures have here been grouped under 'Murshidabad Painting', but the artist may well have been a Murshidabad emigré who at times worked in Calcutta. Gilbert's collection is now dispersed, but surviving pictures show that he employed an Indian artist for a number of years and took him with him on his various postings. This artist was with Gilbert at Hazaribagh and Sambalpur between 1822 and 1828 and was employed to keep a topographical journal of the houses Gilbert lived in and the places he visited. Servants and clerks were portrayed with grave dignity, and interesting specimens of natural history, such as an enormous lotus plant, were delicately recorded.

The making of sets of paintings for the British continued in Calcutta until about the eighteen-sixties. After about 1830, however, the style gradually changed and was influenced by Victorian taste. Sombre greys and browns gave way to gayer colours – pinks, mauves, blues and yellows. The figures became more naturalistic with, in the case of the women, prettier faces. Many sets of servants and occupations were made between 1830 and 1860, and several Calcutta painters had flourishing businesses. A certain E. C. Das signed many pictures during the eighteen-forties (no. 62), but most prolific of all was Shaikh Muhammad Amir of Karraya, a suburb of Calcutta. This painter not only produced vivid sets of figures notable for their dignified postures and subtle composition (no. 61) but also toured Calcutta in search of individual commissions. When engaged he would paint a set of pictures for the patron, including his house, carriages, horses and servants. The Library possesses examples from two such sets. In one case the name of the patron is unknown (no. 60). In the second, he was a business man, Thomas Holroyd who lived at no. 5 Park Street, Chowringhee, in the eighteen-thirties. Not only is his cool green-shuttered mansion depicted but also his servants in their smart liveries, his carriage, horses, tonjon and palanquin, as well as familiar bazaar characters (no. 59). There is little doubt that of all Calcutta painters specialising in work for the British Muhammad Amir was by far the most talented and original.

In the second half of the century, with the coming of the camera, the market

[4] Nugent, i, 130, 133.

for Company paintings declined. Artists took work wherever they could find it. Paintings made for the North East India General Mission about 1870 were probably by a Calcutta painter who had gone to Manipur (no. 63). Nevertheless Calcutta still attracted painters from other areas and it is known that the Patna painter Shiva Lal and the Benares painter Bihari Lal marketed much of their work in Calcutta in the eighteen-sixties and seventies.

Bibliography

Archer, Mildred. 'British patrons of Indian artists', *Country Life*, 18 August 1955, 340–341.

Archer, Mildred. 'Indian paintings for British naturalists', *Geographical Magazine*, September 1955, 220–230.

Archer, Mildred. *Natural history drawings in the India Office Library* (London, 1962).

Archer, Mildred. 'Baltazard Solvyns and the Indian Picturesque', *The Connoisseur*, January 1969, 12–18.

Archer, Mildred. *British drawings in the India Office Library* (London, 1969), ii, 397–400, 469.

Archer, Mildred, and W. G. *Indian painting for the British, 1770–1880* (Oxford, 1955).

Eden, Emily (ed. Eleanor Eden). *Letters from India*, 2 vols. (London, 1872).

Nilsson, S. *European architecture in India: 1750–1850* (London, 1969).

Nugent, Maria. *A Journal from the year 1811 till the year 1815*, 2 vols. (London, 1839).

43 The Shwehmawdaw Pagoda, Pegu, Burma.
Probably by an Indian artist in Calcutta, *c.* 1800.
Inscribed: *Choemadoo, the Great Temple at Pegue. See Syme's Ava, p. 186. Height 361;* on back a note written by Sotheby's in 1888.
Water-colour; 18 by 23 ins. Pink border with Indian ink rules.
Purchased 6 May 1913. *Add. Or. 568*

NOTE: An interest in Burma was aroused in the British by the expedition to the Kingdom of Ava led by Michael Symes, February to December 1795. After his return he published 'Of the City of Pegue, and the Temple of Shoemadoo Praw', *Asiatick Researches*, v, Calcutta, 1798, 111–122, and *An Account of an embassy to the Kingdom of Ava sent by the Governor-General of India in the year 1795* (London, 1800). The present picture is very similar to the engraving, 'Shoemadoo, the Great Temple at Pegue. Drawn by Singey Bey', facing p. 186 in the above book. It seems probable that copies and versions of this picture were made by Indian artists in Calcutta after the publication of Symes' book, and were incorporated into series of views.

44–50 Seven groups of drawings (totalling 138) depicting monuments, manners and customs mounted and bound into a volume.
By artists resident in Calcutta, *c.* 1798–1804.
Inscribed on title-page: *Drawings illustrating the Manners and Customs of the Natives of India. Originally prepared by Order of Marquis Wellesley when Governor-General of India. See Council Minute dated 16th August 1866.*

Water-colour; size of album: $17\frac{1}{4}$ by $11\frac{1}{2}$ ins.
Purchased 16 August 1866.

Add. Or. 1098–1235

NOTE: This volume was acquired together with 27 volumes of drawings depicting plants, birds, quadrupeds, insects and fishes of India and the East Indies. These have already been catalogued (see Archer (1962), 6–8, 22, 23, 29–31, 55, 56, 58, 71, 74–76, 91–98). Like the natural history drawings, the present paintings were purchased from a certain J. Fletcher (*ibid*, 91), and were probably also made by artists resident in Calcutta. The drawings can be divided into seven groups. No sets quite like them are known and although certain stock paintings are included, the drawings would appear to have been made especially for Wellesley. They were probably acquired on loose sheets from a number of different artists. By the time they reached the library they had apparently lost their original order and after mounting were bound indiscriminately into one volume with a suitably inscribed title-page. In the present catalogue, an attempt has been made to group these drawings in sets by style.

44
i–xvi

16 drawings of picturesque scenes with Indian monuments.
By a Calcutta artist, *c.* 1798–1804.
Water-colour; broad black borders; approx. $9\frac{1}{2}$ by $13\frac{1}{2}$ ins.

Add. Or. 1131–1146 (ff. 34–49)

NOTE: These drawings include (iv) a free rendering of William Hodges' 'A View of the Ruins of part of the Palace and Mosque at Futtypoor Sicri', plate 11 in his *Select Views* (London, 1785–88); and (iii), a free rendering, in reverse as if from a tracing, of 'A View of the Mosque at Futtipoor Sicri', plate 12 in the same publication. All, though clearly by an Indian artist working in British style, incorporate idioms peculiar to Hodges. Compare, in this respect, the dead trees in (xi) and (xii) with the tree in 'A View of the Gate of the Caravan Serai at Rajemahel', *Select Views*, plate 4; the dead top to a tree and dead branches in (ix), (x) and (xiii) with branches in 'A View of a Mosque at Rajemahel' and 'A View of a Hill Village in the District of Baugelepoor', plates 14 and 25; and the tall palm in (xi) with the tree in 'A View of the Pagodas at Deogur', plate 22. At the same time the drawing of the architecture is extremely inaccurate and is clearly not made from a study on the spot. It seems probable that Calcutta artists in the seventeen-nineties were availing of William Hodges' *Select Views* to make sets of landscape drawings depicting Mughal monuments for the British.

 i Pavilion with river-gate; perhaps the Begams' Quarters, Agra Fort, seen from the river.
Add. Or. 1131
 ii A muslim tomb, perhaps an inaccurate rendering of the mausoleum of Salim Chishti, Fatehpur Sikri.
Add. Or. 1132
 iii Exterior of the Jami Masjid with the Buland Darwaza, Fatehpur Sikri.
Add. Or. 1133
 NOTE: Free rendering of W. Hodges, *Select Views*, plate 12, 'A View of the Mosque at Futtipoor Sicri' but in reverse.

iv Distant view of the exterior of the Jami Masjid and Buland Darwaza, Fatehpur
Sikri (*Plate 23.*) *Add. Or. 1134*

NOTE: Free rendering of W. Hodges, *Select Views*, plate 11, 'A View of the Ruins of part
of the Palace and Mosque at Futtypoor Sicri.'

v The Taj Mahal.
Inscribed: *Taj-Mhal.* *Add. Or. 1135*

vi Muslim tomb, perhaps near the mausoleum of Salim Chisti, Fatehpur Sikri.
Add. Or. 1136

vii Palladian mansion with formal garden. *Add. Or. 1137*

viii Mausoleum of Akbar, Sikandra. *Add. Or. 1138*

ix River scene and shrine on the Jumna or Ganges, probably in the U.P.
Add. Or. 1139

x Bridge across tank, probably Ahmad Khan's mausoleum, Ahmadpur.
Add. Or. 1140

NOTE: Perhaps a distorted rendering of 'A View of a Mausoleum at Etmadpoor' (see
W. Hodges, *Select Views*, plate 36).

xi River scene with shrine, probably on the Jumna or Ganges in the U.P.
Add. Or. 1141

xii Entrance gateway to the Taj Mahal. *Add. Or. 1142*

xiii Perhaps a distant view of Agra Fort. *Add. Or. 1143*

xiv Naqqar Khana, perhaps in Agra Fort. *Add. Or. 1144*

xv A pavilion or palace, perhaps at Fatehpur Sikri. *Add. Or. 1145*

xvi The Great Imambara, Lucknow. *Add. Or. 1146*

45 i–v 5 drawings depicting festivals or occupations.
By a Calcutta artist perhaps from Murshidabad, *c.* 1798–1804.
Inscribed with titles.
Water-colour, black rule border; approx. 10½ by 16 ins.
Add. Or. 1127–1130; 1235

NOTE: The black borders, elongated figures with ragged drapery, monochrome colouring and
subdued tones, characteristic of Company painting at Murshidabad, suggest that the artist may have
migrated to Calcutta from that centre.

i f.30 Brahmins bathing and praying by a river or tank.
Inscribed: *Brahmins at their Ablutions.* *Add. Or. 1127*

ii f.31 Worship at a Kali temple, Titaghar (Bengal); a courtyard full of worship-
pers, some carrying goats for sacrifice (*Plate 24*).
Inscribed: *The worship of the Hindoo Goddess Bhawannie. Tytoghur near
Barrackpoor.* *Add. Or. 1128*

iii f.32 A liquor shop.
Inscribed: *Retail of Spirituous Liquors.* *Add. Or. 1129*

iv f.33 Apparatus for distilling liquor.
Inscribed: *Distillation of Spiritous Liquors.* *Add. Or. 1130*

v f.138 Snake-charmer.
　　　　Inscribed: *Snake Charmer.*　　　　　　　　　　　*Add. Or. 1235*

46　29 drawings depicting festivals, characters taking part in festivals, occupations and
i–xxix　methods of transport.
　　　　By a Calcutta artist, perhaps from Murshidabad, *c.* 1798–1804.
　　　　Many inscribed with titles.
　　　　Water-colour; cream border with black rule; approx. 7¾ by 9½ ins.
　　　　　　　　　　　　　　　　　　　　　　Add. Or. 1147–1174; 1230

NOTE: A set similar in style to no. 45 but smaller in size, perhaps by another artist who had migrated
to Calcutta from Murshidabad. It is significant that the two soldiers in (xvi) are identical with two
soldiers in the foreground of a Murshidabad picture in the Victoria and Albert Museum (*11 (10)-
1887 I.S.*).

　　i f.50　A goat being slaughtered at Kali Puja.
　　　　　　Inscribed: *Kallea Pujah.*　　　　　　　　　　*Add. Or. 1147*
　　ii f.51　Two dancers at Kali Puja accompanied by three musicians.
　　　　　　Inscribed: *Kallea Dehwan Dancers.*　　　　　*Add. Or. 1148*
　iii f.52　Muhammadan fakir with his family.
　　　　　　Inscribed: *Mahomedan Fakeer.*　　　　　　　*Add. Or. 1149*
　iv f.53　Shaiva ascetic with arm upraised (*urdhvabāhu*).
　　　　　　Inscribed: *A Sunnassie of a religious Sect of Hindoos.*　*Add. Or. 1150*
　　v f.54　A man performing penance at the Hook-swinging Festival (*charak
　　　　　　pūjā*), a wire through his lips.
　　　　　　Inscribed: *Penance at the Churak Pujah.*　　　*Add. Or. 1151*
　vi f.55　Four men dancing at the Hook-swinging Festival (*charak pūjā*).
　　　　　　Inscribed: *Churak Poojah.*　　　　　　　　　*Add. Or. 1152*
　vii f.56　Dancer at the Hook-swinging Festival.
　　　　　　Inscribed: *as the former.*　　　　　　　　　*Add. Or. 1153*
　viii f.57　Dancers at Kali puja.
　　　　　　Inscribed: *Dancers at the Kallea Poojah.*　　*Add. Or. 1154*
　ix f.58　Two men playing on tambourines at the Holi Festival.
　　　　　　Inscribed: *Hooley.*　　　　　　　　　　　　*Add. Or. 1155*
　　x f.61　A standard-bearer at the Muharram Festival.
　　　　　　Inscribed: *Standard Bearer at the Moharrum.*　*Add. Or. 1158*
　xi f.62　Man playing on a *vīna*.
　　　　　　Inscribed: *The Hindoo Instrument called Bheem.*　*Add. Or. 1159*
　xii f.76　Male dancer.
　　　　　　Inscribed: *A Figure Dancer.*　　　　　　　　*Add. Or. 1173*
　xiii f.59　Sweetmeat-seller with his stall and customer.
　　　　　　Inscribed: *Confectioner.*　　　　　　　　　*Add. Or. 1156*

xiv f.65 Sweetmeat-seller's shop.
Inscribed: *Confectioner's Shop.* *Add. Or. 1162*

xv f.60 Two women carrying water-pots.
Inscribed: *Hindoo women carrying water.* *Add. Or. 1157*

xvi f.63 Armed retainers (*barqandāz*) (*Plate 26*).
Inscribed: *Asiatick Infantry Soldiers, called Buck-um-dang.*

 Add. Or. 1160

xvii f.66 Muslim weaver seated at a pit-loom.
Inscribed: *Weavers, Musselmauns called Joolahs.* *Add. Or. 1163*

xviii f.67 Hindu weavers combing a stick-warp.
Inscribed: *Weavers. Hindoos called Sauttie.* *Add. Or. 1164*

xix f.68 Potter spinning his wheel.
Inscribed: *A Potter.* *Add. Or. 1165*

xx f.69 Potter shaping a pot at his wheel.
Inscribed: *A Potter.* *Add. Or. 1166*

xxi f.70 Blacksmith's shop.
Inscribed: *A Blacksmith's Shop.* *Add. Or. 1167*

xxii f.71 Silversmith's shop.
Inscribed as above. *Add. Or. 1168*

xxiii f.72 Sawyers.
Inscribed as above. *Add. Or. 1169*

xxiv f.133 Fishmonger.
Inscribed: *Fishmongers.* *Add. Or. 1230*

xxv f.75 Water-cooler (*ābdār*).
Inscribed: *Aub-daar cooling water.* *Add. Or. 1172*

xxvi f.74 Dancing bear.
Inscribed as above. *Add. Or. 1171*

xxvii f.77 A dancing monkey.
Inscribed as above. *Add. Or. 1174*

xxviii f.73 A camel laden with tents.
Inscribed as above. *Add. Or. 1170*

xxix f.64 Bullock carriage (*rath*).
Inscribed: *A Rhutt, a carriage of a native of Rank.* *Add. Or. 1161*

47
i–xxx
30 drawings depicting occupations and ceremonies.
By a Calcutta artist, perhaps from Murshidabad or Lucknow. *c.* 1798–1804.
Many inscribed with titles.
Water-colour; varying sizes, 9 by 7¾ to 10¼ by 16 ins.

 Add. Or. 1098–1126; 1234

NOTE: The set is marked by brilliant colouring – orange, red, brown, yellow, lime and peacock-blue. Shading is strongly defined and in many cases a background of shops, houses or landscapes is included. (xiv) is similar in composition to 98 xxxii.

(xvi) and (xxv) are reproduced Archer (1955), plate 15, fig. 31; plate 8, fig. 18, and were there assigned to Lucknow. Further research, however, has led to the conclusion that they were more likely made in Calcutta by a Murshidabad artist working in the early Murshidabad style (c.f. no. 38). It is significant that a painting of hook-swinging in the Victoria and Albert Museum in similar style (*11 (37)–1887 I.S.*) is part of a group which also includes Murshidabad paintings of the sombre type.

i f.1	Ascetic (*naqshbandī*) with a lamp being received by a Muslim lady sitting on a stool (*morhā*).	
	Inscribed: *Dervise*.	*Add. Or. 1098*
ii f.2	Madras broker (*dobāshī*).	
	Inscribed: *A Madras Dubassi or Sircar*.	*Add. Or. 1099*
iii f.3	Unidentified hawker.	*Add. Or. 1100*
iv f.4	Performing bear and its master.	*Add. Or. 1101*
v f.5	Comb-maker.	*Add. Or. 1102*
vi f.6	Gram or pulse seller.	*Add. Or. 1103*
vii f.7	Shawl embroiderer.	*Add. Or. 1104*
viii f.8	Bangle (*chūrī*) seller and customer.	
	Inscribed: *Chouree walla*.	*Add. Or. 1105*
ix f.137	Bangle-seller.	
	Inscribed: *Chauk Bangle Seller*.	*Add. Or. 1234*
x f.9	Seller of medicines(?)	*Add. Or. 1106*
xi f.10	Sweetmeat-maker.	
	Inscribed: *A maker of sweetmeats*.	*Add. Or. 1107*
xii f.11	Woman selling tobacco and tobacco holders (*chilam*) for hookahs.	
	Inscribed: *A maker and vendor of Chillums*.	*Add. Or. 1108*
xiii f.12	Making of lime (*chunam*) from shells.	
	Inscribed: *Making Shell Chunam*.	*Add. Or. 1109*
xiv f.13	Seamstress sewing with her little daughter sitting beside her.	
		Add. Or. 1110
xv f.14	A bookbinder.	
	Inscribed as above.	*Add. Or. 1111*
xvi f.15	Cloth-seller.	*Add. Or. 1112*
xvii f.16	Pedlar.	*Add. Or. 1113*
xviii f.17	Dyer.	*Add. Or. 1114*
xix f.18	Firework-maker.	
	Inscribed: *A maker of Fireworks*.	*Add. Or. 1115*
xx f.19	Seller of turned wooden goods.	*Add. Or. 1116*
xxi f.20	Jewel-seller.	*Add. Or. 1117*
xxii f.21	Muhammadan woman of rank holding a hookah and attended by a maid with a musical instrument (*tambūrā*).	*Add. Or. 1118*
xxiii f.22	Shoe-maker.	*Add. Or. 1119*

xxiv f.23 Muhammadan wedding. Inscribed: *A Marriage.*	Add. Or. 1120
xxv f.24 Hindu wedding. Mis-inscribed: *A Saint receiving offerings.*	Add. Or. 1121
xxvi f.25 Hindu procession headed by a band carrying a model boat as an offering to the Ganges. Inscribed: *An offering to the Ganges.*	Add. Or. 1122
xxvii f.26 Hindu funeral.	Add. Or. 1123
xxviii f.29 Muslim funeral. Inscribed: *A Funeral Procession.*	Add. Or. 1126
xxix f.28 Hindu cremation. Inscribed: *Cremation.*	Add. Or. 1125
xxx f.27 Muslim burial.	Add. Or. 1124

48
i–xxxii

32 drawings depicting occupations.
By a Calcutta artist, *c.* 1798–1804.
Some inscribed with titles.
Water-colour; approx. 9 by 7¼ ins.
Add. Or. 1175–1182; 1184; 1186–1192; 1203; 1206; 1207; 1211–13; 1215–1220; 1222; 1226; 1227; 1229

NOTE: This set is marked by its delicate technique with stippling and small wrinkles on the faces. Heavy shadows are attached to the feet. Uncoloured backgrounds. Closely related to nos. 49 and 50 but by a different hand. The style suggests links with provincial Mughal centres.

i f.78 Mace-bearer (*chobdār*) with long staff. Inscribed: *Chub-daar.*	Add. Or. 1175
ii f.79 Silver-stick bearer (*suntābardār*). Inscribed: *Soontaba-daar.*	Add. Or. 1176
iii f.80 Hookah-bearer (*Plate 25*).	Add. Or. 1177
iv f.81 Servant.	Add. Or. 1178
v f.85 Servant.	Add. Or. 1182
vi f.82 Subadar of Bengal Native Infantry. Inscribed: *Soubadar.* NOTE: The shoulder belt plate is perhaps inscribed: *48.*	Add. Or. 1179
vii f.83 A tailor or sewing man.	Add. Or. 1180
viii f.84 Perfume (attar)-seller. Inscribed: *Ottah Foorosh.*	Add. Or. 1181
ix f.87 A bullock carriage (*rath*). Inscribed: *Rhutt.*	Add. Or. 1184
x f.89 Man smoking a hand hookah (*nārgīla*).	Add. Or. 1186
xi f.90 Carpenter.	Add. Or. 1187

xii f.91	Barber.	*Add. Or. 1188*
xiii f.92	Fisherman.	*Add. Or. 1189*
xiv f.93	Man carrying water-pots on a yoke.	*Add. Or. 1190*
xv f.94	Water-carrier with goat-skin.	*Add. Or. 1191*
xvi f.95	Grass-cutter.	
	Inscribed as above.	*Add. Or. 1192*
xvii f.106	Seller of sweetmeats (*mithāī*).	
	Inscribed: *Metie, or sweetmeats.*	*Add. Or. 1203*
xviii f.109	Goldsmith.	
	Inscribed as above.	*Add. Or. 1206*
xix f.110	Carder or cleaner of cotton.	
	Inscribed: *Cleaning cotton.*	*Add. Or. 1207*
xx f.114	Muslim woman with water-pot.	*Add. Or. 1211*
xxi f.115	Woman sweeper.	*Add. Or. 1212*
xxii f.116	Lamp-wick maker.	
	Inscribed as above.	*Add. Or. 1213*
xxiii f.118	Muhammadan woman spinning.	
	Inscribed: *Spinning.*	*Add. Or. 1215*
xxiv f.119	Woman cleaning cotton.	
	Inscribed: *Cleaning cotton.*	*Add. Or. 1216*
xxv f.120	Woman cooking.	*Add. Or. 1217*
xxvi f.121	Woman pounding rice.	
	Inscribed: *Pounding rice.*	*Add. Or. 1218*
xxvii f.122	Woman sweeper.	*Add. Or. 1219*
xxviii f.123	Woman selling curds.	
	Inscribed: *Tise, a kind of Buttermilk* (Cheese?).	*Add. Or. 1220*
xxix f.125	Garland-maker.	*Add. Or. 1222*
xxx f.129	Hill porter from Assam.	
	Inscribed: *a Hill Porter.*	*Add. Or. 1226*
xxxi f.130	Inhabitant of the Garo Hills, Assam, in war-dress.	
	Inscribed: *A Mountaineer.*	*Add. Or. 1127*

xxxi f.130 NOTE: This appears to be a copy of the engraving by John Alefounder reproduced in J. Eliot, 'Observations on the inhabitants of the Garrow Hills made during a Publick Deputation in the Years 1788 and 1789', *Asiatick Researches*, iii, Calcutta, 1792, pp. 17–37.

xxxii f.132	Milkman carrying pots of milk.	
	Inscribed: *Milkman.*	*Add. Or. 1229*

49 i–ix 9 drawings depicting occupations.
By a Calcutta artist, *c.* 1798–1804.
Some inscribed with titles.
Water-colour; approx. 9 by 7¼ ins.

Add. Or. 1185; 1205; 1214; 1221; 1223; 1224; 1228; 1231; 1232

NOTE: These drawings are very similar to no. 48 but in a slightly cruder style. Uncoloured backgrounds. (viii) is similar in composition to 98 lxxix.

i f.88	Potter.	
	Inscribed as above.	*Add. Or. 1185*
ii f.108	Weaver seated at a pit-loom.	
	Inscribed: *Weaver.*	*Add. Or. 1205*
iii f.117	Muslim woman.	*Add. Or. 1214*
iv f.124	Woman basket-maker.	*Add. Or. 1221*
v f.126	Woman grinding.	
	Inscribed: *grinding corn.*	*Add. Or. 1223*
vi f.127	Woman ginning cotton.	
	Inscribed: *Cleaning the cotton from the Seeds.*	*Add. Or. 1224*
vii f.131	Milkman milking a cow, its calf beside it.	
	Inscribed: *Cow will not allow milking unless calf present.*	*Add. Or. 1228*
viii f.134	Woman fish-seller.	*Add. Or. 1231*
ix f.135	Bullock-cart loaded with wood.	*Add. Or. 1232*

50
i-xvii

17 drawings depicting occupations.
By a Calcutta artist, *c.* 1798–1804.
Some inscribed with titles.
Water-colour; approx. 9 by $7\frac{1}{4}$ ins.
Add. Or. 1183; 1193–1202, 1204, 1208–1210, 1225, 1233

NOTE: This set is executed in a highly individual style with strange sketchy broken lines and pale colouring – pale blues, pinks, greens, greys. Uncoloured backgrounds. (vii) is similar in composition to 98 xviii.

i f.86	Table-servant (*khidmatgār*) carrying a fish on a dish.	*Add. Or. 1183*
ii f.96	Turner.	
	Inscribed as above.	*Add. Or. 1193*
iii f.97	Gold-beater.	
	Inscribed as above.	*Add. Or. 1194*
iv f.98	Turner.	
	Inscribed as above.	*Add. Or. 1195*
v f.99	Locksmith.	
	Inscribed as above.	*Add. Or. 1196*
vi f.100	Carpenter.	*Add. Or. 1197*
vii f.101	Native infantry.	
	Inscribed: *Matchlock man*	*Add. Or. 1198*
viii f.102	Parasol-bearer.	*Add. Or. 1199*
ix f.103	Boatman (*Sarhang*).	
	Inscribed: *Serang.*	*Add. Or. 1200*

x f.104	Link-boy (*mashālchī*).	
	Inscribed: *Musalzee, or Lamp Bearer.*	*Add. Or. 1201*
xi f.105	Weaver stick-warping.	*Add. Or. 1202*
xii f.107	Steward (*sarkār*).	
	Inscribed: *Sircar.*	*Add. Or. 1204*
xiii f.111	Archer.	*Add. Or. 1208*
xiv f.112	Jemadar of native infantry with sword and shield.	
	Inscribed: *A Jemadar of native infantry.*	*Add. Or. 1209*
xv f.113	Parsee from Bombay.	
	Inscribed: *Parsee from Bombay.*	*Add. Or. 1210*
xvi f.128	Woman spinning by hand.	
	Inscribed: *Spinning.*	*Add. Or. 1225*
xvii f.136	Bangle-maker.	
	Inscribed: *Making Bangles.*	*Add. Or. 1233*

51
i–xvi

16 drawings bound into a volume depicting occupations in Bengal.
By a Calcutta artist, probably from Murshidabad, *c.* 1805.
Entitled: *Indian Drawings, Military and Domestic;* inscribed with titles.
Pencil and water-colour, some unfinished; 18½ by 12 ins., (xii) 10 by 8 ins.
Purchased 19 October 1914. *Add. Or. 993–1008*

NOTE: All except (xii) are in similar style with black rule border. In some drawings the figures are shown against a landscape but in others the background is unfinished or omitted. (xii) has a water-mark of 1804, is smaller in size and has been pasted into the volume.

i	Ascetic in saffron robe holding a rosary in his right hand.	
	Inscribed: *Fakir.*	*Add. Or. 993*
ii	Muslim ascetic.	
	Inscribed: *Derveish.*	*Add. Or. 994*
iii	Porter, his yoke and bundles lying beside him, making a net.	
	Inscribed: *Palki bearer.*	*Add. Or. 995*
iv	Water-carrier with goat-skin.	
	Inscribed: *Water Carrier.*	*Add. Or. 996*
v	Muslim ascetic.	
	Inscribed: *Derveish.*	*Add. Or. 997*
vi	Astrologer.	
	Inscribed: *A Pundit who makes almanacs.*	*Add. Or. 998*
vii	Brahmin Pandit.	
	Inscribed: *Pundit.*	*Add. Or. 999*
viii	Dancing-girl.	
	Inscribed: *Nach woman.*	*Add. Or. 1000*
ix	Cook's assistant carrying a covered tray of food on his head.	
	Inscribed: *A Cook room Bearer.*	*Add. Or. 1001*

 x Georgian.
 Inscribed: *A Georgian Man.* *Add. Or. 1002*
 xi Water-carrier for Indian sepoys.
 Inscribed: *A water carrier to the Sipahi.* *Add. Or. 1003*
 xii Native soldier with sword and shield. *Add. Or. 1004*
xiii Fifer.
 Inscribed as above *Add. Or. 1005*
 xiv Muslim Irregular with matchlock.
 Inscribed: *Najib soldier.* *Add. Or. 1006*
 xv Subadar of the Bengal Native Infantry (*Plate 27*).
 Inscribed: *Subahdar.* *Add. Or. 1007*
 xvi Sepoy of the Bengal Native Infantry with 'sundial' hat.
 Inscribed: *Sipahi.* *Add. Or. 1008*

52 An inhabitant of the Poggy Islands, near Sumatra. He is tattooed and carries a bow and arrow.
By Manu Lal, a Patna artist resident in Calcutta, *c.* 1810.
Inscribed on front in English: *A Native of the Poggy Islands;* in Persian characters: *Rāqim i īn taṣwīr Manū Laʻl muṣauwir sākin i ʻAẓīmābād* (The painter of this picture [was] Manu Lal of Azimabad i.e. Patna); on back: *Parry. 26 June, 1812.*
Water-colour; 9½ by 5¾ ins.
Presented 26 June 1812, together with Richard Parry's collection of 202 drawings of 'Plants and Animals from Sumatra'. *Add. Or. 490*

NOTE: Manu Lal, a Patna painter, appears to have been living in Calcutta *c.* 1798 to 1812 where he made natural history drawings. A painting by him of animals is in the Wellesley collection (*NHD 32 f. 81*). He appears to have also worked for Richard Parry of the Bengal Civil Service and to have been taken to Sumatra by Parry when the latter became Resident of Fort Marlborough 1807 to 1811 (see *NHD 2, nos 286–299* and Archer (1962), 19, 55, 61, 87, 93, 97). Azimabad is the Muslim name for Patna.

 For early accounts of the Poggy or Nassau Islands, see J. Crisp, 'An account of the inhabitants of the Poggy, or, Nassau Islands, lying off Sumatra', *Asiatick Researches*, vi, 1799, 77–92 and T. S. Raffles, 'Account of the Poggies', *MSS. Eur. F. 32*, 81–114 (see G. R. Kaye, *Catalogue of manuscripts in European languages in the India Office Library* (London, 1937), ii, part ii, no. 238).

53 i–iv 4 drawings of Indian soldiers of the 1st Battalion of the 21st Bengal Native Infantry. Probably by a Calcutta artist, *c.* 1815.
Water-colour.
Circumstances of acquisition unrecorded.
 India Office Albums, vol. 58, 'Arms and Armour', nos. 5344–5347

NOTE: These appear to be the original drawings for J. Williams, *An Historical account of the rise and progress of the Bengal Native Infantry Arms from its first formation in 1757 to 1796* (London, 1817).

 i Subadar, with curved sabre.

Inscribed: *A Subadar, or Native Commissioned Officer, B.N.I. Command our Lives, thro' the Medium of our Affections.*

13¾ by 8½ ins.

NOTE: Original drawing for Williams, frontispiece. *No. 5344*

 ii Havildar holding a spear.

Inscribed: *A Hawuldar, of Bengal Native Infantry, Agra.*

12¾ by 7¾ ins.

NOTE: Original drawing for Williams, 278. *No. 5345*

 iii Grenadier Sepoy, holding a musket.

Inscribed: *Bengal Grenadier Sepoy. Forward.*

12½ by 8 ins.

NOTE: Original drawing for Williams, 171. *No. 5346*

 iv Light infantry sepoy presenting arms.

Inscribed: *Light Infantry Bengal Sepoy. Napaul.*

NOTE: Original drawing for Williams, 331. *No. 5347*

54 i–iii 3 drawings depicting elephant housings and harness.

By a Calcutta artist, *c.* 1815.

Water-colour; various sizes.

Circumstances of acquisition unrecorded. *Add. Or. 535–537*

NOTE: The inscription on (i) suggests that these drawings were made for Steuart and Co, who were famous coach-makers at 8 Old Court House Corner, Calcutta, from 1783 to 1907, to illustrate the type of work that they could undertake.

 i Two elephants with leather harness drawing a gun.

Inscribed: *Steuart & Co., Calcutta.*

13 by 19½ ins. *Add. Or. 535*

 ii An elephant with green and gold housings bearing a dark green howdah with a canopy. On the housings a crescent moon and seven stars.

21¼ by 19 ins. *Add. Or. 536*

 iii An elephant with red and gold housings bearing a deep crimson and gold howdah.

On the housings a crescent moon and seven stars.

22 by 18½ ins. *Add. Or. 537*

55 Central pillar, Diwan-i-Khas, Fatehpur Sikri.

Probably by an Indian artist from Calcutta. *c.* 1816.

Inscribed: *View of a building in the palace of the Emperor Akber at Futtihpore Sicri called the Ek Khumba or Hall of the Pillar. 1816.*

Water-colour; 16 by 16 ins.
Purchased 23 September 1952. *Add. Or. 949*

NOTE: The style of this drawing with its elongated figures suggests that the artist had Murshidabad antecedents. He was probably an artist from Calcutta working as a draftsman and accompanying a British officer on an up-country assignment.

56 i–xii 12 drawings made for Lieutenant-Colonel W. R. Gilbert depicting his houses, gardens, servants and local scenery at Hazaribagh (Bihar), Sambalpur (Orissa) and Surguja (Central Provinces).
By a Calcutta artist, perhaps from Murshidabad. *c.* 1825.
Water-colour; 17¼ by 26 ins (unless otherwise stated).
Purchased, together with *WD 2058–2063* (*2060* being a sketch-book by Sir Charles D'Oyly), 19 March 1963. *Add. Or. 2514–2525*

NOTE: Lieutenant-Colonel Gilbert (1785–1853), later Lieutenant-General Sir Walter Raleigh Gilbert, first baronet, G.C.B., went to India with the 15th Native Infantry in 1801. At the time when these paintings were made, he was Commandant of the Ramgarh Battalion based on Hazaribagh (Bihar) from 1822 to 1828. During the period 1825 to 1827, he was also Political Agent for the South West Frontier with head-quarters at Sambalpur (Orissa).

Gilbert belonged to a circle which was intensely interested in painting. From June 1812 to May 1813 he was A.D.C. to Sir George and Lady Nugent who collected paintings of India by both British amateurs and Indian artists (see p. 71). In 1814 he married Isabella Ross, the sister of Eliza, wife of Sir Charles D'Oyly, the skilled amateur artist and later patron of Indian artists in Patna (p. 99). D'Oyly was in Calcutta from 1818 to 1821 as Collector of Customs and Town Duties, when Gilbert was there as Commandant of the Calcutta Native Militia, and later (1821–22) Superintendant of the Mysore Princes. These contacts may have stimulated Gilbert's own interests in painting and led him and his wife to acquire pictures. Besides owning a number of standard sets by Calcutta artists (still in private hands), the couple made a collection documenting their life in Hazaribagh and Sambalpur, of which the present pictures are examples. The artist who made them may have been privately retained by Gilbert, but it is more likely that he was a survey draftsman in Company employment who accompanied Gilbert officially on his various assignments and from time to time executed private commissions. The artist, perhaps of Murshidabad ancestry, was probably recruited in Calcutta. For other pictures from the same series, see Victoria and Albert Museum, *I.S. 10–1963* to *I.S. 16–1963*.

 i Bungalow of Lieut.-Colonel W. R. Gilbert, Commandant of the Ramgarh Battalion, Hazaribagh (Bihar); silver-stick bearers and a carriage and pair at the door; goat, cows and guinea-fowl in the foreground.
 Inscribed: *Our House at Hazareebaug.* *Add. Or. 2514*
 ii Plan of Lieut.-Colonel W. R. Gilbert's bungalow at Hazaribagh (Bihar).
 Inscribed with scale and key to the various rooms.
 Pen-and-ink and water-colour; 13½ by 19¾ ins. *Add. Or. 2515*

iii Landscape showing the countryside around Hazaribagh (Bihar) with hills, paddy fields, a small Muslim tomb and a lotus pool.
Inscribed: *A Tank of Lotus's near Hazareebaug.* *Add. Or. 2516*

iv Lieut.-Colonel W. R. Gilbert's bungalow at Sambalpur (Orissa) on the banks of the Mahanadi River. Hills in distance, river with rocky bed in foreground (*Plate 32*).
Inscribed: *Sumbhulpore. Commandant's House. Banks of the Mahanuddee*; on back: *House at Sumbhulpore.* *Add. Or. 2517*

v View from the Commandant's house at Sambalpur (Orissa), showing the fort at the foot of the hills, river bed in foreground.
Inscribed: *Sumbhulpore. View from the House*; on back: *Fort of Sumbhulpore.* *Add. Or. 2518*

vi The fort at Sambalpur (Orissa) on the banks of the Mahanadi River. Sentries in look-out towers.
Inscribed: *The Fort of Sumbhulpore*; on back: *The Old Fort of Sumbhulpore.* *Add. Or. 2519*

vii Temple in the fort, Sambalpur (Orissa). Fenced well in foreground, sentry on duty on right.
Inscribed: *Sumlye Temple in the Fort. Sumbhulpore*; on back: *Sumlie . . . in the Fort of Sumbhulpore.* *Add. Or. 2520*

viii The Old Palace in the fort at Sambalpur (Orissa). The Commandant, Lieut.-Colonel W. R. Gilbert, and his wife approaching mounted on an elephant accompanied by silver-stick bearers, lance-bearers and cavalry.
Inscribed: *Remains of the Old Palace in the interior of the Fort of Sumbhulpore*; on back: *Remains of Old Palaces in the Fort of Sumbhulpore.* *Add. Or. 2521*

ix The Commandant, Lieut.-Colonel W. R. Gilbert, and other British officers, being entertained with a nautch by the Raja of Sambalpur (Orissa). They are seated under a tent in a courtyard of the palace. On the left the Raja and his guests, on the right, nautch girls and musicians, in the foreground armed retainers and silver-stick bearers. The whole scene is lit by oil lamps (*Plate 34*).
Inscribed: *Entertainment at the Rajah's*; on back: *Entertainment given by the Rajah of Sumbhulpore.* *Add. Or. 2522*

x The Commandant's camp near Surguja (Central Provinces). Tents under a great tree with horses, elephants, bullock carts, servants and villagers in foreground. A palanquin and tonjaun beside the tents (*Plate 33*).
Inscribed in *nāgarī* characters: *Chal*; in English: *Chal-near Sugoojer*; on back: *Chaul.* *Add. Or. 2523*

xi A group of Lieut.-Colonel W. R. Gilbert's servants on the verandah of a bungalow. The ayahs and a child are seated on the floor, another ayah carries a plate of bread-and-butter, a *khidmatgār* pours tea at a table from a silver teapot, while an *ābdār* pours water into a glass carried on a tray by another *khidmatgār*. The male servants wear red liveries (*Plate 31*).

Inscribed: *Our Old Servants.*

18¼ by 25¼ ins. *Add. Or. 2524*

xii Landscape with huge banyan tree beside a river. Country boats and villagers bathing in fore-ground.

20 by 24 ins. *Add. Or. 2525*

57 The Kinwun Mingyi (or Prime Minister) proceeding to the Hlutaw (or King's Supreme Court) at Nyaungbinzeik, near Prome (Burma) to treat with the British Commissioners for peace, 2 October 1825.

Probably by a Calcutta artist, 1825.

Inscribed: *Kee Woonjee proceeding to the Letoo at Necoongbenzeik to meet the British Commissioners on the 2nd Octr. 1825 to treat for Peace.*

Water-colour; 11¾ by 8½ ins.

Purchased 29 October 1951. *Add. Or. 749*

NOTE: For the meeting of the British Commissioners with the 'Kee Woonjee', see T. A. Trant, *Two years in Ava* (London, 1827), 291. Nyaungbinzeik is twenty-five miles north of Prome. The artist was probably a Calcutta draftsman accompanying the British Commissioners. A somewhat similar drawing is amongst the Amherst collection of drawings in the Indian Section, Victoria and Albert Museum.

58 A man with elephantiasis of the scrotum.

Probably by a Calcutta artist, 1830.

Inscribed on back: *No. 27 Representation of the case referred to in para 199 of Letter to Honble Court dated 15 Nov 1830. Recd Duchess of Athol 14th March 1831.*

Water-colour; 16 by 10¼ ins.

Received by East India Company, 14 March 1831. *Add. Or. 744*

NOTE: The letter referred to in the inscription cannot be traced in the India Office Records. The drawing was clearly sent to London to illustrate a medical communication, and is an example of an Indian artist engaged on official work.

59 A sweeper (*mehtar*) and water-carrier (*bihishtī*) cleaning a drain or water-channel in a garden.

By the Calcutta artist, Shaikh Muhammad Amir of Karraya, c. 1835–40.

Inscribed on front in English: *Bhisty; Mayter;* in Persian characters: *bihishtī; mihtar; Shaikh Muḥammad Amīr muṣauwir.*

Water-colour; 6¼ by 9¼ ins.

Purchased 30 May 1969. *Add. Or. 2553*

NOTE: A picture from an album of paintings made for Thomas Holroyd, a Calcutta business man, and presented by him to the Oriental Club, London. When Holroyd was elected to the Oriental Club in 1839 he was described in its 'Annals' as 'Late of Fergusson & Co.,' having been in 1836

'an assignee of Cruttenden and Co.' The album contained a whole set of paintings by Shaikh Muhammad Amir (see p. 76) depicting Holroyd's house (no. 5, Park Street, Chowringhee), his carriage, horses, palanquin and servants, as well as familiar Calcutta sights and scenes. Each picture was signed by the artist in Persian. For other paintings from this album, see Maggs Bros., *Oriental miniatures and illumination, Bulletin no. 3* (London, 1962), nos. 57–66. The following notes by Holroyd occur on the picture of a horse, '*Maidan Calcutta. One of ten – driven alternately in the Coach – each could do her mile in 3 minutes*'; on the painting of his house, '*Our House in Park Street Chowringhi Calcutta by a Native Artist*'; on a picture of a palanquin, '*T. H.'s Livery Colours in Turban and Cumberband band of servant*'; on the picture of a horse-drawn vehicle, '*Indian barouche and native lady of rank. Plain Livery – Costume au naturel*'.

60 i–iii Three drawings made for an Englishman in Calcutta depicting his house, horses, gig and servants.
By the Calcutta artist, Shaikh Muhammad Amir of Karraya, *c.* 1845.
Purchased 14 January 1957. *Add. Or. 487–489*

NOTE: These pictures are from a set similar to no. 59, executed by the same artist for another Calcutta resident. In the present drawings the figures are shown against a blue sky with a simple landscape background.

For other pictures from this set see Mildred and W. G. Archer, *Romance and poetry in Indian painting* (Wildenstein, London, 1965), no. 79; and Indian Section, Victoria and Albert Museum, *I.S.5 and 6–1957*.

i A Calcutta house surrounded by a garden with tank and out-houses (*Colour plate B*).
Water-colour; 18 by $26\frac{3}{4}$ ins. *Add. Or. 488*

ii A tandem harnessed to a high-wheeled gig; the grooms standing by, a dog in the foreground (*Plate 29*).
Inscribed in Persian characters: <u>Sh</u>ai<u>kh</u> *Muḥammad Amīr muṣauwir sākin i Karraya* (Shaikh Muhammad Amir painter, resident of Karraya); on back of original mount: *Maggy Lauder* (perhaps the names of the horses).
Water-colour; 18 by $26\frac{3}{4}$ ins. *Add. Or. 487*

iii A flea-bitten grey horse with its groom holding a fly whisk and a red and blue horse-cloth (*Plate 30*).
Inscribed in Persian characters: *– – d Amīr muṣauwir*; on back of original mount: *Hermit* (perhaps the name of the horse).
Water-colour; $11\frac{1}{2}$ by $17\frac{1}{2}$ ins. *Add. Or. 489*

61
i–xvii 17 drawings depicting household servants, castes and tradesmen.
By the Calcutta artist, Shaikh Muhammad Amir of Karraya, *c.* 1846.
Inscribed with titles and iii–vi, viii, xv, xvi, signed by the painter.
Water-mark of 1845.
Water-colour; 11 by $7\frac{3}{4}$ ins.
Purchased 10 September, 1955. *Add. Or. 171–187*

NOTE: These pictures by Shaikh Muhammad Amir are from one of his standard sets depicting servants, castes and occupations. Apart from xiv, xvi, xvii, which fill the sheet, the figures are shown against an uncoloured background with a low landscape. The writer, Fanny Parks, appears to have bought a set of drawings by this artist since four lithographs in her *Wanderings of a pilgrim in search of the picturesque* (London, 1850, i, plates 5, 8, 15, and 16) are clearly based on his work. She visited Calcutta for the last time in 1844.

i House-steward holding papers and pen-case.
 Inscribed: *Sirkar.* *Add. Or. 171*
 NOTE: See Fanny Parks, *Wanderings*, plate 16.

ii Door-keeper holding a staff.
 Inscribed: *Darwan.* *Add. Or. 172*

iii Steward holding bills; a palanquin and balustrade in the background (*Plate 28*).
 Inscribed: *Diwan. S. Mohammed Ameer Pa^r Std at Kurraya* (Shaikh Muhammad Amir, painter stationed at Karraya). *Add. Or. 173*

iv Valet (Sirdar bearer).
 Inscribed: *S. Bearer. S. Mohammed Ameer. Pa^r Std at Kurraya.*
 1845 water-mark. *Add. Or. 174*

v Head table-servant holding a tureen.
 Inscribed: *Khansama. S. Mohammed Ameer. Pa^r Std at Kurraya.* *Add. Or. 175*

vi Wine and water-cooler holding a tumbler and bottle.
 Inscribed: *Abdar. S. Mohammed Ameer. Pa^r Std Kurraya.* *Add. Or. 176*

vii Sweeper (*mehtar*) with broom.
 Inscribed: *Matur.* *Add. Or. 177*

viii Language-teacher (*munshī*) with walking stick.
 Inscribed: *Moonshee. S. Mohammed Ameer. Pa^r Std at Kurraya.* *Add. Or. 178*

ix Language-teacher with walking stick (duplicate of viii).
 Inscribed: *Moonshee.* *Add. Or. 179*

x Groom (*sāis*) with fly-whisk, holding a horse's reins.
 Inscribed: *Sayees.* *Add. Or. 180*

xi Coachman with whip.
 Inscribed: *Cochman.* *Add. Or. 181*

xii Water-carrier with goat-skin (*bihishtī*).
 Inscribed: *Bhishty.* *Add. Or. 182*

xiii Water-carrier with pots on a yoke.
 Inscribed: *Bankwalla.* *Add. Or. 183*
 NOTE: *Bankwalla* is a corruption of *bahangī wālā*, a porter who balances two loads at either end of a *bahangī* (a yoke).

xiv Cook (*bāwarchī*) in his kitchen with oven and spit.
 Inscribed: *Baborchee.* *Add. Or. 187*

xv Brahmin with brass vessel and dish of flowers; river scene in background.

Inscribed: *Bruhman. S. Mohammed Ameer. Pa^r Std at Kurraya.*
1845 water-mark. *Add. Or. 184*

xvi Woman sweetmeat-seller (*halwāīn*) with customer.
Inscribed: *Hulwaen. S. Mohammed Am(eer).* *Add. Or. 185*

xvii Woman sweetmeat-seller (*halwāīn*) with customer (duplicate of xvi with different colouring.)
Inscribed: *Halwayen.* *Add. Or. 186*

62 i–iv 4 drawings depicting occupations.
By E. C. Das, a Calcutta artist, *c.* 1846.
Inscribed with titles and signed by the artist.
Water-colour; $11\frac{1}{4}$ by $7\frac{3}{4}$ ins.
Purchased 6 January 1957. *Add. Or. 478–481*

NOTE: Although the figures are on a slightly smaller scale these drawings are clearly related to to no. 61 in both subject and style.

i Language-teacher with walking stick.
Inscribed: *Moonshee or Teacher. E. C. Doss.* *Add. Or. 478*
ii Steward.
iii Barber.
Inscribed: *Barber. E. C. Doss.* *Add. Or. 480*
Inscribed: *Dewan or Bill Collector. E. C. Doss.* *Add. Or. 479*
iv House-steward holding pen-case and papers.
Inscribed: *Sircar or Bill Collector. E. C. Doss.* *Add. Or. 481*

63 i–x 10 drawings bound into a volume depicting people of Manipur (Assam) and the neighbouring hill tracts.
By an Indian artist at Manipur for the North East India General Mission, *c.* 1870.
Inscribed with titles.
Water-colour and gouache; 11 by 10 ins.
Presented by the C.M.S. Mission, London, 18 November 1956. *Add. Or. 572–581*

NOTE: Since no other paintings of costumes and occupations from Manipur have so far come to light these drawings were almost certainly made especially for the Mission. They are a crude version of the Company style of Bengal. Most of the figures are shown in isolation against an uncoloured background; in others a simple landscape is introduced.

i Three Manipur villagers transplanting rice seedlings in a paddy field.
Inscribed: *Natives transplanting rice (Manipur State).* *Add. Or. 572*

ii Two Manipur women cleaning and husking rice.
 Inscribed: *Cleaning and husking rice for the day's meal in Manipur.*

Add. Or. 573

iii Manipur drummer.
 Inscribed: *Manipur Musician.* *Add. Or. 574*

iv Manipur woman washing clothes.
 Inscribed as above. *Add. Or. 575*

v Manipur man and woman playing *pachīsi*.
 Inscribed: *Native game.* *Add. Or. 576*

vi Two Manipur warriors with feathered head-dresses and a dog, attacking a tiger with spears.
 Inscribed: *Attacking tiger.* *Add. Or. 577*

vii Three women and two drummers before a shrine to Krishna.
 Inscribed: *Dancing before a Hindu God.* *Add. Or. 578*

viii Naga warrior, perhaps an Angami, with spear and plumed shield.
 Inscribed: *Naga Warrior.* *Add. Or. 579*

ix Hillman with a basket on his back, smoking a pipe.
 Inscribed: *A Hillman.* *Add. Or. 580*

x Kuki man carrying two baskets on a yoke.
 Inscribed: *A Kookie coolie.* *Add. Or. 581*

(iii) CUTTACK

In the early years of the nineteenth century, a minor branch of Company painting developed in Orissa. As part of the campaign against the Marathas, the Fort of Cuttack was captured by the British in 1803 and the surrounding area was soon brought under administration. Cuttack, situated two hundred and fifty-three miles south-west of Calcutta, became the capital of the province of Orissa and its administrative headquarters. Almost immediately engineer officers began to map the area and in 1804 the first settlement for land-revenue purposes was made, to be followed by others in quick succession. From 1810 to 1811 Bengal engineers were on survey training in Cuttack and from 1818 to 1821 the Madras Engineers and their draftsmen were also in Orissa.[1] Some of these draftsmen were almost

[1] See *WD 2874*, a drawing of Konarak by William George Stephen, and *WD 857–886*, drawings in the collection of Colonel Colin MacKenzie (Archer (1969), 323–324; 495–498).

certainly South Indian painters, for during this period a number of drawings of Orissa temples at Konarak, Puri and Bhuvaneswar, similar to architectural draw-ings from Madura (see pp. 52–54) were produced for sale to British officers.[1]

A little later, when a British station of the conventional type had grown up at Cuttack, pictures were produced illustrating occupations, festivals and local scenes similar to those made at Calcutta in the eighteen-twenties to forties. A set made in about 1840 (no. 64) is reminiscent of the work of Shaikh Muhammad Amir of Karraya (nos. 59–61). The original set included pictures of servants and pets, as well as various scenes in the neighbourhood and local occupations. It is significant that in one case, victims of famine in Orissa were depicted, and in several others inscriptions specifically mention Cuttack.

Bibliography

Archer, Mildred. *Indian architecture and the British* (London, 1968).
Archer, Mildred. *British drawings in the India Office Library* (London, 1969).
O'Malley, L. S. S. (*ed.* E. R. J. R. Cousins) *Bihar and Orissa Gazetteers: Cuttack* (Patna, 1933).

64 i–x 10 drawings depicting local scenes, occupations and military uniforms.
By a Cuttack artist, *c.* 1840.
Water-colour; $8\frac{3}{4}$ by 11 ins.
Purchased 20 April 1970.

Add. Or. 3130–3139

NOTE: These paintings were part of a larger set which included a drawing of an English woman being carried in a tonjon, and dressed in the fashion of *c.* 1840. It also included portraits of servants and pet dogs. All were inscribed with notes clearly intended for a relative in England, and several inscriptions referred to Cuttack.

i A corpse, lying on a river bed at Cuttack, being devoured by dogs, vultures, adjutant birds and a jackal.
 Inscribed: *A scene from the river side at Cuttack. The natives throw down the dead bodies and the wild beasts come and devour them. The one with the bone is a jackal. The two large birds are Adjutants. The others are vultures.* Add. Or. 3130

ii A group of starving villagers outside the Pilgrims' Hospital, Cuttack.
 Inscribed: *A scene at the Pilgrims' hospital during the famine taken from life. This is the way the natives sit down and clean each others heads and catch game.*
 Add. Or. 3131
 NOTE: In 1836, 1837 and 1842 Cuttack suffered severely from drought followed by food shortage. The inscription may well refer to one of these periods.

iii Cook surrounded by utensils crouching in the kitchen in front of a hearth.
 Inscribed: *A Cook – but not a good representation of one.* *Add. Or. 3132*

[1] Archer (1968), 61, plates 35, 36.

iv Brahmin, seated on the verandah of his thatched house being shaved by a barber.

Inscribed: *A Brahmin being shaved.* Add. Or. 3133

v Carpenter planing wood.

Inscribed: *A Carpenter.* Add. Or. 3134

vi Shoemaker at work.

Inscribed: *A Chuckler or Shoemaker.* Add. Or. 3135

vii Man and woman with a pair of bullocks working an oil press.

Inscribed: *Making cocoa nut oil which is the oil we burn in our lamps.*

Add. Or. 3136

viii Sepoy of the 30th (?) Regiment Madras Native Infantry in full dress holding a musket with triangular bayonet. He wears a red jacket with buff facings, white trousers and a black turban.

Inscribed: *Native Infantry Sepoy in full dress. 30th Regt.* Add. Or. 3137

NOTE: White facings were worn by the 30th Regiment; buff facings by the 35th to 38th Regiments. It is possible, therefore, that the inscriptions on (viii) and (x) are mistaken.

ix Sepoy of the 30th (?) Regiment Madras Native Infantry in light Marching Order holding a musket with triangular bayonet. He wears a red jacket with buff facings, black trousers and a black turban.

Inscribed: *A Native Infantry Sepoy in light Marching Order.* Add. Or. 3138

x Sepoy of the 30th (?) Regiment Madras Native Infantry in heavy Marching Order holding a musket with triangular bayonet. He wears a red jacket with buff facings, black trousers and a white turban.

Inscribed: *A Native Infantry Sepoy in heavy Marching Order. 30th Regt.*

Add. Or. 3139

(iv) PATNA

In 1704 Azim-ush-Shan, second son of the Mughal Emperor Bahadur Shah (ruled 1707–12), became Subadar of Bengal and made Patna his capital, calling it Azimabad after himself. Although he was killed in 1712 during the war of succession that followed his father's death, Patna had already become the flourishing capital of a Mughal province. Artists working there painted in a provincial manner similar to that at Murshidabad. This style is illustrated by a picture of

Azim-ush-Shan riding on an elephant[1] and by a group of portraits in the Library (*Add. Or. 735–738*) which show the subjects silhouetted against a broad sweep of the Ganges.[2] With the political confusion of the mid-eighteenth century, the city declined in importance, patronage was reduced, and some of the painters drifted to Calcutta in search of work. In the closing years of the eighteenth century, artists are found painting in Calcutta and describing themselves as 'painters of Azimabad' (see p. 87).

Side by side with this migration from Patna, several painter families of the Kayasth caste appear to have moved to Patna from Murshidabad in about 1760, and they were soon followed by others. Patna was less affected by the general anarchy than lower Bengal, and although it can hardly have held out any great prospects for these artists, life may have seemed less precarious for them there than at Murshidabad. The East India Company had long had a factory at Patna, and as the British gradually assumed control in Bengal the city grew increasingly prosperous and regained its administrative importance. By 1800 it had become the headquarters of one of the provincial committees into which the Bengal Presidency had been divided. As at Murshidabad the new arrivals soon found a new market among the British. Their work developed on similar lines to that of their castemen in Murshidabad and was concentrated on the same two types of subject-matter – festivals and occupations. The earliest Patna paintings are strongly linked in style to the two contrasting strands of Murshidabad painting. A set (no. 65) made for Ephraim Pote, Commercial Resident at Patna from 1787 to 1800, strongly resembles Murshidabad painting of the European-influenced type (see p. 60), with elongated figures, ragged drapery and sepia wash. A group of occuptions (no. 66) dated 1803 has much in common with Murshidabad paintings of a more traditional type (no. 38), with brighter colours and sharp outlines.

After about 1800, the development of painting in Patna is well documented as a result of the recording of the memories and family traditions of the Patna artist, Ishwari Prasad (see below p. 101). It appears that by the turn of the century the painter Sewak Ram (*c.* 1770–*c.* 1830), who had come from Murshidabad, had a flourishing shop which specialised in pictures of costumes and trades (nos. 67, 70) as well as larger and more ambitious pictures of festivals. A number of these entered the collection of the Earl of Minto and are dated 1807 and 1809 (no. 68). In the early years of the nineteenth century another painter, Hulas Lal (*c.* 1785–1875), arrived in Patna and besides painting similar subjects also attempted more ambitious scenes, such as Krishna celebrating Holi with the milkmaids (no. 77). Hulas Lal probably worked for the East India Company since one of his note-books is inscribed 'Hoolas Lal, Draughtsman',[3] and it is evident from his work that

[1] Mildred Archer, *Indian miniatures and folk paintings* (Arts Council, London, 1967), fig. 2.
[2] S. C. Welch, *The Art of Mughal India* (New York, 1963), pl. 86 (*Add. Or. 736*).
[3] For full documentation of Sewak Ram and Hulas Lal, see Archer (1947) and (1955).

he had acquired European skills such as the squaring-up of drawings for enlargement (no. 77). The work of both Hulas Lal and Sewak Ram has close affinities with the British-influenced stream of Murshidabad painting. The same sombre colours are used – sepia wash with touches of dull blue, green or crimson, but the figures are more realistic and the strange elongated forms of Murshidabad have disappeared. Other artists were also at work as is shown in a set of costumes, made for Buchanan-Hamilton in about 1814, which is slightly different in style from the work of Sewak Ram or Hulas Lal (no. 71). In fact, Lady Nugent in her journal for 1812 gives the impression that at this time many pictures, by various hands, could be bought by casual visitors. When halting at Patna on her way up the Ganges she lunched with Mr Wilton, a Company servant, and noted 'several people attended with drawings for sale, and I bought a number of different works, done by natives, to add to my collection.' On her way down the Ganges, when the boat tied up at Patna, she recorded, 'All the morning crowded with visitors, tradesmen, etc. Bought a great many drawings.'[4]

Between about 1815 and 1840, the popularity of Patna paintings rapidly increased. In 1821 Sir Charles D'Oyly[5] was posted to Patna and quickly stimulated an interest in such work among the officials living at Bankipore, the civil station of Patna. He himself was a talented amateur artist and in July 1824 he encouraged the local British residents to form a light-hearted society, 'The United Patna and Gaya Society, or Behar School of Athens.' It included not only the officials at Bankipore, the civil station of Patna, but officers posted at Gaya, such as Christopher Webb Smith (see p. 115) and George Beauchamp, the Collector of Pilgrim Tax there. Sketching parties were organised and a lithographic press was installed at Patna. On this Sir Charles printed not only his own illustrated books, but a periodical, *The Behar Lithographic Scrapbook*, which included the work of Bihar residents. To assist with the press, D'Oyly employed one of the Patna artists, Jairam Das. This activity continued until D'Oyly left Patna in 1832.[6] During this time Patna artists came into close contact with British techniques and, through D'Oyly in particular, had access to British books and prints. It is clear that some of the artists were actually copying figures and animals from British books and from the work of D'Oyly and Webb Smith (no. 83). Although some of the bazaar shops went on producing costume drawings of the old sombre type (nos. 74, 75), artists such as Jairam Das acquired a more delicate and graceful style (no. 78), which had an immediate appeal. A volume of thirty-six pencil and water-colour drawings by him, presented in 1834, is in the Royal Asiatic Society, London, and when Lord and Lady Amherst visited Patna in 1826 and 1827 they

[4] Nugent, ii, 185.
[5] Archer (1969), i, 162–169.
[6] For miscellaneous lithographs by D'Oyly mounted in scrapbooks, see India Office Library, W 35 and X 294.

acquired a number of Patna paintings, among them work by Jairam Das.[7] About this time Patna painters, including Jairam Das, appear to have added the making of portrait miniatures on both paper and ivory to their repertory.

From about 1830, three flourishing shops, headed by Jhumak Lal (died 1884), Fakir Chand Lal (*c.* 1790–*c.* 1865) and Tuni Lal (born *c.* 1800), specialised in costumes and occupations. Hulas Lal was still working and producing more ambitious large-scale pictures of festivals and scenes of Indian life, such as wrestling or gambling at Diwali. With the exception of his work, however, Patna painting of this period had become stereotyped, and standard compositions were being produced over and over again (nos. 79–82).

By the middle of the century, Fakir Chand Lal's son, Shiva Lal (*c.* 1817–*c.* 1887), and Tuni Lal's son, Shiva Dayal Lal (*c.* 1820–80), had taken over the shops and had become the leading Patna painters. Shiva Lal maintained close contact with certain British officers and appears to have been involved in work for William Tayler, Commissioner of Patna, and Dr Lyell, Personal Assistant in charge of Opium. He made portraits on paper and ivory and had a regular practice with both European and Indian clients. He was clearly a skilled draftsman and had a deft and sensitive style (nos. 84–86). He also ran a flourishing shop and over the years employed as assistants a number of Patna painters: Gopal Lal (1840–1911), Gur Sahay Lal (1835–1915), Bani Lal (1850–1901), his cousin Bahadur Lal (1850–1933), Kanhai Lal (1856–1916), and Jaigovind Lal (1878–1908). These produced sets of pictures illustrating, in particular, costumes and occupations (nos. 87–90). They also drew birds. Shiva Lal supervised the marketing, and the products of his shop were sold in Calcutta, Dinapore, Benares and Allahabad. Although the work of his assistants was in general less accomplished, Bani Lal stands out as a competent draftsman. His sets of occupations, though produced in the eighteen-eighties, are similar to British prints of the eighteen-thirties with their soft colouring, figures poised against a blue sky and low horizon, a rock, stones or grass-tufts in the foreground, and a branch of a tree in the upper corner (no. 90).

While Shiva Lal was conducting his successful business, his cousin, Shiva Dayal Lal, ran a similar shop employing as assistants Jamuna Prasad (1859–84) and his brother Bahadur Lal II (1850–1910), both sons of Jhumak Lal. Shiva Dayal Lal appears, however, to have been a less astute business man than his cousin and to have relied to a great extent on patronage from Indian gentry in Patna city, especially the zemindar Rai Sultan Bahadur, for whom he made bird and flower paintings. This Indian bias led him to use bright colours more reminiscent of Mughal painting, whereas Shiva Lal's shop still imitated British prints both in colour-scheme and composition.

[7] Indian Section, Victoria and Albert Museum, I.S. 23 to 56–1964, I.S. 60–1964, I.S. 63–1964, I.S. 72–1964.

After about 1880 British patronage declined. Ishwari Prasad (1870–1950), the talented grandson of Shiva Lal, from whom as a boy he had learnt his trade, was forced to work for an Indian landlord, Raja Lachman Seth of Mathura. This patronage did not prove adequate and Ishwari went to Calcutta to look for commercial work. When E. B. Havell (no. 91) was posted to Calcutta he discovered Ishwari drawing patterns for a European firm which imported Manchester piece-goods.[8] In his eagerness to revive and preserve traditional Indian painting, Havell found a place for Ishwari on the staff of the Calcutta Art School in 1904. Ishwari provided Havell, and later Percy Brown, with much information on the technique of Indian miniature painting. When he retired, he returned to his native Patna and did repair work and mounting for the collector, P. C. Manuk, and sometimes made small pictures in Patna style (no. 92). When I met Ishwari there from 1941 to 1942 he was seventy years old but still lively and alert. He would come to the bungalow, trimly dressed in white *dhotī*, black jacket and little round black hat, and relate his memories and family traditions. These are incorporated in my *Patna Painting* and in *Indian Painting for the British*. His memory for facts and dates has proved astonishingly reliable, his information on Sewak Ram being confirmed by inscribed and dated pictures in the Minto collection (no. 68), on Jairam Das by D'Oyly lithographs in the Library and by the Amherst collection in the Victoria and Albert Museum, and on Markham Kittoe and Benares painters by the Kittoe collection in the Library (*WD 2876–2878*).[9] With his death in 1950, Company painting in Patna came to an end.

Besides paintings on paper, Company artists in Patna also produced pictures on mica, adapting to Patna conditions the subjects popularised in Murshidabad. Although produced in substantial quantities throughout the nineteenth century, Patna mica paintings proved less successful than those made at Benares. Since, in style, both are virtually indistinguishable, it is under Benares that the Library's collection of north Indian mica paintings has been catalogued (see pp. 146–154).

Bibliography

Archer, Mildred. *Patna painting* (London, 1947).
Archer, Mildred. 'Birds of India', *Geographical Magazine*, December 1963, 470–481.
Archer, Mildred. *British drawings in the India Office Library* (London, 1969).
Archer, Mildred. 'The talented baronet: Sir Charles D'Oyly and his drawings of India', *The Connoisseur*, November 1970, 173–181.
Archer, Mildred and W. G. *Indian painting for the British: 1770–1880* (Oxford, 1955), 27–40.
Brown, P. *Indian painting* (2nd edition, Calcutta, 1927), 62.
Buchanan, F. (ed. V. H. Jackson) *Journal of Francis Buchanan kept during the survey of the districts of Patna & Gaya in 1811–1812* (Patna, 1925).

[8] Havell, 238.
[9] Archer (1969), ii, 466–468.

Buchanan, F. (ed. J. F. W. James) *An Account of the district of Bihar and Patna in 1811–1812*, 2 vols. (Patna, 1936).

Havell, E. B. *Indian sculpture and painting* (London, 2nd edition 1928), 238.

Manuk, P. C. 'The Patna school of painting', *Journal of the Bihar Research Society*, xxix, September 1943, 143–169.

Martin, R. M. *The History, antiquities, topography and statistics of Eastern India*, 3 vols. (London, 1838).

Mehta, N. C. *Studies in Indian painting* (Bombay, 1926), 107.

Nugent, Maria. *A Journal from the year 1811 till the year 1815*, 2 vols. (London, 1839), i, 220–230, ii, 185–186.

**65
i–viii**

8 drawings depicting Hindu and Muslim festivals and ways of life.
By Patna artists, *c.* 1795–1800.
Inscribed on back with titles and notes. Watermark of 1794 on (vi).
Water-colour; various sizes.
Purchased 4 June 1959. *Add. Or. 937–944*

NOTE: These drawings appear to be part of a set given by Ephraim Pote to Elizabeth Collins. Pote served in Bengal from 1773 to 1800. Assistant at the Rangpur Factory, 1775–80; Commercial Resident, Rangpur, 1780–87; Commercial Resident, Patna, 1787–1800. It seems probable that the drawings were made for him while he was stationed in Patna. (i–vii) appear to be by the same artist, (viii) is by a different hand. These drawings, therefore, are some of the earliest examples of paintings made for the British in Patna. In style they are similar to the work of Murshidabad artists (see pp. 70–71) with the same awkward elongated figures wearing costumes with jagged folds. They would thus confirm the oral tradition (recorded Archer (1947), 5) that Murshidabad artists migrated to Patna to work for the British. Nothing is known of Elizabeth Collins.

i An Indian gentleman in his *morpankhī* or peacock boat on the river Ganges. Before him stands a servant with two yak's-tail fly-whisks.
Inscribed: *No. 5. The Gift of E. E. Pote, Esqʳ. Elizaᵗʰ Collins;* also *A more-punkih. The pleasure boat of a person of distinction.*
10¼ by 23¾ ins. *Add. Or. 937*

ii The Muharram festival; the *ta'ziyah* in the imambara (*Plate 36*).
Inscribed: *No. 18. The Gift of E. E. Pote Esq. Elizaᵗʰ Collins. This is a Representation of the Mohurrum; and is the Commemoration of the Murder of Hussen and Hosain two Mahomedan Saints: continued for ten days. A Machine is constructed very superbly painted and gilt, supposed to represent their Tomb – Before which is a Priest reading the circumstances of their Death which in general has a most enthusiastic effect upon the Audience who weep, groan and beat their breasts with the greatest violence, loudly calling upon the names of Hussein Hossein, prostrating themselves before the Tomb, and offering the sacrifice of their lives in the defence of the cause of these two Saints. Under the Canopy are the various Standards and Flags of the Mahomedans – before them is the figure of the Borak – An imaginary animal with the face of a Woman, the breast and Tail of a Peacock, with wings on the*

Body and feet of a deer; on which animal, Mahomet (as he says) was transported to Heaven from his chamber and held seventy thousand conferences with God, and was brought back to his Chamber by the same animal in so short a space of time that a small pitcher of water which had been thrown down on his departure had not emptied itself on his return. The place in which this exhibition is made, is very grand with ornamented illuminations, and this Scenery accompanied by the sincere and enthusiastic beating on their breasts and their Fears, groans and exclamations has the most solemn effect upon the Mahomedan Devotees; also *The Mohurram. No. 1.*

13¾ by 20 ins. *Add. Or. 938*

iii The Holi festival, an Indian gentleman seated on a painted stool watches the celebrations. Men sing and dance and play on instruments; women squirt coloured water.

Inscribed: *No. 4. The Gift of E. E. Pote Esq^r. Eliza^{th} Collins. This is a Hindoo Festival celebrated, among other sports, by throwing a red powder enclosed in globes of Lak which break instantly and cover the party with the Powder – this is immediately returned – and thus by partial and promiscuous peltings – the whole Party are entirely covered with the red Powder. The Powder is also put in Water, and the Assembly attack each other with squirts filled with the red water – by the time the Party break up, they are so disfigured as scarce to be known;* also *The Festival of the Hoolee.*

10 by 22½ ins. *Add. Or. 939*

iv The Chait festival being celebrated on the banks of the Ganges at Patna.

Inscribed: *No. 1. The Gift of E. E. Pote Esq. Eliza^{th} Collins Offerings of fruit to the Ganges: a religious Ceremony at which the Women are permitted to attend, and come down to the River side to celebrate: and as it is supposed avail themselves of this liberty to see and be seen which is gratified, by the Men bringing boats to anchor along the Banks of the River;* also *Offering of Fruits to the Ganges.*

13½ by 20¼ ins. *Add. Or. 940*

NOTE: The Chait festival is the Hindu New Year's Day festival held on the 1st of Chait (March–April) which is the beginning of the Hindu calendar. For observing it, women stand in a tank or river and offer fruit either to the Sun or to the water.

v The Dasehra festival; effigies of Rama, Lakshmana and Sita being carried in procession, accompanied by musicians and bearers of standards and lanterns.

Inscribed: *No. 27 The Gift of E. E. Pote Esq. Eliza^{th} Collins;* also *Religious Procession. Music and Dancing Girls. Men in the character of their Gods.*

10¾ by 19¾ ins. *Add. Or. 941*

vi A Hindu marriage; the bridegroom is being carried in procession in a palanquin, preceded by elephants, musicians and dancing girls.

Inscribed: *No. 7. The Gift of E. E. Pote, Esq. Eliza^{th} Collins;* also *A Hindoo marriage No. 2. The public procession made by the Bridegroom after the marriage with Dancing Girls carried on a stage on men's shoulders.*

10½ by 20 ins. *Add. Or. 942*

vii Swinging; six women are swinging inside a room while other women sing (*Plate 35*).
Inscribed: *The Gift of E. E. Pote Esq. Elizath Collins*; also *No. 2 The interior amusement of the Swing. Female attendants singing.*
11¾ by 18 in. *Add. Or. 943*

viii Zenana scene; women sitting on a rug, playing *pachīsī* and dressing themselves.
Inscribed: *No. 10. The Gift of E. E. Pote Esq. Elizath Collins*; also *Ladies playing at Pachecia. The dress of women of distinction. Shoes.*
11¾ by 20 ins. *Add. Or. 944*

66 i–iii 3 drawings of occupations.
By a Patna artist, 1803.
Water-colour, varying sizes.
Presented by H. C. Maggs, July 1965. *Add. Or. 2604–2606*

NOTE: From a series of drawings depicting occupations.

i Hindu ascetic, playing a *sārangī*.
Inscribed on front: *Biraggee or A Religious Beggar*; on back: *? or Religious Beggar July 1803 Patna.*
7½ by 6¾ ins. *Add. Or. 2604*

ii Conjuror and his assistant playing on a snake charmer's pipe.
Inscribed on mount in ink: *A Conjuror.*
6½ by 6½ ins. *Add. Or. 2605*

iii Water-cooler (*ābdār*).
Inscribed on back in pencil: *Water-cooler.*
6½ by 6¾ ins. *Add. Or. 2606*

67 i–ix 9 drawings depicting occupations.
Probably by Sewak Ram (*c.* 1770–*c.* 1830), a Patna artist, *c.* 1804.
Watermark of 1801 on (ix)
Water-colour; various sizes.
Presented by Mildred and W. G. Archer, 14 May 1956. *Add. Or. 526–534*

NOTE: Obtained by W. G. Archer in 1948 from Ishwari Prasad, grandson of the Patna painter, Shiva Lal. They were attributed to Sewak Ram by family tradition.

i Two musicians; a drummer and a flute player.
9¾ by 7¾ ins. *Add. Or. 526*

ii Four musicians; playing *tabla*, cymbals and *shahnāī*.
9¾ by 7 ins. *Add. Or. 527*

iii Six musicians playing *tabla*, cymbals, *shahnāī* and brass horn.
9¾ by 7¾ ins. *Add. Or. 528*

iv Sugar press. On reverse, unfinished drawing of singers.
$8\frac{3}{4}$ by $6\frac{3}{4}$ ins. *Add. Or. 529*
NOTE: The drawing on the reverse is similar to no. 98 lxxiv.

v Weaver.
8 by $5\frac{1}{4}$ ins. *Add. Or. 530*

vi Turner.
8 by $6\frac{1}{4}$ ins. *Add. Or. 531*

vii Grain-seller.
6 by $4\frac{1}{4}$ ins. *Add. Or. 532*

viii Two merchants (?) talking together.
9 by 7 ins. *Add. Or. 533*

ix Reciter of verse.
8 by $6\frac{3}{4}$ ins. *Add. Or. 534*
NOTE: Similar to no. 98 xcv.

68 i–v 5 drawings of Muhammadan and Hindu ceremonies.
By Sewak Ram (*c.* 1770–*c.* 1830), a Patna artist, 1807–1809.
Water-colour; 17 by 23 ins.
Purchased 14 June 1954. *Add. Or. 15–19*

NOTE: These drawings belonged to the first Earl of Minto, Governor-General of Fort William 1807–13. Other pictures from the same series were purchased by the Victoria and Albert Museum (I.S. 74–1954) and the Chester Beatty Library. As Minto did not visit Patna himself, the drawings may have reached him as a gift. Although only one drawing (i) is inscribed with the artist's name, the others (ii–v) are in the same style and by the same hand.

i The Muharram festival; prayers being held in the imambara (*Colour plate C*).
Inscribed on back: *Mohurrum is a mournful ceremony held by the Mussulmans in commemoration of the death of Hassan and Hossein, the Grandsons of Mohammed. The drawing represents them at prayers. Sheiwak Ram, delt. 1807.* *Add. Or. 18*

ii Marriage procession of a Muslim bridegroom proceeding to the bride's house. The bridegroom in cloth of gold is riding on a white horse, preceded by a band and a procession of men carrying trays of sweetmeats on their heads. Behind follow gentlemen in a tonjon, on horseback and on elephants (*Plate 38*).
Inscribed on back: *Procession of the Sanchac.* *Add. Or. 16*

iii The Harihar Kshetra festival at Sonepur, near Patna (Bihar). The river is thronged with boats; in the background the tents of the fair and in the foreground people embarking (*Plate 37*).
Inscribed on back: *Herriher-Chitter is a place of worship dedicated to Herriher-nát'h-Mahadeva at Sonepoor in the District of Sarun in the Northern Division of the Province of Bahar, at which place there is annually a Maila, a religious assembly, on the day of the full Moon in the month of Cartic (October or November) when a vast multitude of people assemble from all parts to pay their devotions to Herriher-nát'h,*

and to bathe at the junction of the river Salgirami, or Gunduck, with the Ganges. 1809. *Add. Or. 15*

 iv Hook-swinging festival (*charak pūjā*) being held in an open space in front of a large European-style house. *Add. Or. 17*

 v Durga puja. To the left an image of Durga on the verandah of a house before which a goat is being sacrificed in the courtyard.

Inscribed on back: *Doorga-Puja. A religious festival held in honour (sic) Devi, and in commemoration of her victory over the giant Doorg, in consequence of which she obtained the title of Doorga-Bhavāni. This festival is celebrated in the month of Asin at the commencement of the new year. The fable of Bhavāni, or the female principle, destroying the giant Doorg, under the form of a Buffalo-headed monster, is the same as the Egyptian tale of Horus slaying the river horse, and is merely allegorical of the periodical rising of the Ganges about the autumnal equinox; goats, and sometimes Buffalos, are sacrificed on this occasion. This festival is regularly kept up in Bengal, but the Hindoos of the Province of Bahar seldom engage in these ceremonies. The figure under the above represents Bhavāni standing on a lion, (Mahadeva under that form) and piercing the monster with her spear. 1809.* *Add. Or. 19*

69 Durga Puja. Male dancers and musicians performing before an image of the goddess Durga installed inside a house. On the left a group of three men seated on painted stools, one smoking a hookah.
By Sewak Ram (*c.* 1770–*c.* 1830), a Patna artist. *c.* 1809.
Water-colour; 11 by 8½ ins.
Purchased 14 November 1954. *Add. Or. 29*

NOTE: In the same style as 67 and 68.

70 i, ii Two drawings of social types.
By Sewak Ram (*c.* 1770–*c.* 1830), a Patna artist, *c.* 1810.
Presented by Mildred and W. G. Archer, 2 April 1961. *Add. Or. 1852; 1856*

NOTE: Obtained by W. G. Archer at Patna in 1948 from Ishwari Prasad, who attributed them to Sewak Ram.

 i Three dancing girls with three musicians.
 Wash; 7¾ by 6½ ins. *Add. Or. 1852*
 ii Lovers embracing; on reverse, two European ladies.
 Brush drawing and wash; 5¾ by 3¾ ins. *Add. Or. 1856*

NOTE: The unfinished sketch of the two European ladies is a copy of an English fashion-plate, 'Walking Dresses', from N. Heideloff, *Gallery of Fashion*, 1796 (J. Laver, *17th and 18th century costume* (Victoria and Albert Museum, London, 1959), fig. 88).

71
i–xlii

42 drawings depicting the dress worn by Hindu and Muhammadan men and women of various classes and castes in both the hot and cold seasons.
By a Patna artist, *c.* 1814.
Inscribed with numbers and titles.
Water-colour; 10 by 8 ins.
Deposited by F. Buchanan-Hamilton, *c.* 1820. *Mss.Eur.C.14* (Kaye 170)

NOTE: For Francis Buchanan (later Buchanan-Hamilton) see Archer (1969), ii, pp. 397–400. Although these costume drawings were there included in the Buchanan-Hamilton collection, they are listed more fully in the present catalogue in view of their importance for the study of Company painting. Between 1811 and 1812 Buchanan made a survey of Bihar and Patna districts. The water-marks of 1812 and 1813 on the costume drawings show that they could not have been acquired by Buchanan during his survey work. But he almost certainly encountered Patna painters while he was in the city and he probably ordered a set of pictures which were later supplied to him. In table 41 of the appendix to his Patna report, he enumerates 12 'Musawir Wallahs' or professional painters as working there. The present group differs from conventional sets of Patna paintings which do not depict 'summer' and 'winter' dress in this way. Nevertheless a few 'type' pictures from such sets are included, the Gwalin (xl), for example, being closely similar to 89.

The present group of drawings was used by R. M. Martin to illustrate his *The History, antiquities, topography and statistics of eastern India* (London, 1838). Nos. i, ii, xxiv, xxv were reproduced in Martin I, frontispiece and plates 1 and 2; v, vi in Martin II, plate 2. The remaining six costume illustrations in Martin II and III showing 'Hindoos of high rank in full winter dress', 'Hindoos of high rank in common summer dress' and 'Hindoos of high rank in common winter dress' are missing in the present collection and account for the numbers 26–31. It seems probable that these paintings were mislaid after being lithographed for Martin's book.

 i Muhammadan gentleman in white muslim costume holding a letter.
 Inscribed: *1. Moslem of high rank in full Summer Dress.*
 ii Muhammadan lady in white sari holding a rose.
 Inscribed: *2. Moslem of High Rank in full Summer Dress.*
 iii Muhammadan gentleman with a sword.
 Inscribed: *3. Moslem of High Rank in common Summer Dress.*
 iv Muhammadan lady in blue trousers with a hand punkah.
 Inscribed: *4. Moslem of High Rank in common Summer Dress.*
 v Muhammadan gentleman with green shawl.
 Inscribed: *5. Moslem of High Rank in full winter dress.*
 vi Muhammadan lady in crimson dress and purple shawl.
 Inscribed: *6. Moslem of High Rank in full winter dress.*
 vii Muhammadan gentleman with yellow shawl and walking stick.
 Inscribed: *7. Moslem of High Rank in common winter dress.*
 viii Muhammadan lady in striped trousers and red shawl.
 Inscribed: *8. Moslem of High Rank in common winter dress.*

 ix Muhammadan man in plain white costume.
 Inscribed: *9. Second Rank of Moslems in full summer dress.*

 x Muhammadan woman in striped trousers and pink veil.
 Inscribed: *10. Second Rank of Moslems in full dress for summer.*

 xi Muhammadan man holding a punkah.
 Inscribed: *11. Second Rank of Moslems common dress in summer.*

 xii Muhammadan woman holding a punkah.
 Inscribed: *12. Second Rank of Moslems in common summer dress.*

 xiii Muhammadan man with purple flowered shawl.
 Inscribed: *13. Second Rank of Moslems in full winter dress.*

 xiv Muhammadan man in plain white costume.
 Inscribed: *14. Second Rank of Moslems in common Winter dress.*

 xv Muhammadan woman in striped trousers and purple veil.
 Inscribed: *15. Second Rank of Moslems in common winter dress.*

 xvi Muhammadan man in plain white dress with *dhotī*.
 Inscribed: *16. Third class of Moslems in Summer.*

 xvii Muhammadan woman in plain white sari.
 Inscribed: *17. Third class of Moslems in summer in Sari.*

 xviii Muhammadan man with red spotted wrap.
 Inscribed: *18. Third class of Moslems in winter.*

 xix Muhammadan woman in red checked trousers and white veil.
 Inscribed: *19. Third class of Moslems in winter dress.*

 xx Muhammadan man in short red *dhotī* and white wrap
 Inscribed: *20. Lowest dress of Moslems in summer.*

 xxi Muhammadan woman in plain white sari.
 Inscribed: *21. Lowest dress of Moslems in summer.*

 xxii Muhammadan man in short white *dhotī* and dark wrap.
 Inscribed: *22. Lowest dress of Moslems in winter.*

 xxiii Muhammadan woman in white sari and dark veil.
 Inscribed: *23. Lowest dress of Moslems in winter.*

 xxiv Hindu gentleman in white muslim costume and pink turban.
 Inscribed: *24. Visiting summer dress of a Hindu of High rank.*

 xxv Hindu lady in dark blue skirt and red veil holding a punkah.
 Inscribed: *25. Full Summer dress of a Hindu of High rank.*

 xxvi Hindu man in white costume.
 Inscribed: *32. Second rank of Hindus in summer visiting dress.*

 xxvii Hindu man in pinkish *dhotī* and white wrap.
 Inscribed: *33. Second rank of Hindus common dress in summer.*

 xxviii Hindu woman in pink sari with punkah.
 Inscribed: *34. Second Rank Hindu common dress in summer.*

 xxix Hindu man in white costume.
 Inscribed: *35. Second Rank of Hindus visiting dress in winter.*

xxx Hindu man in white costume and yellow *dhotī*.
Inscribed: *36. Second rank of Hindus common dress in winter.*

xxxi Hindu woman in purple skirt and yellow flowered shawl.
Inscribed: *37. Second rank of Hindus common dress in winter.*

xxxii Hindu woman in yellow skirt and white veil.
Inscribed: *38. Second rank of Hindus in full dress for marriages.*

xxxiii Hindu woman in pink dress and green veil.
Inscribed: *39. Second rank of Hindus in dress for marriages.*

xxxiv Hindu woman in blue shirt and red veil.
Inscribed: *40. Second rank of Hindus visiting dress.*

xxxv Hindu man in short white *dhotī* and wrap.
Inscribed: *41. Third class of Hindus in Summer.*

xxxvi Hindu woman in white sari.
Inscribed: *42. Third class of Hindus in summer.*

xxxvii Hindu man in short *dhotī* and white wrap.
Inscribed: *43. Third class of Hindus in winter.*

xxxviii Hindu woman in dark blue skirt and white veil.
Inscribed: *44. Third class of Hindus in winter.*

xxxix Milkman (*gwāla*) in short yellow *dhotī* carrying a stick.
Inscribed: *45. Lowest dress of Hindus in summer. Goyala of Magadha in the (kacha) lowest dress of the country.*

xl Milkman's wife (*gwālīn*) carrying a basket of cow-dung cakes.
Inscribed: *46. Hindus in lowest summer dress. Goyalia of Magadha in the (kiluya) lowest dress of the country.*

xli Hindu in short *dhotī* and wrap.
Inscribed: *47. Lowest dress of Hindus in winter.*

xlii Hindu woman in white sari.
Inscribed: *48. Lowest dress of Hindus in the cold season.*

72 Courtyard of a house with canopy. Door-keepers in red and green liveries stand on each of the verandahs.
By a Patna artist, *c.* 1815.
1814 water-mark.
Unfinished water-colour; 17 by 25½ ins.
Presented by Mildred and W. G. Archer, 6 November 1959.　　*Add. Or. 992*

NOTE: Obtained by W. G. Archer at Patna in 1948 from Ishwari Prasad.

73
i–xxiii 23 drawings of musical instruments.
Probably by a Patna artist, *c.* 1820.
Inscribed with titles in Persian and in some cases in *nāgarī* characters.
Water-colour; various sizes.
Purchased 10 November 1965.　　*Add. Or. 2617–2639*

NOTE: The inscriptions in *nāgarī* characters appear to have been copied on to the drawings by a writer ignorant of the script. The colouring and technique suggest a Patna provenance.

i A small tambourine. Inscribed: *khanjarī.*
 A bunch of bells. Inscribed: *khokhzad.*
 A one-stringed guitar decorated with a feather. Inscribed: *yak-tārah.*
 7 by 7½ ins. *Add. Or. 2617*

ii Tambourine. Inscribed: *rubātah.*
 Two-stringed guitar. Inscribed: *do-tārah.*
 6½ by 7¼ ins. *Add. Or. 2618*

iii Lyre-like stringed instrument with peacock feather. Inscribed: *nīgas.*
 Stringed instrument with bow. Inscribed: *kīgrī.*
 7¼ by 7¾ ins. *Add. Or. 2619*

iv Vina. Inscribed: *bīn.*
 5¼ by 7¾ ins. *Add. Or. 2620*

v Two fiddles with bows. Inscribed: *sārindah.*
 4½ by 7¾ ins. *Add. Or. 2621*

vi One-stringed guitar with peacock feather. Inscribed: *yak-tārah.*
 One-stringed guitar with bow. Inscribed: *ornī.*
 7¼ by 7½ ins. *Add. Or. 2622*

vii Jew's harp. Inscribed: *morchang.*
 Tubular one-stringed instrument. Inscribed: *tufang.*
 7 by 4¼ ins. *Add. Or. 2623*

viii *Sitār* with three strings. Inscribed: *sitār.*
 7½ by 3½ ins. *Add. Or. 2624*

ix Small double-ended drum. Inscribed: *dholak.*
 Foot Cymbal. Inscribed: *majīrā.*
 Viol or rebeck. Inscribed: *rabāb.*
 7¼ by 7½ ins. *Add. Or. 2625*

x *Mridangam*; double-ended drum, broader at middle than ends.
 Inscribed: *mridang.*
 Stringed instrument. Inscribed: *namūrah.*
 Cymbals. Inscribed: *jhānjhah.*
 7¾ by 8 ins. *Add. Or. 2626*

xi Pair of fiddles with bows. Inscribed: *juft sārinde.*
 Foot cymbal. Inscribed: *majīrā.*
 Pair of drums. Inscribed: *juft tablā.*
 Entitled: *sāmān i raqṣ* (Musical instruments for dancing).
 5 by 6¾ ins. *Add. Or. 2627*

xii Conch shell. Inscribed: *sankh.*
 Gong for sounding the hours. Inscribed: *pīcheghanṭa.*
 Bell. Inscribed: *ghanṭa.*

Cymbals. Inscribed: *jhānjhah.*
Gong. Inscribed: *ghaṛi.*
5 by 8 ins. *Add. Or. 2628*

xiii Bass tambourine without cymbals. Inscribed: *daf.*
Cymbals. Inscribed: *jhānjhah.*
5 by 5¼ ins. *Add. Or. 2629*

xiv Foot cymbal. Inscribed: *majīrā.*
Anklet of small bells. Inscribed: *painjnī.*
Castanets. Inscribed: *karnāl.*
Cymbals. Inscribed: *jhānjhah.*
4¾ by 3¼ ins. *Add. Or. 2630*

xv Earthen pot with covered mouth. Inscribed: *khada.*
Tambourine without cymbals. Inscribed: *dara.*
Earthen pot with covered mouth. Inscribed: *bhicha.*
4½ by 7½ ins. *Add. Or. 2631*

xvi Rattle. Inscribed: *dogargī.*
Rattle used by public criers and jugglers. Inscribed: *ḍonrū.*
Snake-charmer's pipe. Inscribed: *tūmrī.*
Plate. Inscribed: *thālī.*
6¼ by 8 ins. *Add. Or. 2632*

xvii Two different types of drum. Inscribed: *thorak.*
6¼ by 8 ins. *Add. Or. 2633*

xviii Tambourine. Inscribed: *ḍaflā.*
Two flutes. Inscribed: *bānsrī.*
Tambourine. Inscribed: *ḍaflā.*
· 5¼ by 7¾ ins. *Add. Or. 2634*

xix Cymbals. Inscribed: *jhānjhah.*
Horn. Inscribed: *singhā.*
Kettle-drum. Inscribed: *naqqārah.*
Oboe. Inscribed: *surnāy.*
Two drums. Inscribed: *ḍhol.*
6¾ by 7¾ ins. *Add. Or. 3635*

xx Two cymbals. Inscribed: *jhānjhah.*
Drum beaten with the fingers. Inscribed: *mandal.*
4½ by 7¼ ins. *Add. Or. 3636*

xxi Drum sounded for successful wrestler. Inscribed: *dhaṛ.*
5¼ by 8 ins. *Add. Or. 3637*

xxii 2 oboes. Inscribed: *surnāy.*
Small drum. Inscribed: *khūrūk.*
Two bass drums. Inscribed: *bam.*
Small drum. Inscribed: *khūrūk.*
Cymbals. Inscribed: *jhānjhah.*

Two horns. Inscribed: *qarnāy*.
Pair of large drums. Inscribed: *juft athālah*.
Bugle. Inscribed: *tūrhī*.
Entitled: *sāmān i naubat* (Military musical instruments).
10 by 7¾ ins. *Add. Or. 2638*

xxiii Five rockets. Inscribed: *bān*.
Drum. Inscribed: *marfah*.
Cymbals. Inscribed: *jhānjhah*.
Two flags. Inscribed: *nishān*.
Two hemispherical drums. Inscribed: *tāshah*.
Large drum. Inscribed: *ḍhol*.
Entitled: *lawāzimah i bārāt* (Things needed for a marriage procession).
10 by 8 ins. *Add. Or. 2639*

74 i–vi 6 drawings depicting occupations.
By a Patna artist, *c.* 1820.
1815 watermark on (vi).
Water-colour; various sizes.
Presented 19 October 1914. *Add. Or. 394–399*

NOTE: These drawings are similar in style to the work of Sewak Ram but somewhat cruder.

 i Two silversmiths.
 5 by 5½ ins. *Add. Or. 394*
 ii Silversmith.
 6¾ by 6¾ ins. *Add. Or. 395*
 iii Butter-churner.
 7 by 7 ins. *Add. Or. 396*
 iv Hookah-snake maker (?)
 4¾ by 8 ins. *Add. Or. 397*
 v Seller of hookah-chilams and tobacco.
 7½ by 6¼ ins. *Add. Or. 398*
 vi Cloth merchant measuring cloth, a customer squatting nearby.
 5 by 7½ ins. *Add. Or. 399*

75 Pilgrim carrying Ganges water.
By a Patna artist, *c.* 1820.
Water-colour; 6 by 7 ins.
Presented by Mildred and W. G. Archer, 1 May 1961. *Add. Or. 1836*

NOTE: Obtained by W. G. Archer from Ishwari Prasad at Patna in 1948.

76 i–ix 9 drawings of elephants and their riders in various poses.
By Patna artists, *c.* 1830.
i, iii–ix pencil; ii pencil and water-colour; approx 7 by 9 ins.
Presented by Mildred and W. G. Archer, 4 November 1962.

Add. Or. 2381–2389

NOTE: Obtained by W. G. Archer at Patna in 1948 from Ishwari Prasad who said the sketches had been kept by members of his family as models for drawing elephants. For a later version of iv (*Add. Or. 2385*), see Manuk (1943), plate 13.

i–iii Elephants carrying Indian gentlemen in howdahs.	*Add. Or. 2381–2383*
iv Elephant breaking a branch from a tree.	*Add. Or. 2385*
v Elephant with mahout and two spearmen.	*Add. Or. 2384*
vi Elephant with mahout.	*Add. Or. 2386*
vii Kneeling elephant with mahout.	*Add. Or. 2389*
viii Elephant killing a tiger.	*Add. Or. 2387*
ix Elephant with shooting party.	*Add. Or. 2388*

77 Krishna celebrating the Holi festival with a crowd of milk-maids in a courtyard under a red canopy.
By Hulas Lal (*c.* 1785–1875), a Patna artist, *c.* 1830.
Water-colour; squared for enlargement; 9 by 12 ins.
Presented by Michael Archer, 10 May 1968.

Add. Or. 952

NOTE: Obtained by W. G. Archer in Bihar from Shyam Bihari Lal, grandson of Hulas Lal. The drawing is a sketch for a larger picture by Hulas Lal in the possession of Shyam Bihari Lal, reproduced Archer (1947), plate 8.

78 Woman carrying a water-pot.
By Jairam Das (*fl.* 1810–40), a Patna artist, *c.* 1830.
Pencil; $8\frac{1}{4}$ by $6\frac{1}{2}$ ins.
Presented by Michael Archer, 10 May 1968

Add. Or. 955

NOTE: Obtained by W. G. Archer at Patna in 1948 from Ishwari Prasad who attributed it to Jairam Das.

79 i–ix 9 drawings depicting occupations and methods of transport.
By Fakir Chand Lal (*c.* 1790–*c.* 1865), a Patna artist, *c.* 1840.
Presented by Mildred and W. G. Archer, 1 May 1961. *Add. Or. 1843–1851*

NOTE: Obtained by W. G. Archer at Patna in 1948 from Ishwari Prasad who attributed them to Fakir Chand Lal, see Archer (1947), pp. 20, 22, 45 and Archer (1955), pp. 35, 36, 116.

 i Indian gentleman riding on his elephant accompanied by a retainer on foot.
 Water-colour; $8\frac{1}{4}$ by $6\frac{3}{4}$ ins. *Add. Or. 1851*
 NOTE: Similar to no. 98 iii.

 ii Ploughing with two bullocks.
 Water-colour; 9 by $7\frac{1}{2}$ ins. *Add. Or. 1849*

 iii Churning butter.
 Wash; $7\frac{1}{2}$ by $4\frac{1}{2}$ ins. *Add. Or. 1848*

 iv Man with two puppets (*Plate 39*).
 Wash and water-colour; 6 by $3\frac{3}{4}$ ins. *Add. Or. 1847*
 NOTE: Similar to no. 98 lxxiii.

 v Tumblers.
 Wash and water-colours; $4\frac{3}{4}$ by 8 ins. *Add. Or. 1846*

 vi Two jugglers.
 Wash; 8 by 5 ins. *Add. Or. 1844*

 vii Dancing-girl and drummer.
 Wash and water-colour; $5\frac{3}{4}$ by $7\frac{1}{2}$ ins. *Add. Or. 1843*

 viii Entertainers; musician and a boy disguised as a monkey.
 Wash and water-colour; $8\frac{3}{4}$ by $5\frac{1}{2}$ ins. *Add. Or. 1845*

 ix Woman seated at a table by a window overlooking the Ganges. She is smoking a hookah and writing a letter, a child beside her.
 Gouache; $8\frac{3}{4}$ by $6\frac{3}{4}$ ins. *Add. Or. 1850*

80 Three musicians.
 By a Patna artist, *c.* 1840.
 Brush drawing; $5\frac{3}{4}$ by $3\frac{3}{4}$ ins.
 Presented by Mildred and W. G. Archer, 1 May 1961. *Add. Or. 1837*

 NOTE: Obtained by W. G. Archer from Ishwari Prasad at Patna in 1948.

81 i–iii Three drawings of a dancing-girl and musicians.
 By a Patna artist, *c.* 1840.
 Presented by Mildred and W. G. Archer, 1 May 1961. *Add. Or. 1838–1840*

 NOTE: Obtained by W. G. Archer from Ishwari Prasad at Patna in 1948. Similar to 112 i–iii.

 i *Sitār* player.
 Brush drawing; 5 by 3 ins. *Add. Or. 1838*

 ii Cymbals player.
 Water-colour; 6 by $4\frac{1}{2}$ ins. *Add. Or. 1840*

 iii Dancing-girl.
 Water-colour; 6 by $4\frac{1}{2}$ ins. *Add. Or. 1839*

82 i–iii Three drawings depicting occupations in Bihar.
Probably by Tuni Lal (born *c.* 1800), a Patna artist, *c.* 1840–50.
Presented by Michael Archer, 30 January 1969. *Add. Or. 2547–2549*

NOTE: Obtained in Patna by W. G. Archer in 1948.

i Butcher seated cutting up goat's meat, his wife seated beside him brushing
away flies with a feather.
Water-colour; 9 by 7½ ins. *Add. Or. 2547*

ii Three blacksmiths; one working the bellows and two hammering a piece of
red-hot iron.
Water-colour; 10¾ by 8½ ins. *Add. Or. 2548*

iii Two tailors at work seated on a striped rug.
Water-colour; 10¾ by 8½ ins. *Add. Or. 2549*

83 A pair of Nuktas or Old World Comb-ducks (*Sarkidiornis melanotos*) swimming on
a lake with a group of Pintails (*Anas acuta*) in the background.
By Fakir Chand Lal (*c.* 1790–*c.* 1865), a Patna artist, *c.* 1850.
Water-colour; 7¼ by 9 ins.
Presented by Michael Archer, 30 January 1969. *Add. Or. 2550*

NOTE: Obtained by W. G. Archer at Patna in 1948 from Ishwari Prasad who attributed it to
Fakir Chand Lal.

The picture is a copy of a painting by Christopher Webb Smith which is now in the Newton
Library (Zoology Library), Cambridge. Christopher Webb Smith was a Bengal civilian and an
enthusiastic ornithologist. From his arrival in India in 1811 until his retirement in 1842 he studied
and made drawings of birds. From 1825 until 1827 he was posted in Patna where he cooperated
with Sir Charles D'Oyly in making illustrations for *The Feathered fowl of Hindoostan* (1828) and
Oriental Ornithology (1829), Smith drawing the birds and D'Oyly supplying the landscape back-
grounds. The two were old friends from the days when Smith had been posted to Gaya from 1819
to 1823. Drawings of Smith's house at Gaya occur in D'Oyly's sketchbook (*WD 2060 ff. 73, 74*).
When D'Oyly founded the 'Behar School of Athens' in 1824, Smith was made Vice-President.
Even when Smith was posted to Arrah in 1827, their cooperation continued as the town was only
forty miles distant from Patna. It was during this time that they appear to have embarked on a
more ambitious project of large water-colour drawings in which Smith again painted the birds
and D'Oyly the landscapes. Probably because of D'Oyly's departure on leave to South Africa
in 1832 and Smith's transfer to Calcutta in 1834, the work came to nothing and Smith's magnificent
bird-drawings remain at Cambridge, still unpublished.

It is clear that Patna painters had access to these drawings for a number of copies were con-
stantly made by them over the years. As has already been seen (p. 99), D'Oyly was in close contact
with Patna painters and Jairam Das worked at the lithographic press. Smith's drawings, therefore,
could easily have been seen by Patna painters during the period that the two bird books were being
printed there. As late as 1880, Bahadur Lal II (1850–1910) was still making bird-studies which were
based on drawings by D'Oyly and Smith (see Archer, 1947, pls. 38–40). For further discussions of

Webb Smith's work, see Archer (1963) and A. Gordon-Brown, *Christopher Webb Smith: an artist at the Cape of Good Hope, 1837–1839* (Cape Town, 1965).

84 i–xx 20 drawings depicting various processes in the manufacture of opium at the Gulzarbagh Factory, Patna.
By Shiva Lal (*c.* 1817–*c.* 1887), Patna, 1857.
Inscribed on back by W. G. Archer: *Shiva Lal. Sketch for an opium set, c. 1857.*
Unfinished; ii–xx pencil, i pencil and water-colour; $9\frac{1}{4}$ by $7\frac{1}{4}$ ins.
Presented by Mildred and W. G. Archer, 1 May 1961. *Add. Or. 1816–1835*

NOTE: Obtained at Patna in 1948 by W. G. Archer from Ishwari Prasad, grandson of Shiva Lal. According to him they were first made by Shiva Lal in 1857 as part of a scheme for a series of wall-paintings in the Gulzarbagh Factory at Patna to illustrate the manufacture of opium. They were prepared, he said, at the suggestion of 'Lyell Sahib, a personal assistant in charge of opium', Bihar, who was later killed in the Mutiny riots at Patna. According to Ishwari Prasad, his grandfather, Shiva Lal, went weeping to his house and 'painted his portrait as he lay dead'. When the scheme for the murals did not materialise, Shiva Lal used the designs for stock sets on paper and mica for which these were preliminary drawings. (vii), showing an Englishman testing opium, may well be a portrait of Lyell.

Ishwari Prasad's information based on oral family tradition is remarkably in line with what is known of Dr Robert Lyell (1825–57) as officially recorded. He had come to India as a member of the Bengal Medical service in 1845. After being posted as an Assistant Surgeon in the Punjab and on the North West Frontier, he went in 1854 as opium examiner and first assistant to the Benares Opium Agency, and in February 1856 was transferred to Patna as principal assistant to the Opium Agent, Bihar. He was shot by members of a Muslim mob in Patna on 3 July 1857 when boldly riding towards them in the hope that a resolute act would disperse them. Lyell was the author of 'Notes on the Patna Opium Agency', 1857 (see D. G. Crawford, *Roll of the Indian medical service 1615–1930* (London, 1930), p. 133). Lyell's suggestion for wall-paintings may have been prompted by earlier sets of drawings on paper and mica. When the botanist, Joseph Hooker, visited the Gulzarbagh factory on his way to Sikkim in March 1848 he watched the manufacture of opium there and was given a complete set of specimens, implements and drawings of the process. They were exhibited at Kew in the Museum of Economic Botany (see Mea Allen, *The Hookers of Kew: 1785–1911* (London, 1967), 163).

i–v Receipt of raw opium and weighing.	
	Add. Or. 1830, 1825, 1829, 1831, 1827
vi–ix Testing of purity of opium	*Add. Or. 1820, 1828, 1823, 1821*
x–xiv Mixing.	*Add. Or. 1826, 1824, 1819, 1818, 1817*
xv–xviii Balling.	*Add. Or. 1816, 1822, 1834, 1833*
xix Weighing and drying the balls	*Add. Or. 1832*
xx The opium crated and ready for despatch.	*Add. Or. 1835*

85 i–iv 4 portraits of Indian gentlemen.
By Shiva Lal (*c.* 1817–*c.* 1887), a Patna artist, *c.* 1860.

Presented by Mildred and W. G. Archer, 4 November 1962.

Add. Or. 2390–2393

NOTE: Obtained by W. G. Archer at Patna in 1948 from Ishwari Prasad, grandson of Shiva Lal. For portraits by Shiva Lal, see Archer (1955), 36.

i Portrait of a Hindu gentleman seated cross-legged on a bed on a verandah.
Water-colour; $6\frac{1}{2}$ by $4\frac{3}{4}$ ins. *Add Or. 2390*

ii Portrait of a Muslim gentleman seated on a striped rug on a verandah.
Water-colour; $7\frac{1}{2}$ by $5\frac{1}{2}$ ins. *Add. Or. 2391*

iii Portrait of a Muslim gentleman, half-length, with a red fez, black suit and gold watch-chain.
Oval, water-colour; $5\frac{1}{2}$ by $4\frac{3}{4}$ ins. *Add. Or. 2392*

iv Portrait of an Indian gentleman, half-length, with beard, black suit and gold watch-chain.
Water-colour; $9\frac{3}{4}$ by $7\frac{1}{2}$ ins. *Add. Or. 2393*

86 Bullock-cart loaded with furniture (*Plate 41*).
By Shiva Lal (*c.* 1817–*c.* 1887), a Patna artist, *c.* 1860.
Water-colour; $6\frac{3}{4}$ by $8\frac{1}{2}$ ins.
Presented by Michael Archer, 10 May 1968. *Add. Or. 2545*

NOTE: Obtained by W. G. Archer at Patna in 1948 from Ishwari Prasad who attributed it to Shiva Lal.

87 i, ii 2 drawings of occupations.
By Gur Sahay Lal (*c.* 1835–1915), a Patna artist, *c.* 1860.
Water-colour; $7\frac{1}{2}$ by 6 ins.
Presented by Mildred and W. G. Archer, 1 May 1961. *Add. Or. 1853; 1854*

NOTE: Obtained by W. G. Archer at Patna in 1942 from Ishwari Prasad who attributed them to Gur Sahay Lal.
REPRODUCED: Archer (1947), plates 19 and 18.

i Candle-maker. *Add. Or. 1853*
ii Pilgrim carrying Ganges water. *Add. Or. 1854*

88 i, ii Two drawings of occupations.
By Gopal Lal (1840–1911), a Patna artist, *c.* 1870.
Presented by Mildred and W. G. Archer, 1 May 1961. *Add. Or. 1841; 1842*

NOTE: Obtained by W. G. Archer from Ishwari Prasad at Patna in 1948 who attributed them to Gopal Lal.

 i Ascetic.
 Pencil; 8 by 6¼ ins. *Add. Or. 1841*
 ii Brahmin with folded hands.
 Brush drawing; 5½ by 2 ins. *Add. Or. 1842*

89 Milkman's wife (*gwālīn*) carrying cow-dung cakes.
 By a Patna artist, *c.* 1870.
 Water-colour; 9 by 7 ins.
 Presented by Mildred and W. G. Archer, 1 May 1961. *Add. Or. 1855*

 NOTE: Obtained by W. G. Archer in Patna in 1948 from Ishwari Prasad.

90 i–iii Three drawings depicting costume and customs in Bihar.
 By Bani Lal (*c.* 1850–1901), a Patna artist, *c.* 1880.
 Presented by Michael Archer, 10 May 1968. *Add. Or. 956: 957, 958*

 NOTE: Obtained by W. G. Archer at Patna in 1942 from Ishwari Prasad, who attributed them to Bani Lal.

 i Two women carrying water in pots; the river Ganges and a bungalow in the background.
 Water-colour; 9½ by 8 ins. *Add. Or. 956*
 NOTE: This drawing is clearly based on an earlier model. See no. 78.
 ii Two women grinding.
 Water-colour; 9¼ by 7 ins. *Add. Or. 957*
 NOTE: Reproduced Archer (1947), plate 31.
 iii Cook returning from the bazaar followed by a coolie carrying vegetables and poultry (*Plate 40*).
 Water-colour; 9 by 7½ ins. *Add. Or. 958*
 NOTE: Reproduced Archer (1947), plate 26.

91 Portrait of Ernest Binfield Havell (1861–1934), half-length, seated on an ivory chair, a red, rolled blind above.
 By Ishwari Prasad, a Patna artist working in Calcutta, *c.* 1904.
 Water-colour; 7¾ by 5¼ ins.
 Presented by the subject's daughter, Lady Sonia Wilson, together with Photo 273, 18 October 1968. *Add. Or. 2537*

 NOTE: After studying at the Royal College of Art and in Paris and Italy, Havell went to India in 1884 in the Indian Educational Service. Until 1892 he was Superintendent of the Madras School of Arts. From 1892 until 1896, he acted as Reporter to the Government on Arts and Industries, and conducted an official investigation into indigenous handicrafts. From 1896 until 1906, he was Principal of the Calcutta School of Art and Keeper of the Government Art Gallery, Calcutta. He was a Fellow of Calcutta University and active in University reform. He also drew up the report of

a committee appointed by the Government in 1901 to revise the system of vernacular education. In 1906 he retired to England, but from 1916 until 1923 served in the British Legation, Copenhagen.

While in India Havell played an important part in the nationalist revival. He helped revive hand-loom weaving, reorganised art education on Indian lines and stimulated the development of the Neo-Bengal School of painting. He wrote several books, re-evaluating Indian painting and sculpture.

The present portrait was painted by Ishwari Prasad (1870–1950), grand-son of the Patna painter, Shiva Lal. After working as the retained artist of Raja Lachman Seth of Mathura, Ishwari was appointed by Havell as a teacher at the Calcutta Art School in 1904. The appointment was probably due to Havell's eagerness to revive traditional Indian painting. Ishwari had been trained by his grand-father who was expert in making miniature portraits from photographs. Similar paintings by Ishwari, using idioms of Rajput painting such as the rolled blind, were formerly in the collection of P. C. Manuk of Patna.

For E. B. Havell, see W. G. Archer, *India and modern art* (London, 1959). For Ishwari Prasad, see Archer (1947); Archer (1955), 28, 35, 115, 116.

92 i–iii 3 miscellaneous subjects.
By Ishwari Prasad (1870–1950), a Patna artist, *c*. 1930.
Presented by Mildred and W. G. Archer, 4 November 1962.

Add. Or. 2394; 2395; 2557

NOTE: Obtained by W. G. Archer at Patna in 1942 from Ishwari Prasad himself. His work illustrates the final phase of Patna painting. See Archer (1947), plate 47, and Archer (1955), 116.

 i 'Innocence, Knowledge and Experience'; three Indian women standing under a tree.
Water-colour; $6\frac{1}{4}$ by 4 ins. *Add. Or. 2394*
 ii 'Art, the Lady'; an Indian woman embracing four children – English, Indian, Chinese and South-sea Island.
Water-colour; $8\frac{1}{2}$ by $6\frac{3}{4}$ ins. *Add. Or. 2395*
iii A grasshopper, painted on a letter from Ishwari Prasad to W. G. Archer.
Water-colour; 8 by $5\frac{1}{2}$ ins. *Add. Or. 2557*

(v) CHAPRA

In the late eighteenth century a group of Indian artists were working for the British at Chapra, headquarters of Saran, a district north of the Ganges from

Patna. This district had come under British administration in 1764, but Europeans had been living in the area for many years. Factories had been established by the Dutch in the mid-seventeenth century and by the British in the early eighteenth century. Little is known about Chapra artists' activities, but since their work resembles that of painters in Patna, it is likely that they were either a branch of the Patna families, or were immigrants from Murshidabad.

The first drawings that can be connected with them are pictures of houses. British officers were stationed in Chapra, and planters were scattered throughout the district living in large classical-style bungalows. It seems probable that, like painters in Calcutta (p. 76), the artists called at the houses and made drawings for the occupants. A painting in the Library with a 1794 water-mark (no. 93 i) is inscribed 'East View of Chuprah'.

Between about 1800 and 1804, a group of Chapra artists illustrated two sets of the Hindu epic, the *Ramayana*, for the District Judge and Magistrate, Charles Boddam. Boddam had gone to Chapra in 1793, where he stayed until his death in 1811. He was clearly interested in the Hindu religion and its classical texts. Soon after his arrival he must have visited the neighbouring city of Benares and met a pandit named Anand Gyan. 'In the year 1794', he wrote, 'I became acquainted with Anand G'han, with whom I frequently conversed, and he, perceiving that I wished to obtain an insight into Eastern literature, gave me a copy of his [Persian] translation of the Ramayan, which he had then finished. Being much pleased with this work I attempted to render it in English, during the hours of leisure from my official avocations' (see p. 121). By 1804 this work was finished and Boddam had it fair-copied in a copper-plate hand (no. 94). A second copy was also made (no. 95), probably as a precaution against loss, and both were copiously illustrated by Chapra artists. In the preface to both copies, dated 'Chuprah, 18 December 1804', Boddam notes, 'The pictures annexed to this work were drawn by native artists under the superintendence of some Pandits who explained to them the figures as described in their books'. The style of these paintings is very similar to that of early artists working at Patna.

From time to time paintings have appeared in the London sale-rooms with inscriptions connecting them with Chapra. On 16 December 1957, a group of eight drawings belonging to an army officer, Charles Miles, were sold at Sotheby's sale rooms (Lot 11). These depicted Hindu deities, occupations and customs and were in a style similar to those in the Library. One drawing was inscribed 'Chapra 1808'.

Bibliography

O'Malley, L. S. S. *Bengal District Gazetteers: Saran* (Calcutta, 1908).

93 i, ii 2 drawings of European houses.

By a Chapra artist, *c.* 1796.
Purchased 20 February 1967. *Add. Or. 2660: 2661*

i A single-storeyed European house at Chapra (Bihar) standing in a large grassy compound; a European couple standing at the door.
Inscribed on back: *East View of Chuprah.* *Add. Or. 2600*
Water-mark of 1794.
Pen-and-ink and water-colour; $18\frac{1}{4}$ by 25 ins. Black rule border.
NOTE: The inscription was copied from an original mount by the dealer from whom the picture was purchased. The British residential quarter lay to the east side of Chapra where the civil courts and public offices were situated.

ii A classical European-style house with a garden in the foreground. Two gardeners are at work and a sepoy with a sundial hat is seated by the gate (*Plate 42*).
Pen-and-ink and water-colour; $14\frac{1}{4}$ by $20\frac{1}{2}$ ins. Indian ink and red rule border.
 Add. Or. 2661

94 85 paintings in two volumes illustrating a translation by Charles Boddam into English of a Persian version of the *Adhyātma Rāmāyana.*
By artists at Chapra (Bihar), *c.* 1803–04.
Inscribed on title page: *The Adhy Atma Ramayan, a History of the Seventh Incarnation of Vishnu; Translated from the Sanscrit into Persian by Anand G'han, a member of the College of Brahmins at Benares and again translated from the Persian into English. In two Volumes. Vol. I, Vol. II. MDCCCIV.*
Watermarks of 1802.
Water-colour; size of volumes $10\frac{3}{4}$ by $7\frac{3}{4}$ ins.
Presented by Miss L. M. Boddam, 16 March 1944. *MSS.Eur.C.116,1,2*

NOTE: Charles Boddam went to Bengal in the East India Company's service as a writer in 1780. It is not clear from the Records where he was posted in his early years but in February 1788 he was appointed 'Second Assistant to the Collector and Registrar to the Judge of Bihar'. In May 1793 he went to Saran District as 'Judge of Dewanny Adawlut and Magistrate'. He died at Fort William on 13 August 1811.

 The first two drawings portray Vyasa, traditional author of the *Adhyātma Rāmāyana,* and Anand Gyan, the translator of the work into Persian. It was from Anand Gyan, a Brahmin professor at the Benares Sanskrit College, that Boddam obtained a Persian translation of the Sanskrit *Adhyātma Rāmāyana.* Boddam wrote in the preface to this manuscript dated Chapra 1804, 'In the year 1794 I became acquainted with Anand G'han, with whom I frequently conversed, and he, perceiving that I wished to obtain an insight into Eastern literature, gave me a copy of his translation of the Ramayan which he had lately finished. Being much pleased with this work I attempted to render it in English, during the hours of leisure from my official avocations. . . . The pictures annexed to this work were drawn by native artists under the superintendence of some Pandits, who explained to them the figures as described in their books.'

 For a discussion of Boddam see Mildred Archer, 'Benares and the British', *History Today,* June 1969, 405–410 and for a portrait, see Anne Crookshank and the Knight of Glin, *Irish portraits 1660–1860* (London, 1969), no. 72.

MSS.Eur.C.116.1, 285 ff., 61 drawings inscribed with titles.

f.3v The sage, Vyasa, traditional author of the *Adhyātma Rāmāyana*.
Inscribed: *Vyasa*.

f.6v Anand Gyan, a Benares pandit, author of the Persian version of the *Adhyātma Rāmāyana* translated by Boddam.
Inscribed: *Anand G'han*.

f.8 Fish incarnation, Matsya avatara, first incarnation of Vishnu.
Inscribed: *Incarnation of the Fish*.

f.9v Tortoise incarnation, Kurma avatara, second incarnation of Vishnu.
Inscribed: *Incarnation of the Tortoise*.

f.10v Boar incarnation, Varaha avatara, third incarnation of Vishnu.
Inscribed: *Incarnation of the Boar*.

f.11v Man-lion incarnation of Vishnu, Narasimha avatara, fourth incarnation of Vishnu.
Inscribed: *Narsingha*.

f.12v Jamadagni, father of Parasurama.
Inscribed: *Jamadagna*.

f.13v Rama, seventh incarnation of Vishnu.
Inscribed: *Incarnation of Rama*.

f.14v Krishna, eighth incarnation of Vishnu.
Inscribed: *Crishna*.

f.16 Buddha, ninth incarnation of Vishnu.
Inscribed: *Budd'ha*.

f.17v Kalki, tenth incarnation of Vishnu.
Inscribed: *Incarnation of Calanc'i*.

f.21v Suta relating the *Rāmāyana* to the sages.
Inscribed: *Suta relating the Ramayan to the Saints*.

f.24v Brahma and Saraswati.
Inscribed: *Brahma and Sereswati*.

f.31v Shiva and Parvati.
Inscribed: *Mahadeva and Parvati*.

f.39v Vishnu and Lakshmi.
Inscribed: *Vishnu and Lacshmi*.

f.44v King Dasaratha, king of Ayodhya, and father of Rama.
Inscribed: *Dasarat'ha*.

f.46 The sage, Sringi.
Inscribed: *Sringi*.

f.49v The sage, Bhirgu.
Inscribed: *Bhirgu*.

f.51v Kausalya, mother of Rama.
Inscribed: *Caus'halya.*

f.55 Kagabhusanda, a crow devotee of Rama.
Inscribed: *Bhusanda.*

f.56v The sage, Vrihaspati.
Inscribed: *Vrihaspati.*

f.59 The sage, Viswamitra.
Inscribed: *Viswa Mitra.*

f.63v Tarka, a demoness killed by Rama.
Inscribed: *Tarca.*

f.68 Gautama, sage and husband of Ahalya.
Inscribed: *Gautam.*

f.69v Ahalya, wife of the sage Gautama, who was turned to a stone.
Inscribed: *Ahilyah.*

f.71 Kamadeva, the God of Love.
Inscribed: *Cama-Deva.*

f.75v Sagara, a king of Ayodhya and ancestor of Rama.
Inscribed: Sagara.

f.77 The sage, Kapila.
Inscribed: *Capila.*

f.79v Ganga, the sacred river Ganges.
Inscribed: *Ganga.*

f.81v Bhagiratha, an ancestor of Rama, doing penance.
Inscribed: *Bhagiratha.*

f.84 Rama and the ferryman.
Inscribed: *Rama and the Boatman.*

f.86 Janaka, king of Mithila and father of Sita.
Inscribed: *Janaca.*

f.98v Parasurama, 'Rama with the Axe', sixth incarnation of Vishnu.
Inscribed: *Parasurama.*

f.106v The Sage, Narada.
Inscribed: *Nared.*

f.113 The sage, Vashishtha, teacher of Dasaratha.
Inscribed: *Vashisht'ha.*

f.123v Kaikeyi, wife of King Dasaratha and mother of Bharata and Shatrughana.
Inscribed: *Caiceyi.*

f.142v Arundhati, wife of Vashishtha.
Inscribed: *Arund'hati.*

f.146 The sage, Vamadeva.
Vama-deva.

f.153 Nishada, a tribal chief and devotee of Rama.
Inscribed: *Nik'had.*

f.158v The sage, Bharadwaja.
　　　 Inscribed: *Bharadwaja.*
f.161 The sage, Valmiki, author of the *Rāmāyana.*
　　　 Inscribed: *Valmic.*
f.172 Shravana, carrying his parents on pilgrimage.
　　　 Inscribed: *Serwan.*
f.183v Bharata, half-brother of Rama.
　　　 Inscribed: *Bharat.*
f.188 A peacock boat.
　　　 Inscribed: *Morepankhi.*
f.190v Kamadhenu, the cow of plenty.
　　　 Inscribed: *Cama-d'henu.*
f.193 The foot of Rama.
　　　 Inscribed: *The foot of Rama.*
f.200 Sesha, the serpent on which Vishnu lies.
　　　 Inscribed: *Sesha Naga.*
f.205 The sage, Atri.
　　　 Inscribed: *Atri.*
f.210 Viradha, a man-eating demon, encountered by Rama.
　　　 Inscribed: *Virad'ha.*
f.213v Sarabhanga, a hermit visited in the forest by Rama and Sita.
　　　 Inscribed: *Sara-B'hanga.*
f.216v Sutikshana, a hermit visited by Rama and Sita.
　　　 Inscribed: *Sutechana.*
f.221 Agastya, a sage, adviser of Rama.
　　　 Inscribed: *Agastya.*
f.230v Jatayu, King of the Vultures.
　　　 Inscribed: *Yatava.*
f.237 Surpanakha, sister of Ravana.
　　　 Inscribed: *Supa-Neg'ha.*
f.240v Khara and Dushana, demon brothers who fought Rama and Lakshmana, here linked as one demon.
　　　 Inscribed: *K'herdook'han.*
f.248 Maricha, a demon who assumed the form of a golden deer.
　　　 Inscribed: *Marich.*
f.257v Ravana, demon king of Lanka.
　　　 Inscribed: *Ravan disguised as a Sanyasi visits Seeta.*
f.265v Ganesha, the elephant god, son of Shiva and Parvati.
　　　 Inscribed: *Ganesa.*
f.271v Kabandha, a demon slain by Rama.
　　　 Inscribed: *Caband'ha.*
f.274 King of the Gandharvas, the celestial musicians.

Inscribed: *Gandharba Rajah.*

f.279v Shavari, a tribal woman and devotee of Rama.
Inscribed: *Sibari.*

MSS.EurC.116.2, 413 ff., 24 drawings inscribed with titles.

f.4v Hanuman, a monkey chief, meeting Rama at Rishyamuka.
Inscribed: *Hoonoman meeting Rama at Rishya Muc'ha.*

f.7v Sugriva, the monkey king, ally of Rama.
Inscribed: *Sugriva.*

f.12 Matanga, a sage visited by Rama and Sita.
Inscribed: *Matang.*

f.17v Bali, the monkey king of Kishkindhya, brother of Sugriva, but enemy of Rama.
Inscribed: *Vali.*

f.25v Tara, wife of Bali.
Inscribed: *Tara.*

f.47 Jambavat, king of the Bears.
Inscribed: *Jambuvan.*

f.52 Swayamprabha, daughter of the king of the Gandharvas and devotee of Rama.
Inscribed: *Swayam-prabha.*

f.57 Angada, son of Bali and ally of Rama.
Inscribed: *Angada.*

f.61 Sampati, a mythical bird, son of Garuda and brother of Jatayu.
Inscribed: *Sampati.*

f.65 The sage, Chandraman.
Inscribed: *Chandraman.*

f.74v Hanuman, monkey chief, and ally of Rama.
Inscribed: *Hoonoman.*

f.78 Chhayagriha, a demon.
Inscribed: *Ch'haya-griha.*

f.81 Lankini, a demoness of Lanka.
Inscribed: *Lanc'ini.*

f.128v Vibhishana, demon younger brother of Ravana and devotee of Rama.
Inscribed: *Vib'hishana.*

f.145 The lingam of Shiva.
Inscribed: *The Linga of Mahadeva.*

f.147 Ravana, demon king of Lanka.
Inscribed: *Ravan.*

f.162v Sushena, physician in the army of Rama.
Inscribed: *Sushena.*

f.171 Kalanemi, uncle of Ravana.
Inscribed: *Cala-nemi.*
f.253v Pulastya, a sage and father of Visvavas, the father of Kuvera and Ravana.
Inscribed: *Pulastya.*
f.266 Brahma, first member of the Hindu trinity.
Inscribed: *Brahma.*
f.311v The sage, Chayavan.
Inscribed: *Chaman.*
f.314v Shatrughana, brother of Lakshmana.
Inscribed: *Satrughna.*
f.331v The sage, Durvasa.
Inscribed: *Durvasa.*
f.335v Lakshmana's penance.
Inscribed: *Lacshman's penance.*

95 111 paintings in two volumes illustrating a translation by Charles Boddam of a Persian version of the *Adhyātma Rāmāyana.*
By artists at Chapra (Bihar), *c.* 1803–04.
Inscribed on title page: *The Adhy Atma Ramayan of Vyasa, a History of the Seventh Incarnation of Vishnu; Translated from the Sanscrit into Persian by Anand G'han, Member of the College of Brahmins at Benares and again translated from the Persian into English. In two Volumes. Vol. I, Vol. II. MDCCCIV.*
Inscribed on fly-leaf of Vol. I: *Major Hungerford Boddam – in remembrance of Mrs Lisle Hall. October 1869*; also mourning card of Mrs Lisle Hall.
Water-marks of 1803.
Water-colour; size of volumes 10¾ by 7¾ ins.
Purchased 10 July 1968. *Mss.Eur.C.215.1,2*

NOTE: These two volumes appear to be a fair copy of Boddam's translation (see no. 94). A list of illustrations is included as well as a larger number of paintings (*MSS. Eur. C. 116.1, 2.*).

MSS.Eur.C.215.1, 347 ff., 70 drawings inscribed with titles.

f.1v The sage, Vyasa, traditional author of the *Adhyātma Rāmāyana.*
Inscribed: *Vyasa.*
f.8v Anand Gyan, a Benares pandit, author of the Persian version of the *Adhyātma Rāmāyana*, translated by Boddam.
Inscribed: *Anand G'han.*
f.10 Fish incarnation, Matsya avatara, first incarnation of Vishnu.
Inscribed: *Incarnation of the Fish.*

f.11v Tortoise incarnation, Kurma avatara, second incarnation of Vishnu.
Inscribed: *Incarnation of the Tortoise.*

f.12v Boar incarnation, Varaha avatara, third incarnation of Vishnu.
Inscribed: *Incarnation of the Boar.*

f.13v Incarnation of the dwarf, Vamana avatara, fifth incarnation of Vishnu.
Inscribed: *Incarnation of the Dwarf.*

f.14 Man-lion incarnation of Vishnu, Narasimha avatara, fourth incarnation of Vishnu.
Inscribed: *Narsingha.*

f.16v Jamadagni, father of Parasurama.
Inscribed: *Jamadagna.*

f.17v Rama, seventh incarnation of Vishnu.
Inscribed: *Incarnation of Rama.*

f.18v Krishna eighth incarnation of Vishnu.
Inscribed: *Incarnation of Crishna.*

f.19 Nanda and Yasoda, foster-parents of Krishna.
Inscribed: *Nanda and Yasodha.*

f.21 Buddha, ninth incarnation of Vishnu.
Inscribed: *Budd'ha.*

f.25v Suta relating the *Rāmāyana* to the sages.
Inscribed: *Suta relating the Ramayan to the Saints.*

f.28 Brahma and Saraswati.
Inscribed: *Brahma and Sereswati.*

f.30v Shiva and Parvati.
Inscribed: *Mahadeva and Parvati.*

f.42 Vishnu and Lakshmi.
Inscribed: *Vishnu and Lacshmi.*

f.47v King Dasaratha, king of Ayodhya and father of Rama.
Inscribed: *Dasarat'ha.*

f.49 The sage, Sringi.
Inscribed: *Sringi.*

f.51 Kagabhusanda, a crow devotee of Rama.
Inscribed: *Bhusanda.*

f.53v The sage, Bhirgu.
Inscribed: *Bhirgu.*

f.55v Kausalya, mother of Rama.
Inscribed: *Caus'halya.*

f.59 The sage, Vrihaspati.
Inscribed: *Vrihaspati.*

f.61v The sage, Viswamitra.
Inscribed: *Viswa Mitra.*

f.65v Tarka, a demoness killed by Rama.

Inscribed: *Tarca.*

f.67v Ganesha, the elephant god, son of Shiva and Parvati.
Inscribed: *Ganesa.*

f.72 Ahalya, wife of the sage Gautama, who was turned to a stone.
Inscribed: *Ahilya.*

f.73v Kamadeva, the God of Love.
Inscribed: *Cama-Deva.*

f.78 Sagara, a king of Ayodhya and ancestor of Rama.
Inscribed: *Sagara.*

f.79v The sage, Kapila.
Inscribed *Capila.*

f.82 Ganga, the sacred river Ganges.
Inscribed: *Ganga.*

f.84 Bhagiratha, an ancestor of Rama, doing penance.
Inscribed: *Bhagirat'ha.*

f.86 Rama and the ferryman (*Plate 43*).
Inscribed: *Rama and the Boatman.*

f.88 Janaka, king of Mithila and father of Sita.
Inscribed: *Janaca.*

f.90 Sita, wife of Rama.
Inscribed: *Seeta.*

f.101 Parasurama, 'Rama with the Axe', sixth incarnation of Vishnu.
Inscribed: *Parasurama.*

f.109 The sage Narada.
Inscribed: *Nared.*

f.114v The sage Vashishtha, teacher of Dasaratha.
Inscribed: *Vashisht'ha.*

f.125 Kaikeyi, wife of King Dasaratha and mother of Bharata and Shatrughana.
Inscribed: *Caiceyi.*

f.143v Arundhati, wife of Vashishtha.
Inscribed: *Arund'hati.*

f.146v The sage, Vamadeva.
Inscribed: *Vama-deva.*

f.153 Nishada, a tribal chief and devotee of Rama.
Inscribed: *Nik'had.*

f.159 The sage, Bharadwaja.
Inscribed: *Bharadwaja.*

f.162 The sage, Valmiki, author of the *Rāmāyana.*
Inscribed: *Valmic.*

f.172 Shravana, carrying his parents on pilgrimage.
Inscribed: *Serwan.*

f.189v The foot of Rama.
 Inscribed: *The foot of Rama.*

f.196 Sesha, the serpent on which Vishnu lies.
 Inscribed: *Sesha Naga.*

f.201 The sage, Atri.
 Inscribed: *Atri.*

f.206 Viradha, a man-eating demon, encountered by Rama.
 Inscribed: *Virad'ha.*

f.209v Sarabhanga, a hermit visited in the forest by Rama and Sita.
 Inscribed: *Sara-B'hanga.*

f.212v Sutikshana, a hermit visited by Rama and Sita.
 Inscribed: *Sutecshana.*

f.216v Agastya, a sage, adviser of Rama.
 Inscribed: *Agastya.*

f.225v Jatayu, King of the Vultures.
 Inscribed: *Yatava.*

f.232 Surpanakha, sister of Ravana.
 Inscribed: *Supa-Neg'ha.*

f.235v Dushana, a demon who fought Rama and Lakshmana.
 Inscribed: *Dook'han.*

f.243 Maricha, a demon who assumed the form of a golden deer.
 Inscribed: *Marich.*

f.252v Ravana, demon king of Lanka.
 Inscribed: *Ravan disguised as a Sanyasi visits Seeta.*

f.264 Kabandha, a demon slain by Rama.
 Inscribed: *Caband'ha.*

f.266v King of the Gandharvas, the celestial musicians.
 Inscribed: *Gand'harba Rajah.*

f.268v Ashtavakra, a Brahmin with eight crooked limbs whose story is told in the
 Mahābhārata.
 Inscribed: *Ashta-vactra.*

f.272 Shavari, a tribal woman and devotee of Rama.
 Inscribed: *Sibari.*

f.278 Hanuman, a monkey chief, meeting Rama at Rishyamuka.
 Inscribed: *Hanuman meeting Rama at Rishya Muc'ha.*

f.281v Sugriva, the monkey king, ally of Rama.
 Inscribed: *Sugriva.*

f.286 Matanga, a sage visited by Rama and Sita.
 Inscribed: *Matang.*

f.298 Tara, wife of Bali, monkey king of Kishkindhya.
 Inscribed: *Tara.*

f.319v Jambavat, king of the Bears.

Inscribed: *Jambuvan.*

f.326 Swayamprabha, daughter of the king of the Gandharvas and devotee of Rama.
Inscribed: *Swayam-prabha.*

f.329 Angada, son of Bali and ally of Rama.
Inscribed: *Angada.*

f.333 Sampati, a mythical bird, son of Garuda and brother of Jatayu.
Inscribed: *Sampati.*

f.337 The sage, Chandraman.
Inscribed: *Chandraman.*

f.340 Vayu, god of the Wind.
Inscribed: *Vayu.*

MSS.Eur.C.215.2, 330 ff., 41 drawings inscribed with titles.

f.5 Hanuman, a monkey chief.
Inscribed: *Hanuman.*

f.7 Surasa, a demoness who swallowed Hanuman.
Inscribed: *Sursa.*

f.9v Chhayagriha, a demon.
Inscribed: *Ch'haya-griha.*

f.12v Lankini, a demoness.
Inscribed: *Lancini.*

f.59 Vibhishana, younger brother of Ravana.
Inscribed: *Vib'hishana.*

f.69v Shucha, a spy of Ravana.
Inscribed: *Suca.*

f.75 Nala, a monkey chief who built the bridge from India to Ceylon.
Inscribed: *Nala.*

f.79 The lingam of Shiva.
Inscribed: *The Linga of Mahadeva.*

f.89v Ravana, demon king of Lanka.
Inscribed: *Ravan.*

f.93v Sushena, physician in the army of Rama.
Inscribed: *Sushena.*

f.101v Kalanemi, uncle of Ravana.
Inscribed: *Cal-nemi.*

f.111 Mandhata, a mythical king.
Inscribed: *Mand'hata.*

f.115v Kumbhakarna, brother of Ravana.
Inscribed: *Cumb'ha Carna.*

f.125 Meghanada or Indrajit, son of Ravana.

Inscribed: *Megh'ha-nada.*

f.131 Sukra, guru of Bali and the demons.
Inscribed: *Sucra.*

f.134 Mandodari, wife of Ravana.
Inscribed: *Madoodri.*

f.160 Kuvera, brother of Ravana, son of Visravas.
Inscribed: *Cuvera.*

f.185 Pulastya, a sage and father of Visravas.
Inscribed: *Pulastya.*

f.186v Visravas, father of Ravana.
Inscribed: *Visasrava.*

f.188v Sumali, mother of Kaikasi and Kaiskasi, the mother of Ravana.
Inscribed: *Sumali and Caicaci.*

f.195 Varuna, a Vedic deity and maker of heaven and earth.
Inscribed: *Varuna.*

f.198 Brahma, first member of the Hindu trinity.
Inscribed: *Brahma.*

f.200v Jaya and Vijaya, two brothers whose story occurs in the *Bhāgavata Purāna.*
Inscribed: *Jaya and Vijaya.*

f.204 The sun.
Inscribed: *The Sun.*

f.220v Narga, a prince who was changed to a lizard by a curse.
Inscribed: *Nirga.*

f.236v The sage Chayavan.
Inscribed: *Chaman.*

f.239v Lava, a twin son of Rama and Sita.
Inscribed: *Lava.*

f.240v Kusha, with Lava, a twin son of Rama and Sita.
Inscribed: *Cusa.*

f.247 Bhudevi, the earth goddess, with Sita, the wife of Rama.
Inscribed: *Bhu-devi and Seeta.*

f.254 The sage, Durvasa.
Inscribed: *Durvasa.*

f.263v Garuda, a mythical bird-man, the vehicle of Vishnu.
Inscribed: *Garura.*

f.270 Aswini and Kamaras, twin sons of the sun.
Inscribed: *Aswin and Cumar.*

f.277 Rati, wife of Kamadeva.
Inscribed: *Reti.*

f.281 Priyavrata, son of Swayambhuva, a prince who became a yogi.
Inscribed: *Priya-vrata.*

f.282v Shastika, one of the forms of the great goddess.
Inscribed: *K'hashtica-Devi.*

f.288 Kashya, a devotee of Vishnu, and his wife, Aditi.
Inscribed: *Cush and Aditi.*

f.291 Suruchi, wife of Uttanapada.
Inscribed: *Saruchi.*

f.292 Suniti, also wife of Uttanapada.
Inscribed: *Suniti.*

f.305 Prabha, wife of the sun.
Inscribed: *Prab'ha.*

f.316 Swaha, wife of Agni.
Inscribed: *Swaha.*

f.319 Jalindra, offspring of water and the flame from Mahadeva's eye.
Inscribed: *Jalindra.*

(vi) ARRAH

Besides working at Chapra, certain other members of the Kayasth painter community settled in Arrah, headquarters of Shahabad District which borders Patna District across the River Son. As with Chapra artists, little is known of these painters or of their work, but the descendant of Patna painters, Ishwari Prasad, recalled that Jagrup Lal, a relative of his own Kayasth ancestors, worked there in the mid-nineteenth century. He attributed a number of paintings to him, two of which (nos. 96, 97) are now in the Library. In style, these closely resemble the work of Jagrup Lal's Patna contemporaries.

Bibliography

O'Malley, L. S. S. (*ed.* J. F. W. James) *Bihar and Orissa Gazetteers: Shahabad* (Patna, 1924).

96 An Indian gentleman on horseback with his groom and an armed retainer.
By Jagrup Lal (*c.* 1800–*c.* 1860), an artist of Arrah (Bihar), *c.* 1840.
Wash and water-colour; $6\frac{1}{4}$ by $6\frac{3}{4}$ ins.
Presented by Mildred and W. G. Archer, 1 May 1961. *Add. Or. 1857*

NOTE: Obtained by W. G. Archer at Patna in 1948 from Ishwari Prasad who attributed it to Jagrup Lal. He identified the subject as the Mutiny hero, Kunwar Singh, Zamindar of Jagdishpur, Shahabad district, Bihar (died 1858).

97 A Crimson Horned Pheasant (*Tragopan satyra*).
Inscribed on front in *nāgarī* characters: *bunugmohanas* (?).
By Jagrup Lal (*c.* 1800–*c.* 1860), an Arrah artist, *c.* 1850.
Water-colour; 9 by $7\frac{1}{4}$ ins.
Presented by Michael Archer, 30 January 1969. *Add. Or. 2546*

NOTE: Obtained by W. G. Archer at Patna in 1948 from Ishwari Prasad, who attributed it to Jagrup Lal.

(vii) BENARES

Until 1775, when it was ceded to the East India Company, Benares had formed part of the Mughal province of Oudh. Although provincial Mughal painting had flourished at Faizabad and Lucknow in the mid-eighteenth century, no well-established school of Mughal painting developed at Benares. Nor, in view of the Hindu character of the city, is this surprising. No mention of artists is made by Deane in the 1801 Benares 'census' which listed trades. The painters working there appear to have been *nuqqāsh*, bazaar painters, who made designs for textiles or decorated the walls of houses.

It was not until the growth of a sizeable British community at Benares that Company painting developed. This was in the early years of the nineteenth century when a number of British officers had been posted there, a civil station had grown up at Secrole, and cantonments had been built to the north-west of the city. British rule was being extended northwards, more and more travellers visited Benares as they passed up and down the Ganges and these were to prove the main patrons of Company painting.

According to oral tradition, painting in Benares was an off-shoot from that in Patna. A certain Dallu Lal (*c.* 1790–*c.* 1860), whose parents had migrated from Murshidabad to Patna at about the same time as Sewak Ram, settled in Benares about 1815. He specialised in miniature portraits, some of which are preserved at Bharat Kala Bhawan, Benares. He was followed about three years later by another

Patna casteman, Kamalpati Lal (*c.* 1760–*c.* 1838), who came to teach at the newly founded school of Maharaja Jai Narain Goshal Bahadur. This artist gradually built up a flourishing shop which produced paintings of the Patna type on both paper and mica, depicting occupations, costumes, festivals and transport. Other Patna painters also drifted to Benares. The names of some are remembered; among them Phulchand, a cousin of Kamalpati who arrived about 1830, and another, Mulchand.

Sets by a number of different hands date from the years 1815 to 1830. It is not possible to relate these to specific artists but it seems probable, in view of its early water-mark of 1815, that no. 98 may be the work of Kamalpati, the earliest painter of such sets in Benares. Kamalpati died in 1838, but his business was carried on by sons born to him late in life – Chuni Lal (*c.* 1820–1908), Muni Lal (*c.* 1820–1901) and Bihari Lal (1838–1914). Chuni Lal specialised in painting on paper, Muni ran the shop and made mica paintings, while Bihari marketed the sets, going as far afield as Patna and Calcutta and even despatching some to London. Chuni Lal's son, Ramanand (1860–1905), continued the business and followed his father's trade. The shop was also assisted over the years by two sons of Kamalpati's maternal aunt, Ganesh Prasad (1815–80) and Mahesh Prasad (1825–1900), and by two sons of Phulchand, Misri Lal (1850–1910) and Muni Lal II. As the shop flourished, so the sets became increasingly standardised. Certain subjects proved particularly popular – dancing-girls with their musicians, ascetics for which Benares was famous, and servants. Misri specialised in painting servants, and it is said that he visited one of the Paris exhibitions.

A few of the Benares painters received patronage from some of the local wealthy landlords, especially from Raja Ishwari Narain Singh (1835–89). As a young man the Raja had employed Dallu Lal and, on assuming the title, he engaged him as court artist to train two other painters, Gopal and Lal Chand (no. 101). Another artist, Shiva Ram, joined them later and was followed by his son Suraj. They were employed in making portraits of courtiers and in painting birds, flowers or other subjects that interested the Raja.

In style, Benares paintings on paper are very similar to those from Patna though the figures tend to be stiffer, the colours cruder and the whole effect heavier and rougher. For painting on paper, Benares must be regarded as the poor relation of Patna.

It is in paintings on mica that Benares artists excelled. In 1831 Fanny Parks, after buying some mica paintings there, commented 'the best are executed at Benares.' These too were based on Patna models, but Benares artists appear to have developed the technique on a more prolific and business-like scale. They sold mica paintings in packets of a dozen relating to particular subjects such as dancing girls or servants. A novelty was the production of sets of costume-pictures painted on mica with the face and background left blank. A card was included on which a face and the background of a river or a striped rug was painted and on which the

pieces of mica could be superimposed. The whole was sold in a box decorated with a painting on the lid (no. 109) or covered in kincob. Mica painting in Benares persisted until the end of the century, examples being sent to the Glasgow exhibition of 1888. These paintings varied greatly in quality. At their best they were painted with delicate and meticulous skill; others were crude to a degree. Many showed the figure against a plain background, but some introduced a heavy draped curtain, the branch of a tree, or a shop (no. 114). In style and to some extent in subject matter they differed from those produced in the South. Although Fanny Parks mentions buying a large set of Hindu deities at Benares, this subject was not so popular as in Trichinopoly; nor do views of temples appear. Greater prominence is given to pictures of ascetics, dancing girls and servants, and to the Muharram festival, with separate studies of all the different characters taking part in the ceremony. The colour scheme also differs. South Indian mica pictures are characterised by a palette of yellow ochre, acidic green and reddish brown often applied with thick juicy strokes. At Patna and Benares, pink, blue and red were the favourite colours and were applied with enamelled care. For the purposes of this catalogue, all mica paintings from both centres have been grouped together, it being virtually impossible to distinguish between them.

Throughout the first half of the nineteenth century, contacts with the British steadily increased. Benares frequently attracted the more scholarly type of British administrator and a number of those posted to Benares were themselves competent artists. The scholar, James Prinsep, was Assay Master at the Benares Mint from 1820 to 1830, and between 1831 and 1834 he published a series of lithographs from his own drawings of the city. With his artistic interests so keenly developed, it is likely that he met Benares artists. But perhaps the closest contacts on the technical side came through Markham Kittoe, who from 1848 to 1853 was Archaeological Enquirer to the Government in the Northwest Provinces. He excavated the Buddhist stupa at Sarnath and unearthed many pieces of sculpture in and around Benares. He also designed and built the Gothic Queen's College. In the course of this work he trained a number of Benares artists – Pyari Lal, Mahesh and Ganesh Lal, Mahesh and Ganesh Prasad, and Girdhari Lal. Some of these painters helped with the drawings for the College, others assisted him in recording the sculpture that was excavated. So expert did these artists become that in his collection of drawings (WD 2876–2879) it is almost impossible to tell which drawings are by Kittoe and which by his assistants.

Bibliography

Anon. 'Benares painting on ivory and talc', *The Journal of Indian Art*, i, no. 7, supplement, July 1885, 1–2.

Archer, Mildred. 'Indian mica paintings', *Country Life*, 16 February 1956, 298–299.

Archer, Mildred. 'Benares and the British', *History Today*, June 1969, 405–410.

Archer, Mildred and W. G. *Indian painting for the British, 1770–1880* (Oxford, 1955), 41–50.

Havell, E. B. *Benares* (Calcutta, London, 1905).

Mehta, N. C. *Studies in Indian painting* (Bombay, 1926), 83–84.

Murdoch, J. *Kasi or Benares, compiled from Sherring, Buyers, Kennedy, Caine and other authors* (Madras, 1894).

Nicholls, G. *Sketch of the rise and progress of the Benares Patshalla or Sanscrit College, now forming the Sanscrit Department of the Benares College* (Allahabad, 1907).

Parker, A. *A Handbook of Benares* (Benares, 1895).

Prinsep, J. *Benares illustrated in a series of views*, 3 parts (London, 1831–34).

Sherring, M. A. *The Sacred city of the Hindus* (London, 1868).

(*a*) *Paintings on paper.*

98 i–c 100 drawings, bound into two volumes, depicting methods of transport (*sawārī*), occupations, costumes, and ascetics.

By a Benares artist, *c.* 1815–20.

Inscribed in ink by an Indian with vernacular and English titles; also in certain cases in pencil with titles in *nāgarī* characters.

Water-marks of 1814 and 1815.

Water-colour; size of volumes 9¾ by 7½ ins.

Purchased 3 October 1950. *Add. Or. 71–170*

NOTE: These volumes consist of a number of standard sets bound together. They strongly resemble Patna paintings and are often based on Patna models. Compare (xxiv) with a Patna painting reproduced in Archer (1955), fig. 15, and (i) with Archer (*Patna painting*, 1947), plate 4. There are also resemblances between this set and pictures of Murshidabad origin in the Wellesley collection: compare (xviii) and 50 vii; (xxxii) and 47 xiv; (lxxix) and 49 viii. These similarities would tend to confirm the oral tradition that the ancestors of Patna and Benares painters came from Murshidabad. In view of the reputation of Benares for its great variety of ascetics, the emphasis on this subject in the present set reinforces its Benares attribution.

 i Indian gentleman being carried in a tonjon accompanied by a sword bearer and parasol bearer.
 Inscribed: *1. Soaurey Tonjhom . . . Tonjhom.* *Add. Or. 121*

 ii Indian gentleman being carried in a palanquin.
 Inscribed: *2. Soaurey Paulkey . . . Hindustanney Palankeen.* *Add. Or. 122*

 iii Indian gentleman riding on an elephant, accompanied by a sword bearer.
 Inscribed: *3. Soaurey . . . Eliphant.* *Add. Or. 123*

 iv Indian gentleman, with a hawk on his wrist, on horseback.
 Inscribed: *4. Ghorah . . . Horse.* *Add. Or. 124*

 v Closed carriage drawn by two bullocks.
 Inscribed: *5. Karauchey Gaurey. Hindustanney Bullock Chariot.*
 Add. Or. 125

 vi Purdah bullock cart.
 Inscribed: *6. Gaurey. Hindustanney Chariot.* *Add. Or. 126*

 vii Pony carriage (*ekkā*).
 Inscribed: *7. Ekkah . . . Hindustanney Buggy.* Add. Or. 127
 viii Bullock carriage (*rath*).
 Inscribed: *8. Soaurey Ruth. Hindustanney Post Chaise.* Add. Or. 128
 ix Woman's litter.
 Inscribed: *9. Soaurey Doolley. Hindustanney Chair Palankeen.*
 1815 watermark. Add. Or. 129
 x Man knitting blue and white stockings.
 Inscribed: *10. Mojah Bonnaunawallah. (Stocking Maker.)* Add. Or. 130
 xi Gardener with a basket of fruit and vegetables.
 Inscribed: *11. Maulley . . . Gardiner.* Add. Or. 131
 xii Sepoy, front and back view.
 Inscribed: *12. Sepoy . . . Centinal.* Add. Or. 132
 xiii Muhammadan woman cleaning cotton.
 Inscribed: *13. Mussulmauney. (a woman spining Cotton).* Add. Or. 133
 xiv Persian teacher accompanied by his servant.
 Inscribed: *14. Moonshee . . . (Persian Reader).* Add. Or. 134
 xv Muhammadan man and woman of high rank.
 Inscribed: *15. Sauzaudah & Sauzaudey. Sullateen. (Prince & Princess.)*
 Add. Or. 135
 xvi Messenger with letter and staff.
 Inscribed: *16. Hircarrah Hindustanney. Peon.* Add. Or. 136
 xvii Dog-boy with four dogs.
 Inscribed: *17. Dooriah. . . . Dog Matore.* Add. Or. 137
 xviii Matchlock man.
 Inscribed: *18. Bunduckchey. (a man Hindustanney Sepoy).* Add. Or. 138
 xix Woman bangle-seller with customer.
 Inscribed: *19. Chooreywalley. (a Woman Selling Glass Jewells.)*
 Add. Or. 139
 xx Glass-makers and their kiln.
 Inscribed: *20. Seeseegur's Bhaultey . . . (Oven for making Lanthorn etc.)*
 Add. Or. 140
 xxi Bangle-makers and their kiln.
 Inscribed: *21. Choorey wallah's Bhaultey. (Oven for making Glass Jewells.)*
 Add. Or. 141
 xxii Maker of hookah-bases and his kiln.
 Inscribed: *22. Bhauties Goor Goories. (Oven for Goor Goories.)*
 Add. Or. 142
 xxiii Firework-maker carrying lanterns.
 Inscribed: *23. Autusbauz. (a Man Making and Selling Cracker etc.)*
 Add. Or. 143
 xxiv Pedlar with customer.

Inscribed: *24. Bausauttey. (a Man Selling Knives and Seizers etc.)*
Add. Or. 144

xxv Woman sweetmeat-seller and her customer.
Inscribed: *25. Haulwauiun. (A Woman Sweet Meat Seller).* *Add. Or. 145*

xxvi Grain-seller with assistant and customer.
Inscribed: *26. Goledar . . . (Selling Rice).* *Add. Or. 146*

xxvii Spice-seller and customer.
Inscribed: *27. Pussaurey. (Spice Seller).* *Add. Or. 147*

xxviii Hindu schoolmaster with four pupils
Inscribed: *28. Gooroo. (Teacher Boys).* *Add. Or. 148*

xxix Muhammadan schoolmaster with two pupils.
Inscribed: *29. Meeauzie. (Parzee Reader) or Teacher.* *Add. Or. 149*

xxx Garland and flower seller.
Inscribed: *30. Mauley. (Flowerman).* *Add. Or. 150*

xxxi Woman grinding.
Inscribed: *31. Jantah Pesnawalley. (a Woman Mill Grinder).* *Add. Or. 151*

xxxii Seamstress seated with a child beside her.
Inscribed: *32. Sheenahaurey. (a Woman work with Needle).* *Add. Or. 152*

xxxiii Woman spinning cotton.
Inscribed: *33. Churkah (Spinning Wheels.)* *Add. Or. 153*

xxxiv Man selling hookah-bases to a customer.
Inscribed: *34. Goor Goorey Batchanawallah. (a Man Selling Goor Goorey).*
Add. Or. 154

xxxv Butcher and his wife selling goat's flesh.
Inscribed: *35. Buckreeka Shaub. (a Man Selling Kid).* *Add. Or. 155*

xxxvi Seller of myrobalan water.
Inscribed: *36. Hurrauka Pauney Batchnawallah. (A man Selling Gall nuts water).* *Add. Or. 156*
NOTE: *Harrā* is an astringent fruit (myrobalan) used as a dye and a digestive.

xxxvii Potter at his wheel.
Inscribed: *37. Koomaur. (Earthen Pott Maker).* *Add. Or. 157*

xxxviii Money-lender's wife.
Inscribed: *38. Mauhauzoney. Hindooney. (a Richmans Woman).* *Add. Or. 158*

xxxix Cloth-seller with bundle and measuring stick.
Inscribed: *39. Kauprah Batchanawallah. (Cloth Seller).* *Add. Or. 159*

xl Jewelry-seller.
Inscribed: *40. Johurrey. (Selling Emerald Pearls etc.)* *Add. Or. 160*

xli Sweetmeat-seller.
Inscribed: *41. Haulwoye. (Grain Seller).* *Add. Or. 161*

xlii Gold-thread maker.
Inscribed: *42. Baudlah Pitnawallah (a Man Beating Gold and Silver String).*
Add. Or. 162

xliii Gold and silver-leaf beater.
Inscribed: *43. Tubbuck. (a Man leaving Gold & Silver).* *Add. Or. 163*

xliv Man carrying water on a yoke.
Inscribed: *44. Bongeewallah. (Water Carrier).* *Add. Or. 164*

xlv Water-carrier filling a goat skin with water from a skin carried by a bullock.
Inscribed: *45. Bheestey-Paukulka.* *Add. Or. 165*

xlvi Water-carrier with a skin on his back.
Inscribed: *46. Bheestee Mussuckwallah.* *Add. Or. 166*

xlvii Betel-nut vendor with woman customer.
Inscribed: *47. Tommoley. (a Man Selling Beettlenuts).* *Add. Or. 167*

xlviii Perfume-seller.
Inscribed: *48. Ghunddey. (a Man Selling Autor).* *Add. Or. 168*

xlix Seal-engraver and jewel-cutter.
Inscribed: *49. Hauck Cock. (a Man Engraver on the Rings).* *Add. Or. 169*

l Two men dyeing cloth.
Inscribed: *50. Rungraze. (Dyer).* *Add. Or. 170*

li Bricklayers building a compound wall.
Inscribed: *51 Rauz. Bricklayer.* *Add. Or. 171*

lii Woodcutters splitting a log.
Inscribed: *52 Lackery-Faurnawallah (a Man Cutting Wood).* *Add. Or. 72*

liii Sepoy, in undress, squatting by a fire making *chapātīs*; his uniform and matchlock beside him.
Inscribed: *53 Seapoy Roottey Pauchawahay - Making and boiling Bread.*
Add. Or. 73

liv Craftsman painting a stool (*morhā*); an assistant working beside him.
Inscribed: *54. Morah Bonnaunawallah. Morah Maker.* *Add. Or. 74*

lv Bird-catcher carrying a leaf screen on his head, and long sticks and birds in his hand.
Inscribed: *55. Meerseeker. (Fouler).* *Add. Or. 75*

lvi Trader with pack-bullock.
Inscribed: *56. Bapaurey. Sundries Seller.* *Add. Or. 76*

lvii Two women of the Kurmi caste carrying paddy on their heads in baskets.
Inscribed: *57. Koormey Dhaunnawannawally. Bringing Paddy from several places for Rice.* *Add. Or. 77*

lviii Man and woman pounding grain.
Inscribed: *58. Dhakey - a Wooden Instrument to Beat Soorthy or Grains.*
Add. Or. 78

lix Shop-keeper (*baniā*) selling grain to a customer.
Inscribed: *59. Benneah - a man Sundries Selling.* *Add. Or. 79*

lx Man selling hookah 'snakes' to a silver-stick bearer.
Inscribed: *60. Noychawbund. (a Man Selling Snakes).* *Add. Or. 80*

lxi Muslim pilgrim on his way to Mecca.
Inscribed: *61. Hauzeen Mocka Jonnawallah – a Beggar going to Mocka a place of Pilgrimage.* *Add. Or. 81*

lxii Woman husking paddy in a mortar.
Inscribed: *62. Oakley. Wooden Mortar & Pestle.* *Add. Or. 82*

lxiii Muslim woman displaying religious books (*Hājī-kitāb*).
Inscribed: *63. Hauzur Kataub Dakhauna-Muckalla. (a Woman Shewing Books).* *Add. Or. 83*

lxiv Woman ginning cotton.
Inscribed: *64. Churkey. (a Woman Spinng Seed Cotton with Wheels).* *Add. Or. 84*

lxv Tailors.
Inscribed: *65. Durzey. (Taylor).* *Add. Or. 85*

lxvi Knife-grinder with assistant.
Inscribed: *66. Shaun. (a Stone for Edging Knives etc.).* *Add. Or. 86*

lxvii Woman grinding lentils on a stone.
Inscribed: *67. Doll Pessanawalley. (a Woman Grind Doll with Stone).* *Add. Or. 87*

lxviii Goldsmith and assistant at work.
Inscribed: *68. Sonaur. Goldsmith.* *Add. Or. 88*

lxix Sugar press.
Inscribed: *69. Kulloo. Pressing the Sugar Cane by an Instrument.* *Add. Or. 89*

lxx Irrigating fields from a well.
Inscribed: *70. Dhakool. Instrument taken water from Well.* *Add. Or. 90*

lxxi Cultivator ploughing with two bullocks.
Inscribed: *71. Haulzullanawullah. (a Man Fast Plough with Bullocks).* *Add. Or. 91*

lxxii Bird-catcher selling a parrakeet to a customer.
Inscribed: *72. Cheereemaur. Fowler.* *Add. Or. 92*

lxxiii Puppet showman with two puppets.
Inscribed: *73. Pootley Nauchaunawallah. (a Man Dancing Pupet Sho).* *Add. Or. 93*

lxxiv Male dancer with singer and drummer.
Inscribed: *74. Paworeah. (Man Dancing & Singing).* *Add. Or. 94*

lxxv Muslim ascetic carrying a lamp and stick (*naqshbandī*).
Inscribed: *75. Nuckusbund. (a Beggar).* *Add. Or. 95*

lxxvi Ascetic holding a rosary and forked stick.
Inscribed: *76. Sauddoo Bautchaw. (a man Good Piety).* *Add. Or. 96*

lxxvii Muslim ascetic holding a bag and forked stick.
Inscribed: *77. Bennoah. (Beggar).* *Add. Or. 97*

lxxviii *Jangam* (Shaiva) ascetic dressed in saffron robes with a green feathered

headdress and carrying a bell. A bullock stands beside him.
Inscribed: *78. Jungum. (Beggar).* *Add. Or. 98*

lxxix Woman fish-seller cutting up fish.
Inscribed: *79. Mutchwin. Selling Fish.* *Add. Or. 99*

lxxx Engraver decorating a brass hookah-base; a customer beside him.
Inscribed: *80. Goor Gorrey Khodenawallah – a Man Engraver.*
Add. Or. 100

lxxxi Woman sweeper with basket and broom.
Inscribed: *81. Matranney. (a Paria Woman).* *Add. Or. 101*

lxxxii Washerman with his donkey carrying washing.
Inscribed: *82. Dhobey. Washerman* *Add. Or. 102*

lxxxiii Faludah-seller seated under an awning.
Inscribed: *83. Fulloodah. (Juice Seller).* *Add. Or. 103*

lxxxiv Three men embroidering scabbard-cases for daggers (*kata*).
Inscribed: *84. Jurthore. Man Making Gold Embroider* *Add. Or. 104*

lxxxv Man selling necklaces.
Inscribed: *85. Maul Batchnawallah – Selling Wooden Jewells. Add. Or. 105*

lxxxvi Naked ascetic (*tapasvi*, one who performs penances), seated by a fire with
a crooked stick under his armpit.
Inscribed: *86. Tuppersu. (a Priest Man).* *Add. Or. 106*

lxxxvii *Rāmanandī* (Vaishnava) devotee wearing a patchwork coat (*gudrī*) and
holding a rosary.
Inscribed: *87. Raumaunundey. (Hermit man).* *Add. Or. 107*

lxxxviii Ascetic wearing a saffron *dhotī* leaning on a swing; a rosary in his left hand.
Inscribed: *88. Tharra Shree. Hermitman.* *Add. Or. 108*

lxxxix Two *Dhvajādhāri* (Vaishnava) ascetics dressed in red clothes; one holding
a red flag on a pole.
Inscribed: *89. Dhuzzau Dhaurey. Hermitman.* *Add. Or. 109*

xc *Nānakshāhi* ascetic dressed in a white shirt and shawl, a blue punkah in
his hand.
Inscribed: *90. Naunucksoy. Hermitman.* *Add. Or. 110*

xci *Dandi* (Shaiva) ascetic, a follower of Shankaracharya, dressed in saffron
carrying a stick and a calabash.
Inscribed: *91. Dundey. Hermitman.* *Add. Or. 111*

xcii Hindu ascetic dressed in white carrying a rosary in his right hand.
Inscribed: *92. Thoarah. Hermitman.* *Add. Or. 112*

xciii Hindu ascetic carrying a black staff and a white fly whisk.
Inscribed: *93. Zuttee. Hermitman.* *Add. Or. 113*

xciv *Kanphatā* (split-eared) Shaiva ascetic wearing a saffron dress and carrying
a red bag on his left shoulder and a trident in his right hand. He has the
distinctive black earring of his sect.
Inscribed: *94. Kaun Fauttah. (Beggar).* *Add. Or. 114*

xcv Bard or reciter of poetry, dressed in white, wearing black beads and carrying a lance.

Inscribed: *95. Bhaut Kubbit purnawallah. (a Man Verse Reader).*

1814 water-mark. *Add. Or. 115*

xcvi *Bairāgī* (Vaishnava devotee) wearing a loin cloth and carrying a one-stringed instrument (*ektārā*) and clappers (*khartāla*).

Inscribed: *96. Byragey. (Beggar).* *Add. Or. 116*

xcvii *Bairāgī* (Vaishnava devotee) wearing a loin cloth and carrying a bowl of fire and tongs (*chimta*).

Inscribed: *97. Byragey. (a Kind of Beggar Keep a pan on his head for fire flame).* *Add. Or. 117*

xcviii *Kabīrpanthī*, or follower of Kabir, carrying an arm-rest and wearing a white shirt, saffron *dhotī* rosary and red cap; a red bag on his left shoulder.

Inscribed: *98. Kubbeer Puntee. Beggar.* *Add. Or. 118*

xcix Brass-smiths.

Inscribed: *99. Tautara. (Brass Smith).* *Add. Or. 119*

c Seated musician playing on a drum (*dholak*) with cymbals lying beside him.

Inscribed: *100. Hauhaur Koorook – a Kind of Music.* *Add. Or. 120*

99 i, ii 2 drawings depicting occupations.

By a Benares artist, *c.* 1820.

Wash and Water-colour; 6 by 7½ ins.

Presented by Mildred and W. G. Archer 6 November 1962.

Add. Or. 2373; 2374

NOTE: Obtained by W. G. Archer at Benares in 1948 from a Benares dealer who attributed them to Benares artists. The drawings are similar in style to Patna work but somewhat cruder.

i Potter firing his pots in a kiln.

Add. Or. 2373

ii Two men embroidering scabbard-cases for daggers. *Add. Or. 2374*

100
i–xlviii 48 drawings bound into a volume consisting of 4 groups; 11 drawings (i–xi) depicting occupations and Indian scenes; 23 drawings (xii–xxxiv) of household servants; 2 drawings (xxxv, xxxvi) of flowers; 12 drawings (xxxvii–xlviii) of birds.

By a Benares artist, *c.* 1830–32.

Most of these drawings are inscribed with name of subject.

1827, 1828 and 1831 water-marks.

Water-colour; size of volume 11 by 8½ ins; i–xi, xxxv–xlviii 8 by 7 ins. approx.; xii–xxxiv 7 by 4½ ins. approx.

Presented by W. R. Gourlay 4 December 1937. *Add. Or. 765–812*

NOTE: These drawings show the close links between painting in Patna and Benares, the cruder style and brighter colouring suggesting a Benares provenance.

i Indian gentleman being carried by four bearers in a red and gilt palanquin and accompanied by two retainers.
 Inscribed: *A Palkee or litter used at Hindoo Marriages.* *Add. Or. 765*

ii Palanquin with four bearers and a parasol carrier.
 Inscribed: *A Palanqueen or travelling conveyance.* *Add. Or. 766*

iii Two *Jangam* (Shaiva) ascetics in saffron robes with green-feather hats and long braided hair.
 Inscribed: *2 Priests.* *Add. Or. 767*

iv *Munshī* with hookah-bearer.
 Inscribed: *A Moonshee or superior native public officer.* *Add. Or. 768*

v Clerk with parasol-carrier.
 Inscribed: *A Cranee or native English Writer.* *Add. Or. 769*

vi Revenue Survey orderly with survey pole.
 Inscribed: *Revenue Survey Lascar.* *Add. Or. 770*

vii Pilgrim carrying baskets of Ganges water on a shoulder yoke.
 Inscribed: *A Pilgrim.* *Add. Or. 771*

viii Water-carrier with shoulder-yoke and brass pots.
 Inscribed: *A Bearer carrying water.* *Add. Or. 772*

ix Water-carrier with bullock and water-skins.
 Inscribed: *A Bhistee or Watercarrier.* *Add. Or. 773*

x Two dyers at work.
 Inscribed: *A Rungsuz or Dyer.* *Add. Or. 774*

xi The lighting of a funeral pyre.
 Inscribed: *The burning of a dead body.* *Add. Or. 775*

xii Language teacher (*munshī*).
 Inscribed: *Moonshee or reader of letters.* *Add. Or. 776*

xiii Mace-bearer.
 Inscribed: *Chobdār or Mace Bearer.* *Add. Or. 777*

xiv Silver-stick bearer (*suntā-bardār*).
 Inscribed: *Another Chobdar.* *Add. Or. 778*

xv Fly-whisk bearer. (*Chaurī-bardār*).
 Inscribed: *Chowreeburdar.* *Add. Or. 779*

xvi Hookah-bearer (*Plate 45*).
 Inscribed: *Hooqqerburdar or Hooqqer bearer.* *Add. Or. 780*

xvii Chief table-servant (*khānsāmā*) carrying a covered dish.
 Inscribed: *Khansamur or Steward.* *Add. Or. 781*

xviii Head footman (*jamadār*) with letter
Inscribed: *Jemadar or Head Footman.* Add. Or. *782*

xix Footman (*chaprāsī*) with spear.
Inscribed: *Chupprassee or Footman.* Add. Or. *783*

xx Table-servant (*khidmatgār*) with decanter and glass.
Inscribed: *Khitmutgar or Table servant.* Add. Or. *784*

xxi Nurse (*ayah*) with European child.
Inscribed: *Ayah or Female Attendant with a goodlooking baby.* Add. Or. *785*

xxii Valet with keys.
Inscribed: *Sirdar or Head bearer.* Add. Or. *786*

xxiii Cook squatting amongst his utensils.
Inscribed: *Cook.* Add. Or. *787*

xxiv Cook's mate seated by stove.
Inscribed: *Deputy cook.* Add. Or. *788*

xxv Groom (*sāīs*) with horse and fly-whisk.
Inscribed: *Saess or Groom.* Add. Or. *789*

xxvi Tailor (*darzī*) twisting a thread.
Inscribed: *Durzee or Tailor.* Add. Or. *790*

xxvii Gardener (*malī*) with a basket of fruit and vegetables.
Inscribed: *Molee or Gardener.* Add. Or. *791*

xxviii Dog-boy (*doriyā*) with two dogs and a whip.
Inscribed: *Dooreah or dog keeper.* Add. Or. *792*

xxix Water-carrier (*bihi<u>sh</u>tī*) filling earthen pots from a skin.
Inscribed: *Bhistee or Watercarrier.* Add. Or. *793*

xxx Water-cooler.
Inscribed: *Abdar or watercooler.* Add. Or. *794*

xxxi Porter carrying boxes on a shoulder-yoke (*bahangī*).
Inscribed: *Banghy burdar or Porter.* Add. Or. *795*

xxxii Bearer's mate cleaning boots.
Inscribed: *Mate Bearer.* Add. Or. *796*

xxxiii Sweeper (*mehtar*) with broom and basket.
Inscribed: *Meghtur or Sweeper.* Add. Or. *797*

xxxiv Washerman (*dhobī*) ironing clothes.
Inscribed: *Dhobee or Washerman.* Add. Or. *798*

xxxv A bunch of morning glory, roses and solanum. Add. Or. *799*

xxxvi A bunch of morning glory, pansies and a rose. Add. Or. *800*

xxxvii Female Scarlet Minivet (*Pericrocotus flammeus*).
Inscribed: *Peelukh.* Add. Or. *801*

xxxviii Unidentified bird. The colour-pattern and the prominent rectal bristles suggest a Paradise Flycatcher (*Terpsiphone paradisi*) but the brown of the upper parts is too dull and the tail too short even for a female.
Inscribed: *Leelum.* Add. Or. *802*

xxxix Unidentified bird. The pink bill and greenish-yellow tips to the wing and tail feathers suggest a female Oriole (*Oriolus* sp.) but the shape and proportions are inconsistent.
Inscribed: *Chachoee.* *Add. Or. 803*

xl Male Avadavat (*Amandava amandava*) in breeding plumage.
Inscribed: *Lall or Avadavat.* *Add. Or. 804*

xli White-throated Fantail-flycatcher (*Rhipidura albicollis*).
Inscribed: *Dyal.* *Add. Or. 805*

xlii Unidentified bird. The colour-pattern, especially of the face and the red under-tail coverts, suggests the Red-eared Bulbul (*Pycnonotus jocosus*), but the Bulbul is darker above and when adult has a red tuft behind the eye and a crested head.
Inscribed: *Lall Gindee.* *Add. Or. 806*

xliii Spotted Munia or Spicebird (*Lonchura punctulata*).
Inscribed: *Seemabauz.* *Add. Or. 807*

xliv Male Purple-rumped Sunbird (*Cinnyris zeylonicus*).
Inscribed: *Lukno Khora.* *Add. Or. 808*

xlv Baya or Baya Weaver (*Ploceus phillippinus*).
Inscribed: *Byuh.* *Add. Or. 809*

xlvi Unidentified bird, similar in many respects to xxxviii. *Add. Or. 810*

xlvii Green Bee-eater (*Merops orientalis*).
Inscribed: *Hurena.* *Add. Or. 811*

xlviii Unidentified bird, possibly a White-browed Bulbul (*Criniger flaveolus*).
Inscribed: *Khirnich.* *Add. Or. 812*

101 i, ii 2 portraits of Benares gentlemen.
By Lal Chand or Gopal Chand, Benares artists, *c.* 1840.
Faintly inscribed at top in *nāgarī* characters.
Unfinished; faces only completed; pencil and water-colour; 9 by $7\frac{1}{4}$ ins.
Presented by Mildred and W. G. Archer, 6 November 1962.
Add. Or. 2376; 2377

NOTE: Obtained by W. G. Archer at Benares in 1948 and attributed to Lal Chand or Gopal Chand by Babu Sarada Prasad, son of the Benares artist, Ram Prasad.

i Portrait of an unidentified Benares gentleman, three-quarter length.
Add. Or. 2376

ii Portrait of an unidentified Benares gentleman, seated against cushions and holding a hookah-mouthpiece (*Plate 44*). *Add. Or. 2377*

102 Vaishnava ascetic seated cross-legged on a mat holding a rosary in his right hand.
By Shiva Ram, a Benares artist, *c.* 1840.

Water-colour; 8¼ by 6¼ ins.
Presented by Mildred and W. G. Archer, 6 November 1962. *Add. Or. 2375*

NOTE: Obtained by W. G. Archer at Benares in 1948 from a Benares dealer who attributed it to Shiva Ram. For Shiva Ram, see Archer (1955), 46, 48.

103 Portrait of a small Indian boy seated on the ground.
By a Benares artist, *c.* 1860.
Wash; 4¾ by 3¾ ins.
Presented by Mildred and W. G. Archer, 6 November 1962. *Add. Or. 2380*

NOTE: Obtained by W. G. Archer at Benares in 1948 from a Benares dealer, who attributed it to a Benares artist.

104 Portrait of the Raja of Tamughui, a Benares landlord, seated and holding a hookah mouth-piece.
By a Benares artist, 1866.
Inscribed in Persian characters: *Rāja Rājah Tamūghūī*; in *nāgarī* characters: *Raje Tamughuī, samvat 1924* (Raja of Tamughui, A.D. 1866).
Pencil and water-colour; 5 by 3¾ ins.
Presented by Mildred and W. G. Archer, 6 November 1962. *Add. Or 2378*

NOTE: Obtained by W. G. Archer at Benares in 1948 from a Benares dealer who attributed it to a Benares artist.

105 Portrait of a nobleman seated in durbar, perhaps Raja Ram Singh II of Jaipur (ruled 1835–80).
By a Benares artist, *c.* 1870.
Inscribed on back in *nāgarī* characters: *darbār mahārājā man singha jī jaipur ke* (durbar of Maharaja Man Singh of Jaipur).
Pen-and-ink; 6½ by 7½ ins.
Presented by Mildred and W. G. Archer, 6 November 1962. *Add. Or. 2379*

NOTE: 'Man Singh' would appear to be a mistake for 'Ram Singh' The drawing is probably a tracing from a group photograph. Obtained by W. G. Archer at Benares in 1948 from a Benares dealer who attributed it to a Benares artist.

(b) Paintings on mica.

106 i–ii 2 mica paintings of uniforms of the Bengal Native Infantry.
By a Benares or Patna artist, *c.* 1830.
Gouache on mica; 4¾ by 3 ins.

Purchased 20 March 1967. *Add. Or. 2666; 2667*

NOTE: These mica paintings were clearly part of a set similar to no. 109 where the faceless mica paintings were intended to be superimposed on a card. The set probably depicted the uniforms of the Bengal Army at various dates.

 i Sepoy of Bengal Native Infantry with a white saltire on the cummerbund as worn prior to 1806. *Add. Or. 2666*
 ii Officer of Bengal Native Infantry. *Add. Or. 2667*

107 Mica painting of a budgerow with a military officer on board.
By a Benares or Patna artist, *c.* 1830.
Gouache on mica; $5\frac{1}{4}$ by $6\frac{1}{2}$ ins.
Purchased 20 March 1967. *Add. Or. 2672*

108 i–v 5 mica paintings depicting a nautch and methods of transport.
By a Patna or Benares artist, *c.* 1830.
Gouache on mica; (i) $6\frac{1}{4}$ by 8 ins; (ii–v) $5\frac{1}{4}$ by 7 ins.
Purchased 11 May 1953. *Add. Or. 587–591*

NOTE: These mica paintings were originally part of an album belonging to Isabella Dalzell which included drawings (some by Sir Charles D'Oyly) dated 1825–32. See Mildred Archer, *British drawings in the India Office Library* (London, 1969), i, 168–169.

 i Nautch; two dancing-girls and three musicians performing before an Indian gentleman *Add. Or. 587*
 ii Purdah palanquin. *Add. Or. 588*
 iii Sedan chair, or 'short' palanquin (*bochā*). *Add. Or. 589*
 iv Horse and groom. *Add. Or. 590*
 v Purdah bullock-cart. *Add. Or. 591*

109 i–xxxv 35 mica paintings and three cards in a blue box with a painting of a hookah-burdar on the lid. The mica paintings consist of 3 sets, each of twelve (one item missing), depicting dancing-girls and their musicians, occupations and servants. The three cards are each painted with a head and background so that the mica paintings, which have blank faces, can be superimposed.
By a Benares artist, *c.* 1830–40.
Gouache on mica and on card; $4\frac{1}{4}$ by 3 ins.
Purchased 10 April 1956. *Add. Or. 359–393*

 i–vi Dancing-girls. *Add. Or. 359–364*
 vii Jew's harp player. *Add. Or. 365*
 viii *Tabla* and *bayan* player. *Add. Or. 366*
 ix *Sārangī* player. *Add. Or. 367*

x	Cymbals player.	*Add. Or. 368*
xi	*Tambūrā* player.	*Add. Or. 370*
xii	*Sitār* player.	*Add. Or. 369*
xiii	Entertainer with dancing bear.	*Add. Or. 371*
xiv	Entertainer with performing monkey and goat.	*Add. Or. 372*
xv	Snake-charmer.	*Add. Or. 373*
xvi	Conjuror.	*Add. Or. 374*
xvii	Drummer.	*Add. Or. 375*
xviii	Watchman (*chaukidār*) with sword and shield.	*Add. Or. 376*
xiv	Spearman or post-runner.	*Add. Or. 377*
xx	Hookah-seller.	*Add. Or. 378*
xxi	Seller of hookah mouth-pieces.	*Add. Or. 379*
xxii	Cloth-seller.	*Add. Or. 380*
xxiii	Sweetmeat-seller.	*Add. Or. 381*
xxiv	Flower and garland-seller.	*Add. Or. 382*
xxv	Ayah with European baby.	*Add. Or. 383*
xxvi	Hookah bearer.	*Add. Or. 384*
xxvii	Head table-servant (*khānsāmā*) with tureen	*Add. Or. 385*
xxviii	Table-servant (*khidmatgār*) with knives and forks.	*Add. Or. 386*
xxix	Water-cooler (*ābdār*)	*Add. Or. 387*
xxx	Sweeper.	*Add. Or. 388*
xxxi	Water-carrier.	*Add. Or. 389*
xxxii	Cook.	*Add. Or. 390*
xxxiii	Washerman.	*Add. Or. 391*
xxxiv	Palanquin bearer.	*Add. Or. 392*
xxxv	Groom.	*Add. Or. 393*

110–115 78 mica paintings consisting of 6 sets depicting festivals, Muharram festival figures, dancing-girls and musicians, methods of transport, occupations and servants. By a Benares or Patna artist, *c.* 1850–60.
Inscribed in some cases with titles.
Gouache on mica; various sizes.
Presented by Lady Mackworth-Young, 5 October 1929. *Add. Or. 400–475; 582; 583*

NOTE: These mica paintings were originally mounted in an album entitled *Indian Talc Costumes* and inscribed: *Sir William Mackworth Young, K.C.S.I. from his old friend Hilton Bothamley 1908 in remembrance of early days.*

Archdeacon Hilton Bothamley of Bath was the first cousin of Sir William Mackworth-Young, Indian Civil Service 1863–1902. Mr G. Mackworth-Young, when presenting the collection on behalf of his mother, Lady Mackworth-Young, stated that it was not known for certain when or where the collection had been formed, but he believed that it had been made by Archdeacon Bothamley's father-in-law, whose name was King and who had served in India.

The mica paintings are arranged in sets of a dozen as sold to the British.

Benares

Bibliography

Archer (1955), reproducing 111 ii and 114 v, in plate 13, Figs 27, 28.

110 i–vi 6 mica paintings depicting festivals.
5½ by 7½ ins. *Add. Or. 400–404; 583*

 i Durga puja.
 Inscribed: *Devee Pooja. Hindoo.* *Add. Or. 400*
 ii Muharram festival.
 Inscribed: *Mooharrum Procession. Mussalmann.* *Add. Or. 401*
 iii Muslim marriage procession; the bridegroom proceeding to the bride's house.
 Inscribed: *Marriage Procession. Mussalmann.* *Add. Or. 402*
 iv Kali puja.
 Inscribed: *Kalee Poojah. Hindoo.* *Add. Or. 403*
 v Barni puja.
 Inscribed: *Barnee Poojah. Hindoo.* *Add. Or. 404*
 NOTE: The term *Bārni* is a corrupt form of *Bāruni*, a form of worship which is done at long intervals and is similar to (but not identical with) the Chait festival. Its date is determined by astrologers and falls in the month of Chait (March to April). Since it involves the worship of Varuna, the god of water, it is celebrated by women standing in a tank or a river and offering fruit.
 vi Dancing-girls performing before an Indian gentleman. *Add. Or. 583*

111 i–xii 12 mica paintings depicting figures in the Muharram festival procession.
5¼ by 4 ins. *Add. Or. 405–416*

 i Standard-bearer and water-carrier. *Add. Or. 405*
 ii Lantern-carrier. *Add. Or. 406*
 iii Drummer.
 Inscribed: *Mohurrum Figures.* *Add. Or. 407*
 iv Drummer. *Add. Or. 408*
 v Cymbal player. *Add. Or. 409*
 vi Sword and fly-whisk bearer. *Add. Or. 410*
 vii Standard-bearer.
 Inscribed: *Mohurrum Figures.* *Add. Or. 411*
 viii Standard-bearer. *Add. Or. 412*
 ix *Ta'ziyah*, and figure with fly-whisk.
 Inscribed: *Mohurrum Figure.* *Add. Or. 413*
 x Standards under canopy and figure praying beside them.
 Inscribed: *Mohurrum Figures.* *Add. Or. 414*
 xi Club and shield-bearer. *Add. Or. 415*
 xii Quarter-staff and club-bearer. *Add. Or. 416*

112 **i–xii**	12 mica paintings depicting dancing girls and their musicians. 5¼ by 4 ins.

Add. Or. 417–428

i	*Tambūrā* player.	*Add. Or. 417*
ii	*Mridangam* player.	*Add. Or. 418*
iii	Cymbal player.	*Add. Or. 419*
iv	*Tabla* and *bayan* player.	*Add. Or. 420*
v	*Sitār* player.	*Add. Or. 421*
vi	*Sārangī* player.	*Add. Or. 422*
vii	Dancing-girl. Inscribed: *Natch.*	*Add. Or. 423*
viii	Dancing-girl.	*Add. Or. 424*
ix	Dancing-girl.	*Add. Or. 425*
x	Dancing-girl.	*Add. Or. 426*
xi	Dancing-girl. Inscribed: *Natch.*	*Add. Or. 427*
xii	Dancing-girl.	*Add. Or. 428*

113 **i–xii**	12 mica paintings depicting methods of transport. 4 by 5¼ ins.

Add. Or. 429–440

i Camel and rider. *Add. Or. 429*

ii Indian gentleman with fly-whisk bearer on elephant with two servants in front and one behind.
Inscribed: *Suwarrie* (Transport). *Add. Or. 430*

iii Bullock-carriage (*rath*), a servant ahead. *Add. Or. 431*

iv Purdah bullock-cart.
Inscribed: *Suwarrie* (Transport). *Add. Or. 432*

v Purdah palanquin with four bearers, a man-servant in front with covered gun and woman servant at side. *Add. Or. 433*

vi Purdah palanquin with two bearers and servant carrying luggage and water.
Inscribed: *Suwarrie* (Transport). *Add. Or. 434*

vii Pony cart (*ekkā*). *Add. Or. 435*

viii Indian gentleman on horseback with servant running behind. *Add. Or. 436*

ix Wooden 'long' palanquin with four bearers and two spear-bearers ahead.
Add. Or. 437

x Indian gentleman in sedan chair, ('short palanquin' or *bochā*) with four bearers, umbrella-carrier and spearman ahead.
Inscribed: *Suwarrie* (Transport). *Add. Or. 438*

xi Tonjon; open chair with four bearers, umbrella-carrier and sword-bearer ahead. *Add. Or. 439*

xii Palanquin (*jhalledar*) with four bearers, a servant at the side and two in front with covered guns. *Add. Or. 440*

114	24 mica paintings depicting occupations.	
i–xxiv	3¾ by 5 ins.	*Add. Or. 441–464*
	i Potter.	*Add. Or. 441*
	ii Butter-maker.	*Add. Or. 442*
	iii Scabbard-maker.	*Add. Or. 443*
	iv Basket-maker.	*Add. Or. 444*
	v Lacquer-worker painting a *morhā*.	*Add. Or. 445*
	vi Bidriware-maker.	*Add. Or. 446*
	vii Brass-pot maker.	
	Inscribed: *Turner*.	*Add. Or. 447*
	viii Blacksmith.	
	Inscribed: *Blacksmith*.	*Add. Or. 448*
	ix *Pān* maker.	*Add. Or. 449*
	x Embroiderer making caps.	*Add. Or. 450*
	xi Carpenter.	
	Inscribed: *Carpenter*.	*Add. Or. 451*
	xii Silversmith.	
	Inscribed: *Soonar (Goldsmith)*.	*Add. Or. 452*
	xiii Cook making sweetmeats.	
	Inscribed: *Cook*.	*Add. Or. 453*
	xiv Butcher.	
	Inscribed: *Butcher*.	*Add. Or. 454*
	xv *Nārgīla*-pipe maker.	
	Inscribed: *Pipe maker*.	*Add. Or. 455*
	xvi Sweetmeat-seller.	
	Inscribed: *Confectioner*.	*Add. Or. 456*
	xvii Cloth-printer.	
	Mis-inscribed: *Embroiderer*.	*Add. Or. 457*
	xviii Money-changer.	
	Inscribed: *Shroff (Money changer)*.	*Add. Or. 458*
	xix Seller of hookah mouth-pieces.	
	Inscribed: *Hookah maker*.	*Add. Or. 459*
	xx Entertainer with performing monkey and goat.	
	Inscribed: *Conjurer*.	*Add. Or. 460*
	xxi Holy-water seller.	
	Inscribed: *Seller of Ganges water*.	*Add. Or. 461*
	xxii Woman husking paddy.	
	Inscribed: *Rice-cleaning*.	*Add. Or. 462*
	xxiii Woman sweetmeat-seller (*Plate 46*).	
	Inscribed: *Cake-seller*.	*Add. Or. 463*
	xxiv Grain-seller (*Plate 47*).	
	Inscribed: *Grain seller*.	*Add. Or. 464*

115
l-xii

12 mica paintings depicting servants.
5¼ by 4 ins. *Add. Or. 465–475; 582*

 i Head table-servant (*khānsāmā*) carrying tureen.
 Inscribed: *Khansumar. (Butler).* *Add. Or. 465*
 ii Hookah-bearer.
 Inscribed: *Hookah badar.* *Add. Or. 466*
 iii Table-servant (*khidmatgār*) standing beside table with fly-whisk. *Add. Or. 467*
 iv Washerman ironing.
 Inscribed: *Dhobee (Washer-man).* *Add. Or. 468*
 v Gardener (*mālī*). *Add. Or. 469*
 vi Bearer with keys.
 Inscribed: *Kitmugar.* *Add. Or. 470*
 vii Cook (*bāwarchī*).
 Inscribed: *Baboojee (Cook).* *Add. Or. 471*
viii Water-cooler (*ābdār*) cooling bottles.
 Inscribed: *Aubdar (Water-cooler).* *Add. Or. 472*
 ix Tailor.
 Inscribed: *Dhirgee.* *Add. Or. 473*
 x Sweeper.
 Inscribed: *Mehtar.* *Add. Or. 474*
 xi Groom.
 Inscribed: *Ghorawallah-groom.* *Add. Or. 475*
 xii Water-carrier.
 Inscribed: *Bheesti.* *Add. Or. 582*

116
i–xxv

25 mica paintings depicting a festival, occupations and methods of transport, pasted into the journal of Ensign G. W. Eaton.
By Benares artists, *c.* 1858.
Gouache on mica; various sizes.
Purchased 11 December 1952. *MSS.Eur.D.512. 1, 2*

NOTE: George Welby Eaton (1840–64) went to India with the 2nd European Bengal Fusiliers in 1858. He was posted to Delhi and passed through Benares on his way up the river in July 1858. He probably purchased these mica paintings at that time. For his career and journal, see Mildred Archer, *British drawings in the India Office Library* (London, 1969), i, 184.

MSS.Eur.D.512.1. Journal with title page inscribed: *First Volume of the Life, Diary & Adventures of Tittleyeumpshebumpshe. G. W. Eaton Ensn 73rd N.I. Delhi Palace September the 1st 1858.*

 i f.4v The Jagannath festival: the temple car containing the images of Jagannath,

 Balbhadra and Subhadra surrounded by a great crowd.
 Inscribed: *Juggernaut.* $6\frac{1}{2}$ by $10\frac{1}{4}$ ins.

ii f.23v Palanquin with four bearers and an umbrella-bearer.
 4 by $5\frac{1}{2}$ ins.

iii f.26v Pony carriage (*ekkā*).
 4 by $6\frac{1}{2}$ ins.

iv f.31v Water-carrier.
 Inscribed: *The Bhistie.* 3 by $1\frac{3}{4}$ ins.

 v Grass-cutter.
 Inscribed: *The Grasscut.* 3 by $1\frac{3}{4}$ ins.

 vi Sweeper.
 Inscribed: *The Mater.* 3 by $1\frac{3}{4}$ ins.

 vii Groom.
 Inscribed: *The Saas.* $3\frac{1}{2}$ by $2\frac{1}{4}$ ins.

 viii Cook.
 Inscribed: *The Cook.* $3\frac{1}{2}$ by $2\frac{1}{4}$ ins.

 ix Table-servant (*khidmatgār*).
 Inscribed: *The Kitmugkar.* 3 by $1\frac{1}{4}$ ins.

 x Washerman.
 Inscribed: *The Dhooby.* 3 by $1\frac{1}{4}$ ins.

 xi Barber.
 Inscribed: *The Barber.* 3 by $1\frac{1}{4}$ ins.

xii f.32 Bearer.
 Inscribed: *The Bearer.* 3 by $1\frac{1}{4}$ ins.

 xiii Clerk.
 Inscribed: *The Writer.* 3 by $1\frac{1}{4}$ ins.

xiv f.34 Cymbal player.
 3 by $1\frac{1}{4}$ ins.

 xv *Tambūrā* player.
 3 by $1\frac{1}{4}$ ins.

 xvi *Tabla* player.
 3 by $1\frac{1}{4}$ ins.

 xvii *Sārangī* player.
 3 by $1\frac{1}{4}$ ins.

 xviii Dancing-girl.
 3 by $1\frac{1}{4}$ ins.

xix 35v Snake-charmer.
 3 by $1\frac{1}{4}$ ins.

xx 49v Dancing-girl.
 $2\frac{3}{4}$ by $1\frac{1}{2}$ ins.

xxi 50v Bullock carriage.
 $3\frac{1}{4}$ by 4 ins.

xxii 55v Country boat.
 $3\frac{1}{4}$ by 5 ins.
xxiii 63 Watchman (*chaukidār*).
 $2\frac{1}{4}$ by $1\frac{1}{2}$ ins.
xxiv 91 Churning butter.
 $3\frac{1}{4}$ by $2\frac{1}{4}$ ins.

MSS.Eur.D.512.2. Journal with title page inscribed: *Second Volume of the Life, Diary & Adventures of Tittleyeumpshebumpshe. G. W. Eaton. Lieutt. 21st On duty Sylhet 26th 1863.*

xxv 2v Sati scene.
 Inscribed: *Suttee.* $6\frac{1}{4}$ by 10 ins.

117
i-viii

8 mica paintings depicting occupations and methods of transport.
By a Benares or Patna artist, *c.* 1860.
Gouache on mica; 5 by 4 ins.
Presented 10 February 1914, together with 42 Trichinopoly mica paintings, no. 20. *Add. Or. 606–613*

NOTE: These mica paintings were all mounted in an album which also contained 4 photographs of ascetics (see *Photo 34*) and 3 untraced prints of mythological subjects, which, according to a note in the album were 'transferred to portfolio of mythological subjects.'

 i Dog-boy.
 Inscribed: *Dog Servant.* *Add. Or. 606*
 ii Groom.
 Inscribed: *Horse Servant.* *Add. Or. 607*
 iii Cleaning cotton (*dhuniyā*).
 Inscribed: *Native taking the seeds out of Cotton.* *Add. Or. 608*
 iv Vaishnava devotee with fire and tongs.
 Inscribed: *Devotee covered with yellow ochre.* *Add. Or. 609*
 v Ascetic with club.
 Inscribed: *Devotee.* *Add. Or. 610*
 vi Ascetic holding small bowl.
 Inscribed: *Devotee covered with burnt cow dung.* *Add. Or. 611*
 vii Coolie carrying burdens on yoke.
 Inscribed: *Carrier.* *Add. Or. 612*
 viii Bullock-cart carrying furniture.
 Inscribed: *Oxen pulling a cart with native furniture.* *Add. Or. 613*

(viii) OUDH

Company painting in Oudh developed on individual lines. This was largely because the European communities in Faizabad and later in Lucknow differed greatly from those in cities which came under direct British rule. Apart from the British Resident and his staff, and the British garrison, the Europeans who flocked to Oudh in the late eighteenth and early nineteenth centuries were adventurers and tradesmen looking for quick fortunes. They were not the serious-minded soldiers and administrators who, in other parts of India, were purchasing paintings of 'manners and customs' to paste in their scrapbooks or to send home to relatives in England. It followed that there was little demand in Oudh, until later in the nineteenth century, for paintings of this kind. There were undoubtedly a few cultivated Europeans – Colonel Gentil, General Claude Martin, Colonel Polier and Richard Johnson – but they were interested either in European work of good quality or in oriental culture. They patronised the British professional painters who visited Oudh or collected Indian and Persian manuscripts and miniatures.

Oudh was a flourishing centre for acquiring oriental works for, with the break-up of the Mughal libraries at Delhi, many Persian manuscripts had found their way to it. The Nawabs and their courtiers were also lavish patrons of Indian artists. With the decline of patronage at Delhi, Mughal artists had moved to Faizabad and later to Lucknow, and a school of painting had arisen which was marked by feverish brilliance, a fitting expression of Oudh society under Nawab Shuja-ud-daula (1753–75) and Nawab Asaf-ud-daula (1775–97). Many portraits and paintings of musical or literary themes with a semi-erotic flavour were made at this time. The artists were well patronised and felt confident in the traditional character of their work.

In spite of this encouragement, painters in Oudh were gradually influenced by western models. The wealth and extravagance of the Nawabs in the eighteenth century attracted a number of British artists to their courts. As a result Indian painters at Faizabad, and later at Lucknow, saw examples of professional British work. Tilly Kettle visited Faizabad from 1772 to 1773 and was patronised by Nawab Shuja-ud-daula; Zoffany went to Lucknow from 1783 to 1789 and worked for Asaf-ud-daula. They were followed by Ozias Humphry and Charles Smith in 1786, and by Thomas and William Daniell who stayed there from July to October 1789. In about the years 1791 and 1792 Francis Renaldi worked in Lucknow, and George Place lived there from the turn of the century until his death in 1805. There was, in fact, a continuous tradition of British artists working in Lucknow until almost the time when the rulers were finally deposed by the British in 1856. Robert Home was court artist to Ghazi-ud-din Haidar (1814–27) and was followed in 1828 by George Beechey who, until his death in 1852, painted for all the succeeding Nawabs: Nasir-ud-din (1827–37), Muhammad Ali Shah (1837–42),

Amjad Ali Shah (1842–47) and Wajid Ali Shah (1847–56). As a result, British models, chiefly portraits in oils, were constantly to be seen in the palaces and public buildings of Lucknow. They were thus available to Indian painters who were ready to adapt their styles to suit new fashions and markets.

For Indian artists accustomed to the miniature technique, the large oils of these artists must have come as a revelation and shock. Indian portraits were highly stylised, showing the figure in profile, either standing or sitting, but in the work of British portrait painters, they saw figures in natural poses. The size and medium were also different. Indian painters quickly realised that here were new models which could add variety to their stock-in-trade. A few Indian artists even experimented with oils: a portrait of Saadat Ali (1798–1814) on horseback, now in the Foreign and Commonwealth office, is clearly by an Indian painter.[1] Other artists made miniature copies of the large oils or free versions of them. Tilly Kettle's portrait of Shuja-ud-daula and his ten sons was copied in gouache by a Faizabad artist, Nevasi Lal, and a version by him is now in the Musée Guimet, Paris.[2] Mihr Chand made free versions of other portraits by Tilly Kettle[3] and Zoffany's portrait of Asaf-ud-daula, now in the Foreign and Commonwealth Office,[4] was freely copied by another Lucknow artist. A portrait of Asaf-ud-daula in the India Office Library (no. 118) is almost certainly based on a lost portrait by Tilly Kettle.

The same western influences soon showed themselves in sets of pictures produced at the end of the eighteenth century depicting the Mughal emperors and the Nawabs of Oudh. These were water-colour versions of traditional portraits combined with idioms gleaned from British paintings (no. 119). The pillars, looped curtains, tessellated marble floors and patterned carpets are all strongly reminiscent of portraits by Tilly Kettle. Sets of pictures depicting dancing girls and various types of female costume, well suited to the permissive atmosphere of Lucknow society, were also produced; and these included similar backgrounds (no. 120).

Western influences also began to enter the work of Indian artists working for the Nawabs themselves. Under Shuja-ud-daula and Asaf-ud-daula, their work was in the provincial Mughal style of Lucknow painting; but under Saadat Ali, who had grown up among British officers in Calcutta, European tastes become more marked. Once the Nawabs had received the title of 'King' from George III in 1819, these tendencies were even more pronounced in architecture,

[1] W. Foster, *A Descriptive catalogue of the paintings, statues, etc., in the India Office* (London, 1924), no. 562.

[2] I. Stchoukine, *Les Miniatures indiennes au Musée du Louvre* (Paris, 1929), cat. no. 116, 73–74.

[3] Victoria and Albert Museum (Indian Section), I.S. 287–1951; British Museum, 1946–10–10–03; E. Kuhnel, *Berliner Museen*, xliii, Nov. and Dec. 1922, 115–122.

[4] W. Foster, *op. cit.*, no. 106. The copy is in the State Museum, Lucknow.

interior decoration, and painting. Indian artists working under Home and Beechey designed carriages, howdahs, pleasure boats, palanquins, and furniture in a mixed Indo-European style. Designs for them can be seen in the Department of Prints and Drawings, Victoria and Albert Museum (*E685 to 1626–1943*), as well as in drawings by 'Mummoo Jan' in Bharat Kala Bhawan, Benares. Paintings were made for the Nawabs themselves in a similar mixed style. A book, *Customs of the Court of Oudh*, now in the Royal Library at Windsor, was illustrated for Ghazi-ud-din Haidar. Pictures were also made showing the Nawabs with celebrated British visitors – Ghazi-ud-din Haidar with Lord and Lady Moira (no. 122), Nasir-ud-din with Lord and Lady William Bentinck (no. 127). Such pictures appear to have been made as mementoes of important occasions and, like photographs today, were presented as souvenirs after the event to honoured guests. They are marked by bright and gaudy colouring and by restless detail.

It was in about 1800 that the vogue for pictures showing festivals, occupations and scenes of Indian life, so common in other parts of India, first reached Lucknow, and even then these paintings do not seem to have been as standardised or produced in such large quantities as at Patna or Calcutta. The earliest sets (no. 121) are large in size and comparable to the festival scenes at Murshidabad and Patna, but, at times, show more individuality and variety of subject matter. In style they are characterised by spacious backgrounds, swirling drapery and cool tones. By 1830 small-sized sets depicting costumes and occupations, similar in type to those at Patna, were being produced, and these have more fully-developed backgrounds, often with a detailed landscape or domestic interior (no. 124).

By the second half of the nineteenth century, artists in Lucknow were making portraits of Europeans similar to those in Delhi and some even specialised in animal portraits. 'Mummoo Jan' made a considerable reputation among the British in Lucknow for paintings of this type. During the eighteen-fifties he had been employed by the King of Oudh and appears to have worked with George Beechey (died 1852) in painting portraits, copying European pictures, designing furniture and painting carriages and tonjons.[5] After Oudh had been annexed by the British, he turned to them for his livelihood, painting portraits of British officers and of their pets. At Bharat Kala Bhawan, Benares, there are pictures of ponies, dogs, cats and birds. One bears the note, 'Mummoo has done a capital picture of my dog, and also two very excellent ones of a dog of Lt. Strachey's in my regiment. They are very like the animals, and the work is most carefully done. R. Vaughan, Lt, XI B.I. December 1888.' He also seems to have made drawings illustrating handicrafts for international exhibitions in London (no. 130).

Ivory portrait-miniatures, similar to those made in Delhi, were also made in Lucknow, though of inferior quality. Lord Amherst, for example, acquired a portrait of Ghazi-uddin Haidar in 1826 (no. 125). Panoramic scrolls showing the

[5] Bharat Kala Bhawan, Benares, Album 7898–8215.

Kings of Oudh riding in procession past the mosques and palaces of Lucknow appear to have had a vogue in the thirties and forties (no. 129).

Bibliography

Archer, Mildred and W. G. *Indian painting for the British, 1770–1880* (Oxford, 1955), 51–63.

Abbas Ali, Haji, Darogah, *Illustrated historical album of the Rajas and Taluqdars of Oudh* (Allahabad, 1880).

Abbas Ali, Haji, Darogah, *The Lucknow album* (Calcutta, 1874).

Davies, C. C. *Warren Hastings and Oudh* (Oxford, 1939).

Edwardes, M. *The Orchid House* (London, 1960).

Faiz-Bakhsh, Muhammad (trans. W. Hoey). *Memoirs of Delhi and Faizabad* (Allahabad, 1889), ii.

Gentil, J. B. J. *Mémoires sur l'Indoustan ou Empire Mogol* (Paris, 1822).

Hay, S. *Historic Lucknow* (Lucknow, 1939).

Hill, S. C. *The Life of Claud Martin* (Calcutta, 1901).

Nevill, H. R. *United Provinces Gazetteers: Lucknow* (Allahabad, 1904).

Smith, L. F. 'A letter to a friend, containing an historical sketch of the late Asaf-ud-Dowlah, Nawab of Oude,' *The Asiatic Annual Register for the year 1804*, miscellaneous tracts, 10–12 (London, 1806).

Srivastava, A. L. *The First two nawabs of Oudh* (Lucknow, 1933).

'W.C.' 'Major General Claud Martin,' *Bengal Past and Present*, iii, January–March, 1909, 102–110.

118 Portrait of Asaf-ud-daula (Nawab of Oudh 1775–97) holding a sword seated on a green velvet chair in an archway, a red-patterned carpet on the floor (*Plate 48*). By a Lucknow artist, *c.* 1780.
Gouache; 8¼ by 5¼ ins.
Purchased 10 January 1957. *Add. Or. 476*

NOTE: This portrait appears to be based on a British painting by Tilly Kettle.

119 i, ii 2 portraits of Mughal emperors seated on thrones on a tiled terrace. By a Lucknow artist *c.* 1790.
Gouache; 8¾ by 6 ins. Heavy Indian ink border.
Purchased 15 August 1966. *Add. Or. 2657; 2658*

NOTE: These drawings were originally part of a set depicting Mughal emperors.

 i The emperor Akbar (ruled 1556–1605) facing left, seated on a throne with a hawk on his right hand. He wears a pink dress.
 Inscribed in Persian characters: *Abū 'l-Fath Jalāl al-Dīn Muhammad Akbar padshāh i ghāzī*; numbered in *nāgarī* characters: *3*. *Add. Or. 2657*
 ii The emperor Alamgir II (ruled 1754–59) facing right holding a jewel in his right hand.

Inscribed in Persian characters: *Abū 'l-'Adl 'Azīz al-Dīn 'Ālamgīr i thānī bādshāh i ghāzī*; numbered in *nāgarī* characters: *11*: in English: *A Nabob on his Musnad.*

Add. Or. 2658

120 Dancing-girl in a white sari with a red border seated on a western-style sofa on a terrace (*Plate 49*).
Inscribed: *A Dancing Girl.*
By a Lucknow artist, *c.* 1780-90.
Gouache; 8½ by 5¾ ins. Heavy Indian ink border.
Purchased 15 August 1966.

Add. Or. 2659

NOTE: This drawing is almost identical in composition and subject, only in reverse, to 38i. It originally formed part of a set of women in various poses and is closely related in style to portraits of rulers also produced in Lucknow at this time (nos. 118, 119).

121 **i–iii** 3 drawings depicting Indian scenes.
By a Lucknow artist, *c.* 1800.
Purchased 14 July 1962.

Add. Or. 1964–1966

NOTE: These drawings were originally part of a larger set depicting festivals and scenes. They are similar in style to no. 123.

 i Street scene probably in Lucknow, with shops and traders; a horseman with retainers is riding by (*Plate 52*).
 Water-colour; 12¾ by 18 ins. *Add. Or. 1964*

 ii Woman bathing. A lady of rank is seated on steps leading down to a river; her hair is being dried by an old lady, and two other maid-servants stand behind. Another lady is coming out of the water. In the distance elephants and guards are waiting.
 Water-colour; 12¾ by 8¼ ins. *Add. Or. 1965*

 iii The Holi festival. A man, garlanded and crowned with shoes, is being carried on a reversed charpoy by a dancing and singing crowd, accompanied by drums. A broom, in place of a peacock-feather fan, is waved behind him. Some of the crowd wield swords, a man in the foreground gathers dust to throw at him and an ascetic carries a bowl of fire. In the background a gateway and crenellated wall (*Plate 53*).
 Water-colour; 14 by 17½ ins. *Add. Or. 1966*

122 Ghazi-ud-din Haidar (Nawab and, after 1819, King of Oudh, 1814–27) entertaining Lord and Lady Moira to a banquet in his palace. Paintings of horses, mirrors and girandoles decorate the walls and above the window is the coat of arms of the kings of Oudh. The river Gumti is seen through the door (*Plate 54*).

By a Lucknow artist, *c.* 1814.
Inscribed on original mount: *From Lucknow.*
Gouache; 13½ by 18¾ ins.
Purchased 4 March 1961. *Add. Or. 1815*

NOTE: Lord Moira (Governor-General of Fort William 1813–23) visited Ghazi-ud-din, just after his accession, from 11 October to 11 November 1814. He dined at the palace with the King on 27 October and this picture probably commemorates that occasion (see F. Rawdon-Hastings, 1st Marquess of Hastings (ed. the Marchioness of Bute) *The private journal of the Marquess of Hastings, K.G. Governor-General and Commander-in-Chief of India* (London, 1858), i, 198–200). The portrait of Lord Moira is very similar to the kit-kat portrait formerly in Government House, Calcutta, reproduced W. Corfield, *Calcutta faces and places in pre-camera days* (Calcutta, 1910), pl. 24.

It seems probable that the Kings of Oudh ordered their retained artists to record important occasions in the same way as a photographer at a later date would have taken a group photograph. A copy was probably retained by the King and others given to the main guests.

123 i–iv 4 drawings from a set depicting occupations and customs.
By a Lucknow artist, *c.* 1815–20.
Inscribed with titles. 1815 water-mark.
Water-colour; 9¼ by 7¾ ins. Yellow and pink borders with black rules.
Purchased 6 January 1958. *Add. Or. 344–347*

NOTE: For other pictures from this set see Maggs Bros., *Oriental miniatures and illumination, Bulletin no. 3* (London, 1962), no. 55; *Bulletin no. 6* (London, 1964), no. 136; *Bulletin no. 8* (London, 1965), no. 74. In style the series is comparable to nos. 120 and 121 but slightly less formalised.

 i Hindu woman worshipping at a shrine to Ganesh.
 Inscribed: *A Hindoo woman worshipping.* *Add. Or. 344*
 ii Craftsman seated on a striped rug painting charpoy legs.
 Inscribed: *A Painter.* *Add. Or. 345*
 iii Scribe seated on a striped rug writing a manuscript.
 Inscribed: *A Persian Scribe.* *Add. Or. 346*
 iv Artist seated at a table painting a picture. An English colour-box, palettes and brushes are on the table (*Colour plate A. Frontispiece*).
 Inscribed: *A Limner.* *Add. Or. 347*

124 i–l 50 drawings bound into an album, consisting of 2 sets in similar style, depicting occupations and methods of transport.
By a Lucknow artist, *c.* 1825–30.
i–xvii inscribed with titles.
Water-marks of 1825.
Water-colour; (i–xvii) 8¼ by 7 ins with cream, pink and black rule borders;

(xviii–l) 7½ by 4½ ins with black rules.
Purchased 14 June 1953. *Add. Or. 1284–1333*

NOTE: These drawings are similar in style to nos. 121 and 123 but increasingly naturalistic.

 i Arrow-maker.
 Inscribed: *A Teer wallah, or Arrow maker.* *Add. Or. 1284*
 ii Woman reeling thread.
 Inscribed: *A Woman reeling Thread.* *Add. Or. 1285*
 iii Seal-engraver.
 Inscribed: *Turner.* *Add. Or. 1286*
 iv Woman grinding grain.
 Inscribed: *A Woman grinding Grain.* *Add. Or. 1287*
 v Sword-furbisher.
 Inscribed: *A Sicklygur or Furbisher.* *Add. Or. 1288*
 vi Shoemaker.
 Inscribed: *A Chumar or Shoe maker.* *Add. Or. 1289*
 vii Muslim ascetic (*naqshbandī*) carrying a lamp.
 Inscribed: *A Mussulman Priest.* *Add. Or. 1290*
viii Man with a small hookah-pipe.
 Inscribed: *A Man with a Goorgooree, a small Pipe.* *Add. Or. 1291*
 ix Weaver combing a warp.
 Inscribed: *A Colee, or Weaver.* *Add. Or. 1292*
 x Bearded Hindu ascetic, with arm upraised (*urdhvabāhu*).
 Inscribed: *A Fanatic Beggar doing Penance.* *Add. Or. 1293*
 xi Silk-thread or fringe maker.
 Inscribed: *A Jaul banow, or Fringe Maker.* *Add. Or. 1294*
 xii Woman making *chapātī*.
 Inscribed: *A Woman making Chupatties, or Bread Cakes.* *Add. Or. 1295*
xiii Cultivators irrigating their fields.
 Inscribed: *Ryots, or Cultivators, drawing Water for Irrigating their Lands.*
 Add. Or. 1296
 xiv Bow-maker.
 Inscribed: *A Kumlee-gur, or Bow Maker.* *Add. Or. 1297*
 xv Blacksmiths.
 Inscribed: *A Lohar, or Blacksmith.* *Add. Or. 1298*
 xvi Silversmith.
 Inscribed: *A Soonar, or Silversmith.* *Add. Or. 1299*
xvii Fan-bearer.
 Inscribed: *A Bearer carrying a Punkah, or Fan.* *Add. Or. 1300*
xviii Toddy-tappers; one climbing a palm tree, one seated below with pots.
 Add. Or. 1301

xix Camel-rider. *Add. Or. 1302*
xx Muslim ascetic in patchwork coat with peacock-feather fan.
Add. Or. 1303
xxi Sawyers. *Add. Or. 1304*
xxii Porter carrying green boxes (*pitarrah*) on a shoulder-yoke. *Add. Or. 1305*
xxiii Weaver combing a warp. *Add. Or. 1306*
xxiv Head table-servant (*khānsāmā*) carrying a tureen (*Plate 51*). *Add. Or. 1307*
xxv Sweeper. *Add. Or. 1308*
xxvi Hookah-bearer. *Add. Or. 1309*
xxvii Pilgrim carrying Ganges water in baskets decorated with flags and peacock-feathers. *Add. Or. 1310*
xxviii Woman juggler with balls attached to her head. *Add. Or. 1311*
xxix Fan-bearer. *Add. Or. 1312*
xxx Carpenter planing wood. *Add. Or. 1313*
xxxi Woman worshipping at a Shiva shrine and prostrating herself.
Add. Or. 1314
xxxii Link-boy (*mashālchī*) with torch and oil container. *Add. Or. 1315*
xxxiii Woman spinning cotton with a wheel (*charkhā*). *Add. Or. 1316*
xxxiv Embroidering scabbard-cases for daggers (*katār*). *Add. Or. 1317*
xxxv Goldsmith. *Add. Or. 1318*
xxxvi Woman vegetable-seller with customer. *Add. Or. 1319*
xxxvii Trumpeter. *Add. Or. 1320*
xxxviii Weaver at his loom. *Add. Or. 1321*
xxxix Washerman. *Add. Or. 1322*
xl Water-carrier with his skin. *Add. Or. 1323*
xli Water-buffalo carrying a pack and bundle. *Add. Or. 1324*
xlii Potter with his wheel. *Add. Or. 1325*
xliii Woman stick-warping. *Add. Or. 1326*
xliv Woman grinding flour (*Plate 50*). *Add. Or. 1327*
xlv Carriage (*rath*) drawn by two oxen. *Add. Or. 1328*
xlvi Ginning cotton. *Add. Or. 1329*
xlvii Cleaning cotton. *Add. Or. 1330*
xlviii Loaded bullock-cart. *Add. Or. 1331*
xlix Silver-stick bearer. *Add. Or. 1332*
l Woman fish-seller with cutter and scales. *Add. Or. 1333*

125 Portrait of Ghazi-ud-din Haidar (Nawab and, after 1819, King of Oudh, 1814–27). Head and shoulders, wearing a crown and ermine cape.
By a Lucknow artist, 1826.
Inscribed on back, probably by Lord Amherst: *King of Oude 1826. Ghazi ood Deen Hyder King of Oude.*

Oval; water-colour on ivory; 2½ by 2 ins.
Deposited on permanent loan by the 5th Earl of Amherst, M.C., together with
Add. Or. 2538, 2539 and *MSS.Eur.F.140.*　　　　　　　　　　*Add. Or. 2540*

NOTE: William Pitt, 2nd Baron Amherst, who was created 1st Earl Amherst of Aracan in 1826, was Governor-General of India from 1823 to 1828. This miniature was probably acquired by him and his wife during their visit to Lucknow in December 1826.

The Delhi fashion of depicting rulers on ivory appears to have spread to Lucknow in the early nineteenth century.

126　　Asaf-ud-daula (Nawab of Oudh 1775–97) at a cock-fight. The Nawab, in white *jāma* and red trousers, crouches beside an English officer, wearing a red coat and white trousers, watching a cock-fight. Three other European officers stand behind with a number of Indian gentlemen. A servant holds a blue umbrella over the Nawab. A yellow canopy above; baskets for the cocks to left and right.
By a Lucknow artist, *c.* 1830–35.
Water-colour; 13 by 9¾ ins.
Presented by J. Creswell 1929.　　*Add. Or. 3118 (Revised Foster catalogue. n. 683)*

NOTE: This painting is similar in style to no. 127, and probably depicts the famous cockfight between Asaf-ud-daula and Colonel Mordaunt which took place at Lucknow in 1786 and was celebrated by John Zoffany. For an engraving of Zoffany's picture by Richard Earlom with its key, see Edwardes (1960), 48.

127　　Nasir-ud-din Haidar (King of Oudh 1827–37) seated at a table with a British officer on his left and an English lady on his right. His hand rests on the Englishman's hand. An A.D.C. stands behind his chief. The table is spread with glasses and dishes. Four Indian ministers stand on the left and a party of two dancing-girls and two musicians on the right. In the background an elaborately stuccoed doorway with chandeliers and glass shades; in the foreground a fountain and flower beds *(Plate 56)*.
By a Lucknow artist, *c.* 1831.
Inscribed on back in pencil: *All the drawings in this Book were found by me in the 'Kaiser Bagh', a Royal Palace in Lucknow in the beginning of –/58 – after the Capture – I.G.*
Gouache; 13¾ by 9¾ ins.
Purchased 21 December 1964.　　　　　*Add. Or. 2599*

NOTE: The British officer is perhaps Lord Bentinck, Governor-General and Commander-in-Chief 1828–35. He and his wife visited Nasir-ud-din in April 1831.

128 i, ii　　2 drawings depicting military occasions.
By an Indian artist, perhaps at Lucknow, *c.* 1847.
Purchased 10 October 1957.　　　　*Add. Or. 741; 742*

i Hindu priest garlanding the flags of the 35th Bengal Light Infantry at a presentation of colours ceremony. *c.* 1847.

Water-colour; 15¼ by 18¾ ins. *Add. Or. 741*

NOTE: This regiment became Light Infantry in 1843 and was given the Governor-General's Order for Kilmarnocks for Sepoys in 1847. The flags bear the battle honour of 'Cabul 1842'. As the troops are wearing Kilmarnocks and as the regiment was disbanded at the Mutiny the picture must have been painted between 1843 and 1858, perhaps at the same time (1847) as ii, the style of which it resembles. The 35th Bengal Light Infantry figures in both pictures.

Bibliography

R. Ackermann, *Costumes of the Indian army* (London, 1844).

ii Durbar scene showing probably Wajid Ali Shah (King of Oudh 1847–56) embracing the Governor-General, Lord Hardinge, on his visit to Lucknow in November 1847. British civil and military officers, as well as sepoys, are present, and the picture may depict the presentation of new standards to the Oudh troops by the British on the occasion of the King's accession (*Plate 55*).

Water-colour; 19 by 23½ ins. *Add. Or. 742*

NOTE: Officers on the terrace are wearing the following uniforms (numbers and letters indicated on mount): 2. Officer of Bengal European Fusiliers; 4. Officer of Rifle Company of the 35th Bengal Light Infantry; 5. Regular Bengal Light Cavalry (in blue); 8. Field Officer with gilt scabbard and epaulettes; 9. Grenadier with white feather plume. Figures in foreground: B. Officer of Rifle Company of the 35th Bengal Light Infantry; C. Regular Bengal Light Cavalry; D. Peaked cap may denote a sepoy of mixed blood; E. Native Officer of the 47th Bengal Cavalry who were Lancers from 1840 to 1858.

The standards with fish and crown emblems belong to Oudh.

129 Panorama showing the main buildings of Lucknow with a procession of Muhammad Ali Shah (King of Oudh 1837–42) passing along the road. The procession consists of cavalry, camels, riders with kettle-drums, infantry with muskets and pennants, gold-stick bearers, the King and the British resident mounted on elephants, artillery with gun-carriages, a closed elephant carriage and a palanquin. In the foreground are pedestrians, tradesmen and water-carriers. In the background are the main buildings of Lucknow including: The Great Imambara (1), Mosque of the Great Imambara (2), Inner gateway of the Great Imambara (3), Outer gateway of the Great Imambara (4), the Rumi Darwarza (6), side view of the Mosque of the Great Imambara (?) (7), the unfinished Jami Masjid (?) (8), new city with ministers' palaces built by Saadat Ali (11) the Kaiserbagh (12), gateway on the road between the Rumi Darwarza and the Hussainabad Imambara (13), mosque with ornamented dome within the Hussainabad Imambara (15), Hussainabad Imambara (16), second mosque within the Hussainabad Imambara (17). By a Lucknow painter, *c.* 1848.

Water-colour and pencil; unfinished; the buildings and some of the figures are completed but the main part of the procession with the King is indicated only in pencil.

14 by 366 ins.

Water-mark of 1846.

Purchased 4 June 1955. *Add. Or. 739*

130 Woman of Lucknow in red veil, blue skirt and green bodice, loaded with jewellery.

By 'Mummoo' (Mahmud?), a Lucknow artist, *c.* 1872.

Inscribed: *Illustration of the jewellery worn by the lay figure with detail of Nos. of jewellery in list. Painted by Mummoo, a native artist of Lucknow. London Exhibition 1872.*

Water-colour; 16 by 11 ins.

Deposited in India Office, 1872. *India Office Albums*, vol. 59, 'Jewellery', no. 5435

NOTE: This drawing was clearly sent for the London International Exhibition of 1872. 'Mummoo' may be the same artist as 'Mummoo Jan', a collection of whose drawings are in Bharat Kala Bhawan, Benares.

III North India

(i) DELHI AND AGRA

The myth of the 'Great Mogul' and his glittering palaces had always fascinated the British from the earliest days of the East India Company. It had conjured up romantic visions of fabulous wealth and splendour, and of marble halls crowned with swelling domes. The accounts of early travellers confirmed it for the courts of the Mughal emperors, particularly from the time of Akbar (1556–1605) to Aurangzeb (1658–1707), were indeed splendid. Great fortress palaces and soaring mosques had been built at Delhi and Agra; and imposing mausoleums surrounded by beautiful gardens were raised by generation after generation. For miles around Delhi and Agra the countryside was studded with monuments that bore witness to the wealth and taste of the Mughal rulers and their courtiers, as well as to the Muslim invaders who had preceded them.

Although in the eighteenth century Delhi was plundered by the Afghans and Rohillas and the power of the emperors had waned, the British in India were anxious to see the 'Great Mogul' himself and the famous cities about which they had heard so much. But to do this was still an adventure. Delhi was a three months' journey from Calcutta and it was a frontier capital as remote as Peshawar at a later date. The surrounding countryside was dangerously unsettled. The Mughal emperor was a puppet of the Marathas, the Rohillas controlled the country to the north and the Jats dominated it to the west. British administrators were gradually pushing northwards preceded by the surveyors who were quietly covering the ground. The engineer and map-maker James Hoare reached Agra in 1795 and Delhi a year later, but Delhi could only be visited with a strong escort, and even then, as William Hodges found in 1783, this was not always safe or possible.

It was not until the Third Maratha War that the British occupied Delhi in 1803. Civil officers then moved into houses within the city walls and the military were accommodated in a cantonment beyond the Ridge. They were soon followed by traders and business men. As the political situation grew calmer, the city expanded and new houses for civilians were built between the Kashmir Gate and the Ridge. In 1819, Delhi was divided into districts, and in 1832 the territory was formally organised as part of the North West Province and placed under a Commissioner. Delhi was gradually taking on the shape of a conventional British station. Once securely established, the British were free to explore the city and its monuments. Nor did these prove a disappointment. Indeed the ruinous state into

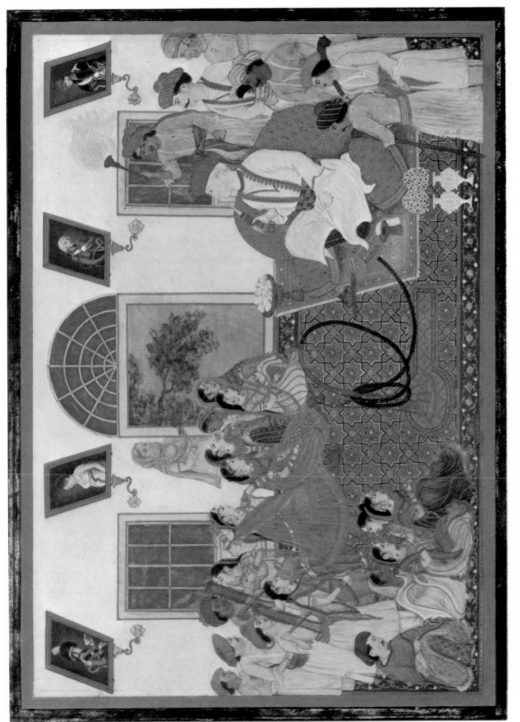

D A European watching a nautch. Delhi, *c.* 1820

which many of them had fallen added a melancholy charm and gave rise to roman-
tic reveries. Viewing the monuments became a fashionable pursuit. Picnics were
arranged to see the Qutb Minar or Tughlukhabad and the British wandered
amongst the broken masonry as though they were in Rome. In the evenings officials
and their families rode out from Delhi among the tombs scattered for miles around.
In Emma Roberts' words, all these sights could not fail 'to impress the mind with
sensations of mingled awe, wonder, and delight',[1] and as Emily Eden remarked,
'Delhi is a very suggestive and moralising place – such stupendous remains of
power and wealth passed and passing away.'[2]

In these circumstances a demand for pictures of monuments soon arose among
the British. It is true that certain monuments had already been depicted by British
artists. William Hodges had published aquatints of Agra, Fatehpur Sikri and
Sikandra, and the Daniells had covered Delhi in *Oriental Scenery*. But these great
volumes were not easy to acquire or preserve in India. It is also true that many
of the British were themselves amateur artists and could make sketches for
themselves, but the intricacy of Mughal architecture was difficult to record with
any degree of accuracy. How much easier if drawings could be purchased from
Indian artists instead!

This posed no difficult problem. Delhi and Agra throughout the Mughal period
had been great centres of painting. Under Akbar, studios had been established and
many artists had been employed by the emperor. This patronage was continued by
Jahangir and Shah Jahan as well as by courtiers and noblemen of the seventeenth
and eighteenth centuries. Numerous miniatures were produced depicting a wide
range of subjects: portraits, genre, natural history, historical and literary themes.
By the time the British occupied Delhi, however, Mughal patronage had become
sadly reduced and many skilled artists were looking for employment. It was not
difficult, therefore, to find painters willing to copy and record Mughal monuments.

It seems that even before the British captured Delhi, drawings of the pietra
dura work on the Taj Mahal were already being made by Indian artists for
European visitors at Agra. James Forbes reproduced one example, dated 1781,
in his *Oriental Memoirs*.[3] Sir Charles Warre Malet acquired similar drawings when
he accompanied an embassy to Delhi in 1785. These were later seen by the artist,
James Wales, who noted in his diary, 'In the evening Sir C. shew'd me some
drawings taken from the famous Mausoleum at Agra, representing panels of
ornamental flowers and borders – all are done in their natural colours and they are
executed in the Mausoleum upon white marble in mosaic. Sir C. who went a
journey of forty days from Surat to see this very grand edifice was struck with
astonishment and exclaimed at first sight how well his journey had been be-

[1] Roberts, iii, 167.
[2] Eden, 98.
[3] J. Forbes, *Oriental Memoirs* (London, 1813), iii, plate after p. 112.

stowed'.[4] But these drawings were apparently only of the pietra dura work, not of the building itself.

By about 1808, large architectural drawings were, however, readily available, depicting a whole range of monuments in Agra, Fatehpur Sikri, Delhi and their neighbourhoods. The Taj Mahal was a favourite subject, with views of the whole mausoleum complex as well as details of the entrance gateway, the mosque, and the central chamber with its screen and two cenotaphs. The Pearl Mosque in Agra Fort, the Private Apartments and Halls of Audience, as well as the tomb of Itimad-ud-daula across the river were also popular. Akbar's mausoleum at Sikandra and the various buildings in the deserted city of Fatehpur Sikri provided further subjects. At Delhi, the Fort with its massive ramparts and Halls of Audience were constantly depicted, as well as the Jami Masjid, the Qutb Minar and the mausoleums of Humayun and Safdar Jang (no. 131). Occasionally buildings further afield, such as the Palace at Dig and the temples at Mathura, were also included.

These drawings were clearly influenced by British taste. The traditional medium of gouache was replaced by pen-and-ink and water-colour. The pictures were executed on large sheets of Whatman paper, in soft washes of cream, buff, grey, and pink with touches of gold, green, red or blue. The whole was surrounded by a black border or black rules. The buildings were shown in perspective against a plain uncoloured background. The style in many ways was similar to that of British engineer draftsmen of the period and it is significant that these officers were amongst the first of the British to arrive in Delhi.

Another possible influence may have been books of European architectural engravings or even drawings of architecture which some of the more cultured officials in Delhi may have possessed. Many of the British in India had visited cities such as Venice, Florence and Rome and some may have owned Italian architectural drawings. Delhi and Agra paintings have much in common with drawings of the type made for tourists by Venuti or Varsi or by draftsmen working for the architect Antonio Visentini (1688–1782).[5] Once the prototypes had been worked out by Indian artists they were repeated over and over again.

At the same time Indian characteristics were also present. The Indian love of meticulous detail is seen in the treatment of pierced marble screens or inlay work. Every brick or marble slab was carefully indicated, whereas in a European drawing they would have been merely hinted at. Although pale colours predominate, from time to time, as in the pictures of the interior of Itimad-ud-daula's mausoleum, the Indian love of scarlet, azure, gold and green asserts itself.

Such paintings continued until the eighteen-thirties but about 1815 a new and parallel type began to appear which became increasingly popular. In these pictures

[4] James Wales MSS. Collection Mr & Mrs Paul Mellon.
[5] Collection Royal Institute of British Architects.

the buildings were shown on a smaller scale set in a landscape with figures and animals (no. 143). There is no doubt that just as in Calcutta aquatints by William Hodges influenced Indian artists (see p. 74), so those of the Daniells influenced Delhi painters. In one set in the Library, two of the drawings, one of the Qudsiya Bagh and one of the Jami Masjid at Delhi, are direct copies from Daniell prints (no. 143, iii and xii).

By about 1825 it must have been clear to Indian painters that there was a steady demand for drawings of monuments, and accordingly they began to standardise their work. Drawings were produced more economically on smaller sheets of paper and of uniform size. The subjects were repeated over and over again and the small variations which had given character and liveliness to the earlier drawings disappeared. The small boats on the Jumna, or buildings viewed from unconventional angles, no longer find a place in these mass-produced pictures. Stock sets of this type continued until about 1850 (nos. 148–160). In the second half of the century ivory became the most popular medium, although cheaper sets on paper were still produced. Buildings were painted on oval or rectangular sheets of ivory in many different sizes. These were either sold individually or mounted in boxes, screens or jewellery. Such work persisted until the present century, the range of the monuments depicted being even further extended. After the Mutiny, for example, views of Cawnpore and Lucknow became popular (no. 165). At Kedleston Hall there is a box presented to Lord Curzon which is decorated with ivory miniatures depicting the Well and Sati Chaura Ghat at Cawnpore, together with the Residency, the Bailey Guard Gate, the Martinière and the Constantinople Gate at Lucknow.

As with most Indian paintings, the names of the artists who made these pictures are not known. But one or two painters built up individual reputations. The best known was Latif of Agra who according to Fanny Parks was also an architect and inlay worker. She bought some drawings from him in 1835 and used two of them for plates in her *Wanderings of a pilgrim in search of the picturesque* (see p. 182). His strong drawings show the buildings isolated in bold simplicity against a plain background.

Monuments, however, were only one facet of Delhi that interested the British. Equally fascinating was the Grand Mogul himself. Although his wealth and power were now greatly reduced, he still lived surrounded with the panoply of greatness, sadly depleted though it may have become. Just as the ruins of Delhi provoked 'reverential melancholy' and sober thoughts, in the same way the old emperor aroused compassion, mixed with pity and sometimes scorn, among the more thoughtful of the British. Emily Eden who saw him sitting alone in a garden remarked that 'the Light of the World had a forlorn and darkened look'. Bishop Heber, who paid his respects to him in the Hall of Audience, noted the broken palanquins and empty boxes lying around and the throne covered in pigeons' droppings. 'Vanity of vanities!', he commented 'was surely never written in

more legible characters than on the dilapidated arcades of Delhi!'[5] Yet whatever their feelings, the British wanted pictures of the emperor and his ancestors.

Several different types of painting met this demand. The first were sets of oval ivory miniature portraits depicting the Mughal line from Timur to Akbar II and showing the subject, head and shoulders, usually in profile (no. 174). These sets became strongly conventionalised so that the grey-bearded Aurangzeb reading his Koran, the portly Muhammad Shah, or long-nosed Alamgir II could be instantly recognised. Similar sets were produced of the empresses and court ladies. Since royal ladies all remained secluded, these portraits were not based on first-hand observation, but were idealised female types. The most expensive of these sets were made on ivory, neatly framed, but cheaper sets on paper could also be procured. Some of the best Delhi painters produced less conventionalised portraits. Ghulam Ali Khan, for example, made large-scale ivory miniatures of the Emperor Akbar II and his sons (no. 175). By about 1850, portraits were being made in many different sizes, minute ones being used for buttons, brooches, earrings and bracelets (no. 180).

The Emperor in durbar was another favourite subject, the Emperor being shown in the centre on his throne surrounded by a great crowd of courtiers, painted with careful precision. These pictures, usually showing Akbar II, can often be dated from the British Resident who stands among the throng wearing his cocked hat. No. 171, for example, includes Sir David Ochterlony, and in pictures at the Victoria and Albert Museum, the Red Fort Museum, Delhi and Bharat Kala Bhawan, Benares, Charles Metcalfe (Resident 1811–19) and Archibald Seton (Resident 1806–11) appear. A variant of this subject showed the Emperor being carried in a palanquin accompanied by the heir apparent on horseback. These pictures were usually painted on paper and were similar in size and style to Mughal miniatures. Long panoramic scrolls, made on sheets of paper stuck together, were also popular in the first thirty years of the nineteenth century. These show the Emperor riding in procession on an elephant followed by princes, officials, courtiers and retainers on elephants, on horseback, in carriages or on foot (nos. 168, 172). Subordinate to this type of painting was the separate depiction of eminent Delhi characters, past and present, such as Mahadaji Sindhia, who had exercised power over the Mughal emperors from 1771 to 1794, or Sir David Ochterlony, Resident of Delhi, 1803 to 1806 and 1818 to 1822 (no. 170).

The technical skill of the Delhi painters soon led to the development of a third type of painting – the making of portraits as private commissions. The most common of these were portrait miniatures on ivory which at times are scarcely distinguishable from British miniatures of the period (no. 177). The ability of the Delhi artists to catch a likeness, or, in the second half of the nineteenth century, to copy a photograph led to a widespread demand for portraits from the British.

[5] Eden, 97; Heber, 562.

In 1954 many of the Delhi painters still owned certificates testifying to the skill of their ancestors. Ghulam Ali Khan (*fl.* 1827), Ghulam Murtaza Khan (*c.* 1760–1840), and his son Ghulam Husain Khan (*c.* 1790–1868) were among the best known of these artists. Others such as Ismail Khan, Faiz Ali Khan, Mirza Shah Rukh Beg, Muhammad Alam, Mazhar Ali Khan, Mahmud Ali Khan, Muhammad Ibrahim, Fath Ali Khan, Qamar-ud-din, and Khair Muhammad Yusuf were listed in books published in 1847 and 1870.[6] A few of the Delhi artists even painted on canvas in oils. Jivan Ram was extremely versatile and could work in a number of styles and techniques.[7] A portrait by him of Lord Combermere dated 1828, which passed through the London sale rooms in 1955, was an ambitious composition with Combermere in Indian dress posed against a colonnade through which a procession with an elephant and a British staff officer on horseback could be seen.

Portraits on paper in a more Indian style were also commissioned. Ghulam Ali Khan had a great reputation for work of this kind, and from time to time he was employed by Colonel Skinner, founder of Skinner's Horse. Three large pictures in the National Army Museum showing Skinner on his country estate at Hansi are signed by him, and it seems probable that a number of portraits in Skinner's album in the Library are also by him (no. 169). These depict members of Skinner's regiment, the famous 'Yellow Boys', as well as a number of his friends and servants. The figure is usually set in a landscape or in a room. Colonel Skinner was in the habit of presenting his guests after a party with a picture of the troupe of dancing-girls and musicians who had entertained them (no. 173), and some of these may also have been painted by Ghulam Ali Khan. Delhi artists were always willing to carry out individual commissions, whatever their nature. They would repair an English miniature which had suffered from the damp or copy an English water-colour. A miniature of Albury Church in Surrey (no. 178) is clearly a copy of a small English landscape sketch.

Delhi painters were perhaps the most skilled and versatile of all the Company painters. In Delhi the indigenous tradition was stronger than in any other city occupied by the British. The demand for 'Mughal miniatures' has never ceased and to this day Delhi artists still make versions of the earlier paintings.

Bibliography

Archer, Mildred. 'The two worlds of Colonel Skinner', *History Today*, September 1960, 608–615.
Archer, Mildred. *Indian architecture and the British* (London, 1968).
Archer, Mildred and W. G. *Indian painting for the British, 1770–1880* (Oxford, 1955).
Baden Powell, B. H. *Handbook of the manufactures and arts of the Punjab* (Lahore, 1872).

[6] Saiyid Ahmad Khan, *Āṣār al-ṣanādīd* (Delhi, 1847); Hakim Ahsan Ullah Khan (ex-vizier of Bahadur Shah) in an Urdu book compiled for Queen Victoria, *c.* 1870.
[7] Archer (1955), 67–68.

Beadon, H. C. *Punjab District Gazetteers: Delhi District* (Lahore, 1913).

Brown, P. *Indian architecture: the Islamic period* (Bombay, 1942).

Eden, Emily (*ed.* E. J. Thompson). *Up the country* (London, 1930).

Heber, R. *Narrative of a journey through the upper provinces of India from Calcutta to Bombay, 1824–1825*, 2 vols. (London, 1828).

Parks, Fanny. *The Wanderings of a pilgrim in search of the picturesque during twenty-four years in the east*, 2 vols. (London, 1850).

Roberts, Emma. *Scenes and characteristics of Hindostan, with sketches of Anglo-Indian society*, 3 vols. (London, 1835).

Sleeman, W. H. *Rambles and recollections of an Indian official*, 2 vols. (London, 1844).

Spear, P. *Twilight of the Mughuls* (Cambridge, 1951).

Thompson, E. J. *The Life of Charles, Lord Metcalfe* (London, 1937).

Watt, E. *Indian art at Delhi, 1903* (Calcutta, 1903).

(a) *Paintings of monuments and landscapes*

131
i–xvi

16 drawings of Mughal monuments at Agra, Sikandra and Fatehpur Sikri.
By a Delhi or Agra artist, *c.* 1808.
Inscribed with titles; seven drawings inscribed: *G. Steell.*
Water-colour; various sizes.
Water-marks of 1801, 1803, and 1807.
Circumstances of acquisition unrecorded. *Add. Or. 921–936*

NOTE: These drawings appear to have belonged to G. Steell whose pencil signature occurs on seven of them. George Steell (1781–1840) served in the Bengal Engineers from 1798 to 1817. Ensign 1798; Lieutenant 1803; Captain 1808. He was posted to Agra from 1807 to 1813.

The monuments are shown in elevation against a plain white background. Double black rules frame the drawings. All are inscribed in the same hand and would appear to have been acquired at the same time. They are not, however, standardised and the sizes are not uniform. At least two hands appear to have been at work. The majority of the drawings are coloured with a soft brownish-pink; others are brighter in colour and harder in execution.

 i The Taj Mahal, Agra, from the river.
 Inscribed on front in ink: *View of the Taaj Mahl at Agra from the River*; in pencil: *G. Steell.*
 1805 water-mark. 29 by $50\frac{1}{2}$ ins. *Add. Or. 921*
 ii West side of the Taj Mahal, Agra (*Plate 62*).
 Inscribed on front in ink: *West side of the Taaj Mahl at Agra.*
 1801 water-mark. $26\frac{1}{4}$ by $39\frac{1}{4}$ ins. *Add. Or. 922*
 iii Entrance door in the marble screen round the cenotaphs in the Taj Mahal, Agra.
 Inscribed on front in ink: *Entrance Door of the Marble Screen round the Tombs in the Taaj Mahl at Agra*; on back in pencil ditto.
 $25\frac{1}{2}$ by $32\frac{1}{2}$ ins. *Add. Or. 923*

iv Part of the pierced marble screen round the cenotaphs opposite the entrance door in the Taj Mahal, Agra.

Inscribed on front in ink: *Part of the Screen round the Emperor's Tomb at Agra opposite the entrance Door*; on back in pencil: *No. 5. Part of the Marble Screen round the Tombs in the Taje Mahl at Agra opposite the entrance Door. G. Steell.*

18½ by 26 ins. Add. Or. *924*

v Side view of the Emperor Shah Jahan's cenotaph in the Taj Mahal, Agra, showing the pietra dura work.

Inscribed on front in ink: *Side view of the Emperor Shah Jehan's Tomb at Agra*; in pencil: *G. Steell.*

1801 water-mark. 29 by 50½ ins. Add. Or. *925*

vi Pietra dura work and relief panels on the walls of the central chamber of the Taj Mahal, Agra.

Inscribed on front in ink: *No. 9. Sculpture & Inlaid Pannels round the interior of the Taaj Mahl*; in pencil: *G. Steell.*

22¼ by 23¾ ins. Add. Or. *926*

vii The mosque on the west side of the Taj Mahal, Agra.

Inscribed on front in ink: *No. 10. The Musjeed on the West Side of the Taaj Mahl.*

20¾ by 29¼ ins. Add. Or. *927*

viii Entrance gateway to the Taj Mahal, Agra. The mausoleum can be seen through the archway.

Inscribed on front in ink: *No. 11. Entrance Gateway of the Taaj Garden.*

21 by 29 ins. Add. Or. *928*

ix Agra Fort from the river Jumna.

Inscribed on front in ink: *No. 12. View of the River Face of the Fort of Agra.*

1803 water-mark. 15 by 51¼ ins. Add. Or. *929*

x Delhi Gate, Agra Fort.

Inscribed on front in ink: *No. 13. Delhi Gate of the Fort of Agra.*

1801 water-mark. 26½ by 29½ ins. Add. Or. *930*

xi Amar Singh's Gate, Agra Fort.

Inscribed on front in ink: *No. 14. Omar Sing's Gate, Fort Agra*; in pencil: *G. Steell.*

32¼ by 25¼ ins. Add. Or. *931*

xii The Pearl Mosque (Moti Masjid), Agra.

Inscribed on front in ink: *No. 15. Mootee Musjeed in the Fort of Agra*; in pencil: *G. Steell.*

20 by 42 ins. Add. Or. *932*

xiii Entrance gatehouse to Akbar's mausoleum, Sikandra.

Inscribed on front in ink: *No. 16. Entrance Gate to the Emperor Ackbar's Tomb at Secundra.*

25¼ by 32¼ ins. Add. Or. *933*

xiv Facade of Akbar's mausoleum, Sikandra.
Inscribed on front in ink: *No. 17. Ackbar's Tomb at Secundra.*
15$\frac{1}{2}$ by 30 ins. *Add. Or. 934*

xv 'Gate of Magnificence' (Buland Darwaza), Fatehpur Sikri.
Inscribed on front in ink: *No. 18. Gateway at Futtypoor Sicri.*
26$\frac{1}{4}$ by 30$\frac{1}{2}$ ins. *Add. Or. 935*

xvi Mausoleum of Salim Chishti in the courtyard of the Great Mosque, Fatehpur Sikri.
Inscribed on front in ink: *No. 19. A Tomb at Futtypoor Sicri*; in pencil: *G. Steell.*
1801 water-mark. 26 by 39 ins. *Add. Or. 936*

132 i, ii 2 drawings of the Taj Mahal, Agra.
By a Delhi or Agra artist, *c.* 1808.
Purchased 11 November 1961 from the collection of Sir Henry Russell.
Add. Or. 1909, 1910

NOTE: Sir Henry Russell, 2nd Baronet (1763–1852), was in India from 1798 to 1820. While it is possible that he acquired these drawings himself, it seems more likely that they came to him along with the collection of Thomas Daniell, purchased sometime between 1840 and 1848. After acquisition, the collection was mounted by him in a uniform style (see Mildred Archer, *British drawings in the India Office Library* (London, 1969), ii, p. 574). The drawings in question are not part of a standard set but appear to be early attempts to record a subject which interested the British. It is possible that the Daniells collected these drawings while on their tour of northern India from 1788 to 1791 but it is more probable that they acquired them in England from friends returning from India in the early years of the nineteenth century. A number of such drawings, some with 1811 water-marks and belonging to the Daniells, reached the Royal Institute of British Architects with the Crace collection. The Daniells appear to have built up a small collection of Indian architectural drawings after their return to England probably because they found them of great use when making their oil-paintings of Indian scenes.

i Interior of the Taj Mahal, Agra, showing the cenotaph chamber.
Inscribed on front: *Inside View of the Tage Mhal.*
Water-colour; 25 by 19$\frac{3}{4}$ ins. *Add. Or. 1909*

ii Detail of pietra dura work in the Taj Mahal, Agra.
Inscribed on front: *A Representation of a Curious Piece of Inlaid Marble in the Hall at the Back of the Tomb in Tage Mhal.*
Water-colour; 18 by 17$\frac{1}{2}$ ins. Cream wash border with black rules.
Add. Or. 1910

NOTE: The inscription appears to be mistaken. The drawing shows a detail of the pietra dura work on the top of the cenotaph of Shah Jahan.

133
i–xxvi
28 drawings of Muslim monuments bound into 2 volumes; the first depicting the Taj Mahal, the second other monuments at Agra and Sikandra.

By Delhi or Agra artists, *c.* 1808–20.

Inscribed with titles in English and sometimes in Urdu. Title-page of volume I (i–xvii) inscribed: *Drawings of the Taj Mahal at Agra 1820*; title page of volume II (xviii–xxvii) inscribed: *Views of Agra & Delhi in the East Indies 1820*.

Water-colour; size of volumes 22½ by 32 ins; drawings of various sizes.

Water-marks of 1804, 1806, 1808 and 1813.

Purchased February 1954. *Add. Or. 1762–1789*

NOTE: A similar collection to no. 131, with the buildings shown in elevation against a blank background, but by several hands. In most cases there are black Indian ink borders and rules. The drawings differ in quality and are on paper with water-marks of varying dates. They were probably collected in India over a period of several years; 1820 may refer to the date of binding. Both volumes bear the book-plate of James Butler East with the motto: *Aequo Pede Propera*. There is no trace of East in the East India Company Records and it therefore seems unlikely that the drawings were collected by him in India. They may have been a gift received by him in 1820 and then bound up into volumes for his library.

 i Entrance gateway to the Taj Mahal, Agra.
 Inscribed on front in English: *The Grand Entrance Gate of the Taj.*
 1813 water mark. 21 by 30 ins. *Add. Or. 1762*
 ii Entrance gateway to the Taj Mahal, Agra.
 Inscribed on front in English: *The Grand Entrance Gateway of the Taje at Agra.*
 16¾ by 21½ ins. *Add. Or. 1763*
 iii West side of the Taj Mahal, Agra.
 Inscribed on front: *The Taj WSW.*
 1813 water-mark. 21¼ by 30 ins. *Add. Or. 1764*
 iv The Taj Mahal, Agra, showing the mosque, assembly hall and mausoleum.
 Inscribed on front: *The Taj with the Musjid and Jumaut Khanu at Agra, founded by Shah Jehan*; also: *The Taje.*
 1813 water-mark. 21¼ by 58½ ins. *Add. Or. 1765*
 v West side of the Taj Mahal, Agra, similar to (iii); plan on back.
 Inscribed on back in Persian characters: [R]*auḍah i munauwarah az bīrūn* (The mausoleum from the outside). *Add. Or. 1766*
 vi Interior of the Taj Mahal, Agra, showing the central chamber with the cenotaphs of the Emperor Shah Jahan and Empress Arjumand Banu Begam (Mumtaz Mahal).
 Inscribed on front: *Section of the Interior of the central chamber of the Taje.*
 21½ by 30 ins. *Add. Or. 1767*

vii Interior of the Taj Mahal, Agra showing the central chamber and cenotaphs.
Inscribed on front: *Section of the Central Chamber of the Taj. no. 4.*
21½ by 30¼ ins. *Add. Or. 1768*

viii Detail of alcoves around walls of the central chamber, Taj Mahal, Agra.
Inscribed on front: *Taje No. 5.*
21½ by 17 ins. *Add. Or. 1769*

ix Relief panel with vases of flowers from wall of central chamber, Taj
Mahal, Agra.
Inscribed on front: *No. 6.*
16¾ by 24 ins. *Add. Or. 1770*

x Detail of relief panel with vase design, central chamber, Taj Mahal, Agra.
Inscribed on front: *No. 7. Taje. Vase and flowers sculptured on marble in
bold Relief in one of the Compartments dividing two arches in the Central
Chamber of the Taj.*
Ink drawing; 17 by 11 ins. *Add. Or. 1771*

xi The screen round the cenotaphs, Taj Mahal, Agra.
Inscribed on front: *No. 8.*
21¼ by 28¾ ins. *Add. Or. 1772*

xii The top of the cenotaph of the Emperor Shah Jahan, Taj Mahal, Agra.
Inscribed on front: *Emperor's Tomb. No. 9*; on back: *No. 9 The Upper
part of the Emperor's tomb (i.e.) top.*
19¼ by 26½ ins. *Add. Or. 1773*

xiii Side elevation of the cenotaph of the Emperor Shah Jahan, Taj Mahal,
Agra.
Inscribed on front in English: *Emperor's Tomb. No. 10*; in Persian characters:
*Marqad i muṭahhar i ḥaḍrat S̲h̲āhjahān bādshāh i g̲h̲āzī az ṭaul nawis̲h̲tah
s̲h̲ud* (The pure cenotaph of the Emperor Shah Jahan has been drawn
lengthways).
1806 water-mark. 16¾ by 41½ ins. *Add. Or. 1774*

xiv Elevation of the end of the cenotaph of the Emperor Shah Jahan, Taj
Mahal, Agra.
Inscribed on front: *Emperor's Tomb. No. 11*; on back: *The Emperor's tomb
facing the entrance.*
19 by 26 ins. *Add. Or. 1775*

xv Side elevation of the cenotaph of the Empress Arjumand Banu Begam,
Taj Mahal, Agra.
Inscribed on front in English: *Begum's Tomb. No. 12*; incorrectly inscribed
in Persian characters: *Marqad i muṭahhar i ḥaḍrat S̲h̲āhjahān bādshāh i g̲h̲āzī
az jānib i ṭaul nawis̲h̲tah s̲h̲ud* (The pure cenotaph of Shah Jahan has been
drawn lengthways); on back in English: *The Begam's tomb at length. No. 12*;
in Persian characters: *Qabr i Begam-Ṣāḥib bālā az ṭaul* (The Begam Sahib's
grave above lengthways).

1806 water-mark. 16½ by 42 ins. *Add. Or. 1776*

xvi The top of the cenotaph of the Empress Arjumand Banu Begam, Taj Mahal, Agra.

Inscribed on front: *Begum's Tomb. No. 13*; on back in English: *The Upper part of the Begum's tomb (i.e.) top*; in Persian characters: *Lauḥ i bālāy i . . . Qabr i Begam-Ṣāḥib* (The slab over the grave of Begam Sahib).

19¼ by 26¼ ins. *Add. Or. 1777*

xvii Elevation of the end of the cenotaph of the Empress Arjumand Banu Begam, Taj Mahal, Agra.

Inscribed on front: *Begum's Tomb. No. 14*; on back: *The Begum's tomb facing the entrance. No. 14.*

22½ by 32 ins. *Add. Or. 1778*

xviii Mausoleum of Itimad-ud-daula, Agra.

Inscribed on front: *The Mausoleum of Eatimad-ul-Dowlah on the Bank of the Jumna facing the City of Agra*; *Mausoleum-Dowlah.*

21¼ by 30 ins. *Add. Or. 1779*

xix Interior of the mausoleum of Itimad-ud-daula, Agra.

Inscribed on front: *Section of the Central Chamber of the Mausoleum of Eatimad-ull-Dowlah.*

21¾ by 29¾ ins. *Add. Or. 1780*

xx Entrance gatehouse to Akbar's mausoleum, Sikandra.

Inscribed on front: *The Grand Gate leading to the Mausoleum of the Emperor Ackbar at Secundra near Agra.*

21¾ by 28¾ ins. *Add. Or. 1781*

xxi Entrance gatehouse to Akbar's mausoleum, Sikandra.

Inscribed on front: *Entrance Akbar's Tomb*; on back: *The Gateway of Entrance to Ackbar's Tomb at Secundra near Agra.*

18½ by 23 ins. *Add. Or. 1782*

xxii Mausoleum of Akbar, Sikandra.

Inscribed on front: *Tomb of Acbar*; on back: *The Tomb of Ackbar at Secundra near Agra.*

18½ by 23 ins. *Add. Or. 1783*

xxiii Mausoleum of Akbar, Sikandra (*Plate 60*).

Inscribed on front: *The Mausoleum of the Emperor Ackbar at Secundra near Agra.*

1813 water-mark. 21¼ by 30 ins. *Add. Or. 1784*

xxiv 'Gate of Magnificence' (Buland Darwaza), Fatehpur Sikri.

Inscribed on front: *The Grand Gateway leading to the Mausoleum College & Musjid at Futtihpore Secri. Mausoleum, College.*

17¼ by 22¼ ins. *Add. Or. 1785*

xxv Mausoleum of Salim Chishti in the courtyard of the Great Mosque, Fatehpur Sikri.

Inscribed on front: *The Mausoleum of Sheikh Salim at Futtihpore Sikri 22 miles from Agra.*

1804 water-mark. $21\frac{1}{4}$ by $29\frac{1}{4}$ ins. *Add. Or. 1786*

xxvi Panorama of the Red Fort, Delhi.

Inscribed on front: *The Palace at Delhi*; also inscribed with names of various buildings.

1808 water-mark. $11\frac{3}{4}$ by 56 ins. *Add. Or. 1787*

xxvii Panorama of the Fort, Agra.

Inscribed on front: *The River face of the Fort at Agra*; also inscribed with names of various buildings.

1808 water-mark. $11\frac{3}{4}$ by 56 ins. *Add. Or. 1788*

xxviii The Pearl Mosque (Moti Masjid), Agra.

Inscribed on front: *The Mootee Musjid within the Fort at Agra.*

1813 water-mark. $21\frac{1}{4}$ by 30 ins. *Add. Or. 1789*

134 Mausoleum of Akbar, Sikandra.

By a Delhi or Agra artist, *c.* 1810.

Inscribed on front: *Akbar's tomb at Secundra near Agra drawn by Thomas Longcroft.*

Water-colour; $13\frac{3}{4}$ by $19\frac{1}{2}$ ins. Narrow Indian ink border.

Presented by Simon Digby, 4 May 1962. *Add. Or. 1962*

NOTE: This drawing is clearly by an Indian artist and not by Thomas Longcroft, although it may possibly be from his collection. Longcroft was in India from 1783 until his death in 1811. He was himself an amateur artist but also possessed a collection of drawings by Indian artists. The whole collection passed to his relative Thomas Twining and the Library possesses seven pictures from it, donated by a descendant, Louisa Twining. These bear inscriptions in handwriting similar to that on the present picture. When making her gift, Miss Twining indiscriminately attributed all pictures in the collection to Longcroft himself (see Mildred Archer, *British drawings in the India Office Library* (London, 1969), i, 245–246). Although this drawing was acquired by the Library from another source it almost certainly came from the Twining family and the inscription is probably yet another example of Miss Twining's mistaken attributions. If Longcroft collected the drawing it must date from *c.* 1810.

135
i–xvi 16 drawings bound into an album depicting Muslim buildings at Delhi, Agra, Sikandra and Fatehpur Sikri.

By a Delhi or Agra artist, *c.* 1817.

Water-colour; size of volume and drawings 20 by 29 ins. Indian ink border and rule. Water-marks of 1811 and 1815. Bookplates of John and Richard Fort of Read Hall.

Presented by Richard Fort, 1 July 1944. *Add. Or. 1746–1761*

NOTE: Richard Fort was the great-grandson of 'General Smith' by whom the drawings were acquired. 'Smith' was most probably Sir Lionel Smith (1778–1842) who served in India from

1807 to 1833 and commanded in the Third Maratha War of 1817 to 1818. He may well have obtained these drawings in Agra or Delhi about 1817. They are uniform in style and size and are probably by the same artist. They show the building in elevation against a white background. Small boats appear on the river. Otherwise no human details.

 i Agra Fort from the river; country boats in foreground.
 1815 water-mark. *Add. Or. 1746*

 ii General view of the Taj Mahal showing the mausoleum, mosque and assembly halls from the river; country boats in the foreground.
 1815 water-mark. *Add. Or. 1747*

 iii Mausoleum of Akbar, Sikandra; a corner view. *Add. Or. 1748*

 iv The Qutb Minar, Delhi.
 1811 water-mark. *Add. Or. 1749*

 v Entrance gatehouse to Akbar's mausoleum, Sikandra.
 1815 water-mark. *Add. Or. 1750*

 vi Entrance gateway of the Taj Mahal, Agra. *Add. Or. 1751*

 vii Mausoleum of Itimad-ud-daula, Agra (*Plate 63*). *Add. Or. 1752*

 viii Mausoleum of Salim Chishti, Fatehpur Sikri.
 1815 water-mark. *Add. Or. 1753*

 ix Central chamber, Taj Mahal, Agra.
 1815 water-mark. *Add. Or. 1754*

 x Upper terrace of Akbar's mausoleum, Sikandra, showing marble cenotaph in centre.
 1815 water-mark. *Add. Or. 1755*

 xi The Pearl Mosque (Moti Masjid), Agra.
 1815 water-mark. *Add. Or. 1756*

 xii Cenotaph of the Empress Arjumand Banu Begam, Taj Mahal, Agra.
 1815 water-mark. *Add. Or. 1757*

 xiii Cenotaph of the Emperor Shah Jahan, Taj Mahal, Agra.
 1815 water-mark. *Add. Or. 1758*

 xiv Details of pietra dura work from the slab on top of the Emperor's cenotaph and from the enclosing screen, Taj Mahal, Agra. *Add. Or. 1759*

 xv Four panels with flower designs in pietra dura work from the screen round the cenotaphs in the central chamber, Taj Mahal, Agra.
 1815 water-mark. *Add. Or. 1760*

 xvi Tops of the cenotaphs in the Taj Mahal, Agra; above, the Empress Arjumand Banu Begam's cenotaph; below, the Emperor Shah Jahan's.
 1815 water-mark. *Add. Or. 1761*

136 i, ii 2 views of the Agra and Delhi Forts.
By a Delhi or Agra artist, *c.* 1820.
Circumstances of acquisition unrecorded. *Add. Or. 539, 540*

i View of Agra Fort from the river; country boats in the foreground. Border cut away.
Water-colour; 12¾ by 40 ins. *Add. Or. 539*

ii View of Delhi Fort from the river; narrow Indian ink border and rule.
Water-colour; 11¾ by 37¼ ins. 1816 water-mark. *Add. Or. 540*

137 i, ii 2 drawings of the Taj Mahal, Agra.
By a Delhi or Agra artist, *c.* 1820.
Water-colour; various sizes.
Purchased 23 September 1952. *Add. Or. 953; 954*

i Interior of the Taj Mahal.
Water-colour; 29 by 18 ins. *Add. Or. 953*

ii The screen round the cenotaphs of the Emperor Shah Jahan and the Empress Arjumand Banu Begam in the Taj Mahal.
Inscribed on front: *The Door and Screens round the Tombs of Shah Jehan and Moomtaz Mahel.*
Water-colour; 18¾ by 23 ins. *Add. Or. 954*

138 The screen round the cenotaphs in the Taj Mahal, Agra.
By a Delhi or Agra artist, *c.* 1820.
Inscribed on back in Persian characters: *Naqshah i majhir i raudah i munauwarah i Mumtāz Maḥall wa-ḥaḍrat Shāhjahān bādshāh i ghāzī andarūn i raudah i muṭahharah* (Picture of the enclosure of the illustrious tomb of Mumtaz Mahal and his majesty Shah Jahan conqueror of infidels, inside the sacred tomb).
Water-colour; 20½ by 27¾ ins.
Purchased 27 September 1906. *Add. Or. 565*

139 The Taj Mahal, Agra, and the entrance gardens with trees, cypresses and flower beds; a gardener with a basket of greenery on his head in the foreground.
By a Delhi or Agra artist, *c.* 1820.
Water-colour; 22 by 27¼ ins. Narrow Indian ink border between double rules. 1816 water-mark.
Purchased 27 September 1906. *Add. Or. 567*

NOTE: Similar to no. 143 with its concentration on a landscape setting.

140 i–iii Three drawings of monuments at Agra.
By a Delhi or Agra artist, *c.* 1820.
Inscribed with titles in Persian characters.
Water-colour; various sizes. Water-marks of 1817. Narrow Indian ink border.
Purchased 27 September 1906. *Add. Or. 558–560*

NOTE: These drawings are executed in a somewhat rougher style than the preceding drawings, the colour is harsh and the line more hesitant.

i Entrance gateway to the Taj Mahal, Agra.
Inscribed on front: *Outer Grand Entrance to the Taj Garden*: on back in Persian characters: *Naqshah i kalān darwāzah i rauḍah i munauwarah i Mumtāz Maḥall u ḥaḍrat Shāhjahān bādshāh i ghāzī. 21* (Picture of the great gate of the illumined tomb of Mumtaz Mahal and his Majesty Shah Jahan, King, conqueror of infidels).
Water-colour; 14 by 18¼ ins. *Add. Or. 558*

ii Delhi Gate, Agra Fort.
Inscribed on back in Persian characters: *Naqshah i Dihlī darwāzah i qil'ah i ṣūbah i mustaqarr al-khilāfah Akbarābād. 23* (Picture of the Delhi Gate of the Fort of the province of the abode of the caliphate Akbarabad).
Water-colour; 14½ by 19 ins. *Add. Or. 559*

iii The Pearl Mosque (Moti Masjid), Agra.
Inscribed on back in Persian characters: *Naqshah i Motī Masjid i qil'ah i ṣūbah i mustaqarr al-khilāfah Akbarābād, 22* (Picture of the Moti Masjid within the Fort of the province of the abode of the caliphate Akbarabad).
Water-colour; 15 by 19¼ ins. *Add. Or. 560*

141 i–iv 4 drawings of monuments at Agra.
By a Delhi or Agra artist, *c.* 1820.
Water-colour; varying sizes.
Purchased 27 September 1906. *Add. Or. 562–564; 566*

NOTE: Elevations against a plain white background. Black border partially cut away.

i Mausoleum of Itimad-ud-daula, Agra.
Inscribed on front: *Aitimal-ood-dowlah's tomb taken from the Gateway.*
Water-colour; 18¼ by 28½ ins. *Add. Or. 563*

ii Interior of the mausoleum of Itimad-ud-daula, Agra (*Plate 64*).
Inscribed on front: *Interior of Atimad-ood-dowlah's Tomb.*
Water-colour; 19¼ by 23¼ ins. *Add. Or. 562*

iii The Private Apartments (Khas Mahal), in the Fort, Agra.
Water-colour and pencil; 19 by 27½ ins. *Add. Or. 564*

iv Entrance gateway to the Taj Mahal, Agra, with the mausoleum in the background.
Water-colour; 15½ by 25¼ ins. Water-mark of 1816.
Purchased 27 September 1906. *Add. Or. 566*

142 i–xx 20 drawings, originally bound into an album, depicting Muslim monuments at Delhi, Agra and Fatehpur Sikri, *c.* 1820–22.

(i–xviii) by Latif, an Agra artist; (xix) and (xx) by a different Delhi or Agra artist. Inscribed with titles in English and Urdu; (i–xvii) inscribed: '*Amal i Laṭif* (The work of Latif). All inscribed *Presented by John Bax Esq. 9th Sep 1824.*
Water-colour; size of original volume 31 by 25 ins; size of drawings 21 by 28 ins.
Presented by John Bax, 9 September 1824. *Add. Or. 1791–1810*

NOTE: John Bax (1793–1863) was in the Bombay Civil Service from 1812 onwards. 1812 assistant to Accountant General; 1813 Secretary of Military Board; 1815 Acting Register to Sadar Adalat and Superior Tribunal. From 1822 to 1826 he was 'out of employ', returning to Bombay as Deputy Collector and Magistrate, Khandesh, 1826. It seems most probable that Bax visited Delhi and Agra some time in 1821 or 1822 and then took his drawings back to England and presented them to the East India Company. Latif appears to have been one of the best known Agra artists as well as an architect. Fanny Parks bought drawings from him in 1835, and used two of them for plates 24 and 26 in the first volume of her book, *Wanderings of a pilgrim in search of the picturesque* (London, 1850).

'The outline of the Taj, that I have annexed, was executed by Luteef, a native artist at Agra. It merely gives a faint idea of the style of architecture; the beauty of the tomb, the handsome buildings that appertain to it, the marble courts, the fine garden, the fountains, the beautiful trees, the river Jumna, – all are omitted, the mere elevation is represented in the sketch' (Parks, i, 349, January 1835).

When describing the tomb of Colonel Hessing at Agra she wrote: 'This beautiful Mausoleum is in the Catholic burial ground at Agra, and is well worth a visit. It was built by a native architect, by name Luteef, in imitation of the ancient Muhammadan tombs. The material is the red stone from Fathipoor Sicri, which is highly carved, but not inlaid. The tomb is beautiful, very beautiful, and in excellent taste. Its cost is estimated at about one lakh of rupees. Luteef's drawings of the Taj and of all the ancient monuments around Agra are excellent; they cost from three to forty rupees each. I bought a large collection of them, as well as of marbles and other curiosities. Luteef inlays marble with precious stones, after the style of the work in the Taj. A chess-table of this sort, with a border of flowers in mosaic, costs from eight to twelve hundred rupees, £80, or £120 and is beautifully executed' (*Ibid*, i, 418, 15 March 1835).

Latif's drawings show the monuments in elevation against a plain background. xix and xx depict the monument in a landscape with figures and are typical of the new type of drawings which developed in Delhi under the influence of English prints and water-colours.

For a similar use of architectural drawings by Delhi and Agra artists as illustrations to a personal narrative, see W. H. Sleeman, *Rambles and recollections of an Indian official*, 2 vols. (London, 1844), plates 1–30.

 i General view of the Taj Mahal from the river showing the mosque, mausoleum and assembly hall; a boat in the foreground.
 Inscribed on front in English: *The Taj Mahl (sic) at Agra*; in Persian characters; *Rauḍah i Arjumand Bānū Begum mukẖāṭab Mumtāz Maḥall 'amal i Laṭif* (The mausoleum of Arjumand Banu Begam called Mumtaz Mahal. The work of Latif). *Add. Or. 1791*
 ii The screen round the cenotaphs in the Taj Mahal, Agra.

Inscribed on front in English: *The Jalee or railing round the Tomb of the Empress (wife) of Sha Jehan at the Taj Mhal at Agra*; in Persian characters: *Jālī i andarūn i rauḍah i Mumtāz Maḥall ʿamal i Laṭīf* (The screen round the cenotaph of Mumtaz Mahal. The work of Latif). *Add. Or. 1792*

iii Cenotaph of the Empress Arjumand Banu Begam in the Taj Mahal, Agra.
Inscribed on front in English: *Tomb of the Empress wife of Shah Jehan in the Taj Mhal*; in Persian characters: *Qabr i Mumtāz Maḥall ʿamal i Laṭīf* (The grave of Mumtaz Mahal. The work of Latif). *Add. Or. 1793*

iv Cenotaph of the Emperor Shah Jahan in the Taj Mahal, Agra.
Inscribed on front in English: *Grave of the Emperor Sha Jehan at the Taj Mhal*; in Persian characters: *Qabr i Shāhjahān bādshāh ʿamal i Laṭīf* (The grave of the Emperor Shah Jahan. The work of Latif). *Add. Or. 1794*

v(a) The top of the cenotaph of the Emperor Shah Jahan in the Taj Mahal, Agra.
Inscribed on front in English: *The Top of the Emperor Sha Jehan's grave at the Taj Mhal*; in Persian characters: *Lauḥ i qabr i Shāhjahān bādshāh ʿamal i Laṭīf* (The top of the grave of the Emperor Shah Jahan. The work of Latif).

(b) The top of the cenotaph of the Emperor Akbar at Sikandra.
Inscribed on front in English: *The Top of the Emperor Akbar's grave at Secundra*; in Persian characters: *Lauḥ i qabr i Akbar bādshāh dar Sikandrah ʿamal i Laṭīf* (The top of the grave of the Emperor Akbar at Sikandra. The work of Latif). *Add. Or. 1795*

vi The Pearl Mosque (Moti Masjid), Agra.
Inscribed on front in English: *The Moota Musjid or Marble Mosque of Agra*; in Persian characters: *Motī Masjid dar qilʿah i Akbarābād ʿamal i Laṭīf* (The Moti Masjid at the fort of Agra. The work of Latif). *Add. Or. 1796*

vii Interior of the private apartments in the Fort, Agra (*Plate 65*).
Inscribed on front in English: *Interior of the private Hall of Audience at Agra*; in Persian characters: *Saqaf i andarūn i khāṣṣ maḥall i qilʿah i Akbarābad ʿamal i Laṭīf* (The ceiling inside the private apartments in the Fort of Agra. The work of Latif). *Add. Or. 1797*

viii Delhi Gate, Agra Fort.
Inscribed on front in English: *Gateway of the Fort of Agra*; in Persian characters: *Darwāzah i qilʿah i Akbarābād mashhūr ba-Dihlī darwāzah ʿamal i Laṭīf* (Gate of the fort of Agra called the Delhi gate. The work of Latif). *Add. Or. 1798*

ix Mausoleum of Itimad-ud-daula, Agra.
Inscribed on front in English: *Tomb of Ittameh ud Dowlah near Agra*; in Persian characters: *Rauḍah i Iʿtimād al-Daulah ʿamal i Laṭīf* (Mausoleum of Itimad-ud-daula. The work of Latif). *Add. Or. 1799*

x Interior of the mausoleum of Itimad-ud-daula, Agra.
Inscribed on front in English: *Interior of the Tomb of Ittamed ud Dowlah*; in Persian characters: *Saqaf i andarūn i rauḍah i Iʿtimād al-Daulah ʿamal i Laṭīf*

(Interior of the mausoleum of Itimad-ud-daula. The work of Latif).

Add. Or. 1800

xi 'Gate of Magnificence' (Buland Darwaza), Fatehpur Sikri.
Inscribed on front in English: *Gateway at Futipoor*; in Persian characters: *Darwāzah i Fathpūr 'amal i Laṭīf* (Gate of Fatehpur. The work of Latif).

Add. Or. 1801

xii Mausoleum of Salim Chishti, Fatehpur Sikri.
Inscribed on front in English: *Tomb of Sheik Selim at Futtipoor*; in Persian characters: *Rauḍah i munauwarah i ḥaḍrat Shaikh Salīm Chishtī ba-maqām i Fathpūr Sikrī 'amal i Laṭīf* (The illumined tomb of the saint Shaikh Salim Chishti at Fatehpur Sikri. The work of Latif).

Add. Or. 1802

xiii Entrance gatehouse to Akbar's mausoleum, Sikandra.
Inscribed on front in English: *Gateway of the Tomb of the Emperor Akbar at Secundra*; in Persian characters: *Darwāzah i Sikandrah i rauḍah i Akbar bādshāh 'amal i Laṭīf* (Gate of the mausoleum of the Emperor Akbar at Sikandra. The work of Latif).

Add. Or. 1803

xiv Cenotaph of Akbar in the mausoleum at Sikandra.
Inscribed on front in English: *Sarcophagus. Grave of the Emperor Akbar at Secundra*; in Persian characters: *Qabr i Akbar bādshāh dar rauḍah i Sikandrah 'amal i Laṭīf* (Grave of the Emperor Akbar at the mausoleum at Sikandra. The work of Latif).

Add. Or. 1804

xv Mausoleum of Akbar, Sikandra; a corner view.
Inscribed on front in English: *Tomb of the Emperor Akbar at Secundra*; in Persian characters: *Sikandrah: rauḍah i Akbar bādshāh 'amal i Laṭīf* (Sikandra: Mausoleum of the Emperor Akbar. The work of Latif).

Add. Or. 1805

xvi Jami Masjid, Delhi.
Inscribed on front in English: *Juma Musjid or Grand Mosque of Delhi*; in Persian characters: *Jāmi' masjid dar Shāhjahānābād 'amal i Laṭīf* (Jama Masjid of Shahjahanabad. The work of Latif).

Add. Or. 1806

xvii The Qutb Minar, Delhi.
Inscribed on front in English . . . *at Delhi*; in Persian characters: *Lāṭh i Quṭb Ṣāḥib dar shahr i Dihlī 'amal i Laṭīf* (Pillar of Qutb Sahib at the city of Delhi. The work of Latif).

Add. Or. 1807

xviii Tops of the cenotaphs of the Emperor Shah Jahan and the Empress Arju-mand Banu Begum in the Taj Mahal, Agra.

Add. Or. 1808

xix Mausoleum of Humayun and the double-domed tomb within the compound, Delhi. Full landscape with trees bushes and figures in foreground (*Plate 66*).
Inscribed on front in English: *Tomb of Hoomauyoon Bad Shah; Tomb of Koaka*; in Persian characters: *Maqbarah i Kokah – Maqbarah i Humāyūn bādshāh i ghāzī* (Tomb of Kokah – tomb of the Emperor Humayun).

Add. Or. 1809

xx Mausoleum of Safdar Jang, Delhi. Full landscape with figures, including

British soldiers in the foreground (*Plate 67*).

Inscribed on front in English: *Tomb of Sufdurjung*; in Persian characters: *Naqshah i maqbarah i Ṣafdar Jang* (Picture of the tomb of Safdar Jang).

Add. Or. 1810

143
i–xix

18 drawings of monuments in landscape settings at Panipat, Delhi, Agra, and Sikandra.

By a Delhi or Agra artist, *c.* 1820–25.

Water-colour; 10¼ by 14¼ ins. Water-mark of 1817.

Purchased 27 September 1906

Add. Or. 547–557 and 3119–3125 (Revised Foster catalogue, nos. 741–747)

NOTE: In this set the monuments are shown in a full landscape setting with clouds in the sky and animated groups of small figures. The drawings are very similar to British water-colours of the period, and show considerable mastery of European perspective and figure drawing. Indian artists at this time were copying British prints and drawings when available, see (iii) and (xii). Titles are inscribed on the front in large and small Persian characters. These drawings were acquired at the same time as no. 147.

 i The tombs of Abu Ali Qalandar and Nawab Muqarrab Khan at Panipat, near Delhi; figures in the foreground.

 Inscribed on front in Persian characters: *Naqshah i dargāh i ḥaḍrat Shāh Sharaf Bū ʿAlī Qalandar dar Pānīpat* (Picture of the shrine of Shah Sharaf Bu Ali Qalandar at Panipat); *Burj i Nauwāb Muqarrab Khān* (Tower of Nauwab Muqarrab Khan); on back in English: *1. The Tomb of Bolie Kulander, Panieputt. The Tomb of Nowab Mukerub Khan.* *Add. Or. 554*

 ii Qadam Rasul, the Court of the Print of the Prophet's Foot, Paharganj, Delhi; figures seated in the courtyard.

 Inscribed on front in Persian characters: *Naqshah i dargāh i qadam i sharīf* (Picture of the shrine of the relic); on back in English: *2. The Court of the Print of Prophet's Foot, Delhi.* *Add. Or. 547*

 iii The Jami Masjid, Delhi.

 Inscribed on front in Persian characters: *Naqshah i masjid i jāmiʿ i dār al-khilāfah Shāhjahānābād* (Picture of the cathedral mosque in the seat of the caliphate Shahjahanabad); on back *3. The Jama Musjid, or Mosque at Delhi.* 1817 water-mark. *Add. Or. 548*

 NOTE: This drawing is a copy of the aquatint by T. and W. Daniell, *Oriental Scenery*, series 1, no. 23, 'The Jummah Musjeed, Delhi' (1797). The grouping of the figures has however been changed.

 iv View of the Red Fort, Delhi, seen across the Jumna; an elephant, cattle and an Indian carriage in the foreground.

 Inscribed on front in Persian characters: *Naqshah i rūkār i qilʿah i mubārak i Shāhjahānābād ba-ṭaraf i daryā i Jamuna* (Picture of the view of the blessed fort of Delhi on the side of the river Jumna).

Add. Or. 3119 (Revised Foster catalogue, no. 747)

v The Hall of Private Audience, Red Fort, Delhi; a red canopy in the foreground, a horse and various figures.

Inscribed on front in Persian characters: *Naqshah i anjuman i Dīwān i Khāṣṣ i qil'ah i Shāhjahānābād* (Picture of the assembly of the Diwan i Khass in the Fort of Shahjahanabad); on back in English: *5. The Hall of Audience in the Fort of Delhi.* Add. Or. 549

NOTE: The Royal Institute of British Architects has an unfinished version of this picture on paper with an 1811 water-mark; the Victoria and Albert Museum has a similar picture (*03538 I.S.*) with figures and horses differently arranged.

vi The Zinat ul-Masajid, Daryaganj, Delhi.

Inscribed on front in Persian characters: *Naqshah i Zīnat al-masājid* (Picture of the Adornment of Mosques); on back in English: *6. The Zeenat Musajid or adornment of Mosques at Delhi.* Add. Or. 550

vii Mausoleum of Nawab Safdar Jang, Delhi. A distant view of the tomb with its gateway and wall with turrets; tents and a cavalcade with elephant, camels and horses in foreground.

Inscribed on front in Persian characters: *Naqshah i darwāzah i maqbarah i Nauwāb Ṣafdar Jang Bahādur* (Picture of the gateway of the mausoleum of Nawab Safdar Jang). Add. Or. 3120 (*Revised Foster catalogue, no. 741*)

viii Mausoleum of Nawab Safdar Jang, Delhi.

Inscribed on front in Persian characters: *Naqshah i maqbarah i Nauwāb Ṣafdar Jang* (Picture of the tomb of Nauwab Safdar Jang); on back in English: *8. The Tomb of Nowab Sufdar Jung, at Delhi.* Add. Or. 551

ix Mausoleum of the Emperor Humayun, Delhi.

Inscribed on front in Persian characters: *Naqshah i maqbarah i Humāyūn Shāh; Naqshah i maqbarah i Humāyūn bādshāh* (Picture of the mausoleum of the Emperor Humayun). Add. Or. 3121 (*Revised Foster catalogue, no. 742*)

x The Qutb Minar, Delhi.

Inscribed on front in Persian characters: *Naqshah i manārah i ḥaḍrat Khwājah Ṣāḥib* (Picture of the tower of the sainted Khwajah Sahib); on back: *The Pillar of Khoijah Kootub, near Delhi.*

Add. Or. 3122 (*Revised Foster catalogue, no. 743*)

xi Firuz Shah Kotla, Delhi.

Inscribed on front in Persian characters: *Naqshah i koṭlah i Fīrūz Shāh* (Picture of the Kotla of Firuz Shah); on back in English: *10. The Fort of Feroz Shah, Delhi.* Add. Or. 552

xii The Qudsiya Gardens, Delhi; a boat and cattle on the left and a number of figures in the foreground (*Plate 61*).

Inscribed on front in Persian characters: *Naqshah i Qudsīyah Bāgh* (Picture of the Qudsiya Bagh); on back in English: *16. The Koodseah grove at Delhi.* Add. Or. 553

NOTE: This drawing is a copy of the aquatint by T. and W. Daniell, *Oriental Scenery*, Series 1, no. 3. 'The Cotsea Bhaug, on the River Jumna, at Delhi' (1795).

xiii The Golden Mosque of Bahadur Ali Khan, Delhi.

Inscribed on front in Persian characters: *Naqshah i masjid i ṭilā i Nauwāb Bahādur ʿAlī Khān* (Picture of the golden mosque of Nawab Bahadur Ali Khan). *Add. Or. 3123 (Revised Foster catalogue, no. 745)*

xiv Entrance gatehouse to Akbar's mausoleum, Sikandra; the mausoleum in the background.

Inscribed on front in Persian characters: *Naqshah i darwāzah i Sikandrah* (Picture of the gate of Sikandrah); on back in English: *12. The Gateway at Secundra.* *Add. Or. 555*

xv Mausoleum of Akbar, Sikandra.

Inscribed on front in Persian characters: *Naqshah i maqbarah i ḥaḍrat Jalāl al-Dīn Muḥammad Akbar Shāh dar Sikandrah* (Picture of Akbar's tomb in Sikandrah); on back in English: *14. The Tomb of Jalaloodeen Akbar Shah, at Secundra, near Agra.* *Add. Or. 556*

xvi Mausoleum of Itimad-ud-daula, Agra; a number of figures in the foreground.

Inscribed on front in Persian characters: *Naqshah i maqbarah i Nauwāb Iʿtimād al-daulah dar Akbarabad* (Picture of the tomb of Nawab Itimad ud-daula in Akbarabad); on back in English: *15. The Tomb of Aitma dowlah, Agra.* *Add. Or. 557*

xvii The Taj Mahal, Agra, showing the entrance gateway, mosque and mausoleum.

Inscribed on front in Persian characters: *Naqshah i rauḍah i Tāj ganj dar Akbarābād* (Picture of the mausoleum of the Crown-Treasure at Agra); on back: *The Tomb of Taj Mahel. Agra.* *Add. Or. 3124 (Revised Foster catalogue, no. 746)*

xviii Delhi Gate, Agra Fort.

Inscribed on front in Persian characters: *Naqshah i darwāzah i qilʿah i Akbarābād* (Picture of the gateway of the fort of Agra). *Add. Or. 3125 (Revised Foster catalogue, no. 744)*

144 The Chaunsath Khambe (Pavilion of Sixty-four pillars) containing the tomb of Azam Khan Kokah, Delhi; in the background, the tomb of Atga Khan.
By a Delhi artist, *c.* 1820–25.
Inscribed in Persian characters: *Naqshah i maqbarah i Aʿẓam Khān Kokah i Humāyūn i pādshāh* (Picture of the tomb of Aʿzam Khan Kokah [i.e. foster brother] of Emperor Humayun); in English: *The Tomb of the Royal Family.*
Water-colour; 10 by 13¾ ins. Indian ink border.
Purchased 20 February 1967. *Add. Or. 2663*

NOTE: This drawing is in the same style as no. 143 and was probably part of a similar set.

The Chaunsath Khambe, a grey marble pavilion, was the family burial place of Aziz Khan Kokah, called Khan i Azam, who died at Ahmedabad in 1624. He was the foster-brother of Akbar,

not, as stated in the inscription, of Humayun. The domed tomb in the background is that of his father Atga Khan (died 1562), foster-father of Akbar. These buildings are all set in the shrine-complex of Nizam-ud-din Aulia, which lies to the south of Delhi.

145 The Taj Mahal, Agra, from the river showing the mausoleum, mosque and assembly hall.

By a Delhi or Agra artist, *c.* 1820–30.

Inscribed on original mount: *The Taj Mahal by an Indian artist, about 1828. The drawing belonged to the late Colonel James Arden Crommelin. R. E. of Darjeeling* (1801–93); on back of picture: *The Tahje Mahl at Agra. Drawn by a Native*; also descriptive notes.

Water-colour; $9\frac{1}{2}$ by $13\frac{1}{2}$ ins. Indian ink border and double rules. Water-mark of 1817.

Presented by Miss Estelle Blyth, grand-daughter of Colonel Crommelin, 26 November 1942. *Add. Or. 340*

NOTE: Colonel Crommelin served in the Bengal Engineers 1820–43 (see Mildred Archer, *British drawings in the India Office Library* (London, 1969), i, 155–156).

He probably acquired this drawing, as well as no. 146, during his early years in India. Although the family's inscription mentions the year 1828, the 1817 water-mark would suggest a slightly earlier date.

146 Mausoleum of Akbar, Sikandra.

By a Delhi or Agra artist, *c.* 1820–30.

Water-colour; $7\frac{1}{2}$ by 9 ins. Narrow Indian ink border and rule.

Presented by Miss Estelle Blyth, 26 November 1942. *Add. Or. 341*

NOTE: From the same group of papers as no. 145. This drawing was probably also collected by Colonel Crommelin, grand-father of Miss Blyth.

147 i–vi 6 drawings of scenes on the North West Frontier and in the Punjab; 1 of a mosque at Peshawar, 5 of forts.

Probably by a Delhi artist, *c.* 1825.

Water-colour; varying sizes. Water-marks of 1819, 1820 and 1822.

Purchased 27 September 1906 *Add. Or. 541–546*

NOTE: These drawings were acquired at the same time as no. 143 and are in a very similar style. Unlike the latter drawings they do not appear to be a stock set and it seems probable that a Delhi painter accompanied some British officer to the Punjab and made these landscapes specially for him. At the date when these drawings were made Ranjit Singh was at the height of his power and the Punjab was still an area little known to the British.

With the exception of (i) which is very like the set no. 143, the drawings are in similar style showing a low flat landscape with a great expanse of sky and a foreground consisting of blurred washes of colour. Shades of brown and dull green predominate. Narrow Indian ink border and rule.

 i The Jami Masjid, Peshawar (North West Frontier Province).

Inscribed on front in Persian characters: *Naqshah i masjid i jamiʻ i Pashāwar* (Picture of the cathedral mosque, Peshawar); on back in English: *11. The Juma Musjid at Peshwar.*

1822 water-mark. 12 by 16 ins. *Add. Or. 546*

 ii The Town and Fort of Khyber (North West Frontier Province); river and boats in the foreground.

Inscribed on front in Persian characters: *Naqshah i shahr u qilʻah i Khaibar* (Picture of the town and fortress of Khyber); on back ditto in English.

1820 water-mark. 21 by 29 ins. *Add. Or. 541*

 iii View of Lahore (Punjab).

Inscribed on front in Persian characters: *Taṣwīr i dār al-salṭanat Lāhaur* (Picture of the seat of government Lahore); on back in English: *The City of Lahore.*

1819 water-mark. 16 by 29 ins. *Add. Or. 542*

 iv View of Amritsar (Punjab).

Inscribed on front in Persian characters: *Naqshah i qilʻah i Gobindgarh yaʻnī Amritsar* (Picture of the fortress of Gobindgarh that is Amritsar); on back in English: *The Fort of Gobindgarh, 18 Coss from Lahore.*

1819 water-mark. 21 by 29 ins. *Add. Or. 543*

 v Another view of the city of Amritsar (Punjab).

Inscribed on front in Persian characters: *Naqshah i shahr i Amritsar* (Picture of the city of Amritsar); on back in English: *The City of Amritsar.*

1822 water-mark. 14 by 29 ins. *Add. Or. 544*

 vi View of the Fortress of Ludhiana (Punjab); a river and rocks in the foreground.

Inscribed on front in Persian characters: *Naqshah i qilʻah i Lūdhiyānah* (Picture of the fortress of Ludhiana); on back in English: *The Fort of Loodianah.*

1819 water-mark. 17½ by 29 ins. *Add. Or. 545*

148 The screen round the cenotaphs in the Taj Mahal, Agra.

By a Delhi or Agra artist, *c.* 1830.

Pen-and-ink and water-colour; 18 by 24½ ins. Narrow Indian ink border and rules. Water-mark of 1827.

Presented by Mildred and W. G. Archer, 6 November 1959. *Add. Or. 990*

149 The Taj Mahal, Agra, from the river, showing the mausoleum, mosque and assembly hall.

By a Delhi or Agra artist, *c.* 1830.

Inscribed on back in Persian characters: *Naqshah i raudah i Mumtāz Maḥall u Shāhjahān bādshāh* (Picture of the tomb of Mumtaz Mahal and the Emperor Shah Jahan).

Water-colour; 14¾ by 21¼ ins. Narrow Indian ink border.

Purchased 27 September 1906. *Add. Or. 561*

150 The Taj Mahal, Agra, with trees on either side.
By a Delhi or Agra artist, *c.* 1830.
Inscribed on back: *The Taj Mahal at Agra. S. View Taj.*
Water-colour; 4½ by 6¼ ins. Narrow ruled Indian ink border between double
black rules.
Purchased August 1955. *Add. Or. 331*

151 i, ii 2 drawings of monuments at Delhi and Agra.
By a Delhi or Agra artist, *c.* 1830.
Water-colour; 4 by 6¾ ins. Ruled Indian ink border.
Purchased 11 May 1953. *Add. Or. 332; 333*

NOTE: These drawings, together with no. 152 came from an album belonging to Isabella Dalzell.
It also contained *WD486–491* and mica paintings no. 108. Dates in the album range from 1825 to
1832 (see Mildred Archer, *British drawings in the India Office Library* (London, 1969), i, 168).

i Lahore Gate, Red Fort, Delhi, with soldiers, horses and elephants in the fore-
ground. *Add. Or. 332*
ii Agra Fort from the river; boats in the foreground. *Add. Or. 333*

152 i–vi 6 drawings of monuments at Agra and Sikandra.
By a Delhi or Agra artist, *c.* 1830.
Water-colour; 4 by 6¾ ins. Narrow Indian ink border and rule.
Purchased 11 May 1953. *Add. Or. 334–339*

NOTE: These drawings, together with no. 151, came from the album belonging to Isabella Dalzell.
The present drawings are in a delicate style in contrast to no. 158 which are naive and crude.

i The Pearl Mosque (Moti Masjid), Agra. *Add. Or. 334*
ii Entrance gateway to the Taj Mahal, Agra. *Add. Or. 335*
iii The Taj Mahal, Agra, from the river, showing the mausoleum, mosque and
assembly hall. *Add. Or. 336*
iv The screen round the cenotaphs of the Emperor Shah Jahan and the Empress
Arjumand Banu Begam in the Taj Mahal, Agra.
Inscribed on front: *Marble enclosure round the Tomb inside the Dome of the
Tagh-Agra.* *Add. Or. 337*
v Entrance gatehouse to Akbar's mausoleum, Sikandra.
Inscribed on front: *Entrance Gateway of the Tomb.* *Add. Or. 338*
vi Mausoleum of Akbar, Sikandra.
Inscribed on front: *Tomb of Sekander.* *Add. Or. 339*

153 Mausoleum of Akbar, Sikandra.
By a Delhi or Agra artist, *c.* 1830.

Inscribed on front in Persian characters: *Sikandrah maqbarah i Akbar bādshāh dū kurūh mufāṣilah az qil'ah i Āgrah. bīst u dū* (Sikandra: mausoleum of the Emperor Akbar, two leagues distant from the Agra fort. No. 22.)
Water-colour; 18 by 25 ins.
Presented by Mildred and W. G. Archer, November 1959. *Add. Or. 991*

154 i, ii 2 drawings of monuments at Agra.
By a Delhi or Agra artist, *c.* 1835.
Water-colour; 7 by 8¾ ins. Narrow Indian ink border between double black rules.
Purchased August 1955. *Add. Or. 329; 330*

 i Mausoleum of Itimad-ud-daula, Agra.
 Water-mark of 1831. *Add. Or. 329*
 ii The Taj Mahal, Agra, with trees on either side.
 Inscribed on back: *The Taj Mahal at Agra.* *Add. Or. 330*

155 i, ii 2 drawings of the Taj Mahal, Agra.
By a Delhi or Agra artist *c.* 1835–40.
Water-colour; 3¾ by 4½ ins. Narrow Indian ink border.
Purchased August 1955. *Add. Or. 328; 305*

 i The mosque on the west side of the Taj Mahal. *Add. Or. 328*
 ii Entrance gateway to the Taj Mahal. *Add. Or. 305*

156 14 drawings of monuments at Agra, Fatehpur Sikri and Sikandra.
i–xiv By a Delhi or Agra artist, *c.* 1835–40.
Water-colour; 7½ by 9 ins. Water-mark of 1834. Narrow Indian ink border.
Purchased August 1955. *Add. Or. 307–319; 326*

 i Entrance gateway to the Taj Mahal, Agra. *Add. Or. 307*
 ii The Taj Mahal, Agra, from the river. *Add. Or. 308*
 iii The Taj Mahal, Agra. *Add. Or. 309*
 iv Side view of the Taj Mahal, Agra. *Add. Or. 310*
 v Interior of the Taj Mahal, Agra. *Add. Or. 311*
 vi The screen round the cenotaphs, Taj Mahal, Agra. *Add. Or. 312*
 vii The cenotaph of the Emperor Shah Jahan, Taj Mahal, Agra. *Add. Or. 313*
 viii The cenotaph of Arjumand Banu Begam, Taj Mahal, Agra. *Add. Or. 314*
 ix The Pearl Mosque (Moti Masjid), Agra.
 1834 water-mark. *Add. Or. 316*
 x Gatehouse to Akbar's mausoleum, Sikandra. *Add. Or. 318*
 xi Mausoleum of Akbar, Sikandra. *Add. Or. 319*

xii Akbar's cenotaph on the upper terrace of the mausoleum, Sikandra.

Add. Or. 315

xiii Mausoleum of Itimad-ud-daula, Agra. *Add. Or. 317*

xiv Mausoleum of Salim Chishti, Fatehpur Sikri. *Add. Or. 326*

157 i–v 5 drawings of Muslim monuments at Agra, Sikandra and Fatehpur Sikri.
By a Delhi or Agra artist, *c.* 1836.
Water-colour; size of volume: 9¾ by 6 ins. Drawings various sizes. Indian ink rule border.
Purchased 1 August 1843. *Persian MSS. I.O.L. 2450*

NOTE: See H. Ethé, *Catalogue of Persian manuscripts in the Library of the India Office* (Oxford, 1903), i, no. 731, and C. A. Storey, *Persian literature* (London, 1939), i, 693. These drawings are illustrations to a Persian manuscript, *Tafrīḥ al-'imārāt*, made for James Davidson, Sessions Judge, Agra, 1836–37. The manuscript is a copy of a topographical and historical account of the principal public buildings, mausoleums, mosques and gardens of Agra and the neighbourhood, originally compiled by Sil Chand, a pupil of the Agra Government College at the request of James Stephen Lushington, Acting Collector, Agra, 1825–26. Although the original manuscript was specially commissioned, the illustrations in the present copy appear to be stock paintings of the period. The buildings are shown in elevation against an uncoloured background with delicate and subdued colour.

 i f.30 The pearl Mosque (Moti Masjid), Agra.
 7 by 9¾ ins.

 ii f.51 The Taj Mahal.
 7½ by 9¾ ins.

 iii f.103 Mausoleum of Itimad-ud-daula, near Agra.
 Inscribed: *Îutimad ud duoluh's tomb.*
 6½ by 8¾ ins.

 iv f.193 Mausoleum of the Emperor Akbar, Sikandra.
 7½ by 9¾ ins.

 v f.210 Mausoleum of Salim Chishti, Fatehpur Sikri.
 6¾ by 9 ins.

158 i–vi 6 drawings of monuments at Delhi, Agra and Fatehpur Sikri.
By a Delhi or Agra artist, *c.* 1840.
Water-colour; 7¼ by 8¾ ins. Narrow Indian ink border.
Purchased August 1955. *Add. Or. 306; 320, 321, 323, 324; 327*

NOTE: This set is marked by its pink (as distinct from reddish-brown) colouring and by its somewhat naive style. The drawings have clearly been copied from others and the architecture has become inaccurate and wrongly proportioned.

　　　i 'Gate of Magnificence' (Buland Darwaza), Fatehpur Sikri.　　*Add. Or. 327*
　　　ii The Jami Masjid, Agra.　　*Add. Or. 306*
　　　iii Unidentified building, perhaps Agra Fort from the river.　　*Add. Or. 320*
　　　iv Lahore Gate, Red Fort, Delhi; a European in the foreground.　　*Add. Or. 321*
　　　v Agra Fort from the river; two boats in the foreground.　　*Add. Or. 323*
　　　vi Delhi Gate, Red Fort, Delhi.　　*Add. Or. 324*

159 i, ii　2 drawings of tombs near Delhi.
By a Delhi or Agra artist, *c.* 1840.
Water-colour; 7¼ by 8¾ ins. Narrow Indian ink border. Water-mark of 1839.
Purchased August 1955.　　*Add. Or. 322; 325*

NOTE: Part of a set in which a suggestion of landscape appears.

　　　i Mausoleum of Nawab Safdar Jang, Delhi. Water-mark of 1839.　　*Add. Or. 322*
　　　ii Mausoleum of Humayun, near Delhi.　　*Add. Or. 325*

160　The China Tomb, Agra.
By a Delhi or Agra artist, *c.* 1840.
Water-colour; 4¾ by 7¼ ins. Indian ink rule border.
Inscribed on mount: *The China Tomb at Agra now in ruins (Extracts from the Koran)*.
Purchased 20 February 1967.　　*Add. Or. 2662*

NOTE: The Chini-ka-rauza (China Tomb) is situated near the tomb of Itimad-ud-daula on the same side of the river. It is covered with mosaic tile-work which gives the tomb its name. It is supposed to be the tomb of Afzal Khan 'Allami, a Persian scholar who entered the service of Jahangir and became Prime Minister to Shah Jahan. He died at Lahore in 1639, and was buried at Agra in the tomb he had erected during his own lifetime.

161　Panorama of Delhi seen from the Ridge (i.e. the north-west) showing the city of Shahjahanabad silhouetted against the sky; in the middle distance, the city wall; from right to left, Garstin's Bastion, the Lahore Gate, the Kabuli Gate, the Shah Bastion and the Kashmir Gate with St. James' Church nearby.
By a Delhi artist, *c.* 1840.
Faintly inscribed in Persian characters with names of gates and buildings. On the back is a damaged Persian seal which appears to be inscribed with the dates 1123 or 1203 Hijri which would relate to the reigns of Shah Alum I or Shah Alum II. A damaged paper scroll on rollers which has now been backed with linen.
Pencil and water-colour; 16¼ by 66½ ins.　　*Add. Or. 887*

NOTE: The date on the seal has no relation to the date of the scroll. Some Englishman may have bought an old seal and used it on his pictures and papers. Since St. James' Church was built in 1836,

the scroll must have been made after that date. There was a fashion for panoramas among the British in the eighteen forties (see also *no. 129*). The stylistic hesitation and muzzy painting suggest that this panorama was made by an Indian artist endeavouring to work in a European style for a particular patron.

162 The Qutb Minar, Delhi; in the foreground an Englishman on horseback with a servant.
By a Delhi artist, *c.* 1848.
Inscribed in Persian characters on border below picture: *Burj i Masjid i Qūwat al-Islām. Naqshah i Mīnār Quṭb Ṣāḥib Burj i nau sākht* (Tower of the Mosque 'Quwat al-Islam'. Picture of the Qutb Tower. Newly repaired).
1843 watermark. Water-colour; 30 by 21¼ ins.
Purchased June 1921. *Add. Or. 3100 (Revised Foster catalogue, no. 123)*

NOTE: The Qutb Minar, which had been badly damaged by an earthquake in 1803, was repaired by Major Robert Smith of the Bengal Engineers in 1828–29. As part of these repairs he replaced the fallen *chhatri* (cupola) of Firuz Shah Tughluq with a late Mughal-style Bengali *chhatri* of red sandstone – an addition which caused great controversy. In 1848 the Governor-General, Lord Hardinge, ordered the *chhatri* to be removed and, as can be seen in the present drawing, it was placed on a mound near the Minar. In 1914 it was installed in the garden south-east of the Minar. The inscription 'Newly repaired' clearly refers to the removal of the *chhatri* in 1848.

 For Robert Smith, see Mildred Archer, *British drawings in the India Office Library* (London, 1969), i, pp. 317–323, and for his repairs to the Qutb Minar, including a discussion of the controversial *chhatri*, see India Office Records, *Boards Collections*, vol. 1324, no. 52472.

 For drawings of the Qutb Minar, showing Smith's cupola on the top, see a water-colour by J. A. Crommelin (*WD 1381*), a pen-and-ink drawing by G. F. White (*WD 3087*), and a painting by a Delhi artist, *c.* 1830–40, reproduced W. H. Sleeman, *Rambles and recollections of an Indian official* (London, 1844), plate 21.

 For a view of the Qutb Minar prior to the earthquake of 1803, see T. and W. Daniell, *Oriental Scenery*, Series 5, no. 24, and W. Daniell, *The Oriental Annual*, i, 1834, vignette title, based on drawings made in 1789.

163 The Pearl Mosque (Moti Masjid), Agra.
By a Delhi or Agra artist, *c.* 1850.
Inscribed on mount: *The Motee Musjeed at Agra.*
Water-colour; 18½ by 27¾ ins.
Purchased 1925. *Add. Or. 3116 (Revised Foster catalogue, no. 630)*

164 i–ix 9 drawings of Delhi buildings mounted in a journal.
By a Delhi artist, 1858.
All but one inscribed with titles in Persian characters.
Water-colour; various sizes; Indian ink rule border.
Purchased 11 December 1952. *MSS.Eur.D.512.1*

NOTE: These drawings are pasted into 'The Life, Diary & Adventures of Tittleyeupshebumpshe', a journal kept by Lieutenant George Welby Eaton (1840–64) between 1858 and 1864. He arrived in Calcutta 8 June 1858 and was sent to Delhi for training with the 2nd European Bengal Fusiliers who were resting at Delhi after taking part in the seige and capture of the city. He left Delhi in January 1859.

The present drawings were clearly purchased by him during his stay in Delhi. They show Delhi buildings in a realistic landscape setting with bright colouring. It is interesting to note that the Delhi painters quickly modified their stock sets in order to illustrate buildings that had figured in the Mutiny operations. Thus the Kashmir Gate is shown damaged, and Hindu Rao's house, which had been held by the Gurkhas, is also drawn in ruins. St. James's Church however is shown in good repair and Eaton comments in his journal that it had been quickly renovated.

 i f.37 Kashmir Gate, Delhi.
 Inscribed in Persian characters: *Naqshah i Kashmīrī darwāzah* (Picture of the Kashmir Gate).
 3 by 5 ins.

 ii f.37v St. James's Church, Delhi.
 Inscribed in Persian characters: *Naqshah i girjāghar kih dar Dihlī* (Picture of the church at Delhi).
 $3\frac{1}{4}$ by $5\frac{1}{4}$ ins.

 iii f.39 Hindu Rao's house, Delhi.
 Inscribed in Persian characters: *Naqshah i koṭī Hindū Rāo* ... (Picture of Hindu Rao's house ...).
 3 by 5 ins.

 iv f.40 The Hall of Private Audience (Diwan-i-Khas), Delhi Fort.
 Inscribed in Persian characters: *Īn naqshah i Dīwān i Khāṣṣ Shāhjahānābād* (Picture of the Hall of Private Audience, Delhi).
 3 by $4\frac{3}{4}$ ins.

 v f.40v The Hall of Public Audience (Diwan-i-Am), Delhi Fort.
 $2\frac{3}{4}$ by $4\frac{1}{4}$ ins.

 vi f.41 Interior of the Jami Masjid, Delhi.
 Inscribed in Persian characters: *Naqshah i Masjid i jāmiʿ i Shāhjahānābād andarūn* (Picture of the interior of the Jami Masjid, Delhi).
 3 by $4\frac{3}{4}$ ins.

 vii f.42 Mausoleum of Safdar Jang, Delhi.
 Inscribed in Persian characters: *Naqshah i maqbarah i Nauwāb Ṣafdar Jang* (Picture of the mausoleum of Nawab Safdar Jang).
 $2\frac{3}{4}$ by $4\frac{1}{2}$ ins.

 viii f.42v The Qutb Minar, Delhi.
 Inscribed in Persian Characters: *Naqshah i mīnār i Khwājah Quṭb al-Dīn ṣāḥib* (Picture of the tower of Khwajah Qutb al-Din).
 3 by $4\frac{3}{4}$ ins.

ix f.43 Mausoleum of Humayun, Delhi.

Inscribed in Persian characters: *Naqshah i maqbarah i Humāyūn pādshāh* (Picture of the mausoleum of the Emperor Humayun).

3 by 4½ ins.

165 i, ii 2 drawings of Lucknow monuments.

By a Delhi artist, *c.* 1860.

Water-colour. Indian ink rule borders.

Purchased 20 February 1967. *Add. Or. 2664; 2665*

i The Turkish Gate (Rumi Darwaza), Lucknow.

Inscribed in Persian characters: *Rūmī darwāzah Lakhnau*; in English: *Roomy Gate Lucknow*.

4½ by 6¾ ins. *Add. Or. 2664*

NOTE: The Rumi Darwaza or Turkish Gate was built by Nawab Asaf-ud-daula (ruled 1775–97) in 1784.

ii The Martinière, Lucknow.

Inscribed in Persian characters: *Koṭhī Marṭinī Lakhnau*; in English: *The Martinière Lucknow*.

4½ by 7 ins. *Add. Or. 2665*

NOTE: The Martinière was the strange baroque palace built by Major-General Claude Martin (1735–1800) who from 1776 served the Nawab of Oudh.

166 The Qutb Minar, Delhi, with Major Robert Smith's cupola on the right.

By a Delhi artist, 1886.

Inscribed on front: *The Kutb from a Native artist in 1886. 245 ft height.*

Water-colour; 25 by 18 ins. Narrow Indian ink border.

Purchased 6 May 1913. *Add. Or. 538*

NOTE: Sombre in colour with a grey sky, brownish-black vegetation and the tower in reddish-brown. Impressionistic figures on the path.

167 The Taj Mahal, Agra.

Probably by a Delhi or Punjabi amateur painter, 1897.

Inscribed on back: *By the brother of Laieq's bearer. . Umballa. 1897.*

Pencil and water-colour; 13 by 16½ ins.

Presented by Major N. V. L. Rybot, 4 February 1958. *Add. Or. 754*

NOTE: Major Rybot served in the Indian army 1896–1920 (see Mildred Archer, *British drawings in the India Office Library* (London, 1969), i, 295–312). A naive drawing, not a standard Delhi painting, probably kept by Rybot because of its decorative charm.

168 Panorama of a durbar procession of Akbar II, Emperor of Delhi, 1806–37, probably on the occasion of the Id or after Ramadan. The Emperor is followed by his sons, by the British Resident, high officials both Indian and British, as well as by troops. The royal procession includes elephants carrying the royal insignia (sun, umbrella, fish standards, etc.), camels, horses, gun-carriages, palanquins and closed bullock-carriages for the ladies (*Plate 58*).
By a Delhi artist, *c.* 1815.
Inscribed on original tin container: *Native Painting. Durbar Procession Baroda.*
Water-colour; 6¼ by 94 ins.
Presented by E. Lennox Boyd, 1903. *Add. Or. 888*

NOTE: Exhibited Festival of Empire 1911. See *Journal of Indian art and industry*, xv, no. 120, October 1912, 89, exhibit no. 505, where it is mis-ascribed to Baroda.

At the time of presentation Mr Boyd stated that the picture had been acquired by W. S. Boyd, Bombay Civil Service, 1818–44, who was for some time Resident at Baroda. Although he may have acquired the scroll in Baroda, it clearly depicts Akbar II. The British Resident is probably Charles Metcalfe, Resident at Delhi, 1811 to 1819. Scrolls of this type were very popular in the early years of the nineteenth century. In the Victoria Memorial Hall, Calcutta, there is a similar scroll which includes Ochterlony (Resident at Delhi 1818–22) in the procession. Another scroll is reproduced in *Journal of Indian Art and Industry*, xvi, no. 123, July 1913, plate 11.

For details of these processions and the symbols of royalty carried in them, see *Journal of Indian art and industry*, xv, no. 120, October 1912, 77–78.

169 42 drawings bound into an album (36 folios); 38 are portraits either of members
i–xlii of Skinner's Horse, or of neighbours and employees of Colonel James Skinner (1778–1841), 2 are mythological subjects and 2 animal studies.
By artists of Delhi or the neighbourhood, probably including Ghulam Ali Khan, *c.* 1815–27.
Most folios inscribed with name of subject in English and sometimes in Persian characters. Index and note on ownership.
Water-colour; size of album 17 by 12 ins.
Purchased 1 February 1960. *Add. Or. 1243–1283*

NOTE: This album belonged to Colonel James Skinner (1778–1841) and was purchased by the Library via Sotheby's from a descendant, Miss Evangeline Ingram. A note in the album reads: 'Album of Indian drawings. Formerly the property of Colonel James Skinner, C.B. of Skinner's Horse, Indian Army. This album descended to the present owner, Miss Evangeline Ingram, through her mother, Mrs Victoria Ingram (née Skinner) who was the only child of Colonel Skinner's eldest son, James Skinner, who was killed by the rebels in Delhi in the Mutiny.'

Although this note was communicated by Miss Ingram, herself a descendant of Colonel Skinner, it contains many errors. James Skinner (junior) was Colonel James Skinner's second son and died of dysentery in 1861. Victoria Skinner was the grand-daughter of Colonel James Skinner's eldest son, Joseph (1807–55), who married a Muslim woman. Joseph's children were George

Henry Skinner, who married Helen Grant in 1855 and was killed in the Mutiny in 1857, and Amelia Sarah Skinner, who married James Richard Grindall George in 1866. George Henry's only child, Victoria Helen Georgina Skinner (1856–1938), married a barrister, Thomas Lewis Ingram, in 1872 and they had twelve children. Victoria was the founder of the 'model village' of Gurgaon in the Punjab with which F. L. Brayne ('Up-lift Brayne') was associated.

Many of the drawings in the present album are almost certainly by Ghulam Ali Khan of Delhi who painted three pictures – 'The Durbar', 'The Farm' and 'Returning from the Review' – on Skinner's estate at Hansi, 113 miles from Delhi. These pictures are in the National Army Museum at Sandhurst and are signed and dated 1827 and 1828. In style they are similar to many drawings in the present album and it seems probable therefore that in addition to practising in Delhi Ghulam Ali Khan was from time to time employed by Colonel Skinner.

Drawings (xviii–xx) were probably painted in 1815 during an expedition in the Punjab Hills. In that year a small detachment from the army of Major-General Martindale, with the political agent, William Fraser, was despatched into the hills to help settle areas that had been affected by the Gurkha invasions. The detachment consisted of a motley collection of irregular troops, Mewatis, Gujars, Sikhs, Pathans as well as Gurkhas who had deserted or capitulated. The hard core of the force were thirty members of Skinner's Horse led by Colonel Skinner himself. It is likely that the paintings showing a group of Mewatis, Jats and Gurkhas, some of them in uniform, were made at this time, a fact which again suggests that Skinner retained an artist. For a description of this force of irregulars, see J. B. Fraser, *Journal of a tour through part of the Himala mountains, and to the sources of the rivers Jumna and Ganges* (London, 1820), 99–102. James Baillie Fraser, brother of the political agent, also accompanied the expedition. He was later to write a life of Skinner.

Although the drawings show western influence in their naturalism and use of shading, they also preserve the clear-cut precision of Mughal painting at Delhi. For portraits of Skinner by Indian artists, see British Museum '*Tadhkirat al-umarā*,' *Add. Ms. 27254*, and a portrait in the Red Fort Museum, Delhi.

Bibliography

Mildred Archer, 'The two worlds of Colonel Skinner', *History Today*, September 1960, 608–615, reproducing iii, viii, ix, xvii, xix, xxxvii.

D. Holman, *Sikander Sahib* (London, 1961), reproducing iv.

 i Full length portrait of a trooper of Skinner's Horse with a sword over his shoulder.
 Inscribed in English: *Khodawun – Trooper.* *Add. Or. 1243*
 ii Four rissaldars of Skinner's Horse seated on the ground.
 Inscribed in English: *Ressaldars of Skinner's Horse: Name unknown, Azimoola Khan, Bhopal Beg, Jelal Khan.* *Add. Or. 1244*
 iii Five rissaldars and jemadars of Skinner's Horse seated on the ground.
 Names inscribed below in Persian characters and in English: *Resaldar Sheik Sunniah Hoosein, Resaldar Gholam Hoosein, Summud Khan (Nishun Burdar), Jemadar Abdul Rahman, Jemadar Mirza Buhtoman Beg. Add. Or. 1245*
 iv Four members of Skinner's Horse seated on the ground.

Names inscribed below in Persian characters and in English: *Naib Sher Baz Beg (Khan), Jemadar Alee Khan, Naib Ameen Khan, Hyder Ali Duffadar.*

Add. Or. 1246

v Three members of Skinner's Horse seated on the ground.

Names inscribed below in Persian characters and in English: *Mirza Mohun Beg Naib Ressaldar (? Moghul) Buhadoor Khan Naib, Buhadoor Beg Duffadar.* *Add. Or. 1247*

vi Portrait of a body-guard of Ranjit Singh with a matchlock, and bow and arrows, mounted on a richly caparisoned horse.

Inscribed in Persian characters: *Taṣwīr i sawār i Ranjīt Singh bahādur* (Picture of a horseman of Ranjit Singh); in English: *Runjeet Singh* (1814). *Add. Or. 1248*

vii Portrait of Saiyid Lal Shah, seated on a chair, a servant standing behind him.

Inscribed: *Syud Lal Shah.* *Add. Or. 1249*

viii Portrait of Maulvi Salamatullah of Cawnpore, seated on the ground leaning against cushions and smoking a hookah. A darvish friend sits beside him.

Inscribed: *Moulvie Salaamut Oolah (of Cawnpore).* *Add. Or. 1250*

ix Portrait of Hayat-ullah Beg, uncle of Nawab Shams-ud-din Khan of Firozpur, seated on a chair smoking a hookah.

Inscribed: *Hutoolah Beg (uncle of Shumsoodeen).* *Add. Or. 1251*

x Portrait of Maharaja Iswari Sain, the young ruler of Jaitpur.

Inscribed: *Maharaj Issree Sein (of Jeitpore).* *Add. Or. 1252*

xi Portrait of a holy man, Rahim Bakhsh, seated against cushions, holding a rosary.

Inscribed: *Raheem Bux.* *Add. Or. 1253*

xii A whiskered gentleman with a shield seated on a rich carpet against a reed screen. *Add. Or. 1254*

xiii A nobleman with a sword standing in a garden. *Add. Or. 1255*

xiv Full length portrait of Raja Kishan Chand of Baroda holding a staff.

Inscribed: *Rajah Kissun Chund of Baroda.* *Add. Or. 1256*

xv Portrait of a gentleman in a black coat seated on a chair. *Add. Or. 1257*

xvi Portrait of Sufi Allah Yar Khan Sahib seated on a *morhā* holding a crutch stick.

Inscribed: *Soofee Allah Yar Khan Sahib.* *Add. Or. 1258*

xvii Five tent orderlies of Skinner's Horse, one dressed in white, four in blue, yellow and red; one holding a huge mallet.

Inscribed in Persian characters: *khalāṣān*; in English: *Kalassies of Skinner Horse.* *Add. Or. 1259*

xviii Portraits of Gurkha chiefs with soldiers standing in a wooded landscape (*Plate 69*).

Inscribed: *Ghoorkha Chiefs and Soldiers.* *Add. Or. 1260*

xix A group of six Jats; one in a yellow and red uniform.
Inscribed: *Jats.* *Add. Or. 1261*

xx Seven Mewatis.
Inscribed in Persian characters: *mewātī*; in English: *Mewatties.*
Add. Or. 1262

xxi Two soldiers of Skinner's Horse skirmishing and firing at each other with blank. *Add. Or. 1263*

xxii Portrait of Diwan Babu Ram seated on the ground with papers, books, pen-cases and spectacles; beside him his adopted son and a peon standing by (*Plate 68*).
Inscribed: *Dewan Baboo Ram. His adopted Son.* *Add. Or. 1264*

xxiii Portrait of Saiyid Mirza Azim Beg of Hansi seated on a cane-stool with Dai Lal Vakil, Kisan Lal Munshi and Pir Bakhsh Khitmatgar.
Inscribed in Persian characters: *Wakīl Rām Laʻl Khatrī. Munshī Kishan Dās Khatrī. Shabīh i Mīrzā Aʻzam Beg jāgīrdār i Hānsī ʻumrash yak ṣad hasht sāl ast wa-nihāyat bahādur būdand dar jawānī* (Picture of Mirza Azam Beg jagirdar of Hansi. His age is 108 years and in his youth he was a great champion). *Shaikh Pīr Bakhsh khidmatgār*; in English: *Dyem Lal Vukeel, Kissunlal Moonshee. Syud Meerza Azim Beg of Hansi aged 107 years. Peer Bux Khit.* *Add. Or. 1265*

NOTE: A similar painting of this old man occurs in the Amherst collection, Indian Section, Victoria and Albert Museum.

xxiv Portrait of Colonel Skinner's bearer, Jawahir, an orderly, Thakur Singh, and a rough-rider, Bahadur Khan.
Inscribed: *Col. Skinner's bearer Jowahir, Chuprassie Thakoor Sing. Buhadoor Khan, Rough Rider.* *Add. Or. 1266*

xxv Portrait of Munshi Keshav Rai and Shambunath Munshi seated with books and pen and ink.
Inscribed in Persian characters: *Keshav Rāi Munshī: Shambūnāth*; in English: *Moonshee Keshur Raie, Sunbodiath Moonshee.* *Add. Or. 1267*

xxvi Composite painting; an angel playing a harp seated on a camel; a demon with a snake running in front. The camel is composite. *Add. Or. 1268*

xxvii A nobleman, possibly a prince of the Delhi house, seated on a chair with his hookah by an open door; an attendant with a peacock feather fan stands behind. *Add. Or. 1269*

xxviii Composite painting; a demon leading a tiger by a string. The tiger is composite. *Add. Or. 1270*

xxix Two cultivators with a buffalo in a landscape. The cultivator on the left is Bardat Jat (see xxxv). *Add. Or. 1271*

xxx Full length portrait of Udham Singh, brother of Iswari Sain of Jaitpur (see x).
Inscribed: *Ooden Singh Rajpoot. Brother of Issree Sein.* *Add. Or. 1272*

xxxi Full length portrait of Daulat Ram of Ujjain, his hands clasped on his sword hilt.
Inscribed: *Dowlut Ram of Oojein.* *Add. Or. 1273*

xxxii Full length portrait of Mahbub Khan, his sword under his arm.
Inscribed. *Mehboob Khan.* *Add. Or. 1274*

xxxiii Full length portrait of Mahabbat Khan with his sword, pistol and shield.
Inscribed: *Mohubbut Khan;* in later hand: *Muhomed Sirdar Dafadar (Segt) great grandson on the Mother's side now in Skinner's Horse.* *Add. Or. 1275*

xxxiv Two Jat cultivators, Ram Dayal Sakim and Jasi Ram.
Inscribed. *Ramdial Sakim. Jusee Ram. Jats.* *Add. Or. 1276*

xxxv Portraits of Bardat Jat (see xix), cultivator, with axe and fork; Kihar Gwala, milkman, and Sanat Jemadar, with matchlock.
Inscribed in Persian characters; *Barḍat, Kihar, Sanwat*: in English: *Burdut Jat. Gwullah. Saamut Jemadur.* *Add. Or. 1277*

xxxvi Bahadur Singh Muqaddam, zamindar's agent, holding a rosary.
Inscribed in Persian characters: *Ṣūrat i Bahādur Singh Muqaddam zamīndār i sāpala*; in English; *Bahadoor Mookuddum.* *Add. Or. 1278*

xxxvii Portrait of a seated musician, Faquir (?) Khan, with his *sitār*.
Inscribed: *Sukeer Khan* *Add. Or. 1279*
NOTE: The musicians depicted in xxxvii–xxxix are probably Skinner's own retained musicians. Major Archer, who visited Skinner in January 1828 refers to 'his own band of Kulamets (men singers)' who 'entertained us during our repasts' (see Major Archer, *Tours in upper India* (London, 1833), i, 101).

xxxviii Portrait of a seated musician, Jangi Khan, with his *sitār*.
Inscribed: *Jungee Khan.* *Add. Or. 1280*

xxxix Portrait of a drummer, Amir Bakhsh, playing on his *tabla*.
Inscribed: *Ameer Buksh (drummer).* *Add. Or. 1281*

xl Portraits of two prisoners in irons. *Add. Or. 1282*

xli a Musk deer.
Inscribed in Persian characters: *Āhūī mushknāfah* (i.e. male musk deer); mis-inscribed in English: *Female Elk; or Cariboo.*

b Female Elk.
Inscribed in Persian characters; *Mādah gawazn* (i.e. female elk); mis-inscribed in English: *Musk deer.* *Add. Or. 1283 a. b*

170 i, ii Two drawings depicting Delhi celebrities.
By a Delhi artist, *c.* 1820.
Gouache, 8¾ by 12½ ins.
Purchased 13 April 1954. *Add. Or. 1, 2*

i A European, probably Sir David Ochterlony (1758–1825), in Indian dress, smoking a hookah and watching a nautch in his house at Delhi (*Colour plate D*).
Add. Or. 2

NOTE: Although this painting is not inscribed, the central figure strikingly resembles other portraits of Ochterlony, e.g. a water-colour in the Red Fort Museum, Delhi.

Ochterlony became a famous Delhi character for he was in and around the city from 1803 to 1825. He had a house there as well as a garden-house on the road to Azalpur and lived in Indian style. He was twice Resident at Delhi, 1803–06 and 1818–22. The lined face and white hair would suggest that this portrait was made in his later years. The family portraits on the wall depict, on the left, a light dragoon and, on the right, a light cavalry man. The Scottish uniform would further support this identification.

ii Mahadaji Sindhia (ruled 1782–94) entertaining a British naval officer and a young British military officer to a nautch in his house at Delhi (*Plate 59*).

Add. Or. 1

NOTE: A similar portrait of Sindhia inscribed with Sindhia's name is in Bharat Kala Bhawan, Benares. See also portraits by James Wales and Thomas Daniell reproduced in C. A. Kincaid and D. B. Parasnis, *A History of the Maratha people* (London, 1925), 168, and J. Sarkar, *Mahadji Sindhia and north Indian affairs 1785–1794* (Bombay, 1936), frontispiece and p. 1.

This painting is in similar style to (i) and must have been made about the same time. The uniforms confirm a date in the early nineteenth century. Sindhia died in 1794 but it is likely that he was included in sets of pictures of Delhi celebrities for some years after his death. The young military officer is probably a light cavalryman.

171 Durbar at Delhi of Akbar II (1759–1837, ruled 1806–37). The Emperor is shown seated on his throne in the Diwan-i-Khas of the Palace at Delhi. Near him stand the Princes of the Blood Royal; on his left Mirza Jahangir Bahadur, Mirza Babar Sahib, Mirza Hussain Bahadur and Mirza KaiQubad, on his right Mirza Salim Bahadur and Mirza Abu Zafar. Nearby is the British Resident at Delhi, Sir David Ochterlony (*Kharnal Akhtarlūnī Ṣāhib*) and the nobles of the court stand around on both sides of the throne (*Plate 57*).
By a Delhi artist, *c.* 1820.
Inscribed on border in Persian: *Sulṭān ibn al-sulṭān ṣāhib al-maghāzī wa-niʿmat i ḥaqīqī khudāwand i majāzī Abū 'l-Naṣr Muʿin al-Dīn Muḥammad Akbar Shāh pādshāh i ghāzī* (The Sultan, son of the Sultan, Lord of warlike qualities and spiritual blessing, sovereign of the temporal world, Abu'l Nasr Mu'in al-Din Muhammad Akbar Shāh, emperor, conqueror of infidels).

Many figures are inscribed with their names e.g. on left: Shiv Lal, Bakhshi Mahmud Khan (the treasurer of the palace), Nawab Mughal Beg, Ghulam Majid al-din, Shadi Ram, Qalandar Beg, Yaqub Ali Khan, Tafazzul Husain Khan, Karamat 'Ali (a distinguished scholar and mathematician), Karamat, Nawab Muhammad Mir Khan, Mustaufi Allah Yar Khan (examiner of accounts), Khwaja Farid Khan; on right: Ghulam Sarwar Khan, Mir Nisar Ali (tutor to the emperor's children), Raja Jai Singh Rai, Najaf Ali Beg, Nawazish Ali Khan (a scholar), Rukn al-daula, Raja Kedarnath, Mir Jahd Khan, Nawab Nazir Mansur Ali Khan, Iqbal Ali Khan, Hisam al-din Junaid Khan; in centre front: Nabi Bakhsh Khan. The names of the princes are also inscribed.

Water-colour; 19 by 16 ins.
Purchased March 1908. *Add. Or. 3079 (Revised Foster catalogue, no. 104)*

NOTE: Sir William Foster (see W. Foster, *A Descriptive catalogue of the paintings, statues, etc. in the India Office* (London, 1924), no. 104) gives the name of the artist as Shaikh Alam, but there appears to be no inscription to confirm this.

 Sir David Ochterlony was Resident at Delhi from 1803 to 1806 and again from 1818 to 1822. His appearance in this painting would suggest that it was made during his second period of office.

 For other paintings of this type, see *Journal of Indian Art*, xii, no. 107, July 1909, 185 and plate 155.

172 i, ii Two unfinished sets of drawings intended as panoramas depicting durbar processions of Akbar II, Emperor of Delhi, 1806–37.
By Delhi artists, *c.* 1820–25.
Inscribed with names of individuals in Persian characters (transliterations added by India Office Library), also with colour notes.
Pencil and water-colour.
Presented by Dr R. J. Walker, 10 May 1955. *Add. Or. 211–304*

NOTE: These sheets were bound into volumes after reaching the Library. Since the principal figures in the procession are not included, these sections were probably extracted at some time for separate mounting. The present drawings with their careful portrait studies are freer and more realistic versions of the type of panorama scroll represented by no. 168. Since it is unlikely that by the eighteen-twenties the Emperor would have possessed as many soldiers and followers as those depicted, the artist may well have exaggerated the numbers for reasons of prestige. Among those included in the procession is a calligrapher (*Add. Or. 289*), a tribute to the high esteem in which scribes were held.

 i 22 drawings, bound into a volume, depicting a durbar procession of Akbar II.
 $11\frac{1}{2}$ by $17\frac{1}{2}$ ins. *Add. Or. 211–232*
 ii 72 drawings, bound into a volume, depicting a durbar procession of Akbar II.
 8 by $12\frac{1}{2}$ ins. *Add. Or. 233–304*

173 Three dancing-girls with five musicians performing on a terrace. Women sit watching on either side and servants stand behind them. In the background part of a pavilion.
By a Delhi artist, *c.* 1838.
Inscribed: *A Nautch at Col. Skinner's given to me by himself 1838.*
Gouache; $5\frac{1}{4}$ by $8\frac{1}{4}$ ins, with border $7\frac{1}{4}$ by $10\frac{1}{4}$ ins.
Purchased 10 December 1964. *Add. Or. 2598*

NOTE: Colonel James Skinner appears to have made gifts of Indian paintings to his guests and friends. They may have been painted by his retained artists (see p. 171) A second picture of a similar

subject by the same artist is reproduced in Maggs Bros. *Oriental miniatures and illumination, Bulletin no. 8* (London, February 1965), no. 85. The dancing-girls and musicians portrayed in both pictures may have belonged to Colonel Skinner's own troupe.

(c) *Paintings on ivory*

174
i–xiii
13 miniatures depicting Mughal emperors of India and Nadir Shah.
Head and shoulders in profile.
By a Delhi artist, *c.* 1815.
Inscribed on back with names and notes in English and Persian.
Water-colour on ivory, oval; 3½ by 2¾ ins.
Circumstances of acquisition unrecorded.

Add. Or. 3101–3113 (Revised Foster catalogue, no. 124)

NOTE: The inscriptions, which are sometimes incorrect, appear to have been written at two different periods: an early inscription in English and Persian and a later inscription, sometimes in red ink, repeating the name and adding regnal dates or notes.

i Timur (ruled 1369–1450).
Inscribed: *No.1. Timour Shah. First Padshah reigned Sixty Years*; in Persian characters: *Tīmūr Sh̲āh auwal bādsh̲āh tā sh̲ast sāl sal̤anat namūdand.*

Add. Or. 3101

ii Babar (1526–30).
Incorrectly inscribed in late hand in red ink: *No. 2. Shah Alam – or Bahadur Shah – the first of the six Mogols of the declining empire – reigned 1707–1712*; in black ink: *Should be Baber.*

Add. Or. 3102

iii Humayun (1530–56).
Inscribed: *No. 3. Humayoon Shah third Padshah reigned Fifty one Years*: in red ink: *Humayun reigned 1530–1556*; in Persian characters: *Humāyūn Sh̲āh siwum bādsh̲āh tā panchāh yak sāl sal̤anat namūdand.*

Add. Or. 3103

iv Akbar (1556–1605).
Inscription torn away.

Add. Or. 3104

v Jahangir (1605–27).
Inscribed: *No. 5. Jehangheer Shah Fifth Padshah reigned Twenty two Years*; in red ink: *Jehangir reigned 1605–1627*; in Persian characters: *Jahāngīr Sh̲āh panchum bādsh̲āh tā bīst dū sāl sal̤anat namūdand.*

Add. Or. 3105

vi Shah Jahan (1628–1657).
Inscribed: *No. 6. Shah Jehan. Sixth Padshah reigned Thirty two Years*; in red ink: *Shah Jehan reigned 1627–1658*; in Persian characters: *Sh̲āhjahān sh̲ashum bādsh̲āh tā sī dū sāl sal̤anat namūdand.*

Add. Or. 3106

vii Aurangzeb (1658–1707).
Inscribed: *No. 7. Aurung Zebe. Seventh Padshah reigned Forty Eight Years*; in red ink: *Aurunzib or Alamghir reigned 1658–1707*; in Persian characters: *Aurangzeb haftum bādsh̲āh tā chihil hash̲t sāl sal̤anat namūdand.*

Add. Or. 3107

viii Bahadur Shah (1707–12).

Incorrectly inscribed: *No. 8. Baber Shah. Second Padshah reigned Fifty six Years*; in later hands: *the first of the six great Emperors of Delhi*; *This seems to be mistake for Bahadur*; in red ink: *Baber reigned AD 1526–1530*; in Persian characters: *Bābur* [blotted] *duwum bādshāh tā panchāh shash sāl salṭanat namūdand.*

Add. Or. 3108

ix Farrukhsiyar (1713–19).

Inscribed in late hand: *9. Farukhshir reigned 1713–1719. 9th Mogol from Baber – assassinated.*

Add. Or. 3109

x Muhammad Shah (1719–48).

Inscribed: *10. Muhammud Shah Tenth Padshah – reigned Thirty years*; in later hand: *He is counted 10th by native historians – because 3 of the puppet kings between Shah Alam & Muhammed Shah are omitted*; in red ink: *Ahmed Shah reigned 1719–1748*; in Persian characters: *Muḥammad Shāh dahum bādshāh tā sī sāl salṭanat namūdand.*

Add. Or. 3110

xi Ahmad Shah (1748–54).

Inscribed: *11. Ahmed Shah. Eleventh Padshah reigned Five Years*; in red ink: *Ahmed Shah reigned 1748–1754*; in Persian characters: *Aḥmad Shāh yāzdahum badshāh tā panj sāl salṭanat namūdand.*

Add. Or. 3111

xii Alamgir II (1754–59).

Inscribed: *No. 12 . . . Alumgeer. Twelfth Padshah & . . . reigned sixty Five years*; in red ink: *Aurungzeb II or Alamgir II reigned 1754–1759 and was succeeded by Shah Alam II – Akbar II & Muhammad Bahadur (of the Mutiny) all pensioners of E. I. Co*; in Persian characters: *Thānī 'Ālamgīr Sāh* [sic] *dawāzdahum badsāh* [sic] *'Alī-gauhar tā shast panch sāl salṭanat namūdand.*

Add. Or. 3112

xiii Nadir Shah, King of Persia 1732–47.

Inscribed: *No. 13. Nader Shah King of Cabul*; in red ink: *Overthrew Mogol Empire 1748*; in Persian characters: *Nādir Shāh shāh i Kābul.* Add. Or. 3113

175 2 ivory miniatures depicting the Mughal emperor, Akbar II, and his second son. By Ghulam Ali Khan, a Delhi painter, *c.* 1827.

Inscribed on back of original frames with a Persian inscription by the artist and an English translation and notes by Lord Amherst.

Water-colour on ivory; 8 by 5 ins.

Deposited on permanent loan by the 5th Earl Amherst, M.C., together with *Add. Or. 2540* and *Mss.Eur.F.140.* *Add. Or. 2538, 2539*

NOTE: William Pitt, 2nd baron Amherst, who was created 1st Earl Amherst of Aracan in 1826, was Governor-General of Fort William from 1823 to 1828. These miniatures were acquired by him and his wife while they were in India, probably during their visit to Delhi in February and March, 1827. For Ghulam Ali Khan, see no. 169.

i Akbar II, a halo round his head, wears a fur-trimmed padded coat. He is seated holding a hookah-snake in his left hand, and a writing case lies on the floor beside him.

Inscribed on back of original frame in Persian with an English translation: *The auspicious Portrait of His Majesty, exalted as Jemshid, whose attendants are like angels, the shadow of the Almighty, the Asylum of the Mahomedan faith, the promoter of the true religion, the glory of Islam, the ornament & representative of the house of Timour, the mighty Emperor, the renowned Sovereign, the Patron of the arts, my Lord & Master, Aboo Nasser, Moyeen ood Deen, Mahommed Akber Shah Padshah, Ghazi, may the Almighty grant him long life & prosperity, & continue to Mankind the benefits of his grace & favor. Dated the 22nd year of His Majesty's reign. By His Majesty's devoted faithful servant Gholam Ali Khan Painter. (A very good likeness of the Great Moghul as I saw him at Delhi in February 1827. A.)*

ii Prince Abu Zafar Siraj al-Din Muhammad Bahadur Shah (1775–1862), second son of Akbar II, later Bahadur Shah II (1837–58). The prince is seated holding a hookah snake in his right hand. He wears a fur-trimmed padded coat; a pillar and draped curtains behind him.

Inscribed on back of original frame in Persian with an English translation: *The Portrait of the Lord of the World and its Inhabitants, the Prince of the Universe & all that it contains, Mirza Mahommed Selim Shah Behadoor. The 22nd year of the accession. By Gholam Ali Khan, His Majesty's Painter. A very good likeness of Prince Selim (one of the sons of the King of Delhi or Great Mogul) as I saw him at Delhi and elsewhere in 1827. A.*

176 Portrait, head and shoulders, three-quarter face of the Mughal Emperor Akbar II (1806–37). He has white hair, wears a blue and red costume ornamented with gold, and he holds a hookah mouthpiece in his right hand. Brown background with part of a pillar on the left hand side.

By a Delhi artist, *c.* 1830.

Inscribed on label on back: *Emperor of Dilhi.*

Water-colour on ivory; 2 by 1½ ins.

Presented by E. Lennox Boyd, 1900. *Add. Or. 2609*

NOTE: Like no. 168 this miniature was acquired in India by W. S. Boyd, Bombay Civil Service, 1818–44.

177 Portrait miniature of Henry Lawrence, half-length, full face, with beard. He wears a black coat, blue waist-coat with watch-chain, white shirt and black neck-cloth.

By a Delhi artist, perhaps Ghulam Husain Khan, *c.* 1847.

Water-colour on ivory; 4¼ by 3¼ ins. Mounted in velvet-lined leather case.

Purchased from Mrs R. Vandeleur, great-niece of Sir Herbert Edwardes, 26 October 1954. *Add. Or. 2409*

NOTE: Henry Lawrence (1806–57) went to India in the Bengal Artillery in 1823. Served in First Burma War 1826; invalided home 1827–29; Revenue Survey North Western Provinces 1833–38; First Afghan War 1840; Assistant to Agent of Governor-General, Kabul 1842; Resident in Nepal 1843–46; First Sikh War, Agent to Governor-General and Resident at Lahore 1847; leave and K.C.B. 1848; Seige of Multan and battle of Chilianwala 1849; President of Board of Administration of Punjab 1849–53; Agent to Governor-General in Rajputana 1854–57; Agent to Governor-General in Oudh 1857. Killed at Lucknow during the Mutiny.

The present miniature came from the collection of Sir Herbert Edwardes who may have received it from Henry Lawrence when they were together at Lahore in 1847. We can infer that it was made in India at about that time since on arrival in England on leave in 1848 Lawrence had already shaved his beard. In her journal for March 1848, when Lawrence arrived home from the Punjab, Honoria Lawrence wrote, 'He looked very worn and weary, the lines in his dear face deeper than ever, and his cheeks looked thinner for want of the beard he had worn for nine years' (see *Mss.Eur.F.85, H.L.Misc.*). Although Lawrence grew his beard again after returning to India, the miniature could hardly have been painted then since an engraving was made from it in 1850, for Sir Herbert Edwardes, *A Year on the Punjab frontier, 1848–49* (London, 1851), i, frontispiece. This engraving is lettered: *S. Freeman pt. From an original miniature by a native artist.* The star of the K.C.B. which Lawrence was given in 1848 does not appear in the miniature but has been added in the engraving.

The National Portrait Gallery possesses a similar miniature, though not as minutely finished as the present portrait. The Gallery received a letter in 1887 from a Mr A. Constable, resident in Lucknow, who said that when in Delhi, a miniature painter, Ismail Khan, told him that his grandfather, Ghulam Khan, had painted Sir Henry Lawrence in 1853 and subsequently painted replicas. It is possible that another miniature was painted in that year, but it is equally possible that Ismail Khan was vague about the date, and that the miniatures in the India Office Library and the National Portrait Gallery may both have been made at an earlier date, i.e. *c.* 1847. Although Ghulam Khan's full name was not cited, it is likely that it was Ghulam Husain Khan, son of Ghulam Murtaza Khan, who was active in Delhi from about 1830 to 1860. For an account of Ghulam Husain Khan (*c.* 1790–1868), see Archer (1955), 69–71.

178 Albury Church, Surrey.
By a Delhi artist, 1858.
Inscribed on back in ink: *Old Albury Church – copied by a native of Delhi from Water Colour by W. P. 1858. E.A.P. to Mrs H.*
Oval, water-colour on ivory; 2 by 2½ ins.
Presented by Miss Vera Blackhall from Lady Invernairn's estate, 10 April 1958.

Add. Or. 2616

NOTE: This miniature came from the collection of Edward Augustus Prinsep (1828–1900, Bengal Civil Service 1847–74) and 'W.P.' probably refers to his father, William Prinsep (see Mildred Archer, *British drawings in the India Office Library* (London, 1969), i, 287–292).

179 Portrait, head and shoulders, of an Indian lady with red, blue and gold dress and pink veil. Blue background.

Probably by a Lahore or Amritsar artist, *c.* 1860–70.
Inscribed on mount: *The Rānī of Jhānsi.*
Oval, water-colour on ivory; 1¾ by 1¼ ins.
Purchased 28 December 1904, together with a set of Sikh ivory miniatures, no.
192. *Add. Or. 2607*

NOTE: This appears to be a conventional portrait of Rani Lakshmi Bai of Jhansi, principal widow
of Raja Gangadhar Rao, whose state had lapsed to the British under Lord Dalhousie. On 10 June
1857, following a massacre of Europeans in Jhansi by local Indian troops, she was proclaimed ruler
and resisted the British in alliance with Tantia Topi, General of Nana Sahib of Cawnpore. She was
killed in June 1858 at Gwalior, wearing male attire and fighting bravely. The Rani became a
symbol of resistance to the British like Dost Muhammad and the Sikh heroes (see p. 210). No
authentic portrait is known of her. Similar in style to no. 192 v.

180 A gold bracelet set with emeralds and ornamented with five ivory miniatures of
Dost Muhammad Khan, Bahadur Shah II and three Mughal court ladies.
Made by a Delhi artist and goldsmith, *c.* 1864.
Names inscribed on back of miniatures in English and in Persian script: *Dost*
Mohommad; Moti Mahal; Bahadur Shah Mogul; Nur Jahan; Taj Mahal.
Miniatures oval, water-colour on ivory; ⅝ by ½ ins.
Presented by Miss Félicité Hardcastle, 17 June 1965. *Add. Or. 2603*

NOTE: This bracelet was acquired in India by Sir William Herschel and given to his sister, Maria S.
Hardcastle, who gave it to her grand-daughter, Miss Félicité Hardcastle on 15 October 1924.
Sir William James Herschel (1833–1917) served in the Bengal Civil Service from 1853 to 1878. He
was on furlough in 1864 and probably gave the bracelet to his sister at this time as a wedding
present. Bijouterie of this type was very popular in Delhi in the eighteen-sixties and seventies.
B. H. Baden Powell refers to miniatures for bracelets in his *Handbook of the manufactures and arts*
of the Punjab (Lahore, 1872). Bahadur Shah II (ruled 1837–58) was the last Mughal Emperor;
Dost Muhammad Khan was Amir of Afghanistan 1826–63. Both were symbols of the old way of
life and of opposition to the British.

(ii) THE PUNJAB

The British took over the administration of the Punjab in 1849 after the Sikh
Wars. Although Lahore had been the capital of a Mughal province, the Punjab

Plains had no great artistic traditions and the Sikhs, who by the early nineteenth century had become its rulers, took little interest in painting. Artists from the Punjab Hills were, however, working for them at Adinanagar (Ranjit Singh's summer capital) and in Lahore and Amritsar, where they made portraits of Sikh rulers and notables.[1] When British travellers or officials visited the Punjab during the reign of Ranjit Singh and his successors, painters of this type were occasionally recruited by them. During the first forty years of the nineteenth century a number of British missions moved through the area. Metcalfe negotiated the Treaty of Amritsar in 1809, Ochterlony attended Kharak Singh's wedding in 1812, Lord Bentinck and his suite paid a visit in 1832. They were followed by Sir Henry Fane in 1837 and by Lord Auckland and his party in 1838. Earlier in the nineteenth century the British had posted an Agent with his staff at Ambala and Ludhiana, and a number of travellers such as Jacquemont and Vigne had also visited the area. All these visitors were fascinated by the enigmatic Maharaja and the splendid and martial Sikhs. Some of the British, such as Emily Eden, her sister Fanny, and her nephew, William Osborne, made their own drawings of the colourful characters they encountered, but on occasion the visitors employed local Indian artists to make drawings of the ruler, his ministers and the local people. No. 181 is an example of such a commission made about 1838 to 1839 and in style is still closely related to the type of picture made for the Sikhs themselves.

After the British had annexed the Punjab in 1849 Indian artists began to cater especially for them, and, probably as a result of being shown Company paintings from other parts of India, began to make stock sets for sale in the bazaars and at the European stations. These drawings depicted Sikh rulers and heroes, occupations and costumes, and famous monuments in the Punjab as well as at Delhi and Agra. That they were intended specially for the British is shown by inscriptions on some of the sets. No. 184 states, 'All the sahibs take it to show in England', and another series which recently passed through the London sale rooms was inscribed: 'Bought at Anarkulle, Lahore, April/62 for Rs 15 from a curiosity vendor. Dak Bungalow. G. R. Gibbs.' The artist or dealer had written, 'This book comprises all the Punjabees, workmen, the Rajah and many other things and this book is written in one year.' To this Mr Gibbs had added his own comments: 'The features of the men and women in these sketches are perhaps the best and truest part of them. There is a decided want of skill in drawing the drapery etc., but a good idea of wearing apparel is given. Very little knowledge of perspective shown. Though most of the men's legs appear not to belong to them, still a native can twist his legs in a very uncomfortable manner to all but himself.' Mr Gibbs had also added his own facetious notes beside the pictures. 'Groom. Takes care of himself.' 'Chowkildar or watchman; sleeps, eats or coughs the whole night.'[2]

[1] Archer (1966).
[2] *Ibid.*, 59.

The high-handed manner in which orders for pictures were sometimes given is reflected in the notes written on some drawings made by Kapur Singh of Amritsar for Augustus Honner of the 1st Grenadiers, Bombay about 1865 (no. 187). 'Painted to my order, i.e. I gave the subject I wanted the man to do.' 'These horrible pictures are the result of an order by me to paint Jyepoor Costumes.' 'Those he painted from his own idea are generally very good and correct, but any done to order are failures.'

The drawings of Sikh rulers and heroes were derived from the earlier Sikh miniatures and preserved the conventional characteristics of these figures, but gradually British influence crept into them – the colours becoming paler, water-colour taking the place of gouache and the line losing its vitality. These portraits were of two types – sets of full-length figures on paper, or sets of oval, head-and-shoulder portraits on ivory or paper. Although made as much for the British as for the Sikhs, they recalled the national heroes who had made the Punjab great and had struggled to hold it against the invaders. Not only Ranjit Singh, his courtiers and successors were portrayed, but the generals who had fought against the British, Mulraj the Governor of Multan, and the Afghan rulers who had resisted the British invaders. Oval ivory miniatures were being made as early as 1850; and portraits of Bahawal Khan and Mulraj were reproduced as a frontispiece to the second volume of Sir Herbert Edwardes, *A Year on the Punjab frontier, 1848–9*, published in London in 1851.

The drawings of monuments were clearly derived from Delhi paintings of such subjects, although on a more limited and far less ambitious scale. The most common subjects were the famous monuments of Lahore: the Badshahi mosque, the Golden mosque, the mosque of Wazir Khan, Ranjit Singh's mausoleum, the Saman Burj, the Bari Khwabgah, the Shalimar Gardens and Jahangir's mauso-leum; as well as the Golden Temple and Fort of Govindgarh at Amritsar. The Taj Mahal at Agra and the Jami Masjid and Qutb Minar at Delhi were also some-times included in the sets. Unlike Delhi paintings which covered the whole sheet, the Amritsar and Lahore pictures usually show the monument in a small landscape isolated in the centre of the paper.

The sets of costumes and occupations were of two types. One type was clearly made by Punjab Hill artists, probably from Guler who had migrated to Amritsar, Lahore and possibly other centres in the Punjab plains. In style they closely resemble Guler miniatures of the mid-nineteenth century and are executed in gouache, with coloured borders, showing the craftsman or subject of the picture in an appropriate setting of a shop or landscape. They are a continuation of the hill tradition and it is mainly in their subject matter that they reflect British taste (no. 182). A second type was cheaper, simpler and more naive, the figures being shown against a plain background without any suggestion of a landscape (nos 184, 185). Some sets, however, such as those drawn by Kapur Singh of Amritsar (no. 187), were more elaborate and placed the figure in an appropriate setting

within a coloured border. These pictures were executed on European paper in water-colour. They were at times sold separately, but were usually bound up together into small volumes with tooled leather covers (nos 184, 185). Ivory portrait miniatures were also marketed in a similar way – either separately or mounted in sets of eight or ten in leather velvet-lined folding mounts (no. 190).

Bibliography

Archer, W. G. *Paintings of the Sikhs* (London, 1966).

Baden Powell, B. H. *Handbook of the manufactures and arts of the Punjab* (Lahore, 1872).

Brown, P. *Indian painting* (2nd edition, Calcutta, 1927), 62.

Eden, Emily (*ed*. E. J. Thompson), *Up the country* (London, 1937).

Griffin, L. *Ranjit Singh* (Oxford, 1892).

Gupta, S. N. 'The Sikh school of painting', *Rupam*, ii, no. 12, 1922, 125–128.

Kipling, J. L. 'The industries of the Punjab', *The Journal of Indian Art*, ii, no. 20, October 1887, 27–42.

Smith, V. A. *A History of fine art in India and Ceylon* (Oxford, 1911), pp. 223, 224.

(a) *Paintings on paper*

181 i–l 50 drawings bound into a volume; 31 depicting people of the Punjab and neighbouring areas, 11 depicting infantry and cavalry of the Punjab and its environs and 8 depicting rulers of the Punjab and their ministers as well as princes of the Punjab Hill states.

By an Indian artist, probably at Amritsar, 1838–39.

The majority inscribed with titles in Persian characters and in English.

Water-marks of 1837 (e.g. *Add. Or. 1348*).

Pencil and water-colour, some drawings unfinished; size of volume: $10\frac{1}{2}$ by $8\frac{1}{4}$ ins.

Purchased 12 December 1919 *Add. Or. 1347–1396*

NOTE: These drawings when acquired by the Library were in a bound volume entitled *Panjabi Characters*, but owing to the poor condition of the Indian binding they were later rebound. They could well have belonged to one of the British visitors to the Punjab in the late eighteen-thirties and early forties. The drawings show marked British influence in the use of pencil and water-colour and uncoloured backgrounds, although the portraits are water-colour versions of conventional Sikh miniatures. They are on English paper and were therefore probably commissioned by an Englishman who supplied the paper. The Persian and English inscriptions suggest that the owner obtained them over a period of about a year from 1838 until some time before October 1839. The fact that certain drawings are unfinished indicates that the owner may have left the Punjab before the drawings were completed (see nos. xxii, xxiii, xxxi, xxxii, xxxiv, xxxvii). The English inscriptions on (xxxvi) and (xxxix) show that some at least of the drawings were supplied in 1838, but the Persian inscription on (xliii) which refers to 'Maharaja Kharak Singh' implies that the drawing was made after June 1839 when Kharak Singh became ruler of the State. A few of the English inscriptions, however, must have been added later; the note on xliv could not have been made until after 1843 when Dhian Singh was murdered.

In 1838 few Europeans knew the Punjab intimately. The British had not advanced beyond the river Sutlej and negotiations with the Sikhs were conducted from Ludhiana. The mixed subject

matter of this volume, which includes types from Tibet and Afghanistan, suggests that the drawings were made by an Indian artist either touring the Punjab with a British traveller or at Amritsar, a great trading mart which attracted many different peoples.

Bibliography

Archer (1966), 58.

i Zalim Sen (ruled 1826–39) of Mandi (Punjab Hills) seated with his nephew, Balbir Sen (ruled 1839–51).
Inscribed in Persian characters: *Balbīr Sen rājah i Manḍī*; in English: *The Mundee Rajah and son.* *Add. Or. 1347*
NOTE: The English inscription is clearly incorrect. The painting must depict Balbir Sen (the smaller figure) with his uncle, Zalim Sen (the larger figure). Zalim Sen abdicated in 1839 in favour of Balbir when the latter was 22 years old. Bijai Sen, son of Balbir Sen, was not born until 1851.

ii Ranbir Chand (? – 1847) and Pramod Chand (1815–51), grandsons of Raja Sansar Chand (ruled 1775–1823) of Kangra (Punjab Hills), seated together.
Inscribed in Persian characters: *Aulād i rājah Sansār Chand* (Descendants of Raja Sansar Chand); in English: *Sons of Raja Sunsur Chund with the Goitres of their mountains.* *Add. Or. 1348*
NOTE: Sansar Chand was succeeded by his son, Anirudh (ruled 1823–28). It is clearly Anirudh's sons who are depicted here.

iii Abyssinian man and woman.
Inscribed in Persian characters: *Ḥabashī* (Negroes). *Add. Or. 1349*

iv A poor *Akālī* mounted on horseback.
Inscribed in Persian characters: *Nihang i muflis* (Poor Crocodile); in English: *Nahung or Akhalee (or 'Immortal').* *Add. Or. 1350*

v A prosperous *Akālī* mounted on horseback.
Inscribed in Persian characters: *Nihang* (Crocodile); in English: *A Nahung or Akhalee.* *Add. Or. 1351*

vi Two Afghans from Maler Kotla (Punjab States).
Inscribed in Persian characters: *Afghānān i Maler Kōṭlah*; in English: *Afghans of Mulair Kotela (Ambala).* *Add. Or. 1352*

vii Punjabi priest, holding a manuscript, seated with a woman.
Inscribed in Persian characters: *Panḍit i Panjāb*; in English: *A Priest of the Punjaub. Lady at Confessional.* *Add. Or. 1353*

viii Schoolmaster of the Jullundur Doab (Punjab) seated with two pupils.
Inscribed in Persian characters: *Miyān-jī doābah i Jālandhar*; in English: *Schoolmaster in the Julundur Dooaab.* *Add. Or. 1354*

ix Man and woman from Kafiristan (Afghanistan); the man has a bow and arrows.
Inscribed in Persian characters: *Mardum i Kāfirī*; in English: *Inhabitants of Kafristan (in Afghanistan).* *Add. Or. 1355*

x The Nawab of Multan (Punjab) mounted on a white horse.
Inscribed in Persian characters: *Nauwāb i Multān*; in English: *The Nawaub of Mooltan.* Add. Or. 1356

xi Horseman of Bannu and Tank district (N.W.F.P.).
Inscribed in Persian characters: *Sawār i Bannu Tānk.* Add. Or. 1357

xii A man from Mankera and a man from Multan (Punjab).
Inscribed in Persian characters: *Az Mankerah Multānī.* Add. Or. 1358

xiii Man and woman from Wazirabad (Punjab).
Inscribed in Persian characters: *Mardum i Wazīrābād.* Add. Or. 1359

xiv Man and woman from Jhang (Punjab).
Inscribed in Persian characters: *Mardum i Jhangiyān.* Add. Or. 1360

xv Man and woman from Pothohar (Rawalpindi district, Punjab).
Inscribed in Persian characters: *Mardum i Pothohar.* Add. Or. 1361

xvi Two money-lenders from Shikarpur (Sind).
Inscribed in Persian characters: *Mahājan i Shikārpūrī*; in English: *Merchants of Shikarpoor (in Sindh).* Add. Or. 1362

xvii Soldiers from Mandi and Bihawi (?).
Inscribed in Persian characters: *Mandhī. Bihāwī*; in English: *Mundee Soldiers.* Add. Or. 1363

xviii Two men from Peshawar (N.W.F.P.).
Inscribed in Persian characters: *Pashāwarī*; in English: *Peshawurees.*
Add. Or. 1364

xix Two Rohilla men (U.P.).
Inscribed in Persian characters: *Ruḥīlah*; in English: *Rohillas.* Add. Or. 1365

xx Two Tibetan men.
Inscribed in Persian characters: *Mardum i Tibit*; in English: *Thibettees.*
Add. Or. 1366

xxi Two Tibetan women.
Inscribed in Persian characters: *Zanān i Tibit*; in English: *Thibettee women.* Add. Or. 1367

xxii Tibetan lama mounted on a yak. Unfinished pencil sketch.
Inscribed in Persian characters: *Gūrū i Lhāsah*; in English: *A priest of Thibet riding the Yak.* Add. Or. 1368

xxiii Man from Ladakh on horseback. Unfinished pencil sketch.
Inscribed in Persian characters: *Ladākhī*; in English: *a Ladakhee.*
Add. Or. 1369

xxiv Man and woman with a dog from Kot Kuru.
Inscribed in Persian characters: *Mardum i Kōṭ Kūrū*; in English: *Inhabitants of Kote guaroo mountains (?).* Add. Or. 1370

xxv Two Kashmiri women.
Inscribed in Persian characters: *Zanān i Kashmīr*; in English: *Cashmeerees.*
Add. Or. 1371

xxvi Two Kashmiri men.
Inscribed in Persian characters: *Kashmīrī*; in English: *Cashmeerees*.
Add. Or. 1372

xxvii Man and woman from Jammu (Punjab Hills).
Inscribed in Persian characters: *Mardum i kūh i Jamūn*; in English: *Inhabitants of Jummoo nr. Cashmere*.
Add. Or. 1373

xxviii Shepherd couple of the *Gaddi* caste from Chamba.
Inscribed in Persian characters: *Mardum i Chambah ya'nī Gaddi*; in English *Tibeteans*.
Add. Or. 1374

xxix Man and woman from Jwalamukhi (Kangra, Punjab).
Inscribed in Persian characters: *Mardum i Jawālah-mukhī*; in English: *Inhabitants of Jawala Mookhee*.
Add. Or. 1375

xxx Two Jat farmers of the Punjab.
Inscribed in Persian characters: *Zamīdār i Panjāb qaum i jaṭ*; in English: *Jat peasants of the Punjaub*.
Add. Or. 1376

xxxi Unfinished pencil sketch of man and child.
Add. Or. 1377

xxxii Unfinished pencil sketch of two women and a girl.
Add. Or. 1378

xxxiii Two money-lenders of Lahore (Punjab).
Inscribed in Persian characters: *Mahājan i Lāhaur*; in English: *Merchants of Lahore*.
Add. Or. 1379

xxxiv Unfinished pencil sketch of two women seated smoking.
Add. Or. 1380

xxxv Sikh sentry.
Inscribed in Persian characters: *Santrī i khālṣah*.
Add. Or. 1381

xxxvi Cavalryman mounted on a white horse and carrying a lance with pennant.
Inscribed in Persian characters: *Sawār i sher rajiman* (Trooper of the lion regiment); in English: *General Allard's Cavalry, Punjaub. 1838*.
Add. Or. 1382
NOTE: General Allard was a French adventurer who trained Ranjit Singh's cavalry from 1822–39.

xxxvii Unfinished pencil sketch of cavalryman with lance.
Add. Or. 1383

xxxviii Cavalryman with lance and saddle-coth ornamented with a lion.
Inscribed in Persian characters: *Sawār i siyah* (black trooper). *Add. Or. 1384*
NOTE: The inscription suggests that this may be an Abyssinian mercenary, but Ranjit Singh is not known to have employed these.

xxxix Body-guard of Ranjit Singh: two horsemen on richly caparisoned mounts (*Plate 71*).
Inscribed in Persian characters: *Sawārān i khāṣṣ*; in English: *Lahore Life Guards 1838*.
Add. Or. 1385

xl Portrait of Jamadar Khushal Singh.
Inscribed in Persian characters: *Jam'dār Khwushhāl Singh*; in English: *Jemadar Kooshal Singh (Runjeet Singh's Man Friday)*. *Add. Or. 1386*
NOTE: Jamadar Khushal Singh (1790–1839) joined Ranjit Singh's bodyguard in 1807 and

became a favourite. He was Chamberlain in 1811 and although superceded by Dhian Singh in 1818 he remained a member of Ranjit Singh's inner council and became Governor of Multan.

xli Portrait of Suchet Singh.

Inscribed in Persian characters: *Rājah Su<u>ch</u>et Singh*; in English: *Rajah Soocheit Singh*. *Add. Or. 1387*

NOTE: Suchet Singh (1801–44) was the third of three Dogra brothers who were members of a junior branch of the Jammu royal family. He entered Ranjit Singh's service in 1812 and became a Raja in 1822. He obtained the eastern half of the Jammu hills as a fief and was murdered at Lahore in March 1844.

xlii Portrait of Nau Nihal Singh seated feeding a pet bulbul; an attendant stands behind him.

Inscribed in Persian characters: *Kunwār Nau Nihāl Singh*; in English: *Konwur or Prince Nao Nihal Singh killed at the Gateway during a Suttee*. *Add. Or. 1388*

NOTE: Nau Nihal Singh (1821–40) was the son of Kharak Singh and superceded his father as Maharaja in October 1839. He was killed at Lahore by a fall of masonry from a gateway when returning from his father's funeral, 5 November 1840. The Persian inscription suggests that the drawing was made when Nau Nihal Singh was still a prince (i.e. 1838 or early 1839) but the English inscription implies a date of 1840 or later.

xliii Kharak Singh seated with Chet Singh standing before him.

Inscribed in Persian characters: *Mahārājah Kharak Singh. <u>Ch</u>ait Singh*; in English: *Maha Raja Kurruk Singh son and Successor of Runjeet Singh. Poisoned. Cheit Singh his attendant murdered in the presence of his master*. *Add. Or. 1389*

NOTE: Kharak Singh (1802–40) was the son of Ranjit Singh and succeeded as Maharaja in June 1839. He was deposed by Nau Nihal Singh in October 1839 and died November 1840. Chet Singh was his Chief Minister and was murdered in October 1839. The English inscription must have been made after November 1840.

xliv Ranjit Singh seated with Dhian Singh standing before him.

Inscribed in Persian characters: *Rājah Dhiyā<u>n</u> Singh. Mahārājah Ranjīt Singh*; in English: *Maharaja Runjeet Singh; his Rajpoot Minister Rajah Dhian Singh/murdered/–*. *Add. Or. 1390*

NOTE: Ranjit Singh (1780–June 1839) was Maharaja of the Punjab from 1799 to 1839. Dhian Singh (1796–1843) was the second of three Dogra brothers and like the third brother, Suchet Singh, entered Ranjit Singh's service in 1812. He became favourite and court chamberlain from 1818 and Raja 1822. He was Chief Minister of Ranjit Singh from 1828 and also served Nau Nihal Singh and Sher Singh. He was murdered in 1843. The English inscription must therefore have been made after that date.

xlv Theologian and preacher from Kabul (Afghanistan) with his servant.

Inscribed in Persian characters: *Ā<u>kh</u>ūn i Kābul. <u>Gh</u>ulām*; in English: *An Akhoon of Caubool; his slave*. *Add. Or. 1391*

xlvi Two Yusufzai infantrymen (N.W.F.P.).

Inscribed in Persian characters: *Piyādah i Yūsufzai*; in English: *Infantry of the Yusufzaee tribe.* *Add. Or. 1392*

xlvii Yusufzai horseman (N.W.F.P.).

Inscribed in Persian characters: *Sawār i Yūsufzai.* *Add. Or. 1393*

xlviii Kabuli horseman in chain mail holding a lance (Afghanistan).

Inscribed in Persian characters: *Zirah-posh i Kābul*; in English: *Caubool cavalry in chain armour.* *Add. Or. 1394*

xlix Two Arab men.

Inscribed in Persian characters: *'Arab*; in English: *Arabs.* *Add. Or. 1395*

l Persian horseman with musket.

Inscribed in Persian characters: *Taṣwīr* (picture). *Sawār i Īrān*; in English: *Persian Cavalry.* *Add. Or. 1396*

182 Two mendicants (*suthra shāhi*) begging alms from a grain seller who is seated in his shop.

By an artist from the Punjab Hills working in the Punjab Plains probably at Lahore or Amritsar. *c.* 1850.

Gouache; red border with black and white rules; $7\frac{1}{2}$ by $9\frac{3}{4}$ ins.

Presented by Mildred and W. G. Archer, 1 July 1969. *Add. Or. 3005*

NOTE: Comparable in style to painting in Guler, Kangra district, *c.* 1830–40 (see Archer, 1966).

Suthra shāhis are non-sectarian mendicants peculiar to the Punjab. They revere Tegh Bahadur, father of Guru Govind Singh, as their founder. When begging, they sing songs and clash together two black sticks. They wear black perpendicular streaks down their foreheads.

183 i, ii Two portraits of diplomats made in Afghanistan.

By Muhammad Azim (perhaps a Punjabi artist), 1854.

Inscribed with names in Persian characters and English.

Gouache and water-colour; $8\frac{3}{4}$ by 7 ins.

Purchased from Mrs Vandaleur, great-niece of Sir Herbert Edwardes, 26 October 1954. *Add. Or. 746; 747*

NOTE: These drawings were among the papers of Sir Herbert Edwardes and the English inscriptions appear to be in his handwriting. Edwardes went to Peshawar in 1854 as Commissioner and became involved in negotiations for a treaty with the Amir of Afghanistan. It is possible that they were made by a painter who had accompanied him from the Punjab.

i Portrait of Hajji Khair Allah Khan, ambassador of Saiyid Muhammad Khan, ruler of Herat, to Kabul, kneeling with clasped hands on a rug, dressed in a grey robe and pinkish turban.

Inscribed in Persian characters: *Taṣwīr i 'ālijāh ḥājjī al-Ḥaramain Ḥājjī Khair Allāh Khān īlchī i sarkār i sardār Saiyid Muḥammad Khān wālī i Harāt 'amal i Muḥammad 'Aẓīm aṣamm abkam sanah 1271* (Portrait of the exalted pilgrim to the

holy places, Hajji Khair Allah Khan, ambassador of His Highness Saiyid Muhammad Khan, ruler of Herat. Work of Muhammad Azim, the deaf and dumb. 1271/1854); in English: *Hajee Kheiroolla Khan. Envoy from Herat to Cabul.* *Add. Or. 246*

ii Portrait of Saiyid Mir Hafiz-ji Sahib, Councillor of the Amir of Afghanistan. Full-length, dressed in green robe and turban and holding a long staff in his left hand.

Inscribed in Persian characters: *Taṣwīr i sulālah al-sādāt al-ʿuẓẓām Mīr Ḥāfiẓ-jī Ṣāḥib ʿamal i Muḥammad ʿAẓīm aṣamm abkam* (Portrait of the descendant of the mighty Saiyids Mir Hafiz-ji Sahib. Work of Muhammad Azim, the deaf and dumb); in English: *Hafiz Jee, Privy Councillor of the Ameer.* *Add. Or. 747*

184 i–lv 55 drawings bound into a volume; 10 depicting rulers of the Punjab and Sikh heroes, 10 buildings and places in Delhi, Agra, Lahore and Amritsar, 35 occupations.

By a Punjab artist, Lahore, *c.* 1860.

The volume has an Indian binding and is entitled: *Punjab Portraits, Buildings & Professions. Coloured Drawings*, the spine and title having been added by the Library. All drawings are inscribed in English by an Indian. On the last page is the following inscription in roman characters in the same hand: *Is ketab men sab Panjab ki chis hai Raja log, naqsha, sab kam karne wala, tin kori panna hai, ekso bis taswir hai, sab sahib log walait dikhlane ko lejate hain, yih kitab lahore men banti hai, qalim ka kam hai* (In this book are all Punjabi things. Rajas, landscapes, all the trades. There are 60 pages, 120 pictures. All the sahibs take it to show in England. This book was made in Lahore. It is done with a pen). Water-colour; size of volume: 9¾ by 7¾ ins. Purchased 23 April 1915. *Add. Or. 1397–1451*

NOTE: As can be seen from the inscription, this is an incomplete set of drawings, five pages being missing when the book was acquired by the Library. Sixty (see no. 185) appears to have been the normal number of drawings in a standard set. The drawings are in a broken-down Indian style, the figures shown in isolation against an uncoloured background. The rulers and heroes are shown in pairs and seated on western-style chairs. In the inscriptions 'King' appears to be a translation of 'Raja' and does not imply that the person so described was actually ruling.

Bibliography

Archer (1966), 59, figs. 93–95.

 i Maharaja Ranjit Singh. Maharaja Kharak Singh.
 Inscribed: *Maha Raja Ranjit Sing King Lahore. Maha Raja Kharak Sing Ranjit Sing son Lahore.* *Add. Or. 1397*
 NOTE: See p. 215.

 ii Maharaja Sher Singh. Maharaja Nau Nihal Singh.
 Inscribed: *Maha Raja Sher Sing Ranjit Sing son Lahore. Maha Raja Nunehal Sing Khirk Sing son Lahore.* *Add. Or. 1398*

NOTE: Sher Singh (1807–43) accepted son of Ranjit Singh; Governor of Kangra state, 1830–31; succeeded Nau Nihal Singh as Maharaja 18 January 1841; murdered September 1843. Nau Nihal Singh, see p. 215.

iii Rani Jindan. Maharaja Dalip Singh.

Inscribed: *Rani Jinda Dalip Sing Mother Lahore. Maha Raja Dalip Sing Ranjit Sing son Lahore.* Add. Or. 1399

NOTE: Rani Jindan was the acknowledged wife of Maharaja Ranjit Singh and accepted mother of Maharaja Dalip Singh. Head of Lahore court and regent, September 1843 to December 1846. Sister of Jawahir Singh. Exiled by the British, August 1847, and died in London 1863. Dalip Singh (1837–93) was the accepted son of Rani Jindan and Ranjit Singh. Maharaja 1843–49; exiled from the Punjab 1850; went to England 1854; died in Paris.

iv Hira Singh. Dhian Singh.

Inscribed: *Maha Raja Hira Sing Raja Thehan Sing son Lahore. Maha Raja Thean Sing Raja Ranjit Sing's Vazir Lahore.* Add. Or. 1400

NOTE: Dhian Singh (1796–1843), second of the three Dogra brothers, entered Ranjit Singh's service 1812. He eventually became Chief Minister of Ranjit Singh 1828–39 and Nau Nihal Singh 1839–40. Served Sher Singh, murdered 1843.

 Hira Singh (*c.* 1816–44) was the son of Dhian Singh. Boy favourite of Ranjit Singh; Chief Minister to Dalip Singh 1843; killed 1844.

v Suchet Singh. Maharaja Gulab Singh.

Inscribed: *Raja Suchet Sing the brother of Maha Raja Golab Sing Lahore. Maharaja Golab Singh King Kashmir.* Add. Or. 1401

NOTE: Gulab Singh (1792–1857), the elder of the three Dogra brothers, entered Ranjit Singh's service 1809; obtained Jammu as fief 1820; Chief Minister to Dalip Singh, January to March 1846. Negotiated first treaty of Lahore with British, March 1846; obtained Kashmir and recognised by British as independent Raja of Jammu and Kashmir. Suchet Singh, see p. 215.

vi Amir Sher Ali Khan. Maharaja Ranbir Singh.

Inscribed: *Amir Sher Aly Khan King Kabul. Maharaja Rambir Sing King Kashmir.* Add. Or. 1402

NOTE: Sher Ali Khan, youngest son of Dost Muhammad Khan, Amir of Afghanistan 1863–79. Ranbir Singh (*c.* 1829–85), third son of Maharaja Gulab Singh. Ruler of Kashmir 1857–85 (reproduced Archer, fig. 95).

vii Sham Singh Atariwala. Chattar Singh Atariwala.

Inscribed: *Sham Sing belongs Atari. Chatar Sing belongs Atari.* Add. Or. 1403

NOTE: Sham Singh Atariwala was a Sikh general, killed at the battle of Sobraon, February 1846 (reproduced Archer, fig. 94). Chattar Singh Atariwala was Commander-in-Chief of the Sikh army during the second Sikh War, 1848–49. He was defeated at the battle of Gujarat, February 1849, surrendered and later was exiled from the Punjab.

viii Mulraj. Sher Singh Atariwala.

Inscribed: *Divan Mul Raj King Multan. Shair Sing belongs Atari.*

Add. Or. 1404

NOTE: Mulraj became Governor of Multan, September 1844. The murder of two British officers there in April 1848 precipitated the second Sikh War. Captured by the British,

January 1849, died *c.* 1850. Sher Singh Atariwala, son of Chattar Singh Atariwala, sided at first with the British against Mulraj, but later joined his father in the second Sikh War. Surrendered after the battle of Gujarat 1849, exiled from Punjab (reproduced Archer, fig. 93).

 ix Tej Singh. Dina Nath.

 Inscribed: *Raja Teja Sing Lahore. Raja Dini Nath Daftari of Maharaj.*

 Add. Or. 1405

 NOTE: Tej Singh, nephew of Jamadar Khushal Singh (p. 214), became Commander-in-Chief of the Sikh army 1845. Member of Regency Council of Maharaja Dalip Singh, December 1846. Dina Nath joined Ranjit Singh's state office 1818. Became head of civil and finance office 1834, Diwan 1838, remained finance minister under Maharajas Kharak, Nau Nihal, Sher and Dalip Singh. Member of Regency Council 1846; collaborated with British after the second Sikh War 1849; died 1857.

 x Amir Dost Muhammad Khan. Ali Akbar Khan.

 Inscribed: *Dost Mohammid Khan King Qabil or Kabil. Aly Akbar Khan King Kabil Dost Mohammud son.* *Add. Or. 1406*

 NOTE: Dost Muhammad Khan, Amir of Afghanistan 1836–40 and 1841–63. Admired by the Sikhs for his opposition to the British. Ali Akbar Khan, eldest son of Dost Muhammad, took part in the 1841 insurrection against the British. He died in 1848.

 xi The Jami Masjid (Badshahi Mosque) Lahore.

 Inscribed: *Juma masjid Lahore.* *Add. Or. 1407*

 xii The Golden Temple, Amritsar.

 Inscribed: *Amritsar Guru Temple.* *Add. Or. 1408*

 xiii The Golden Mosque, Lahore.

 Inscribed: *Gold Masjid Lahore.* *Add. Or. 1409*

 xiv The Jami Masjid, Delhi.

 Inscribed: *Juma Masjid Dihly.* *Add. Or. 1410*

 xv The Qutb Minar, Delhi.

 Inscribed: *Kutab Lat Dihly.* *Add. Or. 1411*

 NOTE: Major Robert Smith repaired the Qutb Minar and added a cupola to the top in 1826. Although this was removed in 1847, the artist, perhaps copying from earlier drawings, shows it as still present.

 xvi The Taj Mahal, Agra.

 Inscribed: *Taj Re ka Roza Agera ka.* *Add. Or. 1412*

 xvii Mausoleum of Ranjit Singh, Kharak Singh and Nau Nihal Singh, Lahore.

 Inscribed: *Ranjit Sing's Grave.* *Add. Or. 1413*

 xviii Mosque of Wazir Khan, Lahore.

 Inscribed: *Masjid of Vazir Khan Lahore.* *Add. Or. 1414*

 xix The Shalimar Gardens, 5 miles east of Lahore.

 Inscribed: *Shalamar Gardin Lahore.* *Add. Or. 1415*

 xx Jahangir's mausoleum at Shahdara, north of Lahore.

 Inscribed: *Jahangir's grave Shah Dara Lahore.* *Add. Or. 1416*

 xxi Man with performing monkey and goat.

Inscribed: *Tamasha karnewala or Qalandar. He Goat. Monkey.*

<div align="right">*Add. Or. 1417*</div>

xxii Silk-thread maker; a Punjabi woman smoking a hookah.
Inscribed: *Silker or Patali. Woman Panjab.* *Add. Or. 1418*

xxiii Water-carrier with his skin beside a well.
Inscribed: *Drink Giver. Panipeyane vala. Pani pinewala.* *Add. Or. 1419*

xxiv Two ascetics; a wandering Hindu mendicant carrying a bell and a Muslim darvish.
Inscribed: *Buni Nawa Faqir Hindus. Banawa Faqir. Mohammidans.*

<div align="right">*Add. Or. 1420*</div>

xxv Persian wheel; a woman washing clothes and a cultivator standing by.
Inscribed: *Well. She is clothes wash. He is going at field.* *Add. Or. 1421*

xxvi Wood-cutters splitting and weighing wood.
Inscribed: *Exeman. Balancer or Lakri tolnewala.* *Add. Or. 1422*

xxvii Army drummer and a soldier with sword and musket.
Inscribed: *Maharaja Ranjit Sing ke waqt nazibon ki paltin ke santari or sepahi.* *Add. Or. 1423*

xxviii Woman spinning and a weaver at work.
Inscribed: *This is wear's wife. Weaver.* *Add. Or. 1424*

xxix Snake-charmers.
Inscribed: *Bengali sapada.* *Add. Or. 1425*

xxx Doctor examining a sick boy.
Inscribed: *Dakter. He is sick boy & she is his mother.* *Add. Or. 1426*

xxxi Herdsman milking a cow; his wife holding the calf.
Inscribed: *Milker. And she is his wife.* *Add. Or. 1427*

xxxii Man with a performing bear.
Inscribed: *Wolf & his master.* *Add. Or. 1428*

xxxiii Punkah-puller. Gold-beater.
Inscribed: *Servant. Gold hiter.* *Add. Or. 1429*

xxxiv Carding cotton.
Inscribed: *Penja. She is coming with his cottin.* *Add. Or. 1430*

xxxv Gold-braid makers.
Inscribed: *Gote Baf.* *Add. Or. 1431*

xxxvi Gold-thread makers.
Inscribed: *He is pulling thread of Gold. Tille wat.* *Add. Or. 1432*

xxxvii Vegetable-seller.
Inscribed: *Woman. Sabzi farosh.* *Add. Or. 1433*

xxxviii Ginning cotton.
Inscribed: *She is comming with her cotton. Run wel ta hai.* *Add. Or. 1434*

xxxix Distiller and a man drinking.
Inscribed: *Sharab wala. Sharab Pinewala.* *Add. Or. 1435*

> xl Sweetmeat-makers.
> Inscribed: *Sweeter.* *Add. Or. 1436*
> xli Huntsman from Bahawalpur shooting deer.
> Inscribed: *Bahol Pur ka Shikari.* *Add. Or. 1437*
> xlii Barber.
> Inscribed: *He is cutting his hair.* *Add. Or. 1438*
> xliii Hill-man and archer.
> Inscribed: *Mountaineer. Faridi lutnewala.* *Add. Or. 1439*
> xliv Woman selling earthen toys to children.
> Inscribed: *Bawa lok ka matti ka tash Bechne wala.* *Add. Or. 1440*
> xlv *Suthra shāhī* mendicants.
> Inscribed: *Suthre Shahi Faqir Hindu.* *Add. Or. 1441*
> xlvi *Akālī* with his wife.
> Inscribed: *Phola Sing sikh log guru. She is his wife.* *Add. Or. 1442*
> xlvii Kashmiri women spinning wool.
> Inscribed: *Kasmir ki awrat Pasham kat ne wali.* *Add. Or. 1443*
> xlviii Cloth merchants.
> Inscribed: *Cloth merchant.* *Add. Or. 1444*
> xlix Opium addicts.
> Inscribed: *Posti. Post Pikar mutwala ho raha hai.* *Add. Or. 1445*
> l Club-carrying fakirs.
> Inscribed: *Gorj mar Faqir Jadu ka Khail Khailne wale musalman.*
> *Add. Or. 1446*
> li Sweeper and his wife with their donkey.
> Inscribed: *Gada. Mihtar. Mihtarani.* *Add. Or. 1447*
> lii Woman with a winnowing fan. Curd-seller.
> Inscribed: *Changri. Gowalin Dudh Dahin Bechne wali.* *Add. Or. 1448*
> liii Potter with his wheel and kiln.
> Inscribed: *Mati ke Bartin Bechne or Bana ne wala.* *Add. Or. 1449*
> liv Goldsmiths.
> Inscribed: *Sunara.* *Add. Or. 1450*
> lv Men preparing and smoking Indian hemp.
> Inscribed: *Chursi. Phangi.* *Add. Or. 1451*

185 i–lx 60 drawings bound into a volume; 10 depicting rulers of the Punjab and Sikh heroes, 10 buildings and places in the Punjab, especially Lahore, 40 occupations. By a Punjabi artist, at Lahore, *c.* 1860.

The volume has an Indian binding and is entitled: *Punjab Portraits, Buildings and Professions – Coloured Drawings*, the spine and title having been added by the Library. All drawings, except xxxiv, are inscribed with titles in Persian characters. Water-colour; size of volume 9¾ by 8 ins.

Purchased 13 May 1911. *Add. Or. 1452–1511*

NOTE: This set is almost identical to no. 184 although by a different hand or shop. The drawings are perhaps closer to the traditional miniature style but the figures are shown in isolation against an uncoloured background. The rulers and heroes, apart from Ranjit Singh on a western-style chair, are shown seated on the ground on rugs. Each drawing is surrounded by a gold, red and blue rule border.

Bibliography

Archer (1966), 59, plate 92 (Maharaja Sher Singh, iii).

 i Maharaja Ranjit Singh seated on a chair with his feet on a stool.
 Inscribed in Persian characters: *Mahārājah Ranjīt Singh* *Add. Or. 1452*

 ii Maharajah Dalip Singh seated on a rug with a small dog beside him.
 Inscribed in Persian characters: *Mahārājah Dalīp Singh.* *Add. Or. 1453*

 iii Maharaja Sher Singh seated on a rug holding a sword over his shoulder.
 Inscribed in Persian characters: *Mahārājah Sher Singh.* *Add. Or. 1454*

 iv Rani Jindan seated on a rug.
 Inscribed in Persian characters: *Rānī Jindān.* *Add. Or. 1455*

 v Dhian Singh seated on a rug.
 Inscribed in Persian characters: *Rājah Dhiyān Singh.* *Add. Or. 1456*

 vi Dina Nath seated on a rug holding a rosary.
 Inscribed in Persian characters: *Rājah Dīnā Nāth.* *Add. Or. 1457*

 vii Maharaja Kharak Singh seated on a rug holding a rosary.
 Inscribed in Persian characters: *Mahārājah Kharak Singh.* *Add. Or. 1458*

viii Suchet Singh seated on a rug holding a jewel and a sword.
 Inscribed in Persian characters: *Rājah Sujet Singh.* *Add. Or. 1459*

 ix Amir Dost Muhammad Khan seated on a rug holding a rosary.
 Inscribed in Persian characters: *Dost Muhammad Khān.* *Add. Or. 1460*

 x Maharajah Gulab Singh seated on a rug holding a rosary.
 Inscribed in Persian characters: *Mahārājah Gulāb Singh.* *Add. Or. 1461*

 xi The Jami Masjid (Badshahi Mosque), Lahore.
 Inscribed in Persian characters: *Masjid i Huzūrī Bāgh.* *Add. Or. 1462*

 xii Mosque of Wazir Khan, Lahore.
 Inscribed in Persian characters: *Masjid i Wazīr Khān.* *Add. Or. 1463*

xiii The Golden Mosque, Lahore.
 Inscribed in Persian characters: *Sonehri Masjid.* *Add. Or. 1464*

xiv The Saman Burj in the North west corner of the palace, Lahore
 Inscribed in Persian characters: *Saman Burj.* *Add. Or. 1465*

 xv The Bari Khwabgah behind the Diwan-i-Am, Lahore.
 Inscribed in Persian characters: *Makān i darbār ya'nī khwābgāh i takht-walī*
 (The durbar hall, that is the sleeping place of the ruler). *Add. Or. 1466*

xvi The Shalimar Gardens, 5 miles east of Lahore.
 Inscribed in Persian characters: *Shālā Bāgh.* *Add. Or. 1467*

xvii Fort of Gobindgarh, near Amritsar.

Inscribed in Persian characters: *Qil'ah i Gobindgaṛh*. *Add. Or. 1468*

xviii Jahangir's mausoleum at Shahdara, north of Lahore.

Inscribed in Persian characters: *Maqbarah i Jahāngīr Sh̲āh bādsh̲āh*.

Add. Or. 1469

xix The Golden Temple, Amritsar.

Inscribed in Persian characters: *Darbār ṣāḥib Amritsar*; in English: *Umritsur Temple*. *Add. Or. 1470*

xx Mausoleums of Ranjit Singh, Kharak Singh and Nau Nihal Singh, Lahore.

Inscribed in Persian characters: *Samādh Mahārājah Ranjīt Singh*.

Add. Or. 1471

xxi Blacksmiths.

Inscribed in Persian characters: *dūkān i āhangarān* (Blacksmith's shop).

Add. Or. 1472

xxii Seal-engravers.

Inscribed in Persian characters: *nigīnah-sāzān*. *Add. Or. 1473*

xxiii Astrologer talking to a woman.

Inscribed in Persian characters: *paṇḍit jōsh̲ī*. *Add. Or. 1474*

xxiv Huntsman with a dead deer on his back and a hawker.

Inscribed in Persian characters: *sh̲ikāriyān*. *Add. Or. 1475*

xxv Woman acrobat with a drummer.

Inscribed in Persian characters: *naṭ ya'nī bāzigarān*. *Add. Or. 1476*

xxvi Dancing-girl with three male musicians.

Inscribed in Persian characters: *ṭawā'if*. *Add. Or. 1477*

xxvii Woman selling earthen toys to children.

Inscribed in Persian characters: *khilauni wālī*. *Add. Or. 1478*

xxviii Club-carrying fakirs.

Inscribed in Persian characters: *faqīrān i gurz-mār*. *Add. Or. 1479*

xxix Knife-grinders.

Inscribed in Persian characters: *saiqalgar*. *Add. Or. 1480*

xxx Goldsmith at work with a woman holding a bracelet.

Inscribed in Persian characters: *zargar*. *Add. Or. 1481*

xxxi Two opium addicts.

Inscribed in Persian characters: *postī*. *Add. Or. 1482*

xxxii Muslim herdsman milking a cow, his wife holding the calf.

Inscribed in Persian characters: *ghosī*. *Add. Or. 1483*

xxxiii Snake-charmers.

Inscribed in Persian characters: *sapolī ba-zabān i panjābī bangālī*.

Add. Or. 1484

xxxiv Ginning cotton. *Add. Or. 1485*

xxxv *Akālī* with his wife and child.

Inscribed in Persian characters: *akālī*. *Add. Or. 1486*

xxxvi Grinding, winnowing and husking rice.
Inscribed in Persian characters: *dhān kaṭṭ. shālī-kūb.* *Add. Or. 1487*

xxxvii Vegetable-seller.
Inscribed in Persian characters: *sabzī-farosh.* *Add. Or. 1488*

xxxviii Man with performing monkey and goat.
Inscribed in Persian characters: *bozna-wālah.* *Add. Or. 1489*

xxxix Woman churning butter.
Inscribed in Persian characters: *ghosī.* *Add. Or. 1490*

xl Army drummer and a soldier with a sword and musket.
Inscribed in Persian characters: *ṭanbūrjī. sipāhī muktā.* *Add. Or. 1491*

xli Distiller and a man drinking.
Inscribed in Persian characters: *kākhānah i sharāb.* *Add. Or. 1492*

xlii Flower and garland-seller.
Inscribed in Persian characters: *phūl-wālah.* *Add. Or. 1493*

xliii Shoe-makers.
Inscribed in Persian characters: *mūchī.* *Add. Or. 1494*

xliv Wood-cutters splitting and weighing wood.
Inscribed in Persian characters: *lakaṛhārā.* *Add. Or. 1495*

xlv Silk-thread maker.
Inscribed in Persian characters: *rīsham sāz ya'nī paṭolī.* *Add. Or. 1496*

xlvi Archer and a hill-man.
Inscribed in Persian characters: *tīr-andāz aur pahārī.* *Add. Or. 1497*

xlvii Washerman with a bullock.
Inscribed in Persian characters: *māskī gāzar.* *Add. Or. 1498*

xlviii Cloth dyers.
Inscribed in Persian characters: *rang-rīz.* *Add. Or. 1499*

xlix Kashmiri women spinning wool.
Inscribed in Persian characters: *Kashmīrin ūn-walī.* *Add. Or. 1500*

l Men preparing and smoking Indian hemp.
Inscribed in Persian characters: *bhangaṛah.* *Add. Or. 1501*

li Money-lenders.
Inscribed in Persian characters: *mahājan shāh-jī.* *Add. Or. 1502*

lii Barber.
Inscribed in Persian characters: *ḥajjām.* *Add. Or. 1503*

liii Water-carrier with a skin standing by a well.
Inscribed in Persian characters: *jāskī.* *Add. Or. 1504*

liv Man with a performing bear.
Inscribed in Persian characters: *khirswālah.* *Add. Or. 1505*

lv Carding cotton.
Inscribed in Persian characters: *naddāf ya'nī panchah.* *Add. Or. 1506*

lvi Two ascetics; a wandering Hindu mendicant carrying a bell and a Muslim darvish.

Inscribed in Persian characters: *faqīrān jangam. benawā*; also inscribed with
Urdu verse. *Add. Or. 1507*

lvii Conjuror and a bird-catcher with a sling.
Inscribed in Persian characters: *madārī shikārī*. *Add. Or. 1508*

lviii Persian wheel; a woman washing clothes and a cultivator standing by.
Inscribed in Persian characters: *haraṭ*. *Add. Or. 1509*

lix Sikh officer and a woman selling curds.
Inscribed in Persian characters: *ghosī*. *Add. Or. 1510*

lx Brass-pot repairers.
Inscribed in Persian characters: *falgi sāz*. *Add. Or. 1511*

186 The Golden Temple, Amritsar (Punjab).
By an Amritsar artist, *c.* 1860.
Inscribed in Persian characters: *Naqshah i srī darbār ṣāḥib jīv wāqiʻah i shahr i Amritsar – jīv parastish-gāh i Sikhān* (Picture of the Holy Sikh Temple situated in the city of Amritsar; the holy worshipping place of the Sikhs); on back in English: *Sent to Exhibition of 1862. Bengal Invoice No. 5133. No. 1659*; and on a label: *No. 51. View of the Holy Sikh Temple (Durbar Saheb) at Umritsur. Drawn at Umritsur under the direction of Lalla Chumba Mull.*
Water-mark of 1854. Water-colour; 10¼ by 16½ ins.
Deposited *c.* 1862. *Add. Or. 486*

NOTE: Although this drawing appears to have been sent to England for showing at the International Exhibition, 1862, it was apparently not exhibited or included in the catalogue (see J. Forbes Watson, *The International exhibition of 1862*, London, 1862).

187 i, ii Two paintings of occupations and costume in the Punjab and Kashmir.
By Amritsar artists, 1866.
Purchased 21 February 1969. *Add. Or. 2551, 2552*

NOTE: These two paintings – the first by Kapur Singh, the second by an unknown painter – were taken from an album of Punjabi costumes and occupations commissioned by Augustus W. Honner of the 1st Grenadiers, Bombay. The album was clearly sent home to relations in England and comments by Honner were written on the paintings and in the album. His remarks are revealing both of himself and of Indian artists. He wrote, 'I have not succeeded in engaging a good painter. I can get nothing done for me while I move about the Country as natives distrust all the English'. On a painting of 'Women grubbing grass' he wrote, 'This is a regular mess! The plain should be perfectly bare with a tuft here & there! & the bundle going home should be 8 times as large, as that much would not feed a goat. The trees are an idea of the artist's & not to be seen in India'. On a picture of 'Boys playing', he wrote, 'Another mess! – The boys holding their tails are running up from bathing & dressing as they come'. 'These horrible pictures are the result of an order by me to paint Jyepoor Costumes.' 'Those he painted from his own idea are generally very good & correct, but any done to order are failures.' 'Painted to my order. i.e. I gave the subject I wanted the man

to do'. For drawings from this album, see Maggs Bros., *Oriental miniatures and illumination, Bulletin no. 10* (London, 1966), nos. 93–105.

Kapur Singh became well known among the British in the Punjab. Percy Brown in his *Indian painting* (Calcutta, 1917), 56, notes that 'In the Punjab, at Lahore and Amritsar, the productions of several Sikh painters found favour at the end of the nineteenth century, their work having a strange mixture of the East and West. One, Kapur Singh, painted a large number of figure subjects, miniature in size, and showing a very fair knowledge of drawing with considerable action'. Two pictures by Kapur Singh were reproduced by Vincent Smith, *A History of fine art in India and Ceylon* (Oxford, 1911), figs 223, 224. Kapur Singh retained many idioms, especially in his landscape backgrounds, deriving from Punjab Hills painting.

 i A Punjabi post-runner with a satchel of letters hanging from a spear over his shoulder (*Plate 72*).
 By Kapur Singh, an Amritsar artist. 15 October 1866.
 Inscribed by Augustus Honner on album page: *Kupoor Sing of Umritsar 15/10/66*; on mount: *A dak Runner or Postman – where there is no 'mail cart'. They run about six miles – in an hour – & pass on to the next man & so on – they usually carry a short javelin with hawk bells attached to jingle & frighten off tigers – as they often have to pass thro' dense jungle at night – his hubble bubble is tied to the Dak bag;* on back in Persian characters: *Halkārah sarkārī dākwālah* (official post runner).
 Water-colour; $5\frac{1}{2}$ by $7\frac{1}{2}$ ins, with mount $8\frac{1}{4}$ by $10\frac{1}{2}$ ins. Orange mount with green inner border and blue and white rules. *Add. Or. 2551*
 ii A Kashmiri woman carrying a small bag.
 By an Amritsar artist, 1866.
 Inscribed on original album page: *Cashmere Woman.*
 Water-colour; $6\frac{1}{4}$ by $4\frac{1}{4}$ ins, with mount $8\frac{1}{2}$ by $6\frac{1}{2}$ ins. Purple mount with red and blue rules. *Add. Or. 2552*

188 i–iv 4 drawings depicting the manufacture and use of narcotics.
By an Amritsar artist, *c.* 1870.
Descriptive notes attached.
Gouache; 10 by 12 ins.
Circumstances of acquisition unrecorded.
 India Office Albums, vol. 49, 'Manners and Customs', nos. 4782–4785

NOTE: These drawings accompanied specimens of narcotics at an exhibition and were supplied by the 'Amritsar Local Exhibition Committee'.

 i Smoking *charras*, a preparation of Indian hemp imported into northern India from E. Turkestan. *No. 4782*
 ii The preparation and consumption of Indian hemp (*bhang*). *No. 4783*
 iii Smoking opium (*post*). *No. 4784*
 iv Smoking tobacco in various types of pipe: *nārgīla, huqqa, gurgurī* and *pechwān*.
 No. 4785

The Punjab

189 i, ii 2 drawings depicting cotton spinning and weaving.
By a Punjab artist *c.* 1872.
Deposited with the Indian Museum 1872.

India Office Albums, vol. 52, 'Trades and occupations', *nos. 4900, 4902*

 i Spinning wheel and spindle.
 Inscribed: *Cotton spinning wheel. Delhi. No. 68. Exhibition 1872.*
 Water-colour; $5\frac{1}{2}$ by $8\frac{1}{4}$ ins. *No. 4900*
 ii Weaver seated at a loom.
 Inscribed: *Weaver. Delhi. No. 67. Exhibition 1872.*
 Water-colour; 8 by $12\frac{1}{2}$ ins. *No. 4902*

(b) *Paintings on ivory*

190 i–viii 8 ivory miniatures of Sikh heroes (head and shoulders) mounted in a folding leather velvet-lined frame.
By a Lahore or Amritsar artist, *c.* 1850–60.
Oval, water-colour on ivory; various sizes.
Purchased 26 October 1954, together with nos. 177 and 183 and *WD 1022–1024, 1343, 1344* from Mrs R. Vandeleur, great-niece of Sir Herbert Edwardes, 26 October 1954. *Add. Or. 2640–2647*

NOTE: These miniatures came from the collection of Sir Herbert Edwardes who served in the Punjab and on the North-West Frontier from 1841 to 1866. A sheet of notepaper enclosed in the mount is inscribed: *Suchet Sing. Tej Singh. Cheragodeen. Nawab of Bhawalpore. Fakeer Nooradeen. Runjeet Sing. Moulraj. Dost Muhommud.* These identifications are correct except for (ii) which is Dina Nath, not Tej Singh, and (iv) which is Sher Singh, not the Nawab of Bahawalpur. Chirag-ud-din (iii) has not been traced. The inscriptions are not in Edwardes' handwriting and may be later attributions.

For Sikh paintings on ivory, see Archer (1966), 65–68, 166–188.

 i Suchet Singh.
 $1\frac{3}{4}$ by $1\frac{3}{8}$ ins. *Add. Or. 2640*
 ii Dina Nath.
 $1\frac{3}{4}$ by $1\frac{3}{8}$ ins. *Add. Or. 2641*
 iii Unidentified subject, perhaps another portrait of Amir Dost Muhammad Khan.
 2 by $1\frac{3}{4}$ ins. *Add. Or. 2642*
 iv Maharaja Sher Singh in armour.
 $2\frac{1}{2}$ by 2 ins. *Add. Or. 2643*
 v Nur-ud-din.
 2 by $1\frac{3}{4}$ ins. *Add. Or. 2644*
 NOTE: Nur-ud-din became Ranjit Singh's personal physician in 1801. He remained a courtier and adviser and was a member of the Council of Regency in 1846.

227

 vi Maharaja Ranjit Singh.
 $1\frac{3}{4}$ by $1\frac{3}{8}$ ins. *Add. Or. 2645*
 vii Mulraj.
 2 by $1\frac{3}{4}$ ins. *Add. Or. 2646*
 viii Amir Dost Muhammad Khan.
 $1\frac{3}{4}$ by $1\frac{3}{8}$ ins. *Add. Or. 2647*

191 i–ix 9 ivory miniatures set in a gold-painted mount; 8 depicting Sikh heroes (head and shoulders) and 1 a Delhi monument.
By a Lahore or Amritsar artist, *c.* 1860–70.
Inscribed on mount with names and: *Punjaub Chiefs.*
Oval, water-colour on ivory; i–viii, 2 by $1\frac{1}{2}$ ins; ix, 1 by $1\frac{1}{4}$ ins.
Purchased 11 February 1932. *Add. Or. 2648–2656*

 i Maharaja Ranjit Singh.
 Inscribed: *Runjeet Sing.* *Add. Or. 2648*
 ii Rani Jindan.
 Inscribed: *Ranee.* *Add. Or. 2649*
 iii Maharaja Gulab Singh.
 Inscribed: *Goleb Sing.* *Add. Or. 2650*
 iv Mulraj.
 Inscribed: *Molraj.* *Add. Or. 2651*
 v Tej Singh.
 Inscribed: *Tej Sing.* *Add. Or. 2652*
 vi Dina Nath.
 Inscribed: *Dena Nath.* *Add. Or. 2653*
 vii Chattar Singh Atariwala.
 Inscribed: *Chatta Sing.* *Add. Or. 2654*
 viii Sher Singh Atariwala.
 Inscribed: *Shere Sing.* *Add. Or. 2655*
 ix The Qutb Minar, Delhi.
 Inscribed: *Kootab Minar, Delhi.* *Add. Or. 2656*

192 i–xx 20 ivory miniatures of Sikh heroes (head and shoulders) framed with a wooden mount.
By a Lahore or Amritsar artist, *c.* 1860–70.
Inscribed with names on mount.
Water-colour on ivory; $1\frac{3}{4}$ by $1\frac{1}{4}$ ins; (v) $1\frac{1}{8}$ by $1\frac{1}{4}$ ins.
Purchased 28 December 1904 with no. 179
 Add. Or. 3080–3099 (Revised Foster catalogue, no. 105)

 i Maharaja Ranjit Singh.
 Inscribed: *Ranjit Singh.* *Add. Or. 3080*

 ii Maharaja Kharak Singh.
 Inscribed: *Kharak Singh.* *Add. Or. 3081*

 iii Maharaja Nau Nihal Singh.
 Inscribed: *Naunihal Singh.* *Add. Or. 3082*

 iv Maharaja Sher Singh.
 Inscribed: *Sher Singh.* *Add. Or. 3083*

 v Maharaja Dalip Singh.
 Inscribed: *Dalip Singh.* *Add. Or. 3084*

 vi Rani Jindan.
 Inscribed as above. *Add. Or. 3085*

 vii Maharaja Gulab Singh.
 Inscribed: *Gulab Singh.* *Add. Or. 3086*

 viii Dhian Singh.
 Inscribed: *Dhyan Singh.* *Add. Or. 3087*

 ix Suchet Singh.
 Inscribed as above. *Add. Or. 3088*

 x Amir Dost Muhammad Khan.
 Inscribed: *Dost Muhammad.* *Add. Or. 3089*

 xi Dina Nath.
 Inscribed as above. *Add. Or. 3090*

 xii Mulraj.
 Inscribed as above. *Add. Or. 3091*

 xiii Chattar Singh Atariwala.
 Inscribed as above. *Add. Or. 3092*

 xiv Sham Singh Atariwala.
 Inscribed as above. *Add. Or. 3093*

 xv Sher Singh Atariwala.
 Inscribed as above. *Add. Or. 3094*

 xvi Phula Singh Akali.
 Inscribed as above. *Add. Or. 3095*

NOTE: Phula Singh was a member of the ascetic sect, Akalis, who wore blue garments and a steel quoit round their turbans. He was a wild rebel and defied Ranjit Singh. He led a mob which attacked Metcalfe in Amritsar in 1809 and attacked Multan in 1816. He was killed at Naushera in 1823.

 xvii Lal Singh.
 Inscribed as above. *Add. Or. 3096*

NOTE: Brahmin. Favourite and lover of Rani Jindan. Chief Minister Lahore, 1845. Instigated Shaikh Imam-ud-din, Sikh Governor of Kashmir, not to surrender Kashmir to Gulab Singh. Arrested and tried by British, December 1846. Exiled to Benares.

xviii Nur-ud-din.

Inscribed: *Fakir Nurruddin.* *Add. Or. 3097*

 xix Tej Singh.

Inscribed as above. *Add. Or. 3098*

 xx Zulfiqar Khan.

Inscribed: *Zulfakar Khan.* *Add. Or. 3099*

NOTE: This is probably the Afghan chief who was an ally of Ali Akbar Khan (see no. 184 x)

193 i–x 10 ivory miniatures of Sikh heroes (head and shoulders) framed with a wooden mount.

By a Lahore or Amritsar artist, *c.* 1860–70.

Inscribed with names on mount.

Water-colour on ivory; $2\frac{1}{2}$ by $1\frac{3}{4}$ ins; (ii) and (ix) 2 by $1\frac{1}{2}$ ins.

Circumstances of acquisition unrecorded.

Add. Or. 3059–3068 (Revised Foster catalogue, no. 80)

NOTE: Exhibited State Cultural Exhibition, Patiala, October 1949.

 i Maharaja Ranjit Singh.

Inscribed: *Ranjit Singh. Maharaja of Lahore.* *Add. Or. 3059*

 ii Maharaja Kharak Singh.

Inscribed: *Kharak Singh, Maharaja of Lahore.* *Add. Or. 3060*

 iii Maharaja Nau Nihal Singh.

Inscribed: *Naunihal Singh, Maharaja of Lahore.* *Add. Or. 3061*

 iv Maharaja Sher Singh.

Inscribed: *Sher Singh, Maharaja of Lahore.* *Add. Or. 3062*

 v Maharaja Dalip Singh.

Inscribed: *Dalip Singh. Maharaja of Lahore.* *Add. Or. 3063*

 vi Rani Jindan.

Inscribed: *Rani Jindan. Mother of Dalip Singh.* *Add. Or. 3064*

 vii Amir Dost Muhammad Khan.

Inscribed: *Dost Muhammad Khan. Amir of Kabul.* *Add. Or. 3065*

 viii Amir Ali Akbar Khan.

Inscribed: *Akbar Khan, son of Dost Muhammad.* *Add. Or. 3066*

 ix Tej Singh.

Inscribed: *Raja Tej Singh. Commander-in-Chief 1845–46.* *Add. Or. 3067*

 x Dina Nath.

Inscribed: *Raja Dina Nath. Diwan of Lahore.* *Add. Or. 3068*

194 i–x 10 ivory miniatures of Sikh heroes (head and shoulders) framed with a wooden mount.

By a Lahore or Amritsar artist, *c.* 1860–70.

Inscribed with names on mount.

Water-colour on ivory; $2\frac{1}{2}$ by $1\frac{3}{4}$ ins; (x) 2 by $1\frac{1}{2}$ ins.

Circumstances of acquisition unrecorded.

Add. Or. 3069–3078 (Revised Foster catalogue, no. 81)

 i Maharaja Gulab Singh.
Inscribed: *Gulab Singh. Maharaja of Kashmir.* *Add. Or. 3069*

 ii Dhian Singh.
Inscribed: *Raja Dhyan Singh. Brother of Gulab Singh.* *Add. Or. 3070*

 iii Suchet Singh.
Inscribed: *Raja Suchet Singh. Brother of Gulab Singh.* *Add. Or. 3071*

 iv Maharaja Ranbir Singh.
Inscribed: *Ranbir Singh. Maharaja of Kashmir.* *Add. Or. 3072*

 v Bahawal Khan.
Inscribed: *Bahawal Khan, Nawab of Bahawalpur.* *Add. Or. 3073*
 NOTE: Nawab Muhammad Bahawal Khan III was Nawab of Bahawalpur, 1825–52. He aided the British to put down the rebellion of Mul Raj at Multan in 1848.

 vi Phula Singh Akali.
Inscribed as above. *Add. Or. 3074*

 vii Sher Singh Atariwala.
Inscribed as above. *Add. Or. 3075*

viii Chattar Singh Atariwala.
Inscribed: as above. *Add. Or. 3076*

 ix Sham Singh Atariwala.
Inscribed as above. *Add. Or. 3077*

 x Mulraj.
Inscribed *Mulraj, Governor of Multan.* *Add. Or. 3078*

(iii) KASHMIR

Kashmir, the favourite retreat of the Mughal emperors, was annexed by Ranjit Singh, the ruler of the Punjab, in 1819. In 1846, after the first Sikh War, it was assigned to Maharaja Gulab Singh, one of the three Dogra brothers who had acted as ministers, advisers or generals to Ranjit Singh. After the British had absorbed the Punjab in 1849 and the countryside had become peaceful, Kashmir developed into a favourite holiday resort for the British in the hot weather. They delighted not only in

its natural beauties but in its arts and crafts, such as shawl and rug-making, metal work and papier maché work. Srinagar, in particular, became a centre where the British congregated and where Kashmir craftsmen had their shops and marketed their wares. These were not the conditions which favoured the development of Company painting, for Kashmir artists were fully employed on the many crafts that flourished there. Unlike artists in the declining Mughal centres on the plains, they had no need to look for work of a novel kind.

From time to time, however, individual commissions were given, resulting in a set such as no. 195. This depicts various occupations with details of the crafts-men's tools. Paintings of this kind are very different from those of Patna or Benares, and in the type of paper, technique and general style make fewer con-cessions to European taste.

Bibliography

Bates, C. E. *A Gazetteer of Kashmir and the adjacent districts* (Calcutta 1873).
Hügel, Baron C. *Travels in Kashmir and the Panjab* (London, 1845).
Lawrence, W. R. *The Valley of Kashmir* (London, 1895).
Panikkar, K. M. *The Founding of the Kashmir state* (London, 1953).
Vigne, G. T. *Travels in Kashmir, Ladak, Iskardo* (London, 1842).

195 i–
lxxxvi
86 drawings bound into a volume depicting trades and occupations in Kashmir. Craftsmen are shown at work with their implements and equipment.
By a Kashmir artist, probably at Srinagar, *c.* 1850–60.
Inscribed on label on cover: *Book contains illustrations of the various traders in Kashmir with their respective implements and the corresponding accounts of processes of manufacture.*
Drawings inscribed in Persian characters with titles and names of implements and equipment, and sometimes with a brief description of the trade.
Gouache; size of volume and drawings $13\frac{1}{2}$ by $9\frac{3}{4}$ ins. Borders of black, red and yellow rules.
Acquired 27 June 1904. *Add. Or. 1660–1745* (formerly *Album 71*)

NOTE: xlii and xvii are reproduced in J. Irwin, *Shawls* (London, 1955), figs 2 and 3; and xvii, xlv and xlii in J. Irwin, 'The Kashmir shawl', *Marg*, VIII, no. 2, March 1955, 120–136.

In his monograph, *Shawls*, Irwin assumes that the present volume was part of the William Moorcroft collection and believes the handwriting on the label to be Moorcroft's. He therefore dates these paintings *c.* 1823. The drawings were, however, acquired by the Library quite separately from the Moorcroft papers and a comparison of the handwriting with that of Moorcroft shows that they are by different hands. Moreover, the printing on the label belongs to the mid-19th century and the costume of the Europeans in lxxix and lxxxiii, as well as the inscription referring to the 'Commissioner Sahib', suggests a date of not earlier than 1850. It was not until after the Second

Anglo-Sikh War of 1848 to 1849 that the British began to go to Kashmir in any numbers and Kashmir artists began to paint pictures especially for the British.

Owing to its Persian inscriptions, the book was numbered and foliated by the Library in the manner of a Persian manuscript. The drawings, however, are arranged from front to back in the European manner (see the series illustrating the cultivation of paddy and shawl weaving); f. 86 (*Add. Or. 1745*) is thus in fact the first drawing in the book and f. 1 (*Add. Or. 1660*) the last.

The volume was originally bound in red cloth with the label on the cover. It has since been rebound with the label pasted inside.

i	Priest and worshippers at the Shiva Temple, Srinagar.	*Add. Or. 1745*
ii	Preacher and worshippers at the wooden mosque of Shah Hamadan, Srinagar, originally the shrine of Mahakali Bhagwati.	*Add. Or. 1744*
iii	Entertainers.	*Add. Or. 1743*
iv	Sowing paddy; ploughing; breaking clods.	*Add. Or. 1742*
v	Ploughing and digging; transplanting paddy; harvesting.	*Add. Or. 1741*
vi	Threshing paddy; weighing it and putting it into saddle-bags.	*Add. Or. 1740*
vii	Boatman and his wife ferrying loads of rice.	*Add. Or. 1739*
viii	Raw shawl wool being distributed to women for spinning.	*Add. Or. 1738*
ix	Woman spinning wool.	*Add. Or. 1737*
x	Women returning the spun shawl wool.	*Add. Or. 1736*
xi	Dyer at work dying cloth.	*Add. Or. 1735*
xii	Cotton-weaver combing a warp; woman reeling cotton.	*Add. Or. 1734*
xiii	Weaver making a border; man reeling coloured wools.	*Add. Or. 1733*
xiv	Women setting up threads for a warp.	*Add. Or. 1732*
xv	Carpenter and wife making a shawl loom.	*Add. Or. 1731*
xvi	Man making combs for looms.	*Add. Or. 1730*
xvii	Shawl-weavers weaving shawls on a loom.	*Add. Or. 1729*
xviii	Washerman and washerwoman.	*Add. Or. 1728*
xix	Two women ginning cotton; man carding cotton.	*Add. Or. 1727*
xx	Weaver at a loom making coarse cloth (*patu*); women stick-warping.	*Add. Or. 1726*
xxi	Man making fine woollen cloth (*mālīda*).	*Add. Or. 1725*
xxii	Carpet-makers.	*Add. Or. 1724*
xxiii	Woman fruit-seller; man roasting maize.	*Add. Or. 1723*
xxiv	Pot-enamellers.	*Add. Or. 1722*
xxv	Fishmongers. Women gutting fish; man drying fish.	*Add. Or. 1721*
xxvi	Men collecting water-chestnuts; man and woman roasting and pounding water-che. tnuts.	*Add. Or. 1720*
xxvii	*Sitār*-maker.	*Add. Or. 1719*
xxviii	Mutton-butcher.	*Add. Or. 1718*

xxix	Makers of mud walls.	*Add. Or. 1717*
xxx	Grain-merchant.	*Add. Or. 1716*
xxxi	Barber.	*Add. Or. 1715*
xxxii	Cloth-printer with hand-block, and dyer.	*Add. Or. 1714*
xxxiii	Boat-builders.	*Add. Or. 1713*
xxxiv	Workers excavating earth and transporting it.	*Add. Or. 1712*
xxxv	Brick-makers with kiln and boat for transporting bricks.	*Add. Or. 1711*
xxxvi	Stone-breakers.	*Add. Or. 1710*
xxxvii	Bricklayers.	*Add. Or. 1709*
xxxviii	Vegetable cultivators with well.	*Add. Or. 1708*
xxxix	Potters.	*Add. Or. 1707*
xl	Punkah-makers.	*Add. Or. 1706*
xli	Coarse embroiderers; needle-worker, for joining shawl-pieces, winding thread into a ball.	*Add. Or. 1705*
xlii	Pattern-drawer (*naqqāsh*) preparing a design for a shawl.	*Add. Or. 1704*
xliii	Papier maché painter.	*Add. Or. 1703*
xliv	Gold lace and braid-makers.	*Add. Or. 1702*
xlv	Craftsmen embroidering felt rugs (*namda*).	*Add. Or. 1701*
xlvi	Bookbinder.	*Add. Or. 1700*
xlvii	Paper-makers.	*Add. Or. 1699*
xlviii	Comb-makers.	*Add. Or. 1698*
xlix	Carpenter.	*Add. Or. 1697*
l	Shoe-maker and his wife making a slipper.	*Add. Or. 1696*
li	Turner.	*Add. Or. 1695*
lii	Saddlers.	*Add. Or. 1694*
liii	Jewellers polishing gems.	*Add. Or. 1693*
liv	Seal-maker; shoe repairer.	*Add. Or. 1692*
lv	Copper-smiths making copper vessels.	*Add. Or. 1691*
lvi	Workers in fine gold (*kundan*) making jewellery and setting jewels.	*Add. Or. 1690*
lvii	Glass-blowers.	*Add. Or. 1689*
lviii	Bangle-maker.	*Add. Or. 1688*
lix	Cooked food and *kawāb* makers.	*Add. Or. 1687*
lx	Milkmen of the Gujar caste in the forest.	*Add. Or. 1686*
lxi	Mat-maker and his wife making mats of split reeds.	*Add. Or. 1685*
lxii	Millers.	*Add. Or. 1684*
lxiii	Basket-maker and his wife.	*Add. Or. 1683*
lxiv	Sweetmeat-makers.	*Add. Or. 1682*
lxv	Bakers.	*Add. Or. 1681*
lxvi	Confectioner making sugar candy.	*Add. Or. 1680*
lxvii	Goldsmiths making jewellery.	*Add. Or. 1679*
lxviii	Rice-parcher and his wife.	*Add. Or. 1678*

IV Western India

Compared with Bengal or Madras, the Bombay Presidency in the late eighteenth and early nineteenth century was a backwater both socially and culturally. Until the Suez route to Britain opened, it was off the main route to the East and, with a few exceptions, never attracted the most brilliant personnel. With the acquisition of the Peshwa's territories in 1818, Cutch in 1819 and Sind in 1843, it became politically more important, but only after many years could it compete socially with the other Presidencies. In comparison with other parts of India, fewer Company servants took a lively interest in the country and in its manners and customs, or, as a corollary, wanted pictures to illustrate these subjects. Nor were there strong Indian artistic traditions in western India to supply such pictures. The Gujarati Jain traditions had long since decayed, and the Marathas were a martial people with little interest in painting. It is not surprising, therefore, that no Company painting on a large scale, similar to that in Tanjore or Patna, developed in Western India. Such pictures as were produced were the result of individual commissions, given by the more intelligent and enterprising of the British.

Sir Charles Warre Malet, Resident at Poona from 1786 to 1796, was one of the most cultivated of the British officials and did much to impose western standards on the Peshwa's court and on local painters. Malet patronised the British painter James Wales, with his assistant Robert Mabon, and helped find commissions for him with the Peshwa and his ministers. According to James Forbes, who was in the East India Company's service in Bombay from 1765 to 1784 and knew him well, Malet trained a Brahmin from Cambay to make drawings of costumes and castes for him. If these are the drawings in Malet's collection (now in the possession of Mr and Mrs Paul Mellon) they are somewhat inept and hesitant water-colours in the British manner, with no assured style. Malet also commissioned a set of clay animals which represented the creatures in the Peshwa's menagerie, and were modelled by the same artist. James Wales trained an Indian assistant while he was in the Bombay Presidency from 1791 to 1795, a Brahmin named Gangaram Tambat. It is just possible that this is the same artist who was employed by Malet. In his journal (also in the Mellon Collection) Wales refers to 'Gongram a native Sculptor' who accompanied him on his expeditions to the rock-cut temples around Bombay. He used him for measuring the temples and making preliminary plans and drawings. A number of water-colours of Ellora in the Malet Collection are inscribed 'Gungaram delt.'; other drawings by him were

presented to the Governor-General Sir John Shore. Wales also employed 'Josee, a young Goa painter' as an assistant.

The Maratha rulers, the Peshwas, occasionally employed painters at their court. The Shanwar Wada palace at Poona, built between 1720 and 1740, had wall-paintings in the Diwankhana done by Jaipur artists. At Malet's prompting, the Peshwa and his ministers, such as Bira Pundit and Nana Sahib, ordered paintings from James Wales during his visits to Poona in 1792 and 1794. These were chiefly portraits of themselves, but Wales' accounts show that they also purchased paintings of 'ladies' and of 'Venus after Sir Joshua'. The Peshwa established an 'art school' where Wales gave some instruction to Indians, and a number of Western Indian painters made copies of the portraits by Wales which can still be found in Poona and Bombay.

It was not until the mid-nineteenth century that sets of pictures depicting trades and castes were produced in Western India and sold in Bombay and in cantonments such as Poona and Belgaum. One set in the Library (no. 198) appears to have been made in Cutch, another (no. 199) in Belgaum. In general scope they differ in no way from those made in other parts of India although they include local subjects like the Rao of Cutch, the Cutch Agency bungalow or the Supply Agent at Belgaum. In style they have their own individual idioms which distinguish them from Company painting in other areas. The figures, with their enormous turbans, are somewhat stunted, compositions are hesitant, and the colours sombre and applied with a stippled technique. Glass-painting also was practised in Western India in the nineteenth century.

Bibliography

Anderson, P. *The English in western India* (Bombay, 1854).
Archer, Mildred and W. G. *Indian painting for the British: 1770–1880* (Oxford, 1955), 85–90.
Bombay Presidency. *Gazetteer of the Bombay Presidency, xviii, parts II and III, Poona* (Bombay, 1885).
Bombay Presidency. *Materials towards a statistical account of the town and island of Bombay, i, History* (Bombay, 1893).
Broughton, T. D. *The Costume, character, manners, domestic habits and religious ceremonies of the Mahrattas* (London, 1813).
Douglas, J. *Glimpses of old Bombay* (London, 1894).
Kincaid, C. A. and Parasnis, D. B. *A History of the Maratha people*, iii (Oxford, 1925).
Mabon, R. *Sketches illustrative of oriental manners and customs* (Calcutta, 1797).
Parasnis, D. B. *Poona in bygone days* (Bombay, 1921).
Sardesai, G. S. *New history of the Marathas*, iii (Bombay, 1948).
Wales, J. MSS. notebooks from the Malet Collection, now in the Mr and Mrs Paul Mellon Collection.

196 Rissaldar of the Poona Auxiliary Horse, *c.* 1835.
By a Western Indian artist, *c.* 1840.

Water-colour; 8¾ by 7¾ ins.
Presented by Simon Digby, 3 July 1962 *Add. Or. 1963*

NOTE: Copy by an Indian artist after a water-colour by Thomas Postans (*WD 485 f.56a*) reproduced Marianne Postans, *Western India in 1838* (London, 1839), ii, 252.

197 12 drawings depicting costumes of Western India.
i-xii By a Western Indian artist, *c.* 1850.
Inscribed with numbers and titles.
Water-colour; 9 by 7 ins.
Circumstances of acquisition unrecorded.
India Office Albums, vol. 48, 'Mythology', nos. 4758, 4759; vol. 53, 'Costume', nos.
5036–5045

NOTE: The drawings, although dispersed in two different albums appear to have originally formed part of a set. Nos. 3 and 12 of the set are missing.

 i Jat woman in a reddish-brown sari carrying a pitcher.
 Inscribed: *No. 1. A Juttunee, or woman of the Jut Caste.* *No. 5037*
 ii Hindu ascetic carrying a bell.
 Inscribed: *No. 2. A Hindoo Devotee.* *No. 4759*
 NOTE: Similar to right hand figure in no. 198, lxvi.
 iii A Muhammadan doctor smoking a *nārgīla* pipe.
 Inscribed: *No. 4. A Moosulman Hakim or Doctor.* *No. 5036*
 iv Hindu ascetic with long finger-nails accompanied by a young attendant.
 Inscribed: *No. 5. Hindoo Devotees.* *No. 4758*
 NOTE: Similar to central figure in no. 198, lxvi.
 v Bearded man smoking a *nārgīla* pipe.
 Inscribed: *No. 6. A Charun.* *No. 5039*
 vi Woman in flowered sari with pots on her head.
 Inscribed: *No. 7. A Hindoo woman with pitchers of water.* *No. 5038*
 vii Rajput in yellow and red *jāma* and turban holding a sword, attended by a servant.
 Inscribed: *No. 8. A Hindoo Rajpoot of Rank.* *No. 5041*
viii Hindu ascetic smoking a *nārgīla* pipe and holding a cane.
 Inscribed: *No. 9. A Jogee or Hindoo Devotee.* *No. 5040*
 ix *Kabīr panthī* female ascetic with staff and brass pot.
 Inscribed: *No. 10. A Hindoo Female Devotee.* *No. 5043*
 NOTE: Similar to female ascetic in no. 198, xviii.
 x Rajput horseman from Cutch.
 Inscribed: *No. 13. A Kutchee Rajpoot Horseman.* *No. 5045*
 xi Muhammadan gentleman with sword, dagger and red shawl.
 Inscribed: *No. 11. A Mahomedan Gentleman of Rank.* *No. 5042*
 xii Muhammadan trader.
 Inscribed: *No. 14. A Moola or Moosulman Trader.* *No. 5044*

198
i–lxxii
72 paintings bound in 2 volumes depicting trades and castes in Cutch, including the Rao of Cutch, Rao Desal II (ruled 1819–60), as well as his palace and other buildings in Bhuj.

By a Western Indian artist probably at Bhuj, Cutch, August 1856.

Inscribed with titles in English by an Indian, perhaps a clerk who supervised the artist.

Water-colour; size of volume 5½ by 9 ins.

Acquired 17 August 1908, together with no. 199. *Add. Or. 1512–1583*

NOTE: The dates when the drawings were made are sometimes given and the inscriptions on xxi and xxvii imply that Friday was a rest day. This would suggest that the artist was a Muslim. Since they were acquired at the same time, it seems probable that these two volumes of drawings as well no. 199 belonged to the same Englishman. He may well have been an army officer posted to Bhuj and also Belgaum. The British had a Resident in Cutch from 1819.

The styles of both sets of drawings are similar. The figures are usually set against a plain background with a wash of light colour for the ground and shadows by the feet. Shading is indicated by minute stippling.

 i Snake charmer (a) with his bag of snakes and (b) playing to them.
 Inscribed: *Serpent catcher.* *Add. Or. 1512*

 ii Sindi pounding a narcotic drug and a Sindi with sword and hookah asking for bread.
 Inscribed: *Sindee pounding nurchotic drug. Sindee asking bread from a Fukeer.*
 Add. Or. 1513

 iii Three potters (*kumbhār*) at work.
 Inscribed: *Kutch Koombar making earthen pots.* *Add. Or. 1514*

 iv Officer of Cutch Irregular Horse, and two foot soldiers.
 Inscribed: *Jeejeebaee Jemedar of K.I. Horse. Rao's foot soldiers.*
 Add. Or. 1515

 v Milkman and milkwoman.
 Inscribed as above. *Add. Or. 1516*

 vi Brahmin and two beggars.
 Inscribed: *Brahmin beggar. Brahmin in his worshipping dress. Ateet.*
 Add. Or. 1517

 vii Musicians with drum and *sitār*.
 Inscribed: *Kulbamut or songsters.* *Add. Or. 1518*

viii Musicians with cymbals and stringed instrument.
 Inscribed: *Dadee Thurr Parker songsters.* *Add. Or. 1519*
 NOTE: Thar Parkar is a district on the eastern side of Sind.

 ix A dancing-girl performing the *Kuharwa* dance with three musicians.
 Inscribed: *Karoa dance.* *Add. Or. 1520*

 x Dancing-girl performing the *gagrī* dance with two musicians.
 Inscribed: *Gugree dance.* *Add. Or. 1521*

xi Marriage ceremony; the bridegroom taking the bride to his house.
Inscribed: *Goldsmith sect bridegroom taking the bride to his own house.*
Add. Or. 1522

xii Sub-assistant surgeon, Bhuj, with patient.
Inscribed: *The sub assistant surgeon at Bhooj with his patient.* *Add. Or. 1523*

xiii Two Muslim gentlemen; one with a sword, the other with a *nārgīla* pipe.
Inscribed: *Kuddoo Meyan, son of Jemedar Fattay Mahomed and his friend*
Fukeer Mahomed. *Add. Or. 1524*

xiv Cultivator in the fields with two women.
Inscribed: *Farmer with his family in the field said to have been finished on the*
14th July at 12 a.m. *Add. Or. 1525*

xv Grain-seller with coolie.
Inscribed: *Grain Seller. Cooly or grain carryer 15th July 1856. Add. Or. 1526*

xvi Pilgrims returning from Dwarka.
Inscribed: *Dwarka branded Bairagees or Pilgrims. 16th, 17th 18th.*
Add. Or. 1527

xvii Four ascetics and worshipper.
Inscribed: *Female Tuppassee with her follower and worshippor. Swamee*
Narain's followers who never go abroad alone at least two and will never
touch female or coin if accidentally touched will abstain from food for two days.
25th friday excluded done in 6 days. *Add. Or. 1528*

xviii Male and female *kabīrpanthī* ascetics.
Inscribed: *Female kubbeer puntee. Male sadoo kubbeer puntee. 26 July,*
27th July. *Add. Or. 1529*

xix Two portrait studies; Sala Muhammad, harbour master, and Papu
Dalal.
Inscribed: *Supposed Salamahomed Bunder Master. Puppoo Dullal. 28 July,*
29 July. *Add. Or. 1530*

xx Women carrying water-pots on their heads and a man carrying water-
pots on a yoke.
Inscribed: *Females with water chattees. Kavree or water, a.m. 30th, 31.*
Add. Or. 1531

xxi Male and female ascetics.
Inscribed: *Kadree Fakeer artful* (last word erased, *clever* substituted) *sect.*
Jogee Sunneasee artful clever sect. 1st Friday. 2 August, 3rd. *Add. Or. 1532*

xxii Two ascetics.
Inscribed: *Moondcheeras or beggars extracting alms by force in inflicting*
wounds by knives & whips on different parts of their bodies. 4th. 5th.
Add. Or. 1533

xxiii Cloth-seller, tailor and his wife.
Inscribed: *Tailor. Bhattia. Tailor woman. 6th. 7th. 8th.* *Add. Or. 1534*

xxiv Rope-makers.

Inscribed: *Borees preparing cords. 9th & 10th Augt 1856.* *Add. Or. 1535*

xxv Two soldiers.

Inscribed: *Bunnee Foot soldiers. Khawra chavallier. 11th, 12th.*

Add. Or. 1536

xxvi Leatherworkers.

Inscribed: *Dubgir or leathern oil rubber makers. August 13th finished.*

Add. Or. 1537

xxvii Shield-makers.

Inscribed: *Shield preparers. 14th, 16th & 17th. 15 Friday.* *Add. Or. 1538*

xxviii Shoe-maker and embroiderer.

Inscribed: *Shoe maker working with silk on cloth flowers etc. Shoemaker. 18th. 19th.* *Add. Or. 1539*

xxix Ascetics.

Inscribed: *Teebria or a kind of gosaee extracting alms by force in stricking (sic) the red hot tongue on the calf of his leg. Nanackshaee or a kind of alms extractor. 20th. 21st.* *Add. Or. 1540*

xxx Bania woman and Bania widow.

Inscribed: *Widow of Banian with her customary dress besides which they are not allowed to ware. Baniaunee with her dress while her husband is living. 22nd Friday. 23rd, 24th August.* *Add. Or. 1541*

xxxi Procession of the Rao of Cutch.

Inscribed: *The Rao's Procession. retinue. Flag or Bairuk. Prepared in six days. 30th August 1856.* *Add. Or. 1542*

xxxii Two musicians; one playing a *vīna* and one a *rawantha*.

Inscribed: *Juntree musick. Burthuree gosaie with rawantha instrument. 31st. 1st September.* *Add. Or. 1543*

xxxiii *Kathrī* (dyer) ornamenting cloth by the wax-painting method (*roghan* work). *Kathrī* ornamenting cloth by the tie-and-dye method (*bandhana* work).

Inscribed: *Kuthree or Dyer painting with varnish on cloth of durable color. Kuthree or Dyer trying with thread on different parts of cloth before dying the cloth.* *Add. Or. 1544*

NOTE: Cutch was a centre for the production of wax-painted cloths. The 'wax' was made by boiling linseed-oil for about 12 hours. The hot oil was then thrown into shallow pans of cold water which converted it into a thick putty-like substance (*roghan*). The *roghan* was coloured with metallic and vegetable pigments. The artisan then put a lump of *roghan* on the palm of his left hand and, with a pointed iron style held in his right hand, whisked the *roghan* until it had the requisite plastic consistency. He then took a lump of *roghan* on the end of the style, placed it on the cotton cloth, drew up the style to form a thread of colour and then guided it over the pattern that had been chalked on to the material, fixing it with a moistened finger tip. In this way patterns were applied to the cloth.

xxxiv Making parched rice.

Inscribed: *Burboonja or parched rosted grain seller.* Add. Or. 1545

xxxv Ascetics.

Inscribed: *Tupposuree beggar. Rama ———nga, beggar who will never take alms from male sex but from females of high birth.* Add. Or. 1546

xxxvi Five women singers.

Inscribed: *Lungees or female songsters.* Add. Or. 1547

xxxvii Perfume-seller and Ahmadabad lady.

Inscribed as above. Add. Or. 1548

xxxviii Portrait of Maharaja Jawan Singh, Raja of Edur. Also servant with water.

Inscribed: *Menial with water Jamboo. Maharaj Jawansing Raja of Edur*; in different hand: *Son in law to H.H. The Rao of Kutch.* Add. Or. 1549

On reverse unfinished drawings in pencil for lvi.

xxxix Ahmad Ali, counsellor of the Rao of Cutch and spearman.

Inscribed: *Peer Oomedally. H.H. The Rao's counseller. Rao's Silladar.*
 Add. Or. 1550

xl Three Jain ascetics, two with masks and brooms.

Inscribed: *Goorjee Sewra. Goorgee Doondia. Goorjee Arja malla follower of Doondia.* Add. Or. 1551

xli Sindi soldier with musket, and wife with hookah.

Inscribed: *Sindee Female. Sindee Sepaee.* Add. Or. 1552

xlii Two soldiers from Kathiawar eating opium.

Inscribed: *Kattyawar opium eater sepaee.* Add. Or. 1553

xliii Cloth-printer.

Inscribed: *Kuthree or cloth stamper with color.* Add. Or. 1554

xliv Two goldsmiths at work.

Inscribed: *Goldsmith.* Add. Or. 1555

xlv Two grass-cutters and two grass contractors to the Rao of Cutch (*Plate 73*).

Inscribed: *Grass Cutters. H.H. the Rao's Grass Mukadums Nos. 1, 2.*
 Add. Or. 1556

xlvi Two sweetmeat-sellers.

Inscribed: *Hulvaee or sweetmeat seller.* Add. Or. 1557

xlvii A dance.

Inscribed: *Coffrees on their native dance.* Add. Or. 1558

xlviii Two sword-furbishers with assistant.

Inscribed: *Sikilkur or Arm cleaners.* Add. Or. 1559

xlix Woman churning butter and another making chapatis.

Inscribed: *Milkwomen making butter & the other breads.* Add. Or. 1560

l Two tinkers.

Inscribed: *Tin man.* Add. Or. 1561

li Man and woman cleaning cotton.

Inscribed: *Cotton Cleaners.* Add. Or. 1562

lii Woman of Cutch spinning thread.
Inscribed: *Kutch woman weaving thread.* *Add. Or. 1563*

liii Two carpenters.
Inscribed: *Carpenters.* *Add. Or. 1564*

liv Two clerks.
Inscribed: *The Agency Shiristadar Mukundjee Oora. Banian with his accounts.* *Add. Or. 1565*

lv Soldier of Native Infantry taking water from a water-carrier.
Inscribed: *Native Regiment Sepaee and Bhistee.* *Add. Or. 1566*

lvi Thar Parkar policeman and figure with sword and dagger.
Inscribed: *Thurr Parkur Police. Akho Malday.* *Add. Or. 1567*

lvii Oil press.
Inscribed: *Oilman.* *Add. Or. 1568*

lviii Two knife-grinders.
Inscribed: *Kuntaree.* *Add. Or. 1569*

lix Rao Desal II (ruled 1819–60) seated on a throne with two attendants, one holding a shield and one a fly-whisk.
Inscribed: *H.H. the Rao of Kutch in his Court apparel.* *Add. Or. 1570*

lx Two portraits.
Inscribed: *Barr Khan Kossa, is a warrior. Bunneeman.* *Add. Or. 1571*

lxi Two ascetics, one holding fire and tongs.
Inscribed: *Ateeth. Khakee.* *Add. Or. 1572*

lxii Two ascetics holding *nārgīla* pipes; one a split-eared ascetic.
Inscribed: *Kappree Raja. Kanputta Jogee.* *Add. Or. 1573*

NOTE: The Kapdis are devotees of the temple of Ashapura Mata at Madh about 50 miles north west of Bhuj. Their high-priest is called the Kapdis Raja. The Kanphata (or Split-eared) ascetics had three sees in Cutch at Dhinodhar (northwest of Bhuj), at Manphara in Vagad, and at Shivra Mandap in Bhuj.

lxiii Rao Desal II (ruled 1819–60) on a throne.
Inscribed: *H.H. the Rao of Kutch in his ordinary dress.* *Add. Or. 1574*

lxiv Portrait of Habib Khan.
Inscribed: *Hubbeebkhan, of Regency Junagur Puncheeatee.* *Add. Or. 1575*

lxv Carpenter seated on a box and stone-mason (*salat*).
Inscribed: *Luda maistry. Kutch Seelat, or Stone Mason.* *Add. Or. 1576*

lxvi Three ascetics; one with gnarled sticks, one with long finger-nails and one with bell and headdress ornamented with cobras.
Inscribed: *Tuppasree's follower. Gosaee Tuppasree. Gosaee Juggum.* *Add. Or. 1577*

lxvii Tomb of Rao Lakha, Bhuj.
Inscribed: *H.H. the late Rao Laka's tomb.* *Add. Or. 1578*

NOTE: Rao Lakha ruled 1741–60. The tomb was built *c.* 1770.

lxviii Mosque.

Inscribed: *Musjid of Peeran Peer.* Add. Or. 1579
lxix Palace of Rao of Cutch, Bhuj.
 Inscribed: *H.H. the Rao's Palace.* Add. Or. 1580
 NOTE: The palace was built by Rao Lakha about 1750.
lxx Courtyard of the Rao's palace, Bhuj.
 Inscribed: *H.H. the Rao's Court.* Add. Or. 1581
lxxi North side of the house of the Cutch Agent.
 Inscribed: *Northern side view of the Kutch Agency Bungalow.* Add. Or. 1582
lxxii South side of the house of the Cutch Agency, with sentry and *chaprāsīs* (*Plate 74*).
 Inscribed: *Southern side view of the Kutch Agency Bungalow.* Add. Or. 1583

199 i–
xxxviii 38 paintings bound into a volume depicting castes and trades in Bombay. By a Western Indian artist, perhaps at Belgaum, *c.* 1856.
i–xxv inscribed with titles in English by an Indian; xxvi–xxxviii inscribed in provincial *nāgarī* characters and at times in English.
Water-colour; size of volume 6½ by 9 ins.
Acquired 17 August 1908 together with no. 198. *Add. Or. 1584–1621*

NOTE: The inscription on xxi suggests that this set may have been made for an army officer in Belgaum, the supply agent probably being a well known camp figure.

i(a) Cake-seller.
 Inscribed: *Country cake seller.*
i(b) Egg-seller.
 Inscribed as above. Add. Or. 1584
ii Country doctor seated amongst his medicines; his servant with bundles of medicine seated beside him.
 Inscribed: *Servant & Hakeem with medicine bags.* Add. Or. 1585
iii Country doctor with coolie carrying baskets of medicine on a yoke.
 Inscribed: *Hakeem & Cooly with medicine basket.* Add. Or. 1586
iv(a) Curd-seller.
 Inscribed: *Khuva or milk curds seller.*
iv(b) Milkman.
 Inscribed as above. Add. Or. 1587
v(a) Male oil-seller.
 Inscribed: *Cooly taking oil for sale.*
v(b) Female oil-seller.
 Inscribed: *Female dealing in oil.* Add. Or. 1588
vi(a) Goanese selling bread and eggs.
 Inscribed: *Goaman selling bread and eggs.*

vi(b)	Muslim selling spiced meats.	
	Inscribed: *Mussulman selling Kubbab and Nan.*	*Add. Or. 1589*
vii(a)	Parsee woman.	
	Inscribed: *Bombay Parsee Female.*	
vii(b)	Bohori woman from Bombay.	
	Inscribed: *Bombay Boree Female.*	*Add. Or. 1590*
viii(a)	Cloth-seller.	
	Inscribed: *Bombay Bhatia cloth seller.*	
viii(b)	Bohori seller of ready-made clothes from Bombay.	
	Inscribed: *Bombay Boree prepared cloth seller.*	*Add. Or. 1591*
ix(a)	Bombay vegetable-seller.	
	Inscribed as above.	
ix(b)	Woman sugarcane-seller.	
	Inscribed: *Bombay female sugar cane seller.*	*Add. Or. 1592*
x(a)	Khoja woman.	
	Inscribed: *Khoja Female.*	
x(b)	Bombay milk-seller.	
	Inscribed: *Bombay milk woman.*	*Add. Or. 1593*
xi	Liquor-seller; a customer seated beside him smoking.	
	Inscribed: *Mussulman Bhutteeara Shopkeeper.*	*Add. Or. 1594*
xii(a)	Bombay tailor.	
	Inscribed: *Bombay Tailor, Toolajee.*	
xii(b)	Bohori woman pedlar.	
	Inscribed: *Bora female selling pretty articles.*	*Add. Or. 1595*
xiii(a)	Scabbard-maker.	
	Inscribed: *Scabbard maker carpenter.*	
xiii(b)	Shopkeeper.	
	Inscribed: *Pooracha Bunia.*	*Add. Or. 1596*
xiv(a)	Parsee priest.	
	Inscribed: *Parsee Andiaroo or priest.*	
xiv(b)	Marwari perfume-seller.	
	Inscribed: *Marwaree perfume seller.*	*Add. Or. 1597*
xv(a)	Bohori mat-seller.	
	Inscribed: *Bora of Bombay selling mats.*	
xv(b)	Kathiawar tailor.	
	Inscribed: *Kattywar Tailor.*	*Add. Or. 1598*
xvi(a)	Toddy seller.	
	Inscribed: *Bombay Tody seller.*	
xvi(b)	Washerman with his bundle.	
	Inscribed: *Bombay washerman.*	*Add. Or. 1599*
xvii(a)	Jewel-cutter.	
	Inscribed: *Bombay stone cutter.*	

xvii(b) Woman making forehead ornaments.
Inscribed: *Female making forehead ornaments.* *Add. Or. 1600*

xviii(a) Portrait of Haji Ayub Gumasta of Dadasett seated with a rosary in his hand.
Inscribed: *Hajee Aeb Goomasta of Dadasett.*

xviii(b) Portrait of Haji Ayub's nephew.
Inscribed: *Hajee Aeb's nephew.* *Add. Or. 1601*

xix(a) Silver-ornament seller.
Inscribed: *Parsee silver ornament seller.*

xix(b) Seller of betel-leaf.
Inscribed: *Beetle leaf seller.* *Add. Or. 1602*

xx(a) Bombay Post Peon with satchel and letters.
Inscribed: *Bombay Post Peon.*

xx(b) Bombay Police Peon with whip.
Inscribed: *Bombay Police Peon.* *Add. Or. 1603*

xxi Portrait of Kassim Bohori, Supply Agent, Belgaum, with a coolie and a basket of goods.
Inscribed: *Kassim Bora Belgaum supply Agent and Basket cooly.*
 Add. Or. 1604

xxii(a) Bombay woman.
Inscribed: *Bombay Purvoo female.*

xxii(b) Konkani Muslim woman.
Inscribed: *Konkun Mussulman.* *Add. Or. 1605*

xxiii Bangle-seller with customer.
Inscribed: *Putting on bangles or Bungrees (armlets).* *Add. Or. 1606*

xxiv Muslim wood-sellers.
Inscribed: *Moman woodseller. Servant and wife. Memaneeanee selling wood.*
 Add. Or. 1607

xxv(a) Seller of roasted gram.
Inscribed: *Roasted gram seller.*

xxv(b) Fruit-seller.
Inscribed as above. *Add. Or. 1608*

xxvi(a) Bengali hookah-snake seller.
Inscribed: *Hooka snake manufacturer & Seller from Bengal*; in *nāgarī* characters: *hukā phāne pheravavālo.*

xxvi(b) Cutchi milkman.
Inscribed: *Kutchee Bhatia*; in *nāgarī* characters: *Kachī bhātīo.*
 Add. Or. 1609

xxvii Carpenters at work.
Inscribed: *Sootars or Carpenters*; in *nāgarī* characters: *sutār malahīgarā* (i.e. *malayagaru*, sandalwood carpenter). *Add. Or. 1610*

xxviii(a) Seller of lamp-black.

Inscribed in *nagārī* characters: *mesha kīnasandhī.*

xxviii(b) Konkani fisherwoman.
Inscribed: *Konkani Fishwoman*; in *nāgarī* characters: *Kokan māchalāvārī.*
Add. Or. 1611

xxix(a) A hill-woman carrying water.
Inscribed in *nāgarī* characters: *gātan bolī pānī bharanārī.*

xxix(b) Gujarati merchant.
Inscribed: *A Guzerath Wanee, or merchant*; in *nāgarī* characters: *Gojarātī vānīo.*
Add. Or. 1612

xxx(a) Gujarati woman.
Inscribed: *A Guzerat Woman*; in *nāgarī* characters: *Gojarātan arat.*

xxx(b) Brahmin.
Inscribed: *Brahmin*; in *nāgarī* characters: *Cobo bherāman.* *Add. Or. 1613*

xxxi A hill Vaidic doctor carrying bundles on a yoke.
Inscribed in *nāgarī* characters: *gātī vaid kālavelīā.* *Add. Or. 1614*

xxxii(a) Cobbler carrying shoes.
Inscribed in *nāgarī* characters: *machi jadā shivanāro.*

xxxii(b) Craftsman of the cobbler caste ornamenting cloth by the wax-painting method no. 198, xxxiii.
Inscribed in *nāgarī* characters: *mochī chakan bharanārī* (mochi filling-in curtains.).
Add. Or. 1615

xxxiii(a) Religious mendicant with tongs.
Inscribed: *Gosain*; in *nāgarī* characters: *gosāi.*

xxxiii(b) Religious mendicant leaning on staff.
Inscribed: *Gosain*; in *nāgarī* characters: *gosāi.* *Add. Or. 1616*

xxxiv(a) Sweetmeat-seller.
Inscribed in *nāgarī* characters: *sedhī sādā.*

xxxiv(b) Hill Brahmin with tray of drinks and a flower in his hand.
Inscribed: *Gatee Brahmin*; in *nāgarī* characters: *gātī bherāman.*
Add. Or. 1617

xxxv Two hill-porters, a man and a woman, seated with baskets.
Inscribed: *Gade Hilkarees (or Porters)*; in *nāgarī* characters: *gātī helakari.*
Add. Or. 1618

xxxvi(a) Merchant.
Inscribed: *Borah*; in *nāgarī* characters: *hālāi bhorī* (a sweetmeat merchant).

xxxvi(b) Arab merchant.
Inscribed: *Arab*; in *nāgarī* characters: *arab bhayarāi.* *Add. Or. 1619*

xxxvii(a) Peshawar man.
Inscribed in *nāgarī* characters: *Peshorī maradh.*

xxxvii(b) Peshawar woman.
Inscribed in *nāgarī* characters: *Peshorī arat.* *Add. Or. 1620*

xxxviii(a) Sweeper with long broom.
　　　　　　Inscribed in *nāgarī* characters: *jādu kāl vāvāro*.
xxxviii(b) Hill barber with satchel.
　　　　　　Inscribed: *Hajam (Barber)*; in *nāgarī* characters: *hajām gātī*.

Add. Or. 1621

200　　A Svetambara Jain monk of the Dhundhiyas sect with brush and mask.
　　　　　By a Western Indian artist, perhaps at Bhuj, Cutch. *c.* 1856.
　　　　　Inscribed on back in Gujarati: *gorajī ḍhunḍtyo hame rā tadṛi khānā pakhana me*
　　　　　luretala vānīāonva padrī.
　　　　　Water-colour; 5¾ by 4½ ins.
　　　　　Presented by Mrs Mavis Strange, 4 September 1958.　　*Add. Or. 748*

NOTE: This drawing closely resembles no. 198 xl and was probably painted at about the same time.
The Svetambara Jains consider the brush, water-pot and mask essential to the character of an ascetic.
The Dhundhiya sect rigorously adheres to the moral code but disregards set forms of prayer and
external worship.

201 i–iv　4 drawings depicting trades and occupations.
　　　　　　By a Bombay artist, *c.* 1873.
　　　　　　Deposited with the India Museum, 1873.
　　　　　　India Office Albums, vol. 52, 'Trades and Occupations', nos. 4896, 4899, 4904, 4972

　　　i Two men ginning cotton.
　　　　　Inscribed: *No. 6. Process of separating seeds from cotton (Back view). Western*
　　　　　India. Vienna Exh. Coll. 1873.
　　　　　Water-colour; 8½ by 8 ins.　　　　　　　　　　　　　　*No. 4896*
　　　ii Woman reeling cotton.
　　　　　Inscribed: *No. 10. Process of reeling. Bombay (Vienna Exh. 1873).*
　　　　　Water-colour; 9 by 8 ins.　　　　　　　　　　　　　　*No. 4899*
　　　iii Weaver at a loom.
　　　　　Inscribed: *No. 12. Process of weaving. Bombay. Vienna Exh.*
　　　　　Water-colour; 8 by 8¾ ins.　　　　　　　　　　　　　*No. 4904*
　　　iv Sugar making.
　　　　　Inscribed: *No. 15. Process of boiling Molasses in water. Bombay. Vienna Exh.*
　　　　　coll. 1873
　　　　　Water-colour; 8¾ by 8 ins.　　　　　　　　　　　　　*No. 4972*

202　　The Durbar at Poona, 6 August 1790, when the ratified treaty between the Mara-
　　　　　thas, the Nizam of Hyderabad, and the British was handed to the Peshwa, Sawai
　　　　　Madhavrao (7th Peshwa, 1774–95) by Sir Charles Malet, British Resident at
　　　　　Poona.

By Supukur Anandrao Damodur, a Poona artist, 21 February 1883.
Inscribed in panel at bottom of picture in Marathi with a translation in English:
Presentation of the ratified Treaty of 1st June 1790 between the English East India Company, the Peishwa and the Nizam against Tippoo. Sir Charles Warre Malet Bart. the British Resident to his Highness Sawaee Madhaorao Narayan Peishwa in full Durbar held in the Gunputtee Rungmahal of the now ruined Shunwar Palace at Poona. Attended by Nana Phadnavi Phudkuy and all the prominent Justerial Characters of the period, on the 6th August 1790. Dr by Supukur Anundrao Damodur. Itour Pet Bohoreeallee. No. 345. 21st Feb 1883 Poona.
Oil painting on glass; 25 by 31 ins.
Presented by the widow of Major General W. A. Watson, 6 March 1945.

<div align="right">

Add. Or. 3127 (Revised Foster catalogue, no. 223A)

</div>

NOTE: This glass-painting is a copy of an engraving by Charles Turner after an oil painting by Thomas Daniell, which was exhibited at the Royal Academy in 1805: *Sir C. W. Malet, Bart., the British resident at the Court of Poonah in the year 1790, concluding a treaty in the durbar with Souac Madarow, the peshwa or prince of the Mahratta empire.* This painting, still in the possession of the Malet family at Chargot, Washford, Somerset, was worked up by Daniell from sketches made by James Wales, an artist who worked in Bombay and Western India from 1790 to 1795. The Daniells had met Wales while they were in Bombay in 1793. Wales died at Thana in the Island of Salsette in November 1795 and his drawings passed into the possession of Sir Charles Malet who in 1799 married Wales' daughter, Susan. Malet gave a number of Wales' drawings to Thomas Daniell, who used some for his painting of the Durbar at Poona, others for the twenty-four aquatints in Part Six of *Oriental Scenery*, entitled *Hindoo Excavations in the Mountain of Ellora, near Aurungabad, in the Deccan, in Twenty-four views. Engraved from the Drawings of James Wales by and under the Direction of Thomas Daniell* (1803), and for an unpublished set of nine aquatints depicting cave-temples.

The Shanwar Palace at Poona was the chief residence of the later Peshwas. It was destroyed by fire in 1827. The Ganpati Rangmahal, the room in which the durbar was held, is described by E. Moor, *The Hindu Pantheon* (London, 1810), 174.

Bibliography

Bombay. *Gazetteer of the Bombay Presidency vol. xviii, part I, Poona* (Bombay, 1885).
T. Sutton, *The Daniells: artists and travellers* (London, 1954), 84, 98, and plate facing 56.

V Nepal

From the eighteenth century onwards the East India Company had intermittent and tenuous contacts with Nepal, and in 1816 a Residency was established in Khatmandu. A number of the British officers posted to it had scholarly and artistic interests, and some of them, such as Dr Oldfield, trained Nepali artists to assist them. Nepal, however, had contacts with India: it possessed strong links with Benares where leading gentry had palaces and houses, and its rulers also visited Calcutta from time to time. An oil painting presented to the East India Company by Maharaja Sir Jung Bahadur Kunwar Rana in 1850 (*Revised Foster catalogue, no. 36*) shows that at least one Nepali painter was capable of executing a large canvas in oils. Company painting proper, however, hardly developed in Nepal, and only a few artists executed individual commissions in a semi-European style.

203　Portrait of H.H. Maharaja Sir Jang Bahadur Kunwar Rana, Prime Minister and Commander-in-Chief of Nepal (1817–77, ruled 1846–77).
By a Nepali artist, Katmandu, 1851.
Inscribed: *Maharaja Sir Jung Bahadur. G.C.B. Nepaul. 1851.*
Water-colour; 13 by 8½ ins.
Presented by Brigadier G. P. Oldfield and Miss Margaret Oldfield, grandson and grand-daughter of Dr Henry Ambrose Oldfield, 27 April 1966, together with *WD 2778–2871, MSS.Eur.C.193* and *no. 204.*　　　　　　　Add. Or. 2615

NOTE: Dr Henry Ambrose Oldfield, from whose collection this drawing came, was Residency Surgeon, Katmandu, Nepal, from 1850 to 1868. He was a keen amateur artist and made many sketches of landscapes and architecture in Nepal (see Mildred Archer, *British drawings in the India Office Library* (London, 1969), i, 262–272). He appears to have made contact with local Nepali artists and to have acquired this drawing soon after his arrival.

The drawing is a copy of the oil painting which was presented to the East India Company by Maharaja Sir Jang Bahadur during his visit to England in 1850 and which now hangs in the Foreign and Commonwealth Office, London (see W. Foster, *A Descriptive catalogue of the paintings, statues, etc., in the India Office* (London, 1924), no. 36, 18–19). Oldfield arrived in Nepal about the time when the Maharaja was setting off for England, and must have acquired this copy soon after.

204 i–v　5 drawings of animals belonging to Dr H. A. Oldfield, Katmandu (Nepal).
By a Nepali artist, *c.* 1862.
Inscribed on back with notes about the animals.

Water-colour; 13 by 16 ins unless specified.
Presented by Brigadier G. P. Oldfield and Miss Margaret Oldfield, grandson and
grand-daughter of Dr H. A. Oldfield, 27 April 1966, together with *WD 2778–
2871, Mss.Eur.C.193,* and *no. 203.* *Add. Or. 2610–2614*

NOTE: Dr H. A. Oldfield (see no. 203) married Margaret Alicia Prescot during his leave in 1856.
She returned to Nepal with him soon after. About 1861 Dr Oldfield's eyesight deteriorated and he
trained a local artist to copy his sketches and work for him.

 i Pony, dogs and their attendant servants standing outside the Residency
 Surgeon's house, Katmandu (Nepal).
 Inscribed on back: *M.A.O.'s Pony 'Titmouse' – by Native Artist.* *Add. Or. 2610*
 ii 'Belle', a deer-hound. *Add. Or. 2611*
 iii 'Minna', a Scotch deer-hound. *Add. Or. 2612*
 iv 'Sultan', an English-bred deerhound. *Add. Or. 2613*
 v 'Corrie', a Scotch terrier with a dead rat lying at its feet.
 $10\frac{1}{2}$ by 13 ins. *Add. Or. 2614*

205 Portrait of a Nepali lady standing beside a table with a rose in her hand.
 By a Nepali artist, late 19th century.
 Wash; $10\frac{1}{4}$ by $6\frac{1}{2}$ ins.
 Presented by Mildred and W. G. Archer, 6 November 1962. *Add. Or. 2396*

NOTE: This drawing was obtained in Benares together with nos. 99, 101–105 and it may well have
been made there. Nepal had close connections with Benares; there is a Nepalese temple on the
ghats and wealthy Nepalese families, accompanied by their retainers, regularly visited the city.

VI Burma

Burma was annexed by the British at a late date (1886) when indigenous artistic traditions were still strong. From time to time Burmese artists were employed by British officers for certain individual commissions, such as designing furniture or illustrating books, but Company painting proper never developed there. For this reason the Library's Burmese material has been omitted from this catalogue. The following pictures and manuscripts show some western influence:

(1) *Add. Or. 569.* Design for a carved wooden stand by a Rangoon artist, 1894.
(2) *Add. Or. 2589–2593.* Drawings by a Burmese artist for Sir Richard Temple's book, *The thirty-seven nats* (London, 1906).
(3) *Burmese MSS. 207–209.* Drawings by a Burmese artist for Sir Richard Temple's book (as above).
(4) *Burmese MSS. 202.* Illustrations of the *Jatakas, c.* 1835.
(5) *Burmese MSS. 203.* Collection of miscellaneous drawings presented by Lord Wynford 1849.

VII Canton

By 1715 the East India Company had established regular trade with Canton, the principal and, after 1757, the only port for Chinese foreign trade. A group of Chinese merchants there, known as the Co-Hong, held the monopoly of this trade and rented 'factories' to the European East India Companies for the trading season. These were situated on the north bank of the Pearl River on the outskirts of the city. Once the fleet of East Indiamen had sailed, the European officials or 'Supercargoes' had to move to Macao until the next trading season.

Although much that was exported from Canton was not made to European order, various types of goods were especially intended for the foreign market; in particular, certain kinds of porcelain, paper-hangings and glass-paintings. Early in the eighteenth century, European requirements exerted a strong influence on this Chinese export art. Porcelain was sometimes made in European shapes and decorated with armorial bearings or with designs based on European prints. Some glass-paintings were similarly derived from western prints. It was not, however, until the end of the century that sets of paintings in a 'Company' style began to be made in Canton. As in India these paintings depicted themes and subjects which specially interested the European merchants in Canton and their families in the west. Exotic insects, birds, fruit and flowers had a special appeal. Sets of pictures were made of the many different types of boat which crowded the Pearl river. Others depicted Buddhist deities, ceremonies, costume, occupations and manufacturing processes. Tortures and classical drama provided further subjects peculiar to China. Another subject of great local interest was the Honam Temple, as well as the houses and gardens of Chinese merchants. The movement of European merchants in Canton was so circumscribed that they were only allowed to visit a very few places. Honam Island, facing the European factories, was one of these and its great temple-complex was a popular place for excursions. Sets of pictures were made showing the courtyards and pavilions and these supplied the purchasers not only with mementoes of sociable occasions but with illustrations of Chinese buildings. The European merchants also on occasion visited their wealthy Chinese counterparts and the design of their gardens as well as the interior decoration and furnishings of their houses aroused great curiosity. These also were depicted in stock sets which may well have had a formative influence on the vogue for Chinoiserie in Regency England.

The Library possesses an early group of such drawings which appear to have resulted from a correspondence which took place between the Court of Directors

and the Canton Factory from 1803 to 1805 (*Mss.Eur.D.562.16*). In 1803 the Court of Directors had written asking for paintings of Chinese plants for its Library, and these were duly sent.[1] On 23 January 1805 the Court again wrote to say that these works had been 'much admired,' and desired 'that drawings on Miscellaneous Subjects be likewise procured.' It seems that as a result of this request a number of paintings were despatched for the Library in about 1806 (nos. 206–215). It is unlikely that they were specially commissioned for they are of the standard type that was being made in the early years of the nineteenth century for Europeans in Canton.

It is significant that the Court of Directors should ask for Chinese drawings at this time. China was a topic of great interest at the turn of the century. As a result of Lord Macartney's Embassy of 1792 to 1794 a number of books had just been published or were in the process of appearing. Sir George Staunton, Secretary to the Embassy, had published his *An Authentic account of an embassy from the King of Great Britain to the Emperor of China* in 1798, John Barrow, Comptroller to the Embassy, had brought out his *Travels in China* in 1804, and William Alexander, the official artist, produced *The Costume of China* in 1805. The interest of the public had clearly been aroused and many people wished to know more about Chinese everyday life. Wealthy gentlemen were experimenting with Chinese plants in their hot-houses, Chinese imports were being used to furnish houses, and the East India Company was on the alert for new openings in trade.

Another early group of three paintings (no. 216) is a clue to the East India Company's interest in trading opportunities, however small. In March 1812 the Court wrote to the Canton Factory asking for samples of Chinese lanterns. On 22 February 1813 these were despatched together with illustrations and detailed instructions for assembling them. Whether any large-scale orders for lanterns resulted from this correspondence, however, is not known (*Mss.Eur.D.562.16*).

During the nineteenth century, painting in Canton for the European market rapidly became standardised. Sets on both ordinary paper and rice-paper were produced and continued to be made throughout the nineteenth century. One such group, comprising four volumes of paintings depicting four different manufacturing processes, is preserved in the Library (nos. 217–220). Another small group, given as a present to a child (no. 221), is typical of the small rice-paper paintings which became popular in England. In the first half of the nineteenth century, many of these novelties reached England through the initiative of the supercargoes of the Canton factory who were allowed to engage in private trading and who shipped them to England.

In China, as in India, a Company style developed in which the local traditional style was modified by European realism. Europeans criticised the Chinese lack of

[1] These drawings were transferred to the Kew Herbarium in 1897 but a few examples of fruit, flower and insect paintings remain in the Library. See Archer (1962), 59–61, 64, 100, plates 6, 12, 21, 22.

perspective, 'incorrect' light and shade, and brilliant colour. As a result, by the beginning of the nineteenth century Chinese artists, working for foreigners, had modified their painting to suit European taste. Landscapes were executed in soft greens and blues, and figures were represented more realistically and with shading. Nevertheless, sufficient of the indigenous style was retained to charm Europeans with its exotic flavour.

Bibliography

Archer, Mildred. *Natural history drawings in the India Office Library* (London, 1962).

Hunter, W. C. *The 'Fan Kwae' at Canton before treaty days, 1825–1844* (3rd edition, Shanghai, 1938).

Jourdain, Margaret, and Jenyns, R. S. *Chinese export art in the eighteenth century* (London, 1950).

Morse, H. B. *The Chronicles of the East India Company trading to China, 1635–1834*, 5 vols. (Oxford, 1926, 1929).

206
i–xli

41 drawings of boats bound into a volume with no. 207.

By a Canton artist, *c.* 1800–1805.

34 drawings are inscribed with titles in Chinese characters.

Water-marks of 1794.

Gouache; $16\frac{1}{2}$ by $21\frac{3}{4}$ ins.

Deposited *c.* 1806. *Add. Or. 1967–2007*

NOTE: These drawings together with nos. 207–215 appear to have reached the Library as a result of a request from the East India Company to the Canton Factory in 1805 for paintings of 'miscellaneous subjects' (see p. 254). A list of the present drawings, on paper with an 1818 water-mark, has been preserved in the Library's records (*Mss.Eur.D.562.16*). It appears to be an early attempt at listing the pictures. These descriptions are given below, together with a rough translation of the Chinese inscriptions which occur on thirty-four of the drawings.

 i 'Cheem-lo-kong Sheun. This is one of the first rate Chinese vessels, some of which are said to carry above a thousand tons. Commonly used to carry presents to the Emperor from different parts of the Country.'
Inscribed: *Tribute boats from Siam.* *Add. Or. 1967*

 ii 'Pac-tchow-Sheun. This differs little or nothing in construction from the preceding. It is the kind of vessel, which makes voyages to Malacca, Batavia, Manilla etc.'
Inscribed: *Boat from Po-ts'ao.* *Add. Or. 1968*

 iii 'Pac-yeem-Sheun. A kind of boat, of which some are large, used to carry Salt from different parts of the Coast. The Chinese name literally signifies White Salt Boat.' *Add. Or. 1969*

 iv 'Kie-heuung-Paw-Sheun. A kind of Vessel used to carry naval Stores to the Emperor's fleet.'
Inscribed: *Gunboat for transporting provisions.* *Add. Or. 1970*

 v 'Tung-cheuung-yeem-Sheun. Tung-cheuung is the name of a place

where there is a great manufacture of salt. The name is literally a Tung cheuung Salt Boat.' *Add. Or. 1971*

vi 'Ma-Yeuung-Sheun.'

Inscribed: *Ma-yang.* *Add. Or. 1972*

vii 'Sie-qua-peen-teang. This is the kind of vessel used for taking cargo to and from the European ships at Wampoa; commonly called Chop boat by Europeans.'

Inscribed: *Boat for sending foreign merchants to Macao.* *Add. Or. 1973*

viii 'Shui-loc-Sheun. Literally a Lantern boat. This kind of boat is decorated with lanterns on a particular festival of the Chinese which takes place in their Seventh month.'

Inscribed: *Boat for celebration of 'Middle of 7th month' festival (sacrifice to spirits on land and in water).* *Add. Or. 1974*

ix 'Tai-hoi-mee-leang. This is a kind of Boat, of nearly the same construction as No. 7, but is only used for Chinese Cargo.'

Inscribed: *Boat with large opening at the stern.* *Add. Or. 1975*

x 'Poo-tow-mie-teang. Chinese boat of war of the smaller size.'

Inscribed: *Rice transport boat with guards against pirates.* *Add. Or. 1976*

xi 'Tie-too-Sheun. A Passage Boat. A kind of large boat employed for carrying passengers from one part of the country to another.'

Inscribed: *Night ferry.* *Add. Or. 1977*

xii 'Hee-Sheun. Boat for Chinese musicians and comedians etc., otherwise a sing-song boat.'

Inscribed: *Theatre boat.* *Add. Or. 1978*

xiii 'Tie-cheuung Sheun. A kind of Custom house Guard boat, employed to look out, for prevention of smuggling.'

Inscribed: *Police boat.* *Add. Or. 1979*

xiv 'Lung Sheun. Literally Dragon or Snake boat. On a particular festival of the Chinese which falls on their fifth month, boats of this construction are used as Race boats.'

Inscribed: *Dragon boat of the festival on the 5th of the 5th month.*

Add. Or. 1980

xv 'Wang-low. Large kind of Boat for the accommodation of Prostitutes.'

Add. Or. 1981

xvi 'Mooc-ma-Sheun. Flat bottomed boat for shallow rivers or canals.'

Add. Or. 1982

xvii 'Kouc-Sheun. Rice Boat.' *Add. Or. 1983*

xviii 'Tsap-shee-Sheun. A Custom house boat employed to prevent smuggling.'

Inscribed: *Patrol boat against smuggling.* *Add. Or. 1984*

xix 'Tic-Sheac-Sheun. Large and strong built boat used for carrying stones for building. Literally a large stone boat.'

Inscribed: *Boat for transporting worked blocks of stone.* *Add. Or. 1985*

xx 'Tie-Shui-lew. Literally a water Shop. A boat in which a kind of Grocer's Shop is kept on the water.'
Inscribed: *Shop on water.* *Add. Or. 1986*

xxi 'Hoon-Sheun. Large kind of Passage Boat used to carry the Mandarins from one part of the Empire to another.'
Inscribed: *Official boat of the customs.* *Add. Or. 1987*

xxii 'Sam-pan-teang. Strong kind of Boat in general use for all sorts of cargo.' *Add. Or. 1988*

xxiii 'Sai-nam-kouc-Sheun. Literally a Sai-nam Rice boat. Sai nam is a district in the province of Canton.'
Inscribed: *South-west rice transport boat.* *Add. Or. 1989*

xxiv 'Yow-Sheun. Literally an Oil Boat. Used to carry oil.'
Inscribed: *Shih-hsing oil boat.* *Add. Or. 1990*

xxv 'Hou-hoc-Sheun. Oyster shell boat. A kind of boat used to carry oyster shells for making Chunam or Lime.'
Inscribed: *Oyster shell boat.* *Add. Or. 1991*

xxvi 'Hue-low-Sheun.'
Inscribed: *Black barge.* *Add. Or. 1992*

xxvii 'Sew-wong-teang. A kind of Passage boat.'
Inscribed: *Going to the four directions boat.* *Add. Or. 1993*

xxviii 'Mie-teang. A Rice boat. A Boat carrying rice dressed ready for use.'
Inscribed: *Rice boat from Hsiang-shan.* *Add. Or. 1994*

xxix 'Tan-Sheun. Charcoal Boat.'
Inscribed: *Charcoal boat.* *Add. Or. 1995*

xxx 'Fie-teang. A fast sailing Boat.'
Inscribed: *Fast boat.* *Add. Or. 1996*

xxxi 'Ap-Sheun. A boat used for breeding and keeping ducks.'
Inscribed: *Duck boat.* *Add. Or. 1997*

xxxii 'Fo-tung-Sheun. Boat for carrying Tiles.'
Inscribed: *Boat with blower for its fire.* *Add. Or. 1998*

xxxiii 'Sha-koo. Boat for Prostitutes.' *Add. Or. 1999*

xxxiv 'Kow-kong-liu-Sheun. Boat for carrying live fish.'
Inscribed: *Fishing boat of Chinchiang.* *Add. Or. 2000*

xxxv 'Tai-tsong-teang. Boat for Prostitutes.' *Add. Or. 2001*

xxxvi 'Ha-lo-teang. Boat for catching Shrimps.'
Inscribed: *Boat carrying baskets for catching shrimps.* *Add. Or. 2002*

xxxvii 'Wang-Shui-tow. A small Ferry or Passage Boat.'
Inscribed: *Ferry for crossing over water.* *Add. Or. 2003*

xxxviii 'Hie-Sheun. Literally a Shoe boat. A sort of Boat used for selling Shoes.'
Inscribed: *Boat for transporting horses' fodder. Shoe boat.* *Add. Or. 2004*

xxxix 'Teen-lew-Sheun. A dung boat.'

Inscribed: *Boat for transporting cane strips. Boat for transporting dung. Small boat.* Add. Or. 2005

xl 'Sun-tuck-huung-teang. A boat of Sun-tuck-huung (the name of a place).' Add. Or. 2006

xli 'Kong-Seu-Sew-teang. A kind of Passage or pleasure boat, such as is used by the Europeans at the Factories in Canton.'
Inscribed: *Company boat.* Add. Or. 2007

207 i–xl 40 drawings of boats in a landscape setting bound into a volume with no 206.
By a Canton artist, *c.* 1800–05.
Gouache; 14¾ by 18¾ ins.
Deposited *c.* 1806. *Add. Or. 2008–2047*

NOTE: No inscriptions or descriptions accompany these drawings. A number of the boats can be identified by comparison with no. 206, but the two sets are by no means identical.

208 i–xxxvi 36 drawings bound into a volume illustrating episodes from Chinese classical drama.
By a Canton artist, *c.* 1800–05.
Inscribed in Chinese characters with description of episode.
Water-colour; 16¾ by 21¼ ins.
Deposited *c.* 1806. *Add. Or. 2048–2083*

NOTE: Translations of the Chinese inscriptions are given below as titles to the paintings.

i Chao-chün passing the frontier.	*Add. Or. 2048*
ii The story of the Chinese guitar.	*Add. Or. 2049*
iii Ts'ao is allowed to escape from Hua Yung.	*Add. Or. 2050*
iv Bidding farewell to his father to receive the seal of office.	*Add. Or. 2051*
v K'ê Yung borrows troops.	*Add. Or. 2052*
vi The capture of I Cheng-ch'ing.	*Add. Or. 2053*
vii The mad monk scolding the Prime Minister.	*Add. Or. 2054*
viii General Hsiang taking leave of his concubine.	*Add. Or. 2055*
ix Yao Ch'i is beheaded by mistake.	*Add. Or. 2056*
x Shooting at Hua Yung.	*Add. Or. 2057*
xi The marriage of Chou Ch'ing.	*Add. Or. 2058*
xii Yü Chi scolding Ch'uang.	*Add. Or. 2059*
xiii Emperor of Ch'i weeping in the palace.	*Add. Or. 2060*
xiv Through friendship Yen Yen is set free.	*Add. Or. 2061*
xv Li Po going to a foreign land as an envoy.	*Add. Or. 2062*
xvi With only himself armed he goes to attend the meeting.	*Add. Or. 2063*
xvii Ts'ui Tzü kills the Emperor of Ch'i.	*Add. Or. 2064*

xviii	While drunk he flogs the God of the Gates.	*Add. Or. 2065*
xix	Three battles against Lü Pu.	*Add. Or. 2066*
xx	Wu-lang rescues his younger brother.	*Add. Or. 2067*
xxi	Judge Rao Kung flogs the royal carriage.	*Add. Or. 2068*
xxii	While delivering the answer he meets his father.	*Add. Or. 2069*
xxiii	The Emperor of Wei is being oppressed.	*Add. Or. 2070*
xxiv	Slaughtering his way through four gates.	*Add. Or. 2071*
xxv	Golden Lotus lifts the screen.	*Add. Or. 2072*
xxvi	Yu-chi shoots an arrow at Shu.	*Add. Or. 2073*
xxvii	While drunk he beats up those at the Mountain Gate.	*Add. Or. 2074*
xxviii	The story of a cabbage-cutting knife.	*Add. Or. 2075*
xxix	Dallying with Fêng in a tavern.	*Add. Or. 2076*
xxx	Wang Ch'ao being initiated as a sworn brother.	*Add. Or. 2077*
xxxi	The fisherman's daughter assassinates Chi.	*Add. Or. 2078*
xxxii	Strings for musical instruments for sale.	*Add. Or. 2079*
xxxiii	Beheading his own son in the Yamen.	*Add. Or. 2080*
xxxiv	Emperor Chien Wên flogs the carriage.	*Add. Or. 2081*
xxxv	Chên-ngo assassinates Hu.	*Add. Or. 2082*
xxxvi	K'ang Yin questioning His Highness.	*Add. Or. 2083*

209
i–xx

20 drawings of the Buddha and of Buddhist deities, bound into a volume together with nos. 210–214.
By a Canton artist, *c.* 1800–05.
Gouache; $15\frac{1}{4}$ by $19\frac{1}{2}$ ins.
Deposited *c.* 1806. *Add. Or. 2107–2126*

210
i–xxiv

24 drawings of the Buddha and of Buddhist deities bound into a volume together with nos. 209, 211–214.
By a Canton artist, *c.* 1800–05.
Watermarks of 1794.
Gouache; $16\frac{3}{4}$ by $21\frac{1}{2}$ ins.
Deposited *c.* 1806. *Add. Or. 2163–2186*

211 i–x

10 drawings of the Court of Justice, Canton, bound into a volume together with nos. 209, 210, 212–214.
By a Canton artist, *c.* 1800–05.
Inscribed: *A Court of Justice, Canton*, and *Court of Justice at Canton*.
Gouache; $16\frac{1}{2}$ by $21\frac{1}{2}$ ins.
Deposited *c.* 1806. *Add. Or. 2129–2138*

NOTE: This group of drawings shows the various courtyards and buildings of which the court was composed. In one picture (vii, *Add. Or. 2135*) prisoners under sentence are shown in chains or with *cangues* around their necks.

259

212
i–xxiii

23 drawings of the Honam Temple, Honam Island, bound into a volume with nos. 209–211, 213, 214.

By a Canton artist, *c.* 1800–05.

All inscribed: *Joss House, Honam.*

Gouache, except for xxiii which is in pen-and-ink.

Deposited *c.* 1806. *Add. Or. 2084–2106*

NOTE: Honam Island, dividing the north-south channels of the Pearl River, lay opposite the British Factory in the suburbs of Canton. Lord Macartney's embassy stayed there from 19 December 1793 to 8 January 1794. Macartney noted in his journal, 'Our quarters are in an island, opposite to the English Factory, which is situated on the mainland in the suburbs of the city of Canton. The river that divides us is about half a mile broad. These quarters consist of several pavilions or separate buildings, very spacious and convenient, and some of them fitted in the English manner with glass windows and firegrates, which latter at this season, although we are on the edge of the tropic, are very comfortable pieces of furniture. Our habitations are in the midst of a large garden, adorned with ponds and parterres, and with flowers, trees, and shrubs, curious either from rarity or beauty. On one side of us is a magnificent *miao*, or bronze temple, and on the other a large edifice from the top of which is a very fine view of the river and shipping, the city and the country to a great extent' (J. L. Cranmer-Byng, *An Embassy to China* (London, 1962), p. 204).

The temple referred to in this passage is the 'Temple of the Sea-Pennant.' It was a favourite spot amongst the foreign merchants at Canton for excursions. It consisted of a whole complex of small temples, pavilions, residential quarters for monks, as well as study rooms and stores for sacred Buddhist texts, all set in a walled enclosure. The garden contained a very old plant, 'the eagle-claw orchid,' which antedated the temple. There was a magnificent panorama from the temple which could be viewed from a special building (see xviii).

The present set of drawings depicts the various parts of the temple; one drawing (xxiii) shows the whole temple-complex. Some of the buildings are inscribed with their names in Chinese characters, rough translations of which are given below. No. 213 is a similar set with minor variations.

i	Tea-shop at the entrance to the temple.	*Add. Or. 2084*
ii	Entrance gateway.	*Add. Or. 2085*
iii	'Hall of the Jewel of Heroism.'	*Add. Or. 2086*
iv	'Pavilion of the Pearl of Desire.'	*Add. Or. 2087*
v	'Hall of the Mystery of Nirvana.'	*Add. Or. 2088*
vi	Courtyard with verandah and balcony.	*Add. Or. 2089*
vii	'Hall of Kuan Yin.' 'Courtyard of Zen.'	*Add. Or. 2090*
viii	Piggery.	*Add. Or. 2091*
ix	'Hall of Clouds and Water.'	*Add. Or. 2092*
x	'Hall of Repose.'	*Add. Or. 2093*
xi	Study quarters.	*Add. Or. 2094*
xii	'Hall of Zen.'	*Add. Or. 2095*
xiii	Hall probably for receiving visitors.	*Add. Or. 2096*

xiv	'Hall of the Three Ancestors.'	*Add. Or. 2097*
xv	Study and store-rooms for sacred books.	*Add. Or. 2098*
xvi	Wash house.	*Add. Or. 2099*
xvii	Refectory.	*Add. Or. 2100*
xviii	'Tower for Enjoying the Distant View.'	*Add. Or. 2101*
xix	'Grasping Happiness Hall.'	*Add. Or. 2102*
xx	Courtyard with residential quarters.	*Add. Or. 2103*
xxi	'Temple of the Many-armed Buddha.'	*Add. Or. 2104*
xxii	Garden and fields within the temple wall.	*Add. Or. 2105*
xxiii	Birds-eye view of the whole temple-complex and monastery.	
		Add. Or. 2106

213
i–xxiv

24 drawings of the Honam Temple, Honam Island, bound into a volume together with nos. 209–212, 214.
By a Canton artist, *c.* 1800–05.
Gouache: $16\frac{1}{2}$ by $21\frac{1}{2}$ ins.
Deposited *c.* 1806. *Add. Or. 2139–2162*

NOTE: A set similar to no. 212 but without the drawing showing the whole temple-complex and with nos. iii, xii, xiii and xvii replacing 212,xi, xv and xxiii. As in no. 212 many buildings are inscribed with their names in Chinese characters, rough translations of which are given below.

i	Tea-shop, restaurant and flower-shop at the entrance to the temple.	
		Add. Or. 2139
ii	Entrance gateway.	*Add. Or. 2140*
iii	'Gateway to Precepts of Religion.'	*Add. Or. 2141*
iv	'Hall of the Jewel of Heroism.'	*Add. Or. 2142*
v	'Pavilion of the Pearl of Desire.'	*Add. Or. 2143*
vi	'Hall of the Mystery of Nirvana.'	*Add. Or. 2144*
vii	'Hall of Kuan Yin.' 'Courtyard of Zen.'	*Add. Or. 2145*
viii	Courtyard with verandah and balcony.	*Add. Or. 2146*
ix	'Hall of Repose.'	*Add. Or. 2147*
x	'Hall of Clouds and Water.'	*Add. Or. 2148*
xi	Piggery.	*Add. Or. 2149*
xii	Temple and courtyard.	*Add. Or. 2150*
xiii	Hall for receiving visitors and store-rooms for sacred books.	*Add. Or. 2151*
xiv	'Hall of Zen'.	*Add. Or. 2152*
xv	Refectory.	*Add. Or. 2153*
xvi	'Temple of the Many-armed Buddha.'	*Add. Or. 2154*
xvii	Refectory for servants with places for cooking and washing-up.	
		Add. Or. 2155
xviii	Wash-house.	*Add. Or. 2156*
xix	'Tower for Enjoying the Distant View.'	*Add. Or. 2157*

xx 'Grasping Happiness Hall.' *Add. Or. 2158*
xxi Hall probably for receiving visitors. *Add. Or. 2159*
xxii 'Hall of the three Ancestors.' *Add. Or. 2160*
xxiii Courtyard with residential quarters. *Add. Or. 2161*
xxiv Garden and fields within the temple wall. *Add. Or. 2162*

214
i–xiv

14 drawings; 2 of the garden of a Chinese merchant and 12 of the interior of the house of a Chinese official, bound into a volume together with nos. 209–213.
By a Canton artist, *c.* 1800–05.
Gouache, 16½ by 21½ ins.
Deposited *c.* 1806. *Add. Or. 2127, 2128, 2187–2196*

NOTE: i and ii (*Add. Or. 2127, 2128*), which are inscribed *Paan Khaquar Gardens*, show the garden of a wealthy Chinese merchant, 'Puan Khequa.' This was the name given by foreigners to P'an Chen-ch'eng (1714–88) and then to his son, P'an Yu-ti, who inherited the firm and died in 1821. He was the chief of the Co-hong from 1796 to 1808 and was one of the two senior Hong merchants sent by the Governor of Kwangtung to the Commissioners of the East India Company in March 1792 to make preliminary enquiries about the projected English embassy (see J. L. Cranmer-Byng, *op.cit.*, note 76). The name was also given to his descendants for William Hunter records 'Pwan-keiqua' as one of the Co-hong in 1825. He also refers to the fine houses of the Chinese merchants and their beautiful gardens: 'Their private residences, of which we visited several, were on a vast scale, comprising curiously laid-out gardens, with grottoes and lakes, crossed by carved stone bridges, pathways neatly paved with small stones of various colours forming designs of birds, or, fish, or flowers. One of the most beautiful was that of Pwankeiqua, on the banks of the river, three or four miles west of the Factories' (see W. C. Hunter, *The Fan Kwae at Canton* (Shanghai, 1938), pp. 20, 24).

iii–xiv (*Add. Or. 2187–2196*) show the interior of the house of a certain Liu who was a Chin-Shih (a successful candidate in the examination for a 'second degree'). His name and rank are inscribed on two lanterns in iii (*Add. Or. 2187*). No. ix (*Add. Or. 2193*) is reproduced in M. Collis, *Wayfoong: the Hongkong and Shanghai Banking Corporation* (London, 1965), plate 44.

215 i–
cxxxiii

133 drawings bound into a volume together with no. 216 illustrating the contents and furnishings of Chinese houses and temples: cane and wooden furniture, vases, gongs, scroll paintings, altars, bronzes, embroideries, lacquered goods, musical instruments, lanterns, toys, mobiles, weapons, trophies, sedan chairs and miscellaneous ornaments.
By Canton artists, *c.* 1800–06.
Water-marks of 1794 and 1805.
Gouache; 14¾ by 18 ins.
Deposited *c.* 1806. *Add. Or. 2197–2313 and 2317–2332*

Bibliography

Mildred Archer, 'Chinese lanterns', *Geographical Magazine*, December 1960, 452–457, reproducing *Add. Or. 2237* and *2332*.

216 3 drawings of lanterns bound into a volume with no. 215.
i–iii By a Canton artist, 1812–13.
Gouache; $14\frac{3}{4}$ by 18 ins.
Deposited 1813. *Add. Or. 2314, 2315, 2316*

NOTE: These three paintings were received as a result of a letter from the East India Company written in March 1812 asking for samples of Chinese Lanterns. On 22 February 1813 the Canton Factory replied saying that 'The Lanterns indented for by the Honourable Court having been reported ready, were this day shipped on the *Royal George*. A description of these Lamps with directions for putting them together drawn up by Mr Bosanquet under whose immediate inspection they were executed will be transmitted, a number in the Packet of that Ships Packet and Captain Gribble has promised that every possible care should be taken of them' (*Mss.Eur.D.562.16*).

Bibliography

Mildred Archer, 'Chinese lanterns', *Geographical Magazine*, December 1960, 452–457, reproducing (i) and (ii) (*Add. Or. 2314, 2315*).

217 i–x 10 drawings illustrating the manufacture of cast iron in China bound into a volume.
By a Canton artist, *c.* 1820.
Inscribed on label on cover: *Cast Iron Manufacture. 10 Drawings*; inside cover and on (i): *Library India Office*. Each drawing inscribed with title in Chinese characters. Rough translations given below.
Gouache; size of volume $17\frac{1}{4}$ by $20\frac{1}{2}$ ins.
Circumstances of acquisition unrecorded. *Add. Or. 2333–2342*

NOTE: This volume is uniform in style with nos. 218–220. All are bound in the same silk brocade and clearly reached the Library at the same time. The inscription *Library India Office* shows that they cannot have been registered by the Library until after 1858 but the drawings may well have been executed and deposited earlier.

i 'Collect together scraps of old round-bottomed cooking pans'. *Add. Or. 2333*
ii 'Pound and sieve earth'. *Add. Or. 2334*
iii 'Make mould holder and put mould in'. *Add. Or. 2335*
iv 'Put colour on; take down the mould'. *Add. Or. 2336*
v 'Close up the halves of the mould and examine the mould'. *Add. Or. 2337*
vi 'Put the mould on the fire'. *Add. Or. 2338*
vii 'When the mould turns red, take it off'. *Add. Or. 2339*
viii 'Put it in water to cool'. *Add. Or. 2340*
ix 'Take away the mould and take out the good round-bottomed cooking pan'.
Add. Or. 2341
x 'Repair any inferior grade products'. *Add. Or. 2342*

218 i–x 10 drawings illustrating the manufacture of white lead in China bound into a volume.

By a Canton artist, *c.* 1820.
Inscribed on label on cover: *White Lead Manufacture. 10 Drawings*; inside cover and on (i): *Library India Office*. Each drawing inscribed with title in Chinese characters. Rough translations given below.
Gouache; size of volume $17\frac{1}{4}$ by $20\frac{1}{2}$ ins.
Circumstances of acquisition unrecorded. *Add. Or. 2343–2352*

i	'Putting in the materials'.	*Add. Or. 2343*
ii	'Use vinegar to moisten lead'.	*Add. Or. 2344*
iii	'Soaking of lead completed'.	*Add. Or. 2345*
iv	'Put material in cauldron and add vinegar'.	*Add. Or. 2346*
v	'Heat in cauldron until it is ready'.	*Add. Or. 2347*
vi	'When the powder is formed, take it out of the cauldron'.	*Add. Or. 2348*
vii	'Soak powder in water'.	*Add. Or. 2349*
viii	'Workmen washing the powder'.	*Add. Or. 2350*
ix	'Heat powder on range'.	*Add. Or. 2351*
x	'Heat until it is dry. Put in buckets'.	*Add. Or. 2352*

219 i–x 10 drawings illustrating the manufacture of red lead in China bound into a volume.
By a Canton artist *c.* 1820.
Inscribed on label on cover: *Manufacture of Red Lead. 10 drawings*; inside cover and on (i): *Library India Office*. Each drawing inscribed with title in Chinese characters. Rough translations given below.
Gouache; 16 by $19\frac{1}{2}$ ins. size of volume $17\frac{1}{4}$ by $20\frac{1}{2}$ ins.
Circumstances of acquisition unrecorded. *Add. Or. 2353–2362*

i	'Putting in lead, sulphur and mercury'.	*Add. Or. 2353*
ii	'Heat the powder the first time'.	*Add. Or. 2354*
iii	'Heat the second time; beginning to turn red'.	*Add. Or. 2355*
iv	'Pounding the powder for the first time'.	*Add. Or. 2356*
v	'Heating of powder completed'.	*Add. Or. 2357*
vi	'Pounding of powder completed'.	*Add. Or. 2358*
vii	'Tossing of powder; mixing with yellow powder'.	*Add. Or. 2359*
viii	'Heat powder until it becomes red'.	*Add. Or. 2360*
ix	'When it has turned red, take red powder out'.	*Add. Or. 2361*
x	'Sift powder – whole process completed'.	*Add. Or. 2362*

220 i–x 10 drawings illustrating the manufacture of vermilion in China bound into a volume.
By a Canton artist, *c.* 1820.
Inscribed on label on cover: *Preparation of Vermilion & 10 Designs*; inside cover and on (i): *Library India Office*. Each drawing inscribed with titles in Chinese characters. Rough translations given below.

Gouache; size of volume 17¼ by 20½ ins.
Circumstances of acquisition unrecorded. *Add. Or. 2363–2372*

 i 'Putting in mercury'. *Add. Or. 2363*
 ii 'Seal the mouth of the pot with clay'. *Add. Or. 2364*
 iii 'Put in the furnace'. *Add. Or. 2365*
 iv 'The firing begins'. *Add. Or. 2366*
 v 'Pour out the small lumps and pound them fine'. *Add. Or. 2367*
 vi 'Grind the vermilion'. *Add. Or. 2368*
 vii 'Washing the vermilion'. *Add. Or. 2369*
 viii 'Baking the vermilion'. *Add. Or. 2370*
 ix 'Sifting the vermilion'. *Add. Or. 2371*
 x 'Wrapping the vermilion'. *Add. Or. 2372*

221 i–vi Six drawings depicting a Chinese soldier, boats, birds, fruit and a butterfly.
By a Canton artist, *c.* 1825.
Water-colour on rice-paper; approx. 6¾ by 10½ ins.
Deposited on permanent loan by Captain K. Oliver-Bellasis, 10 September 1960.
MSS.Eur.G.45.6

NOTE: These drawings are mounted in a scrapbook relating to the childhood of Augustus Fortunatus Bellasis (1822–72), son of Lieut. Col. Daniell Hutchins Bellasis. According to a slip pasted on f. 72, inscribed: *For Fortunatus Augustus Bellasis with Cousin John's love*, they were given to him by his cousin, John Brownrigg Bellasis (1806–90), who served with the Bombay Army from 1822 to 1858. Augustus was born in India and went home with his parents to England in 1827. For the Bellasis family, see Mildred Archer, *British drawings in the India Office Library* (London, 1969), i, 102–129 and Margaret Bellasis, *Honourable Company* (London, 1952).

 The present drawings were probably amongst the Chinese paintings to which John Bellasis refers in his journal of 1829 (*Photo Eur. 35 p. 64*). He notes 'Uncle Dan took home a nice collection (of drawings) and some China ones.' Chinese pictures appear to have been imported into Bombay, for a little later he writes (p. 68), 'I have just received some things from China for Helen and Charlotte', and (p. 74) 'Crosby has lately been down to Bombay and is bringing up my China pictures. The baggage pony sat down in the water crossing a stream on the road, and it has caused the rice paper to crack a good deal – but they are not much worse and are curious as being painted by a Chinese.'

 i f.73 Dragon Boat.
 ii f.74 Chinese soldier with a musket on his shoulder and a shield and helmet on his back.
 iii f.75 Two Porphyrios or purple moorhens (*Porphyrio porphyrio*).
 iv f.76 A pair of Mandarin ducks (*Aix galericulata*) amongst lotuses.
 v f.77 Fruit and butterfly.
 vi f.78 Junk.

222 A great tree on Prince of Wales' Island (Penang).
Probably drawn by a Chinese artist, *c.* 1825.
Inscribed: *Great Tree Prince of Wales' Island. 32 feet in circumference – 120 in height to the first branch.*
Unfinished, pencil; 23 by 18¾ ins.
Presented by Robert Skelton, 14 June 1966. *Add. Or. 2608*

NOTE: Part of a set of drawings of Malayan fruits by Chinese artists in Penang. The drawing is a hesitant copy of the aquatint, 'View of the Great Tree, Prince of Wales Island', in *Views in Prince of Wales' Island* (London, 1821) made by William Daniell after an original drawing by Captain Robert Smith, Superintending Engineer, Prince of Wales' Island, 1814–18 (see Mildred Archer, *British drawings in the India Office Library* (London, 1969), i, 317).

223 Portrait of 'Changkihur or Prince Janghir'.
By a Chinese artist, *c.* 1830.
Inscribed: *Changkihur, the Mahommedan Rebel against China, A.D. 1826–28, or Prince Jangheer who attempted to recover the Kingdom of his Forefathers, failed, was cut to inches, in Peking, June 26 1828. Reign of Taon-Kwang, 8th year 5th moon 15th day.*
Name also given in Chinese characters.
Inscribed on torn folder: *Picture of the Mahommedan Rebel Chang-ki-hur. Ditto, the Chinese Hoo-Loo. Sent to England 1831.*
Water-colour; 13¾ by 10¼ ins.
Presented to the East India Company, 1831. *Add. Or. 743*

Appendix I

Glossary of Anglo-Indian words commonly inscribed on Company paintings

Arrack (*'araq*)	Spirits distilled from the fermented sap of palm trees.
Attar (*'itr*)	Perfume.
Aubdar (*ābdār*)	Servant who cools water or wine.
Ayah	Lady's maid or nurse from Portuguese *aia*.
Baborchee, bobachee (*bāwarchī*)	Cook.
Banghy (*bahangī*)	Shoulder yoke for carrying loads, especially boxes (pitarrahs) used when travelling.
Banneah, baniya (*baniā*)	Shop-keeper.
Bheesty (*bihishtī*)	Water-carrier.
Bochah (*bochā*)	Enclosed sedan chair or 'short palanquin' used in Bengal.
Box-wallah	Itinerant merchant with a box of goods.
Burkundauze (*barkandāz*)	Armed retainer.
Byragey (*baīrāgī*)	Vaishnava devotee.
Chatyr, chatta (*chātā*)	Umbrella.
Chillum (*chilam*)	The part of a hookah which contains tobacco and charcoal balls.
Choorey, churree (*chūrī*)	Bangle.
Choultry	A term peculiar to S. India: a hall, shed or covered platform used as a travellers' resting place.
Chowkidar (*chaukidār*)	Watchman.
Chowry-burdar (*chaurī bardār*)	Servant who wields a fly-whisk made from a yak's or horse's tail.
Chubdar (*chobdār*)	Mace or long silver-stick bearer. Sometimes also called 'assaburdar'.
Chupatty (*chapātī*)	A thin cake of unleavened bread.
Chuprassy (*chaprāsī*)	Messenger or orderly wearing a badge or *chaprās*.
Churkah (*charkhā*)	Spinning wheel.
Churruck-pooja (*charak pūjā*)	Hook-swinging festival.

Classy, kalassie (*khalāsī*)	Tent-pitcher.
Consumah (*khānsāmā*)	Head table-servant or butler.
Crannee, cranny (*karānī*)	Clerk.
Cummerbund (*kamarband*)	Waistband.
Dandy (*dāndī*)	Boatman.
Dassary (*dāsari*)	Vaishnava mendicant.
Dawk (*dāk*)	Post.
Dewan (*dīwān*)	Steward. Servant in confidential charge of the affairs of a large domestic establishment or of a house of business.
Dhoby, dhobee (*dhobī*)	Washerman.
Doonea (*dhuniyā*)	Carder of cotton.
Doorga Pooja (*Durgā pūjā*)	Festival in honour of the goddess Durga held in September or October.
Doria (*doriyā*)	Dog-keeper.
Dhoty, dotee (*dhotī*)	Cloth passed round the waist, drawn between the legs and fastened behind, worn by men.
Dubassi (*dobāshī*)	Literally interpreter, but in the South a broker attached to mercantile houses.
Durwan (*darwān*)	Door-keeper.
Durzee, dhirgee (*darzī*)	Tailor.
Dassera (*dasehrā*)	Autumn festival commemorating Rama's victory over Ravana.
Ecka (*ekkā*)	Small one-horse carriage.
Eed (*'īd*)	A Muslim festival.
Fakeer (*faqīr*)	Muslim ascetic or religious mendicant, but loosely applied to Hindu ascetics also.
Gossyne (*gosāīn*)	Hindu religious mendicant or devotee.
Hackery	A light carriage drawn by bullocks for personal transport probably derived from *chhakra*, a two-wheeled cart.
Hawuldar (*havildār*)	Sepoy non-commissioned officer corresponding to a sergeant.
Hircara, hircarrah (*harkārā*)	Messenger, courier or running footman.
Hookah-burdar (*huqqabardār*)	Hubble-bubble pipe bearer.
Hooley (*holī*)	The Hindu spring festival in the month of March.
Howder, howdah (*haudaj*)	Elephant seat.
Hulwaen (*halwāīn*)	Woman sweet-meat seller.
Jamma (*jāma*)	Part of Indian clothing; a type of coat.

Jemadar (*jamādār*)	Indian officer of the second rank in a company of sepoys, next in rank below a *sūbadār*.
Jompon (*jānpān*)	Chair for use in hill country carried on two poles like a European sedan chair.
Kaleea Pooja (*kālī pūjā*)	Festival of the goddess Kali, the Earth Mother in her ferocious form.
Killadar (*qil'ah-dār*)	Commandant of a fort or garrison.
Kitmutgar (*khidmatgār*)	Table-servant.
Laula, lalla (*lālā*)	Vernacular clerk or merchant.
Mahout (*mahāwat*)	Driver or tender of an elephant.
Mallee (*mālī*)	Gardener.
Mater (*mehtar*)	Sweeper or scavenger.
Moharum (*muharram*)	Period of fasting and public mourning observed during the first month of the Muhammandan lunar year in commemoration of the deaths of Hasan and Husain (A.D. 669 and 680).
Moochy (*mochī*)	Shoe-maker or saddler. In South India a worker in leather who also does painting, gilding and upholsterer's work.
Moolvee, mulvi (*maulawī*)	An honorific denoting a Muslim learned in theology or law.
Moonshy (*munshī*)	Teacher of languages, especially Persian and Urdu; also a writer or secretary.
Moorpunky (*morpankhī*)	Name given to pleasure boats with prows and sterns in the shape of a peacock.
Mora (*morhā*)	Stool.
Mussaulchee (*mashālchī*)	Torch bearer or link-boy; later a servant who looks after lamps and washes dishes.
Mussoola (*masula*)	Surf boat used on the Coromandel Coast.
Mussuck (*mashak*)	Goat-skin used by water carriers.
Nabob (*nawāb*)	Originally a viceroy or chief governor under the Mughals, then a title of rank, and finally a name for an Anglo-Indian who returned to England with a fortune from the East.
Nargeela (*nārgīla*)	Simplest form of hookah made from a coconut shell.
Nautch (*nāch*)	Dance performed by Indian women.
Ordbhawn (*urdhvabāhu*)	Ascetic with upraised arms.
Palankeen, palanquin (*pālkī*)	Litter for travelling of several types.

a. *dholi*. Cot suspended from bamboo pole and covered with cloth.

b. *jhalledar*. Fly palanquin with ornamental pole and awning. Used by Europeans until about 1783.

c. *miyānā* (mahannah, meeana) Box palanquin. Used by Europeans until about 1850.

Parsee (*pārsī, fārsī*) Descendants of the emigrants of Persian stock retaining their Zoroastrian religion who settled in India.

Pawn (*pān*) Leaves of the piper-betel plant which are wrapped around areca nuts and lime, and chewed.

Peon Footman, orderly or messenger. Often used in the south for an orderly in contrast to the north where the term *chaprāsī* would be used. From the Portuguese, *peao*.

Pitarrah (*pitārā*) Travelling boxes used for clothes and carried on a banghy.

Poligar (*pālaikkāran*) Term peculiar to the Madras Presidency. Subordinate feudal chiefs occupying wild tracts.

Pundit (*pandit*) Hindu learned man.

Punkah (*pankhā*) Portable fan or a swinging fan of cloth stretched on a rectangular frame suspended from the ceiling.

Rissaldar (*risāldār*) Indian Officer commanding a troop of horse.

Rut (*rath*) Chariot; at times applied to a four wheeled carriage drawn by a pony or oxen and used by women on a journey. Also applied to the car on which images are carried on festival days.

Sepoy (*sipāhī*) Indian soldier disciplined and dressed in European style.

Serang (*sarhang*) Boatswain, skipper of a small vessel.

Sicleegur (*siklīgar*) Furbisher of arms.

Sirdar (*sardār*) Leader, hence the head of a set of palanquin bearers, or a valet in charge of a master's clothes, his ready money or household furniture. Often of the *Kahār* or palanquin-bearer caste.

Appendix I

Sirkar (*sarkār*)	Superintendent, broker or house-steward who keeps accounts of household expenditure and makes purchases.
Soontah-burdar (*suntābardār*)	Bearer of a silver-stick, usually a curved club, shorter than the mace carried by a *chobdār*.
Soubadar (*sūbadār*)	a. Governor of a province. b. Under the British, chief Indian officer of a company of sepoys.
Sawar, sowar (*sawār*)	Horseman, cavalryman.
Sunnassie (*sanyāsī*)	Hindu religious mendicant.
Suttee (*satī*)	Rite of widow-burning.
Suwarree, swary (*sawārī*)	Cavalcade, or transport equipage.
Swamy (*suāmin*)	Corruption of the Sanskrit word for 'Lord', used especially in South India for Hindu gods, in particular for Shiva or Subrahmanya.
Syce (*sāīs*)	Groom, horse-keeper.
Tazeea (*ta'ziyah*)	Representation of the tombs of Hasan and Husain used during the Muharram festival.
Toddy (*tārī*)	Palm-wine, the fermented sap of the palmyra palm.
Tonjon, tomjohn (*tonjaun*)	A portable chair shaped like a curricle, carried by a single pole and four bearers.
Zemindar (*zamīndār*)	Landlord.
Zenāna (*zanāna*)	The female apartments of a house.

Appendix II

Notes on principal buildings in Agra, Delhi, Fatehpur Sikri and Sikandra depicted in Company paintings.

NOTE: For purposes of identification, references are given to examples in the India Office Library's collection and to illustrations in the following books:

Brown, P. *Indian architecture: the Islamic period* (Bombay, 1942).
Burn, R. (ed.) *The Cambridge history of India, vol. iv: the Mughal period* (Cambridge, 1939).
Hambly, G. *Cities of Mughal India: Delhi, Agra and Fatehpur Sikri* (London, 1968).
Spear, P. *Twilight of the Mughuls* (Cambridge, 1951).

For further books on these monuments see:

Fanshawe, H. C. *Delhi past and present* (London, 1902).
Hearn, G. R. *The Seven cities of Delhi* (London, 1906).
Hurlimann, M. *Delhi, Agra, Fatehpur Sikri* (London, 1965).
Keene, H. G. (ed. Duncan, E. A.) *Keene's handbook for visitors to Delhi re-written and brought up to date by E. A. Duncan* (6th edition, Calcutta, 1906).
Page, J. A. (ed.) *List of Muhammedan and Hindu monuments, Delhi Province*, 4 vols. (Archaeological Survey, Northern circle, Delhi Province, 1913).
Sharma, Y. D. *Delhi and its neighbourhood* (Delhi, 1964).
Wheeler, M. (ed.) *Splendours of the east* (London, 1965).

AGRA (AKBARABAD)

CHINA TOMB
Half a mile north of I'timad-ud-daula's mausoleum. Built by Afzal Khan (died 1639) during his lifetime. Its name derives from the coloured tile-work which decorates the exterior. *Add. Or. 2662*

FORT
The walls, gates and buildings in the s.e. corner date from the reign of Akbar (1556–1605), but most of the buildings were erected by Shah Jahan (1628–57), using the marble so typical of his reign.

General panoramic view from the Jumna. This can be distinguished from the similar view of Delhi Fort by the two pavilions with curved golden roofs to the left and the three domes of the Pearl Mosque to the right. *Add. Or. 929*

Amar Singh's Gate. Southern entrance. Crenellated top. Richly decorated with coloured tile work. *Add. Or. 931*

Delhi Gate. The main entrance on the west, probably completed in 1566. Flanked by two sturdy octagonal towers, inlaid with white marble, and surmounted with open kiosks. Crenellations across the top. *Add. Or. 1798*
Illustrated: Cambridge History, figure 18.

Diwan-i-Am. Hall of Public Audience. Built 1627. Single storeyed, flat roof and three aisles of nine bays with engrailed arches and double pillars on the facade.
Illustrated: Brown, plate LXXXIX (2).

Diwan-i-Khas. Hall of Private Audience. Built *c.* 1637. Single storeyed, flat roof. Three aisles of five bays with graceful double columns of marble inlaid with flowers. Enclosed rooms at the back.
Illustrated: Brown, plate LXXXIX (1).

Khas Mahal. Private Apartments (exterior). Built *c.* 1637. Similar in design to the Diwan-i-Khas at Delhi with three aisles of five bays and flat pillars but only two open kiosks one at either rear side of the roof. Pavilions with curved golden roofs on either side. *Add. Or. 5641*
Illustrated: Hambly, plate 92; Cambridge History, figure 60.

Khas Mahal. Private Apartments (interior). Walls covered with rich inlay work. *Add. Or. 1797, plate 65*

Moti Masjid. Pearl Mosque. Built 1654. White marble with three domes and three aisles of seven bays opening on to a courtyard. *Add. Or. 932*
Illustrated: Cambridge History, figure 64.

ITIMAD-UD-DAULA'S MAUSOLEUM
Built in 1622 to 1628 by Nur Jahan, wife of Jahangir, for her father, the Persian Mirza Ghiyas Beg entitled Itimad-ud-daula (Support of the State).
Exterior view. Central portion with curved Bengali roof, a small kiosk either side and corner turrets with open kiosks. Deep eaves. *Add. Or. 1752, plate 63*
Interior view. Domed chamber richly decorated with pietra dura work. The most colourful subject in Company architectural drawings. *Add. Or. 562, plate 64*

JAMI MASJID
Built 1648. Distinguishable from the Delhi Jami Masjid by the absence of minarets and smaller domes covered with marble zig-zag patterns on red stone. *Add. Or. 306*
Illustrated: Brown plate LXXXVI (1); Cambridge History, figure 79; Hambly, plate 84.

TAJ MAHAL

'Crown of the Palace'. The mausoleum built by Shah Jahan (*c.* 1632–53) for his favourite wife, Arjumand Banu, entitled Mumtaz Mahal ('Chosen of the Palace'). She was the daughter of Asaf Khan, brother of Nur Jahan, the wife of Jahangir, and died in childbirth 1631. Shah Jahan (died 1666) was later buried in the same mausoleum.

General view from the river showing the raised terrace, with the mausoleum in the centre, the three-domed mosque on the right and the identical assembly hall (*jawāb* or 'echo') on the left. *Add. Or. 921*
Illustrated Hambly, plate 58, Brown plate LXXXVI (2).

General view from the garden showing the water-garden in the foreground, the raised terrace with the mausoleum in the centre, the mosque on the left and the assembly hall on the right. *Add. Or. 567*
Illustrated: Cambridge History, figure 84.

View from various angles. *Add. Or. 922, plate 62*

Entrance gateway. Four octagonal corner turrets with open kiosks; eleven small kiosks across the central archway. *Add. Or. 1762*
Illustrated: Hambly, plate 71, Cambridge History, figure 81.

Octagonal tomb chamber containing the cenotaphs surrounded by a marble screen.
 Add. Or. 953

Screen made of perforated marble slabs joined by marble uprights inlaid with pietra dura decorations. Also details. *Add. Or. 1772, 1760*
Illustrated: Hambly, plate 70.

The two cenotaphs. The empress's has a flat top; the emperor's has the addition of a small central marble slab. *Add. Or. 1793, 1794*
Illustrated: Cambridge History, figure 85.

Details of the carved marble panels and pietra dura work on the walls of the tomb chamber. Also of the pietra dura work and inscriptions on the cenotaphs.
 Add. Or. 1769, 1770, 1773–1778

DELHI (SHAHJAHANABAD)

THE RED FORT
Built by Shah Jahan, 1639–48.

General panoramic view from the Jumna. This can be distinguished from the similar view of Agra Fort by the smaller domes of the Pearl Mosque to the right and the domed Musamman Burj projecting from the centre of the wall on the river face.
 Add. Or. 540

Delhi Gate. At s.w. corner of the Fort. Similar in design to the Lahore Gate but two short minarets on either side of the archway which scarcely rise above the small kiosks. *Add. Or. 324*

Diwan-i-Am. Hall of Public Audience. Flat roof with two open kiosks. Three aisles of nine bays with engrailed arches on pillars, with double pillars on the outer faces. *MSS.Eur.D.512.1 f.40v*
Illustrated: Cambridge History, figure 69.

Diwan-i-Am. Hall of Public Audience (throne) An alcove at the back contains a marble canopy which covered the Emperor's throne, with a marble seat for the Wazir below it.
Illustrated: Brown, plate LXXVII (2); Cambridge History, figure 68.

Diwan-i-Khas. Hall of Private Audience (exterior). Similar in design to the Khas Mahal at Agra Fort. Single-storeyed, flat roof with an open kiosk on each of the four corners. In front three aisles of five engrailed arches supported by flat marble piers inlaid with flowers. Contains the famous inscription 'If there is a paradise on earth, it is here, it is here, it is here'. *MSS.Eur.D.512.1 f.40*
Illustrated: Hambly, plates 86, 124; Brown, plate LXXXII (1).

Diwan-i-Khas. Hall of Private Audience (interior). Pillared chamber richly inlaid with flowers.
Illustrated: Cambridge History, figure 71.

Khas Mahal. Private Apartments. Tasbih-Khana ('The Chamber for telling beads'). Marble screen decorated with Scales of Justice.
Illustrated: Brown, plate LXXVIII (2).

Lahore Gate. Main entrance to the Red Fort in the centre of the west side flanked by half-octagon towers crowned with open octagonal kiosks. Two tall minarets on either side of the archway which has a row of seven small marble-domed kiosks along the top. *Add. Or. 322*
Illustrated: Hambly, plate 87, 127; Brown, plate LXVII (2)

Moti Masjid. Pearl Mosque. A small mosque surmounted by three small bulbous domes formerly copper-plated.
Illustrated: Hambly, plate 88, Cambridge History, figure 73.

FIRUZ SHAH KOTLA
Citadel of fifth city of Delhi, Firuzabad. Built by Firuz Shah Tughluq (1351–88). Ramparts, gates, Jami Masjid and Asokan column. *Add. Or. 552*

HINDU RAO'S HOUSE
Probably built by Sir Edward Colebrooke, *c.* 1828, and occupied by William Fraser from 1829–30. Sold to Hindu Rao in 1835. Scene of fighting in the Mutiny. *MSS.Eur.D.512.1 f.39*

HUMAYUN'S MAUSOLEUM
South of Delhi. Built, *c.* 1565. One of the first examples of a garden-mausoleum with a central domed chamber, monumental entrance gates and four corner pavilions. Red sandstone. *Add. Or. 1809, plate 66*

JAMI MASJID

Built by Shah Jahan, *c.* 1650–56.

Prayer Hall. This has lofty minarets, three domes ornamented with black and white stripes and eleven arches on the facade. *Add. Or. 1806*

Illustrated: Hambly, plate 85; Brown, plate LXXXIV (2).

Interior of prayer hall. *MSS.Eur.D.512.1 f.41*

Main entrance gateway. Above a flight of steps. Minarets at corners and a line of nineteen small kiosks across the facade.

Illustrated: Hambly, plate 121.

KASHMIR GATE

Scene of desperate fighting during the mutiny. *MSS.Eur.D.512.1 f.37*

METCALFE HOUSE

Built on the banks of the Jumna, *c.* 1830, by Sir Thomas Metcalfe, Resident at the Mughal Court. Flat roofed bungalow with long colonnaded verandah and curved portico.

Illustrated: Spear, plate II.

NIZAM-UD-DIN AULIA

Tomb complex. The present tomb of the saint (died 1325) was built 1562–63, but many other buildings are sited within the walled enclosure, including the mausoleum of Atga Khan (illustrated Cambridge History, figure 13) and the Chaunsath Khambe containing the grave of his son, Azam Khan Kokah. *Add. Or. 2663*

QUDSIYA BAGH

Built *c.* 1749 by Qudsiya Begam, mistress of Muhammad Shah, on the banks of the Jumna, north of the Kashmir Gate. The palace and other buildings have disappeared leaving only the western gateway. *Add. Or. 533, plate 61*

QUTB MINAR, LALKOT

Minaret (built 1199) of Kutb Mosque (Qūwat al-Islam) begun by Qutb al-din Aibak 1193–1210 and added to by his successor, Iltutmish. Eleven miles south of Delhi. *Add. Or. 1807*

Illustrated: Hambly, plate 3; Brown, plate V.

Dilkusha, the country house of Sir Thomas Metcalfe converted from the domed mausoleum of Muhammed Kuli Khan, near the Qutb Minar. This is sometimes included in pictures of the Qutb Minar.

Illustrated: Spear, plate III.

RESIDENCY

Near the Kashmir Gate. Flat roofed bungalow with long colonnaded verandah and portico.

Illustrated: Spear, plate II.

SAFDAR JANG'S MAUSOLEUM
Safdar Jang (died 1754), Viceroy of Oudh. His mausoleum was built in 1753–54 by his son, Shuja-ud-daula. Double-storyed mausoleum in red and buff stone in a walled garden. *Add. Or. 1810, plate 67*

ST JAMES'S CHURCH
Raised by Colonel James Skinner, consecrated 1836, designed and partially built by Captain Robert Smith, Bengal Engineers. *MSS.Eur.D.512.1 f.37v*
Illustrated: Hambly, figure 25, p. 159.

ZINAT UL-MASAJID
'Ornament of Mosques'; Daryaganj in the east (river) quarter. Built by Aurangzeb's second daughter, Zinat al-Nisa, *c.* 1711. It has three domes and seven arches and is flanked by tall minarets. The domes are faced with alternating stripes of black and white marble. *Add. Or. 550*

FATEHPUR SIKRI

BULAND DARWAZA
'High Gate'. Exterior facade of gateway to the Mosque with a great half-dome forming the portico above a flight of steps. Three large and thirteen small kiosks surmounting the portico. Built 1575–76. *Add. Or. 935*
Illustrated: Hambly, plate 36; Brown, plate LXXIV (1).

MAUSOLEUM OF SHAIKH SALIM CHISHTI
Mausoleum of the saint who foretold the birth of Akbar's son, Salim (Jahangir). White marble with low dome, perforated screens and deep eaves supported by serpentine brackets. Built in 1572, but transformed with marble at the end of Jahangir's reign or at the beginning of Shah Jahan's. *Add. Or. 936*
Illustrated: Brown, plate LXXVI (2).

SIKANDRA, NEAR AGRA

AKBAR'S MAUSOLEUM
Completed by Jahangir 1613.
Entrance gatehouse with four white marble-faced minarets at each corner and four small open kiosks over central arch. *Add. Or. 933*
Illustrated: Hambly, plate 33.
Mausoleum. Pyramidal building of three storeys with terrace ornamented with pavilions. *Add. Or. 1784, plate 60*
Upper terrace and cenotaph. Unroofed terrace surrounded by arcaded cloisters squared floor and white marble cenotaph. *Add. Or. 1755v*
Illustrated: Cambridge History, figure 52.
Details of cenotaph *Add. Or. 1795*

Concordances

I. Additional Oriental Numbers and Catalogue Numbers

Add. Or. Number	Catalogue Number	Add. Or. Number	Catalogue Number
1, 2	170	429–440	113
15–19	68	441–464	114
29	69	465–475	115
32–38	11	476	118
39–70	14	478–481	62
71–170	98	486	186
171–187	61	487–489	60
188–209	8	490	52
211–304	172	491–525	6
305	155	526–534	67
306	158	535–537	54
307–319	156	538	166
320, 321	158	539, 540	136
322	159	541–546	147
323, 324	158	547–557	143
325	159	558–560	140
326	156	561	149
327	158	562–564	141
328	155	565	138
329, 330	154	566	141
331	150	567	139
332, 333	151	568	43
334–339	152	572–581	63
340	145	582	115
341	146	583	110
344–347	123	584–586	42
359–393	109	587–591	108
394–399	74	592–605	19
400–404	110	606–613	117
405–416	111	614–655	20
417–428	112	656–679	21

Add. Or. Number	Catalogue Number	Add. Or. Number	Catalogue Number
680–706	10	1193–1202	50
739	129	1203	48
740	4	1204	50
741, 742	128	1205	49
743	223	1206, 1207	48
744	58	1208–1210	50
745	40	1211–1213	48
746, 747	183	1214	49
748	200	1215–1220	48
749	57	1221	49
754	167	1222	48
755	37	1223, 1224	49
756–764	32	1225	50
765–812	100	1226, 1227	48
887	161	1228	49
888	168	1229	48
921–936	131	1230	46
937–944	65	1231, 1232	49
949	55	1233	50
950, 951	35	1234	47
952	77	1235	45
953, 954	137	1243–1283	169
955	78	1284–1333	124
956–958	90	1334–1346	34
959–988	31	1347–1396	181
989	16	1397–1451	184
990	148	1452–1511	185
991	153	1512–1583	198
992	72	1584–1621	199
993–1008	51	1622–1659	13
1009–1030	38	1660–1745	195
1098–1126	47	1746–1761	135
1127–1130	45	1762–1789	133
1131–1146	44	1791–1810	142
1147–1174	46	1815	122
1175–1182	48	1816–1835	84
1183	50	1836	75
1184	48	1837	80
1185	49	1838–1840	81
1186–1192	48	1841, 1842	88

Add. Or. Number	Catalogue Number	Add. Or. Number	Catalogue Number
1843–1851	79	2409	177
1852	70	2411–2414	22
1853, 1854	87	2415–2424	23
1855	89	2425–2439	24
1856	70	2440–2442	25
1857	96	2443–2474	26
1898–1904	15	2475–2489	27
1909, 1910	132	2490	28
1948, 1949	3	2491–2498	29
1950–1956	7	2499–2513	30
1962	134	2514–2525	56
1963	196	2526–2536	9
1964–1966	121	2537	91
1967–2007	206	2538, 2539	175
2008–2047	207	2540	125
2048–2083	208	2545	86
2084–2106	212	2546	97
2107–2126	209	2547–2549	82
2127, 2128	214	2550	83
2129–2138	211	2551, 2552	187
2139–2162	213	2553	59
2163–2186	210	2554–2556	1
2187–2196	214	2557	92
2197–2313	215	2594	12
2314–2316	216	2595	41
2317–2332	215	2598	173
2333–2342	217	2599	127
2343–2352	218	2600	41
2353–2362	219	2603	180
2363–2372	220	2604–2606	66
2373, 2374	99	2607	179
2375	102	2608	222
2376, 2377	101	2609	176
2378	104	2610–2614	204
2379	105	2615	203
2380	103	2616	178
2381–2389	76	2617–2639	73
2390–2393	85	2640–2647	190
2394, 2395	92	2648–2656	191
2396	205	2657, 2658	119

Add. Or. Number	Catalogue Number	Add. Or. Number	Catalogue Number
2659	120	3059–3068	193
2660, 2661	93	3069–3078	194
2662	160	3079	171
2663	144	3080–3099	192
2664, 2665	165	3100	162
2666, 2667	106	3101–3113	174
2668–2671	17	3116	163
2672	107	3118	126
2674–2743	39	3119–3125	143
3005	182	3127	202
3006–3011	18	3130–3139	64

II. Revised Foster Catalogue, Additional Oriental, and Catalogue Numbers

NOTE: For many years 'Add. Or.' drawings, when framed for office use (together with oil paintings, sculptures, 'Western Drawings', prints and photographs), were given separate numbers for purposes of identification. Five-hundred-and-ninety-one items were so enumerated by Sir William Foster when listing the contents of the old India Office (see W. Foster, *A Descriptive catalogue of the paintings, statues, etc., in the India Office*, 5th edition, London, 1924). This sequence of numbers has been continued since his time and is incorporated in a revised Foster catalogue which is maintained in manuscript in the Library.

Revised Foster Catalogue Number	Add. Or. Number	Catalogue Number
80	3059–3068	193
81	3069–3078	194
104	3079	171
105	3080–3099	192
123	3100	162
124	3101–3113	174
223A	3127	202
630	3116	163
683	3118	126
741–747	3119–3125	143

Concordances

III. European Manuscript Numbers and Catalogue Numbers

Manuscript Number	Catalogue Number
MSS.Eur.C.14	71
MSS.Eur.C.116. 1,2	94
MSS.Eur.C.215. 1,2	95
MSS.Eur.D.152	33
MSS.Eur.D.512. 1,2	116
MSS.Eur.D.512. 1	164
MSS.Eur.G.45. 6	221

IV. India Office Albums and Catalogue Numbers

Album Number	Catalogue Number
43, nos. 4517–4521	36
48, nos. 4758; 4759	197
49, nos. 4782–4785	188
52, nos. 4900; 4902	189
52, nos. 4896; 4899; 4904; 4972	201
53, nos. 5036–5045	197
58, nos. 5344–5347	53
59, no. 5431	5
59, no. 5435	130

V. Johnson Collection Album Number and Catalogue Number

Johnson Number	Catalogue Number
Album 63, ff. 1–8	2

VI. Oriental Manuscript Number and Catalogue Number

Oriental MSS Number	Catalogue Number
Persian MSS., I.O. 2450	157

Indexes

I ARTISTS

II MONUMENTS AND BUILDINGS

III TRADES AND OCCUPATIONS

IV GENERAL

PLATES

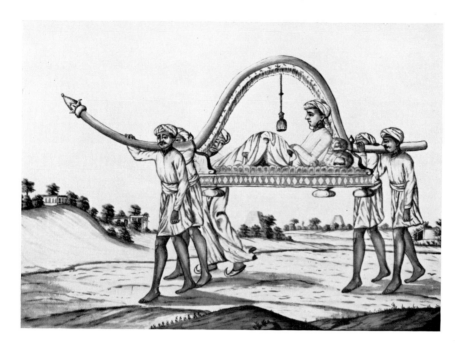

1 Palanquin. Madras, *c.* 1787
2 Irrigation. Madras, *c.* 1787

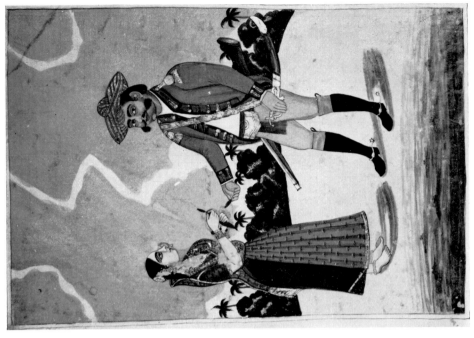

4 Subadar of the Madras Native Infantry and his wife. Tanjore, c. 1800

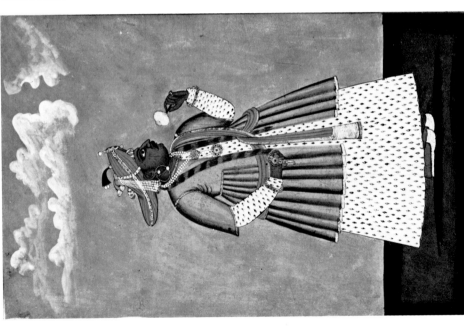

3 Amar Singh, Raja of Tanjore (1787–98). Tanjore, 1797

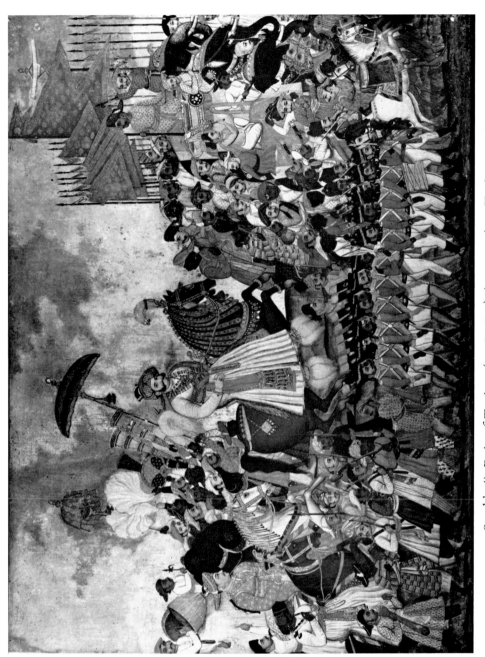

5 Sarabhoji, Raja of Tanjore (1798–1832), in procession. Tanjore, c. 1820

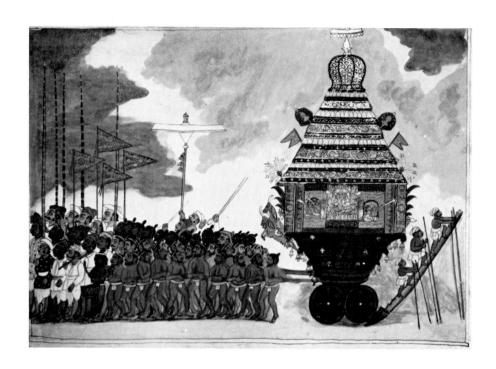

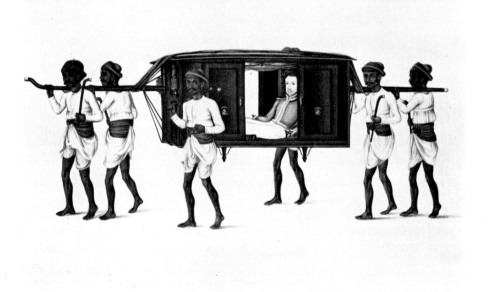

6 Temple Car. Tanjore, *c.* 1800

7 Palanquin with British Officer. By a Tanjore artist working in
Vellore, *c.* 1828

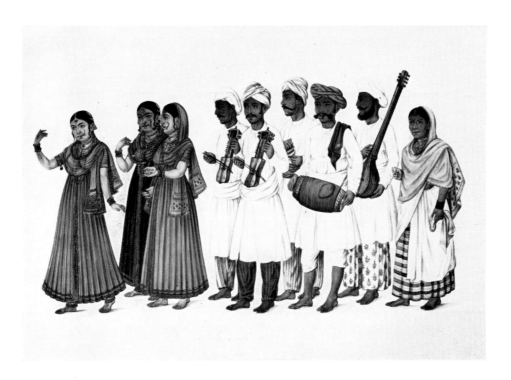

8 Dancing-girls and musicians. By a Tanjore artist working in Vellore,
c. 1828

9 Court scene. Mica painting. Trichinopoly, *c*. 1850

11 Bird-catchers. Mica painting. Trichinopoly, *c.* 1850

10 Mannatha, the God of Love. Mica painting. Trichinopoly, *c.* 1850

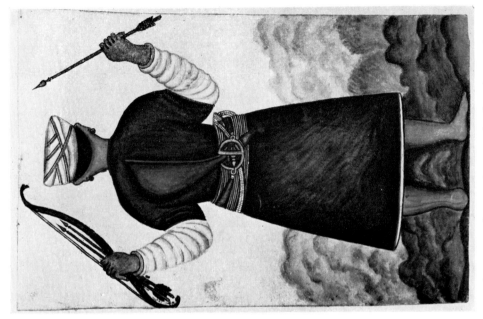

13 A man from Coorg, back view. Coorg, c. 1850

12 A man from Coorg, front view. Coorg, c. 1850

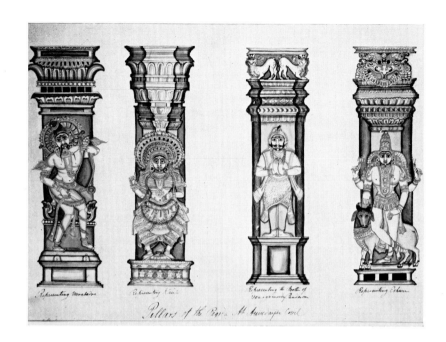

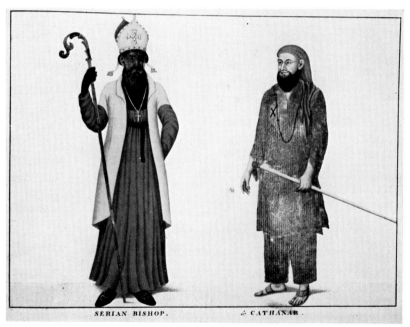

14 Carved pillars on the temple at Avutaiyar Kovil, near Tanjore. Tanjore, 1803

15 Bishop and priest of the Syrian Church. Malabar, *c.* 1828

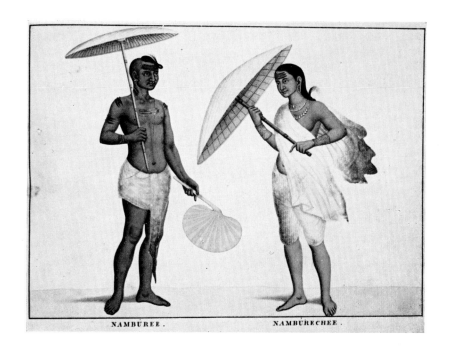

NAMBŪREE. NAMBŪRECHEE.

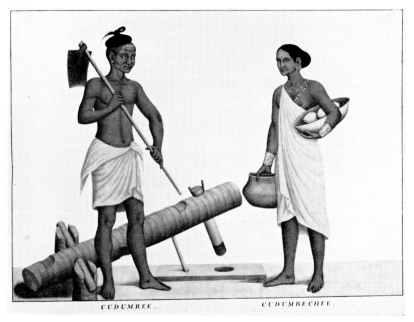

CUDUMBEE. CUDUMBECHEE.

16 Kerala Brahmin and his wife. Malabar, *c.* 1828

17 Man and woman of the rice-pounder caste. Malabar, *c.* 1828

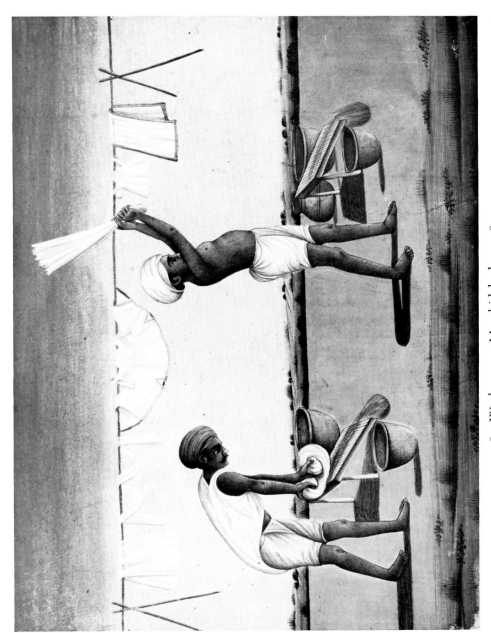

18 Washermen. Murshidabad, c. 1780–90

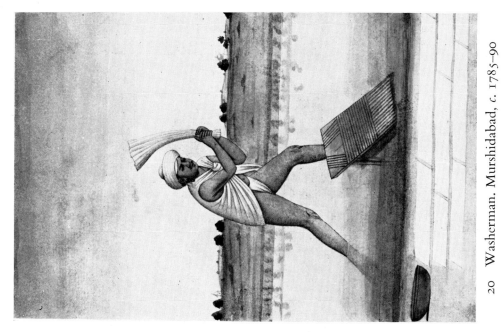

20 Washerman. Murshidabad, *c.* 1785–90

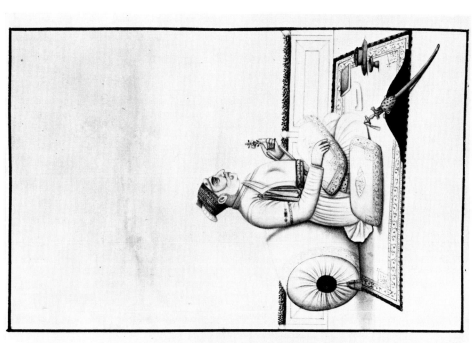

19 Husain Quli Khan, Subadar of Dacca. Murshidabad, *c.* 1785–90

21 Procession scene. Murshidabad, c. 1800

22 Asaf-ud-daula, Nawab of Oudh (1775–97), listening to music. Murshidabad, c. 1812

23 Distant view of the Jami Masjid, Fatehpur Sikri. Calcutta, *c.* 1798–1804

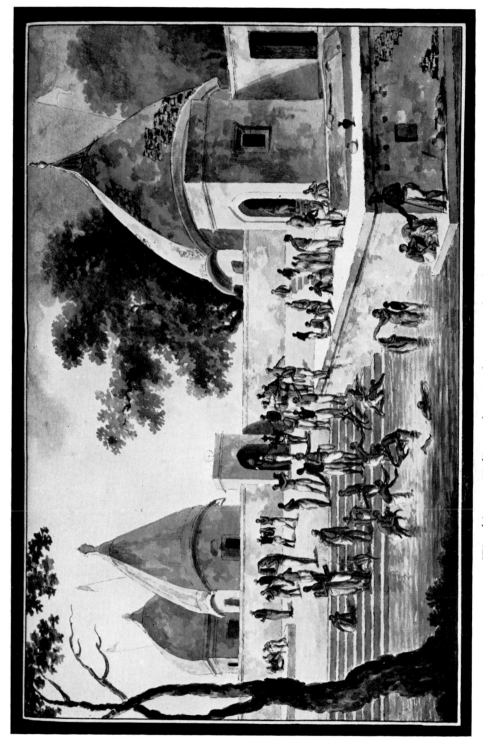

24 Worship at a Kali temple, Titaghar, Bengal. Calcutta, *c.* 1798–1804

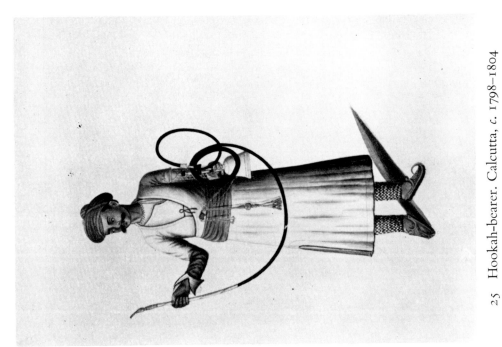

26 Armed retainers. Calcutta, c. 1798–1804

25 Hookah-bearer. Calcutta, c. 1798–1804

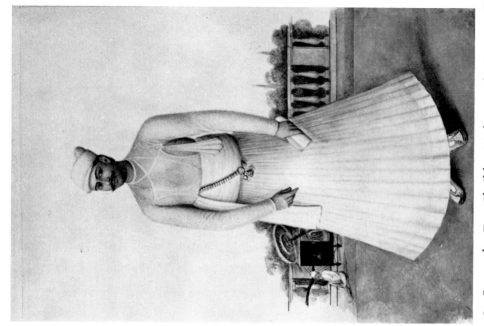

28 Steward. By Shaikh Muhammad Amir of Karraya, Calcutta, *c.* 1846

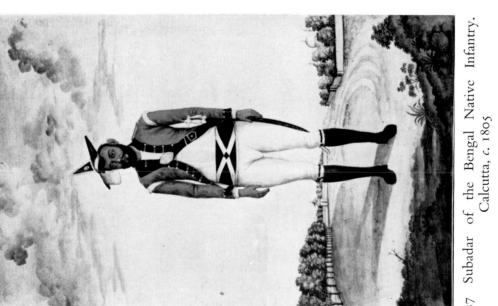

27 Subadar of the Bengal Native Infantry. Calcutta, *c.* 1805

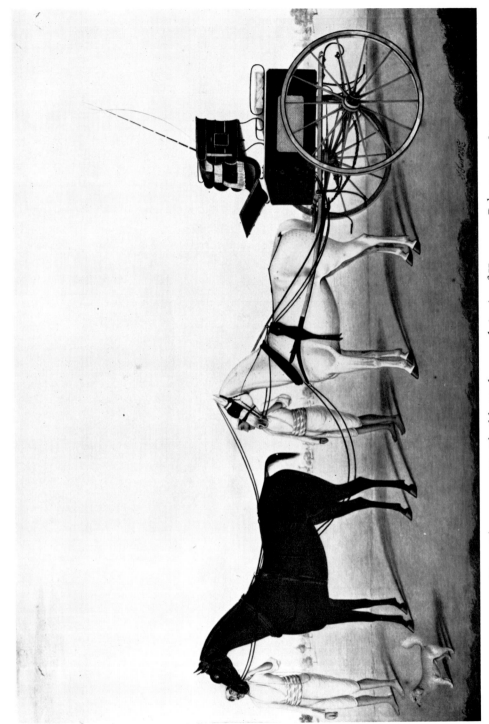

29 Gig with grooms. By Shaikh Muhammad Amir of Karraya, Calcutta, *c.* 1845

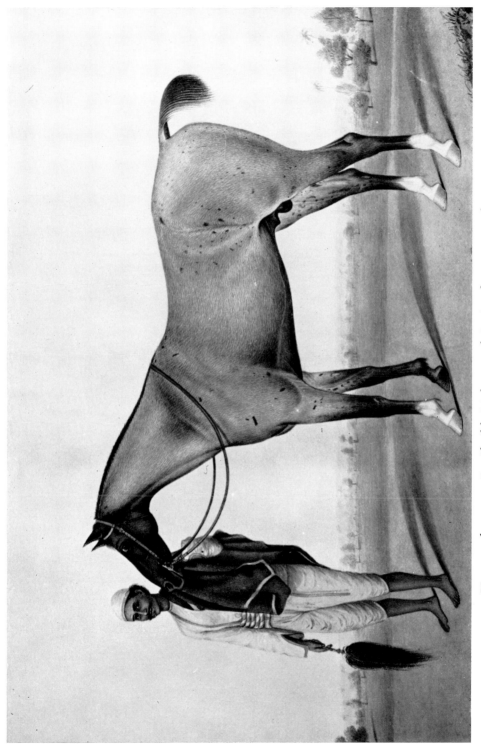

30 Horse and groom. By Shaikh Muhammad Amir of Karraya, Calcutta, c. 1845

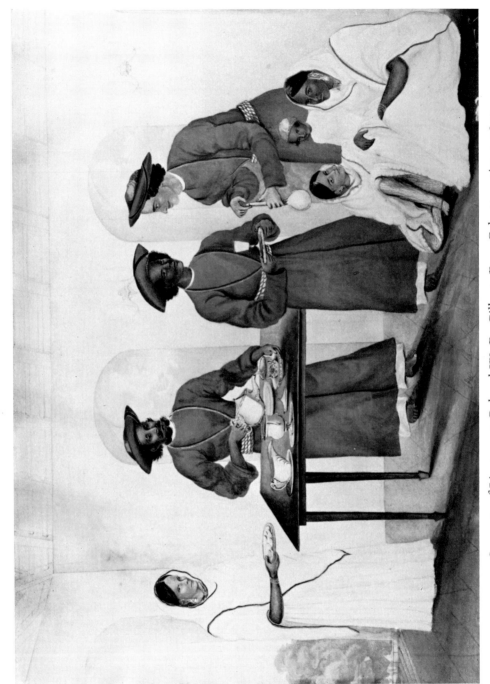

31 Servants of Lieutenant-Colonel W. R. Gilbert. By a Calcutta artist, c. 1825

32 Lieutenant-Colonel W. R. Gilbert's bungalow at Sambalpur (Orissa). By a Calcutta artist, *c.* 1825

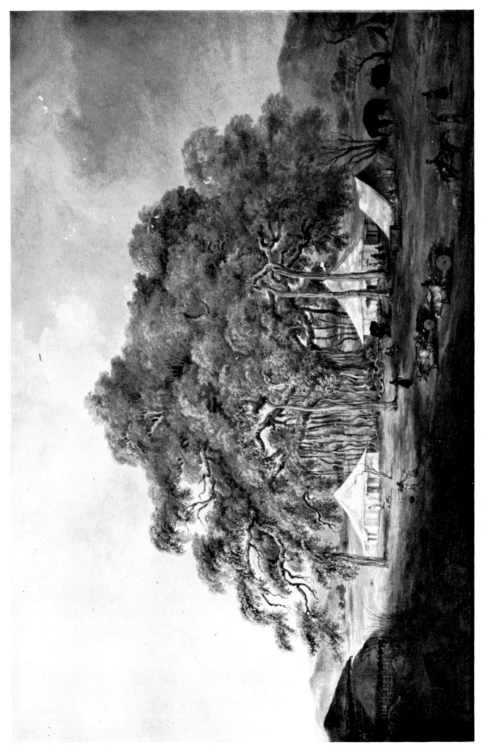

33 Lieutenant-Colonel W. R. Gilbert in camp near Surguja. By a Calcutta artist, *c.* 1825

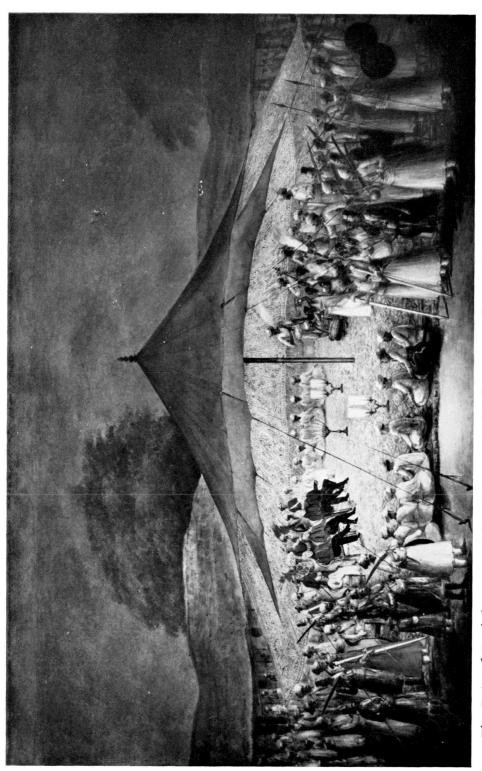

34 The Raja of Sambalpur entertaining Lieutenant-Colonel W. R. Gilbert and his party to a nautch. By a Calcutta artist, *c.* 1825

35 Swinging. Patna, c. 1795–1800

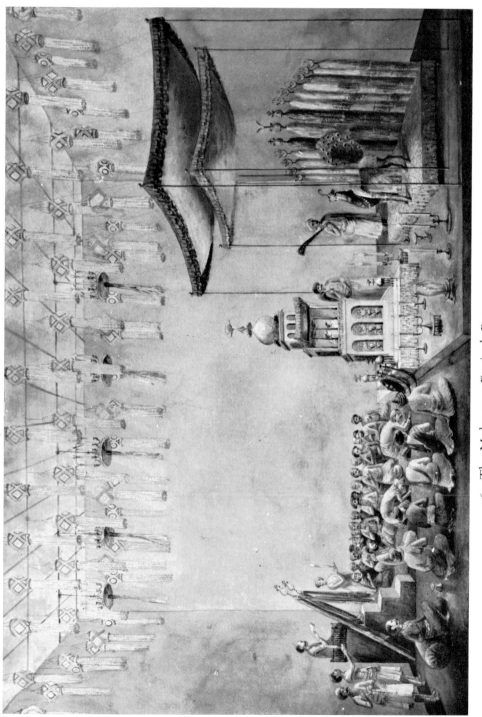

36 The Muharram Festival. Patna, *c.* 1795–1800

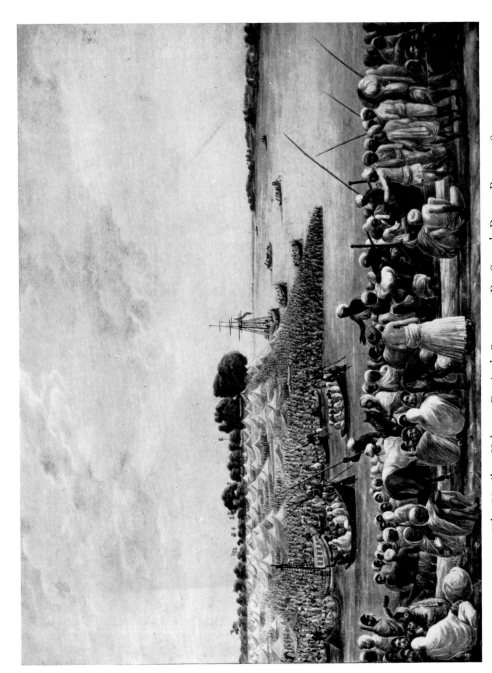

37 The Harihar Kshetra Festival, Sonepur. By Sewak Ram, Patna, 1809

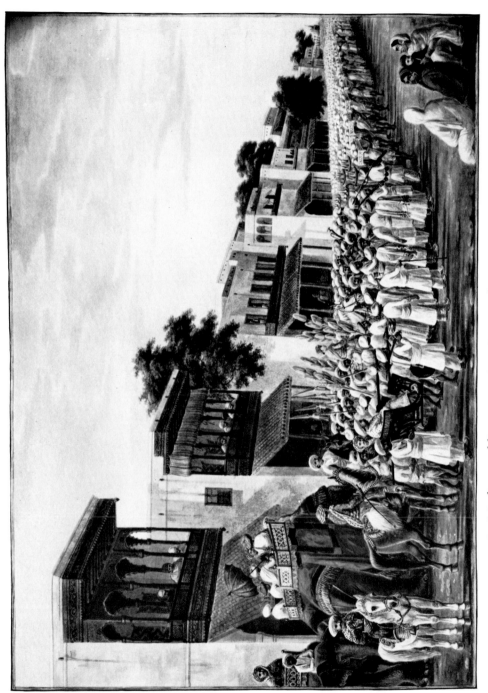

38 Muslim wedding procession. By Sewak Ram, Patna, *c.* 1807

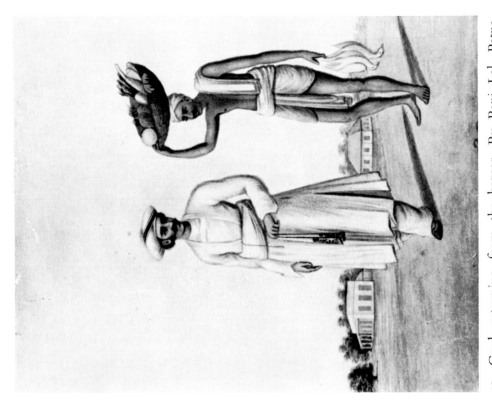

40 Cook returning from the bazaar. By Bani Lal, Patna, c. 1880

39 Man with puppets. By Fakir Chand Lal, Patna, c. 1840

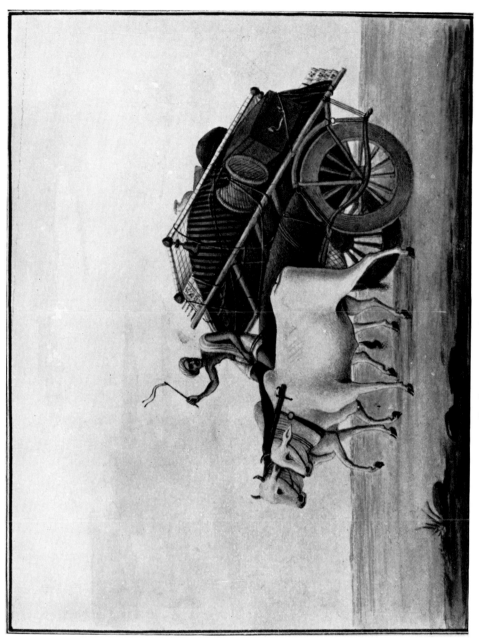

41 Bullock-cart. By Shiva Lal, Patna, c. 1860

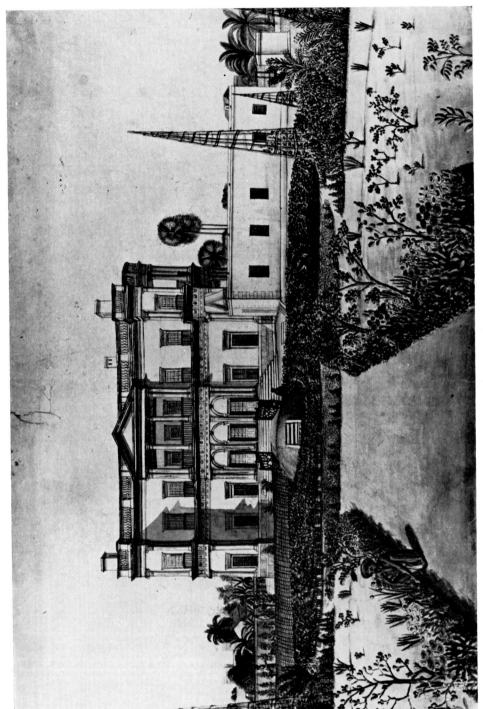

42 European house. Chapra, *c.* 1796

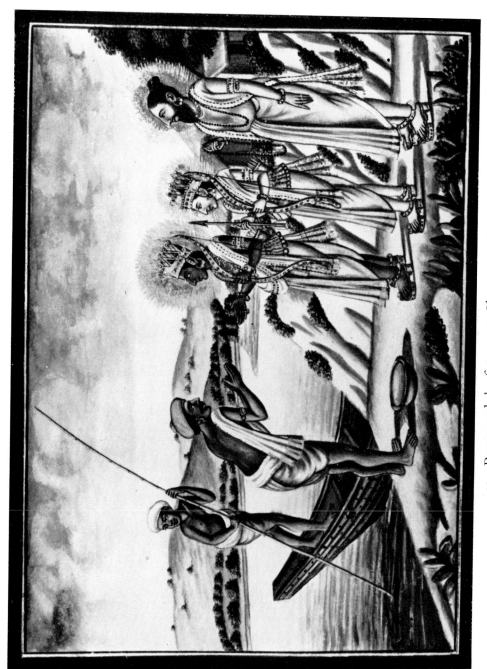

43 Rama and the ferryman. Chapra, c. 1803–04

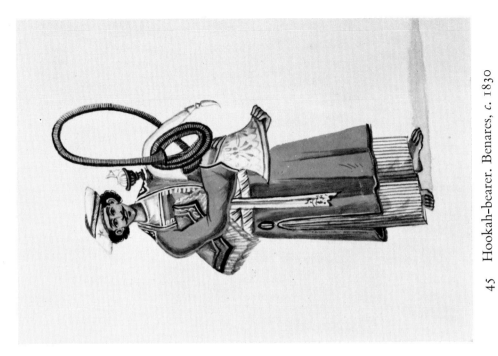

45 Hookah-bearer. Benares, *c.* 1830

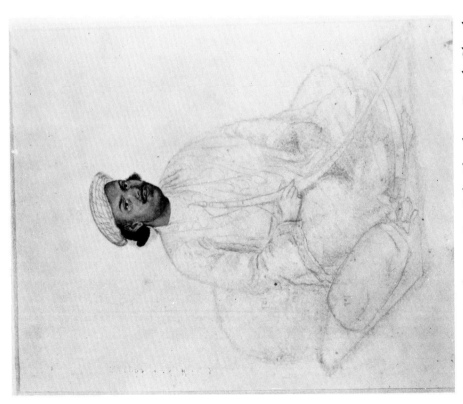

44 Benares gentleman. By Lal Chand or Gopal Chand, Benares, *c.* 1840

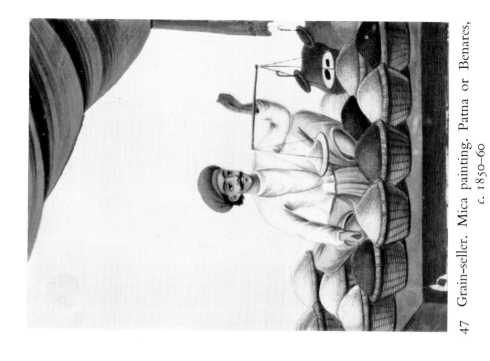

47 Grain-seller. Mica painting. Patna or Benares, c. 1850-60

46 Sweetmeat-seller. Mica painting. Patna or Benares, c. 1850-60

49 Dancing-girl. Lucknow, c. 1780-90

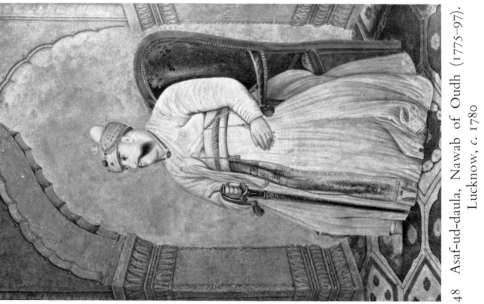

48 Asaf-ud-daula, Nawab of Oudh (1775-97). Lucknow, c. 1780

51 Khansama carrying a tureen. Lucknow, c. 1825–30

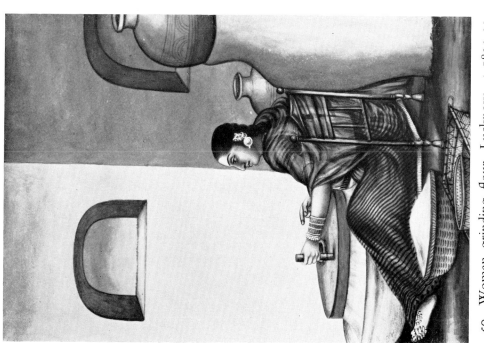

50 Woman grinding flour. Lucknow, c. 1825–30

52 Street scene. Lucknow, *c.* 1800

53 The Holi Festival. Lucknow, *c.* 1800

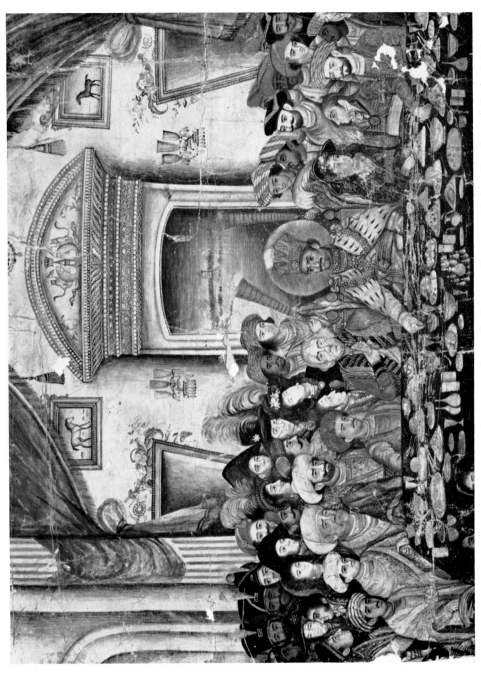

54 Ghazi-ud-din Haidar, Nawab and King of Oudh (1814–27), entertaining Lord and Lady Moira to a banquet. Lucknow, c. 1814

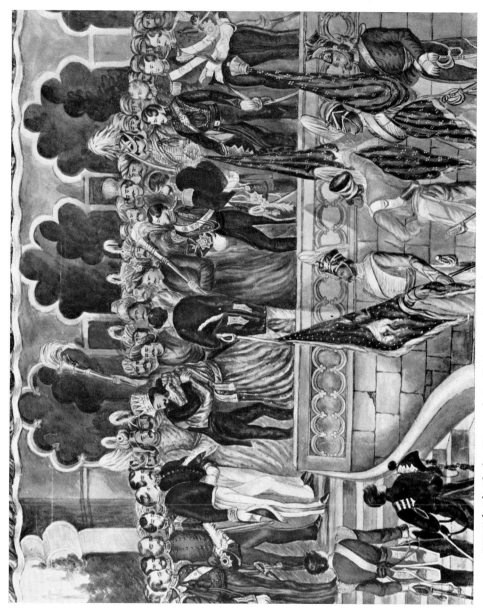

55 Wajid Ali Shah, King of Oudh (1847–56), welcoming Lord Hardinge. Lucknow, 1847

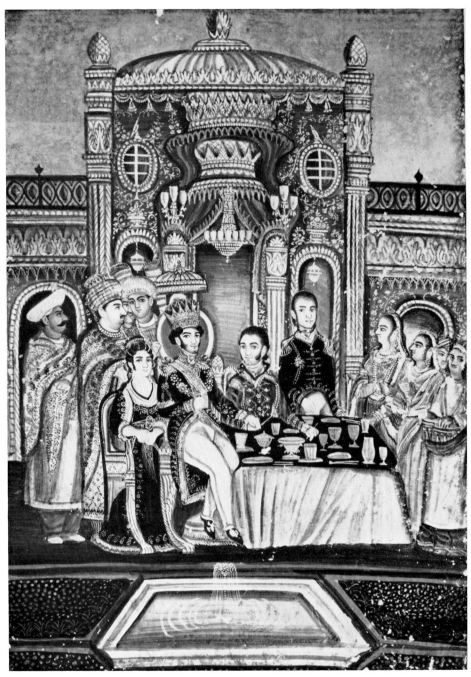

56 Nasir-ud-din Haidar, King of Oudh (1827–37), entertaining British guests.
Lucknow, *c.* 1831

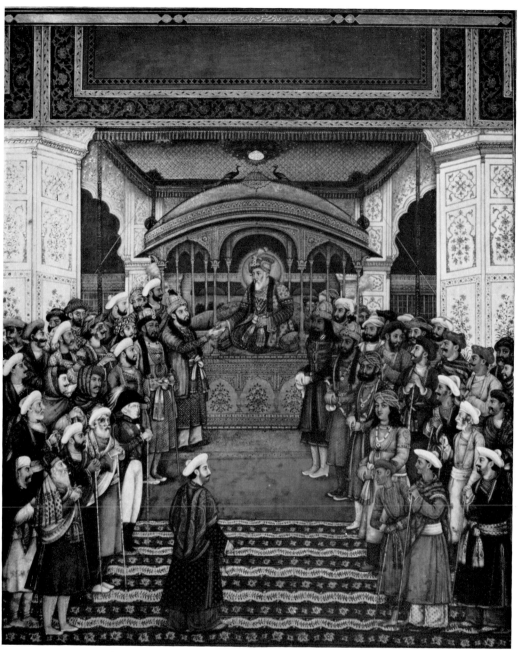

57 Durbar of Akbar II, Emperor of Delhi (1806–37). Delhi, *c.* 1820

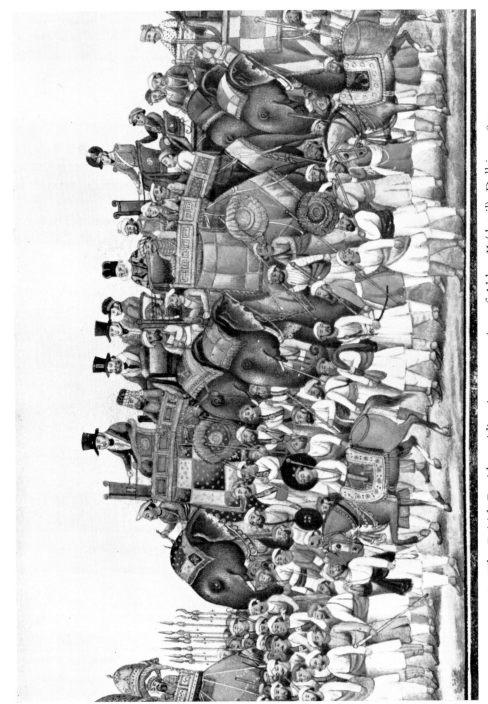

58 The British Resident riding in a procession of Akbar II (detail). Delhi, *c.* 1815

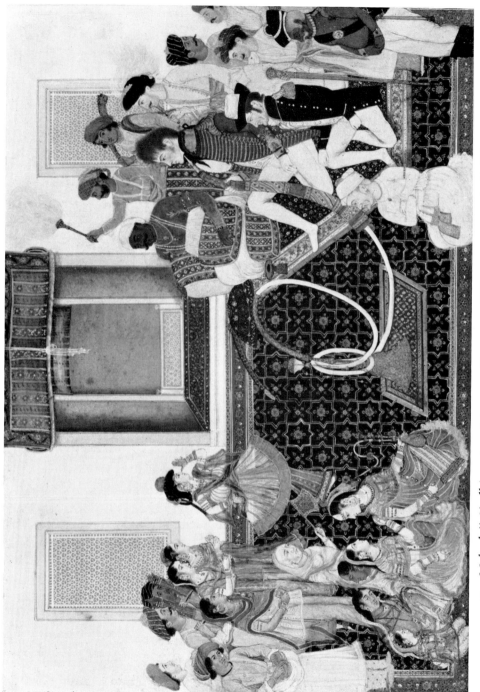

59 Mahadaji Sindhia entertaining two European Officers to a nautch. Delhi, *c.* 1820

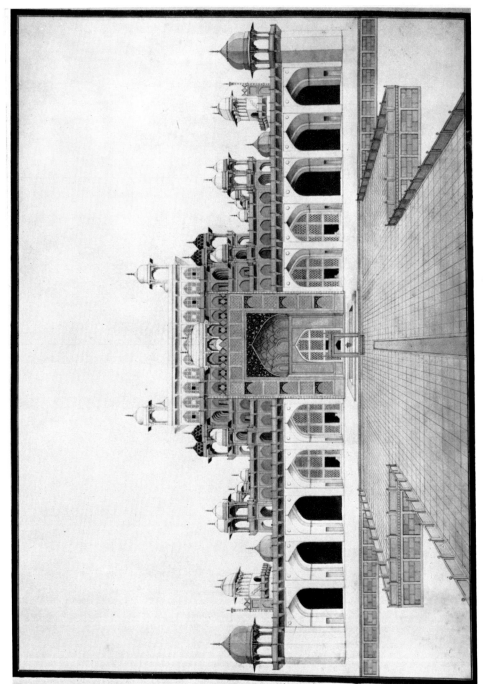

60 Mausoleum of Akbar, Sikandra. Delhi or Agra, c. 1815

61 Qudsiya Bagh, Delhi. Delhi or Agra, c. 1820–25

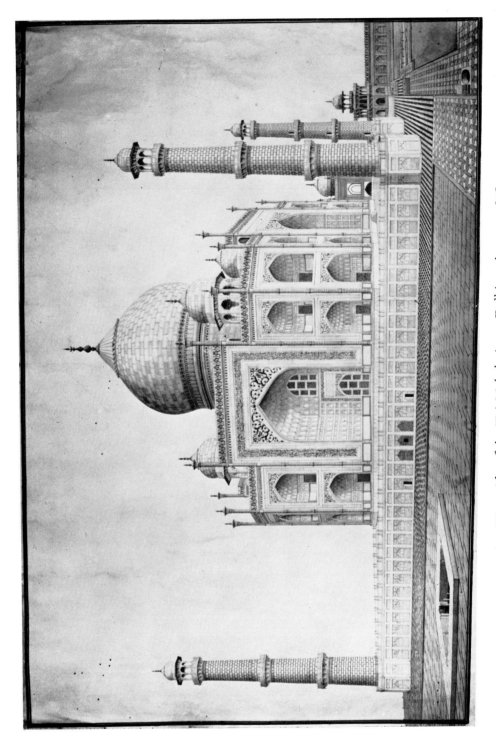

62 West side of the Taj Mahal, Agra. Delhi or Agra, c. 1808

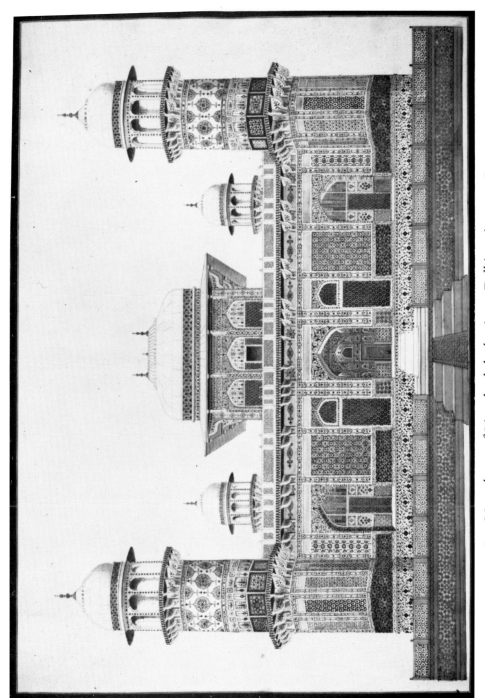

63 Mausoleum of Itimad-ud-daula, Agra. Delhi or Agra, c. 1817

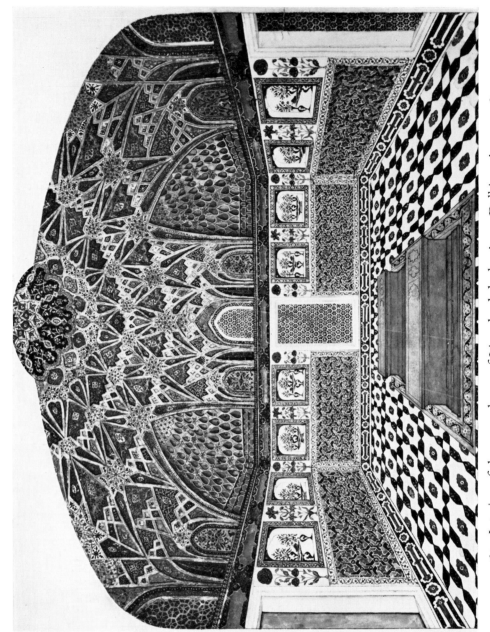

64 Interior of the mausoleum of Itimad-ud-daula, Agra. Delhi or Agra, *c.* 1820

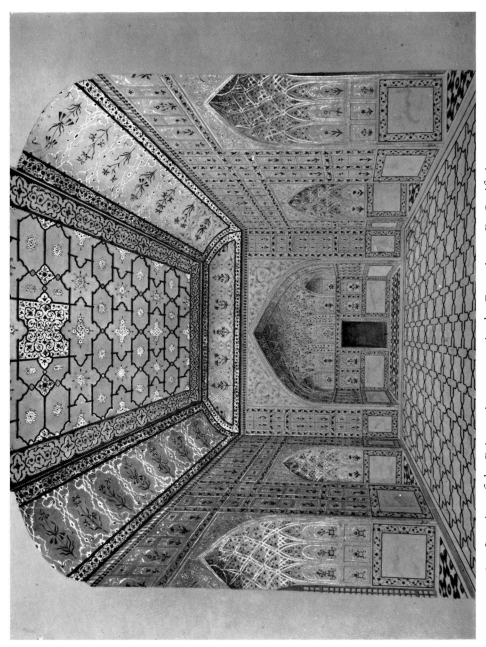

65 Interior of the Private Apartments in the Fort, Agra. By Latif, Agra, *c.* 1820–22

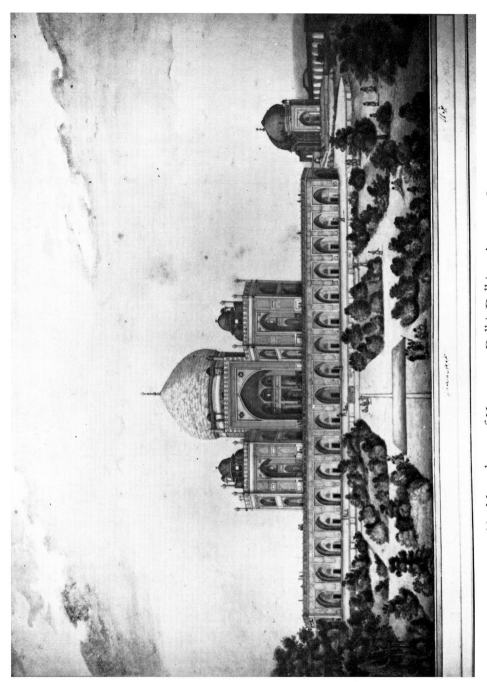

66 Mausoleum of Humayun, Delhi, Delhi or Agra, *c.* 1820–22

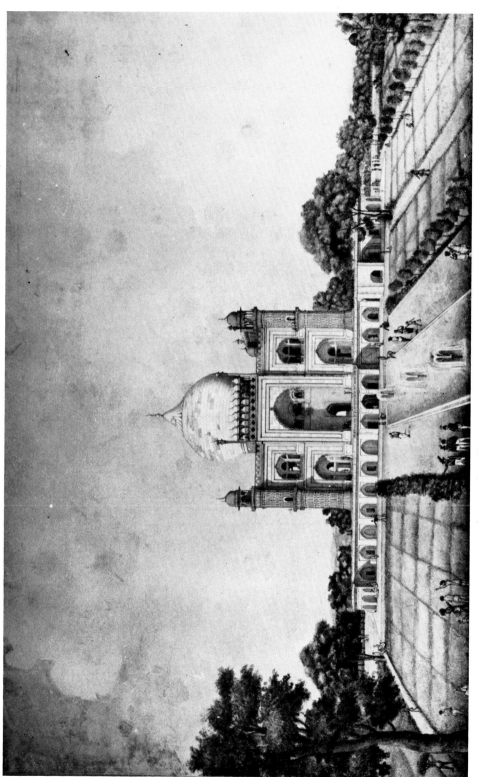

67 Mausoleum of Safdar Jang, Delhi. Delhi or Agra, *c.* 1820–22

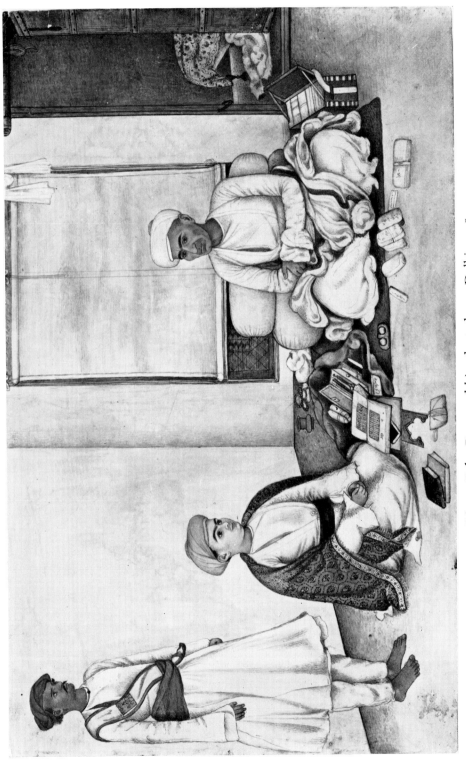

68 Diwan Babu Ram and his adopted son. Delhi, *c.* 1825

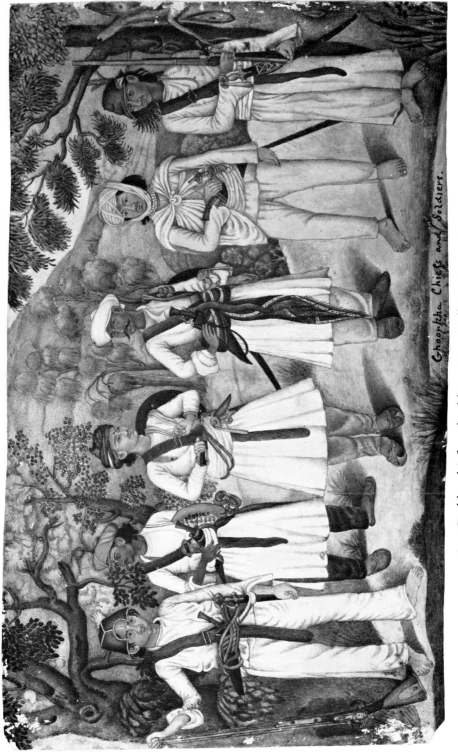

Ghoorkha Chiefs and Soldiers.

69 Gurkha chiefs and soldiers. By a Delhi artist, c. 1815

71 Bodyguard of Ranjit Singh. Punjab, c. 1838–39

70 Oil-press. Kashmir, c. 1850–60

72 Post-runner. By Kapur Singh, Amritsar, 1866

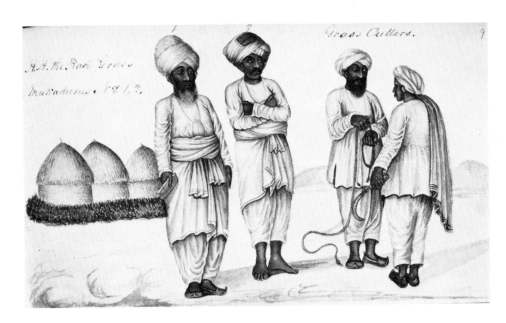

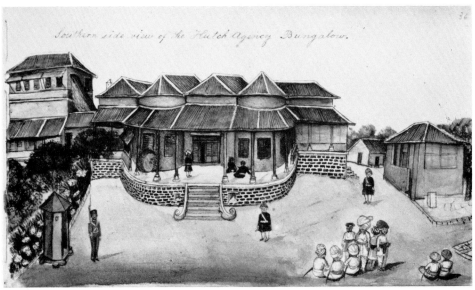

73 Contractors and grass-cutters. Cutch, 1856
74 Cutch Agency Bungalow. Cutch, 1856